Johan Liss

Amor Vincit · The Cleveland Museum of Art, Leonard C. Hanna Jr. Bequest [A 29]

JOHANN LISS

Exhibition

under the protectorate of the President of the German Bundestag
Frau Annemarie Renger,
the International Council of Museums (ICOM),
and supported
by the
National Endowment for the Arts, Washington

Augsburg
Exhibition in the Rathaus, Maximilianstrasse 1
August 2 to November 2, 1975
Open daily 10 am – 6 pm
Wednesday, Friday, Saturday 10 am – 9 pm

Johann Liss Exhibition in The Cleveland Museum of Art
December 17, 1975 – March 7, 1976
Museum hours: Tuesday, Thursday, Friday 10 am to 6 pm
Wednesday 10 am – 10 pm, Saturday 9 am – 5 pm, Sunday 1 pm – 6 pm

Printed in Germany · Typeface: Lino-Garamond-Antiqua
by Presse-Druck- und Verlags-GmbH Augsburg
ISBN 0–910386–25–0
Library of Congress Catalogue Card Number 75–34907

*In Memory
of Wolfgang Stechow
1897–1974*

The exhibition is partially supported by a grant from the National Endowment for the Arts, Washington, as well as by the German Federal Ministry of the Interior, the Bavarian State Ministry for Education and Culture, the District of Swabia, the Deutsche Städtetag and the City of Augsburg.

Dear Dr. Lee:

The President and Mrs. Ford have asked me to express their great pleasure at the opening of the very significant Johann Liss Exhibition. Recognition of the work of the European baroque master is a timely event. Of equal consequence, however, is the collaboration between The Cleveland Museum of Art and the Städtische Kunstsammlungen of Augsburg, Germany. We can all rejoice in a cultural effort which reaches around the world, from Cleveland, Ohio, to Augsburg, Germany, and which draws upon work from the museums of twelve countries. I can think of no greater force for international understanding and cooperation than a collaboration such as this exhibition.

The National Endowment for the Arts is pleased and proud to have assisted in making the Johann Liss Exhibition possible. This event will touch many people – the dedicated museum staffs from many countries who have worked to make this occasion possible, and the numerous citizens of Germany and the United States whose understanding of Johann Liss will be enhanced by the event.

On behalf of the President and Mrs. Ford, I send best wishes for the success of this fine exhibition.

Sincerely,
Signed: Nancy Hanks
Nancy Hanks
Chairman
National Endowment for the Arts
Washington, D. C.

Table of Contents

Preface

A Liss exhibition does not happen as a simple matter of course. Unlike Rubens, this painter from the northernmost part of Germany who spent his short life far from home, in Haarlem, Amsterdam, Antwerp, Paris, Rome, and Venice, does not count among the giants in art. His works, as far as they are still in existence, are few. They comprise approximately forty paintings, and even fewer drawings. Most of them are in German and Italian possession. Three of his paintings and one drawing are in the United States.

These and similar circumstances may explain why no exhibition of his work, neither of his paintings nor of his graphic art, has yet been assembled. No anniversary celebration, which often prompts such exhibitions, offers itself. None of the countries where Liss spent his wandering life claims him as «one of theirs.» He was, more than any of his contemporaries, a truly European painter. His art sprang from the inexhaustible traditions of all of Europe. It owes as much to the old art of printmaking in Germany and the Netherlands as to the genre painters of Haarlem, to the sensuous art of Rubens and the vitality of Jordaens, to the realism of Caravaggio and Fetti; no less to Elsheimer's responsiveness to nature than to the Venetian High Renaissance's delight in color. Yet all his works betray an obstinate striving for artistic independence, an unquenchable thirst for genuine experience: qualities which, much to the displeasure of his biographer, Joachim von Sandrart, caused him to neglect the models of classical antiquity. His constantly regenerating vitality and keen intellect brought his art into full bloom in a few short years. Without ever denying his sources of inspiration, he quickly developed his own world of images and his own pictorial language, which numerous later generations continued to find worthy of admiration, even imitation. The unusually large number of autograph repetitions and those by other artists speaks highly of his art. His most personal achievement lies in a realm which, rightfully, escapes verbal description: in the poetic mood of his imagery and the wondrous beauty of his colors. Therein lies the explanation of the extraordinary influence his art exerts until well into the eighteenth century, not only in Italy, the Netherlands, and France, but also in countries where he had never been active, notably Germany and Austria. This lasting effect upon contemporaries and later generations alike determines his high rank in the history of art.

The exhibition addresses itself, above all, to the friends of great painting, the connoisseurs

9

of Baroque universality, the lovers of joyfully sensuous pictures, the explorers addicted to the discovery of hidden meanings and to all those receptive to the whispered language of musical color tones. For them, it will be a memorable event to see united in this exhibition a group of masterworks never before gathered together in one place. There still remain many points to be clarified concerning the extent, origin, and dates of his works. We are still as uncertain about the early life of Johann Liss as we are about distinguishing between replicas by the artist himself from the numerous copies by other artists. We may expect to gain a more distinct and lively image of Liss. A considerable number of German and American museums have rich holdings in Venetian art, mainly of the eighteenth century. Surely it will be illuminating to discover how liberally Liss contributed to the development of Venetian painting. He provides, indeed, the crucial link between Venetian art of the sixteenth and of the eighteenth centuries.

German art historians anticipate the exhibit with particular expectations. They will wish to seek out the «specifically German element» (to use a much abused expression) in Liss's art. Does German Baroque painting share some of the characteristics which make Liss's unmistakable style so different from the art of his host countries? Can the idiosyncrasies of his art be explained as being the stamp of his birth place, or a consequence thereof? Or are they contained solely in the depths of his own genial personality?

The idea of organizing a comprehensive Liss exhibition was conceived independently at three different places and times. This, perhaps, is the best indication that its time is ripe. Ann Tzeutschler Lurie began to ponder it as early as 1966, prompted by the unforgettable Berlin exhibition, German 17th-Century Painters and Draftsmen. Her idea was particularly well received by Rüdiger Klessmann, one of the collaborators of that exhibition, since he himself independently is working on a new monograph on Liss. Meanwhile, at Augsburg, the German Baroque Gallery had, since its inception in 1970, felt honor-bound to eventually dedicate a special exhibition to Johann Liss, a German Baroque painter, too little known in his homeland, and yet of such European stature. The Georges de La Tour exhibition of 1972, in Paris, did much to confirm the Augsburg Museum's intentions.

Subsequent discussion went on for almost three years, clearing the way for this joint venture, organized in close technical and art historical cooperation between the museums of Cleveland and Augsburg. The exhibition catalogue was compiled by Ann Tzeutschler Lurie and Louise S. Richards of the Cleveland Museum of Art together with Rüdiger Klessmann of the Herzog Anton Ulrich-Museum in Braunschweig who generously contributed the results of the long years of his research on this painter. The exhibition only includes those works which in the opinion of the authors are autograph works by Johann Liss or should at least be brought up for discussion. The individual catalogue texts are signed with the initials of the authors. Rolf Biedermann of the Städtische Kunstsammlungen in Augsburg is responsible for Section E in the catalogue devoted to the material of the study exhibition. Cleveland was responsible for all loan formalities.

Initial inquiries sent to museums, collectors, connoisseurs and art historians met with an unexpectedly positive response. But there still remained the huge problem of putting the idea into practice. Expenses, too high to be absorbed by one museum alone, would

obviously have to be shared. Given the increased risk of sending loan objects to not only two different cities but two separate continents, refusals, reservations and restrictions on the lenders' part – and most certainly high fees and insurance rates – had to be reckoned with from the start. We acknowledge all the more gratefully that most of our loan requests were met with understanding. Though a few works could not be secured for either the Augsburg or the Cleveland showings, and can therefore only be mentioned and reproduced as «desiderata» in the appendix to the catalogue, the exhibition includes the most essential part of Liss's works, comprising paintings, drawings, and authentic etchings. It also includes a small selected group of drawings and prints documenting lost originals by Johann Liss and his influence on other painters. A special section illustrates, by means of enlarged photographs, the most important phases in Liss's life, the places and personalities that marked his development, the sources he used, and the impact he made. We thus hope to make accessible even to the casual exhibition visitor and to those unfamiliar with art history, the richly-colored world of images which sum up the accomplishment of Liss's short life.

We extend our special thanks to those authorities in the USA and the German Federal Republic who made this event possible, and even lent their financial support. We are particularly indebted to the National Endowment for the Arts in Washington, D. C., USA, and, within Germany, to the Federal Ministry of the Interior, the State of Bavaria, the Regional Diet of Swabia, the Diet of German Cities, and above all, to the City of Augsburg whose official in charge of cultural affairs, Arthur Vierbacher, has been of invaluable assistance. The International Council of Museums (ICOM) has once more offered its patronage, thereby acknowledging the exhibition's international stature. We consider it a special honor to be granted the patronage of Frau Annemarie Renger, President of the Deutsche Bundestag. Lack of space prevents us from thanking separately all the many generous individuals and institutions instrumental in bringing this exhibition about. Their names are listed among our acknowledgments of sponsors, advisors and lenders.

Collective thanks must be given to the staff at both the Cleveland and Augsburg museums, whose selfless diligence surmounted the unexpected difficulties and extra problems of showing the exhibition on two continents. We are also grateful to our publisher, the Presse-Druck- und Verlags-G. m. b. H. Augsburg, for the punctual and careful printing of the catalogue and the illustrations.

Bruno Bushart · Sherman E. Lee

List of Lenders

Amsterdam, Rijksprentenkabinet (Director, Dr. J. W. Niemeijer)
Augsburg, Städtische Kunstsammlungen (Director, Dr. Bruno Bushart)
Berlin, Staatliche Museen Preussischer Kulturbesitz Gemäldegalerie
 (Director, Prof. Dr. Henning Bock)
Berlin, Staatliche Museen Preussischer Kulturbesitz Kupferstichkabinett
 (Director, Prof. Dr. Matthias Winner)
Braunschweig, Herzog Anton Ulrich-Museum (Director, Dr. Rüdiger Klessmann)
Bremen, Kunsthalle Bremen (Director, Dr. Günter Busch)
Bremen, Ludwig Roselius Collection of Böttcherstrasse (Director, Edgar H. Puvogel)
Bremen, Private Collection
Budapest, Szépmüvészeti Múzeum (Director, Dr. Klara Garas)
Buenos Aires, Marie E. B. Harteneck Collection
Cambridge, Fitzwilliam Museum (Director, Michael Jaffé)
Chicago, The Art Institute of Chicago (Director, E. Laurence Chalmers, Jr.)
Cleveland, The Cleveland Museum of Art (Director, Dr. Sherman E. Lee)
Cologne, Wallraf-Richartz-Museum (Generaldirector, Dr. Gerhard Bott)
Dresden, Staatliche Kunstsammlungen, Gemäldegalerie Alte Meister
 (Generaldirector, Prof. Dr. Manfred Bachmann)
Dublin, National Gallery of Ireland (Director, James White)
England, Private Collection
England, Private Collection
Florence, Galleria degli Uffizi (Director, Prof. Luciano Berti)
Hamburg, Hamburger Kunsthalle, Kupferstichkabinett (Director, Dr. Eckhard Schaar)
Honolulu, Honolulu Academy of Arts (Director, James W. Foster, Jr.)
Innsbruck, Tiroler Landesmuseum Ferdinandeum (Director, Hofrat Dr. Erich Egg)
Karlsruhe, Staatliche Kunsthalle (Director, Prof. Dr. Horst Vey)
Kassel, Staatliche Kunstsammlungen (Director, Prof. Dr. Erich Herzog)
Lille, Musée des Beaux-Arts (Director, Hervé Oursel)
London, British Museum (Director, Sir John Pope-Hennessy)
London, Denis Mahon

London, National Gallery (Director, Michael Levey)
London and Paris, Dr. Efim Schapiro
Moscow, Pushkin Museum of Fine Arts (Director, Irina Antonova)
Munich, Bayerische Staatsgemäldesammlungen (Generaldirector,
 Prof. Dr. Erich Steingräber)
Munich, Staatliche Graphische Sammlung (Director, Dr. Herbert Pée)
Naples, Palazzo Reale (Soprintendente, Prof. Raphaello Causa)
New York City, M. Knoedler & Co.
Nürnberg, Germanisches Nationalmuseum (Generaldirektor, Dr. Arno Schönberger;
 Director, Dr. Peter Strieder)
Pommersfelden, Schloss Weissenstein, Dr. Karl Graf von Schönborn-Wiesentheid
Schweinfurt, George Schäfer Collection
Switzerland, Private Collection
The Hague, Lent by N. N. Collection
The Hague, Rijksdienst voor Roerende Monumenten (Rijksinspecteur voor Roerende
 Monumenten, Dr. R. R. de Haas)
Venice, Galleria dell'Accademia (Soprintendente, Prof. Francesco Valcanover)
Venice, Museo del Settecento Veneziano di Ca' Rezzonico (Director, Prof. Terisio Pignatti)
Venice, S. Nicolò da Tolentino (Presidente della Pontificia Commissione per l'Arte Sacra
 in Italia, His Eminence Bishop Giovanni Fallani, Rome
Vienna, Gemäldegalerie der Akademie der Bildenden Künste
 (Director, Dr. Heribert Hutter)
Vienna, Graphische Sammlung Albertina (Director, Hofrat
 Prof. Dr. Walter Koschatzky)
Vienna, Kunsthistorisches Museum (Director, Dr. Friderike Klauner, W. Hofrat)
Washington, D. C., National Gallery of Art (Director, J. Carter Brown)

Acknowledgments

Irina Antonova, Director, Pushkin Museum of Fine Arts, Moscow
Giulio Carlo Argan, Consiglio Superiore della Antichità e Belle Arti, Rome
Pamela Askew, Vassar College, Poughkeepsie, New York
Manfred Bachmann, Director, Staatliche Kunstsammlungen, Dresden
Adrian Baird, London
Jacob Bean, Curator of Drawings, Metropolitan Museum of Art, New York
Maria Becker, Librarian, Zentralinstitut für Kunstgeschichte, Munich
Sylvie Beguin, Conservateur, Service d'Etude et de Documentation des Peintures,
 Musée du Louvre, Paris
Penelope B. Benson, College of Wooster, Wooster, Ohio
Pater Eugen Berthold OFM, Franziskanerkloster, Vienna
Luciano Berti, Director, Galleria degli Uffizi, Florence
Peter Beye, Director, Staatsgalerie Stuttgart
Rolf Biedermann, Oberkonservator, Graphische Sammlung, Städtische Kunstsammlungen
 Augsburg
Herbert N. Bier, London
Per Bjurström, Curator of Prints and Drawings, Nationalmuseum, Stockholm
Vitale Bloch, Paris
Julius Boehler, Munich
Thomas Brachert, Germanisches Nationalmuseum, Nürnberg
British Museum Library, London
Rainer Budde, Wallraf-Richartz-Museum, Cologne
Günter Busch, Director, Kunsthalle Bremen
Janet Byrne, Curator, Prints and Photographs, Metropolitan Museum of Art, New York
Marco Chiarini, Director, Galleria Palatina, Pitti Palace, Florence
Malcolm Cormack, Fitzwilliam Museum, Cambridge
Courtauld Institute of Art Library, London
Victor Covey, Chief Conservator, National Gallery of Art, Washington, D. C.
Sanna Deutsch, Registrar, Honolulu Academy of Arts
His Eminence Bishop Giovanni Fallani, Presidente della Pontificia Commissione per
 L'Arte Sacra in Italia, Rome

Oreste Ferrari, Direzione Generale delle Antichità e Belle Arti, Rome
Anna Forlani-Tempesti, Director, Gabinetto Disegni e Stampi, Uffizi, Florence
Frick Art Reference Library, New York
Jacques Fryszman, Boulogne-sur-Seine
Leonhard Gans, Konservator, Hilterfingen
Klara Garas, Director, Szépmüvészeti Múzeum, Budapest
Elizabeth E. Gardner, Curator, European Paintings, Metropolitan Museum of Art,
 New York
Bruno Gebhard, Director Emeritus, Cleveland Health Museum
Heinrich Geissler, Hauptkonservator, Graphische Sammlung, Staatsgalerie Stuttgart
J. A. Gere, Keeper, Department of Prints and Drawings, The British Museum, London
Katalin Görbe, Museum der Bildenden Künste, Budapest
Berthold Hackelsberger, Städtische Kunstsammlungen, Augsburg
Francis Haskell, University of Oxford, England
Bruno Heimberg, Doerner-Institut, Munich
Günther Heinz, Kunsthistorisches Museum, Vienna
Julius S. Held, Old Bennington, Vermont
Christian von Heusinger, Kupferstichkabinett, Herzog Anton Ulrich-Museum,
 Braunschweig
Christian von Holst, Kunsthistorisches Institut, Florence
Michael Jaffé, Director, Fitzwilliam Museum, Cambridge
Harold Joachim, Curator of Prints and Drawings, The Art Institute of Chicago
Walter Keim, Ministerialdirigent, Bayerisches Ministerium für Unterricht und Kultus
Rüdiger Klapproth, Staatsgalerie Stuttgart
Ekhard von Knorre, Oberkonservator, Staatliche Kunsthalle Karlsruhe
Wilhelm H. Köhler, Oberkustos, Staatliche Museen Preussischer Kulturbesitz
 Gemäldegalerie, Berlin
Ora Kohn, Cleveland, Ohio
Gode Krämer, Städtische Kunstsammlungen, Augsburg
Alexandra Kuby, Cataloguer, Cleveland Museum of Art Library
Rolf Kultzen, Oberkonservator, Bayerische Staatsgemäldesammlungen, Munich
Friedrich Lahusen, Oberkustos, Staatliche Kunstsammlungen, Kassel
Ruth Fine Lehrer, Curator, Alverthorpe Gallery, Pennsylvania
Michael Liebmann, University of Moscow
Denis Mahon, London
MAS, Barcelona
Mrs. John Edward Massengale, Noroton, Connecticut
Anneliese Mayer-Meintschel, Kustos, Staatliche Kunstsammlungen, Dresden
Kurt Meissner, Zürich
Ulrich Middeldorf, Director Emeritus, Kunsthistorisches Institut, Florence
Michael Milkovich, Director, University Art Gallery, State University of New York
 at Binghamton
Bruce Miller, Intermuseum Laboratory, Oberlin College, Ohio

Alfred Moir, University of California, Santa Barbara
Laura Neagle, Cleveland, Ohio
J. W. Niemeijer, Director, Rijksprentenkabinet, Rijksmuseum, Amsterdam
Konrad Oberhuber, Consultant, Department of Prints and Drawings, National Gallery
 of Art, Washington, D. C.
Lisa Oehler, Kustos, Staatliche Kunstsammlungen, Kassel
Hervé Oursel, Director, Musée des Beaux-Arts, Lille
Dimitrios Papastamos, Director, National Pinacothek, Athens
Karel Paukert, Curator of Musical Arts, The Cleveland Museum of Art
Ann Percy, Associate Curator for Drawings, Philadelphia Museum of Art
Terisio Pignatti, Musei Civici Veneziani d'Arte e di Storia, Venice
Robert Purrmann, Starnberg
Edgar H. Puvogel, Director, Ludwig-Roselius-Sammlung, Bremen
Elio Rambaldi, Cleveland, Ohio
Charles Reeves, Chairman, Classics Department, Case Western Reserve University,
 Cleveland, Ohio
Rijksbureau voor Kunsthistorische Documentatie, The Hague
David Rosand, Columbia University, New York
Pierre Rosenberg, Conservateur des Peintures, Musée du Louvre, Paris
Elizabeth E. Roth, Acting Chief, Division of Prints, New York Public Library
Anna Moffo Sarnoff, New York
Eckhard Schaar, Hauptkustos, Hamburger Kunsthalle
Efim Schapiro, London and Paris
Erich Schleier, Kustos, Staatliche Museen Preussischer Kulturbesitz Gemäldegalerie, Berlin
Werner Schmidt, Director, Kupferstichkabinett, Dresden
Annegrit Schmitt, Staatliche Graphische Sammlung, Munich
Karl Graf von Schönborn-Wiesentheid, Schloss Weissenstein, Pommersfelden
Count Antoine Seilern, London
Barbara Shapiro, Curatorial Assistant, Department of Prints and Drawings,
 Museum of Fine Arts, Boston
Kay Silberfeld, Conservator of Paintings, National Gallery of Art, Washington, D. C.
Seymour Slive, Harvard University, Cambridge, Massachusetts
Richard Spear, Oberlin College, Ohio
Nicola Spinosa, Museo e Gallerie Nazionali di Capodimonte, Naples
Mildred Steinbach, Librarian, Frick Art Reference Library, New York
Kurt Steinbart, Rome
Erich Steingräber, Generaldirector, Bayerische Staatsgemäldesammlungen, Munich
Charles Sterling, Honorary Curator, Musée du Louvre, and Professor Emeritus,
 Institute of Fine Arts, New York University
Julien Stock, Sotheby & Co., London
Dr. Peter Strieder, Director, Germanisches Nationalmuseum, Nürnberg
Alice Strobl, Kustos, Graphische Sammlung Albertina, Vienna
M. H. Takács, Kustos, Szépmüvészeti Múzeum, Budapest

16

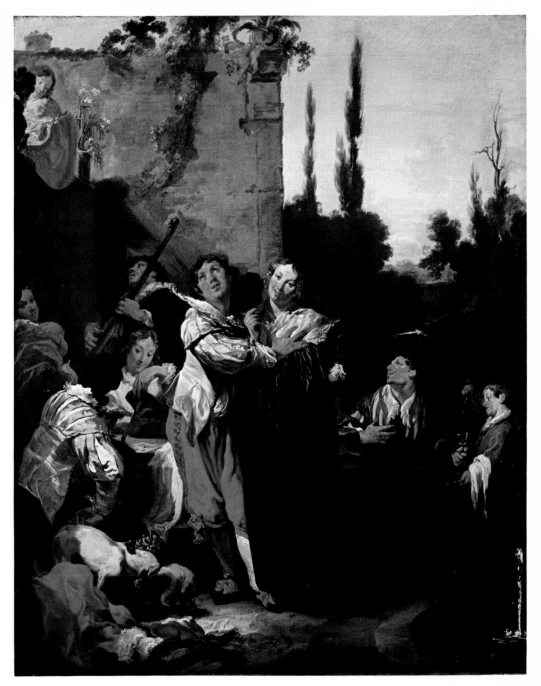

I The Prodigal Son [A 12]
 Gemäldegalerie der Akademie der Bildenden Künste, Vienna

Gunther Thiem, Director, Graphische Sammlung, Staatsgalerie, Stuttgart
Francesco Valcanover, Director, Gallerie dell'Accademia, Venice
Charlotte van der Veer, Cleveland, Ohio
Angelo Walther, Kustos, Gemäldegalerie Alte Meister, Staatliche Kunstsammlungen, Dresden
Z. J. F. Wejsenbeek, Director, Gemeentemuseum, The Hague

Exhibition Committees

CHAIRMANSHIP
Rolf Biedermann
Bruno Bushart
Rüdiger Klessmann
Sherman E. Lee
Ann Tzeutschler Lurie
Louise S. Richards

AUTHORS
Essays
Bruno Bushart, Liss and German Art
Rüdiger Klessmann, Johann Liss – His Life and Work
Ann Tzeutschler Lurie, Liss in Venice
Louise S. Richards, Drawings and Prints

CATALOGUE ENTRIES
Rüdiger Klessmann: Cat. nos. A 1–A 7, A 13–A 27, A 41
Ann Tzeutschler Lurie: Cat. nos. A 8–A 12, A 28–A 40
Louise S. Richards: Cat. nos. B 42–B 56, C 57–C 68

TRANSLATORS
Ursula Korneitchouk: Preface, cat. nos. A 2, A 4–A 8, A 13–A 15, A 17, A 19–A 24, A 26
 to A 27, B 42–B 56, C 57–C 68 and essay by Louise S. Richards
Hannelore Osborne: Cat nos. A 1, A 3, A 9–A 12, A 16, A 18, A 25, A 28–A 41 and essay
 by Rüdiger Klessmann and Ann Tzeutschler Lurie
Harald S. Tzeutschler: Essay by Bruno Bushart

EDITORS
Norma Roberts, Jean K. Cassill, Prof. Klaus Hinze (Cleveland State University),
 Rolf Biedermann, Berthold Hackelsberger, Gode Krämer

18

Exhibition Committee Augsburg

Director: Bruno Bushart
Planning: Bruno Bushart, Berthold Hackelsberger
Assistants: Bodo Beier, Rolf Biedermann, Gode Krämer
Audio-Visual Program: Bodo Beier, Gode Krämer
Technical Director: Berthold Hackelsberger
Technical Assistants: Michael Bieberstein, Franz Kager, Johann Otto, Jürgen Winkler,
 Alwin Wörz
Conservation: Bodo Beier, Michael Bieberstein
Administration: Wilhelm Rehm, Gerhard Leirich
Secretaries: Hannelore Kollmar, Gertrud Kribel, Veronika Schmaus
Photography: Stadtbildstelle Augsburg, Hans Bommer, Margot Konrad, August Beiser
Posters: Alois Eberle, Leo Weber
Advertising and Press: Anton Kribel, Hermann Lamprecht, Heiner Seybold,
 Ludwig Wegele †
Security: Franz Bayr, Josef Korschinsky, Rudolf Wilke

Exhibition Committee Cleveland

Director: Sherman E. Lee
Planning: Ann Tzeutschler Lurie, Louise S. Richards

Research:

Nancy Coe Wixom, Research Assistant, Paintings Department
Hannelore Osborne, Assistant, Paintings Department
Jean K. Cassill, Research Assistant, Paintings Department
Ross Merrill, Conservator of Paintings
Daphne Cross Roloff, Head Librarian
Georgina Gy. Toth, Associate Librarian for Reference

Education:

Gabriel P. Weisberg, Curator of Art History and Education
Janet L. Mack, Assistant Curator in charge of Extension Exhibitions

Johann Liss – His Life and Work

Johann Liss, the painter from Holstein, is one of art history's belated discoveries. As in the case of France's Georges de La Tour or Holland's Hendrik Terbrugghen, he is being rediscovered after centuries, although his traces had never actually been lost. His name is not mentioned in Georg Dehio's *Geschichte der deutschen Kunst* (Berlin, Leipzig, 1931), nor is it to be found in older handbooks.

This may result partly from the fact that – due to an erroneous tradition going back to the Dutch chronicler Feyken Rijp – Liss had long been considered a Dutch painter, and that the major part of his works originated on Italian soil. Netherlandish and Italian elements are indeed the essential factors which shaped Liss's art. Yet it appears hardly conceivable that anyone could mistake a painting by Liss for the work of a Flemish or Dutch master. His art is so imbued with a Romanic spirit that most Italians count him among the exponents of the Venetian School.

Seventeenth-century Germany produced but few forces capable of stimulating the development of European art. There are only three early Baroque painters who stand out from the multitude of master artisans integrated into local schools, and who held their own in the contest of artistic forces outside Germany; Adam Elsheimer, Johann Liss, and Johann Heinrich Schönfeld. All three needed the exposure to Italy before their individuality could unfold.

The biographies of Elsheimer and Liss show striking parallels. Both went south in their youth and found their permanent field of action in Venice and Rome. Both died an untimely death, still in their early thirties, without ever having seen their homeland again. Elsheimer's importance can hardly be overrated. Though he left few works, their impact was crucial for the history of European painting, and they influenced equally such different artists as Rubens and Rembrandt. Perhaps his significance was more readily acknowledged as he revealed himself to be the heir of Germany's old artistic tradition in which his concept of nature was rooted.

Liss, from Holstein, found himself in an entirely different starting position. He hailed from a province which, in contrast to South Germany, had no artistic tradition of its own. He first confronted the international art scene upon his arrival in Holland. This explains the groping quality and the surprising contradictions of his early works, as well as his almost extreme eagerness to embrace the latest trends of European painting, at times to

the point of leading the avant-garde. Compared to the older Elsheimer, whom he equalled in talent, Liss thus appears as the more progressive artist who exerted a more direct influence on succeeding generations.

Almost all data on Liss's life and work are missing. Even the years of his birth and death must be inferred. We owe nearly all that is known about the painter to Joachim von Sandrart's highly personal report of his visit to Venice in 1629, where he was Liss's house guest. This vivid account – an account to which later historians found very little to add – still represents the most important source for our knowledge of the works and development of this painter from Holstein. Unfortunately, his name has been confused almost from the start with the identical or similar names of other Dutch artists, so that later references tend to complicate rather than clarify the issue. If we compare Sandrart's account, which gives no dates, with the essentially acceptable, hypothetical chronology proposed by Kurt Steinbart in 1940, the following picture emerges:

The painter was born around 1597 in the Oldenburg area north of Lübeck, «a remote region from where, to our knowledge, no artist of our profession has ever come forth,» as Sandrart remarked. His origins can only be guessed. Perhaps his father was a painter in the service of the Holstein dukes, for there is proof of a Schleswig painter, Johann Liss, who decorated banners for his sovereign, and whose wife also worked as a painter. The son could have received his first instruction in the workshop of this artist couple before setting out for the Netherlands. Between approximately 1615 and 1619, Liss seems to have been in Haarlem, Amsterdam, and Antwerp. Sandrart observed that during this period Liss emulated the style of Hendrick Goltzius, though it remains doubtful whether the young artist visited the workshop of the famous master, who died in 1617. Liss then went to Paris, and on to Venice where he must have arrived no later than 1621, as the inscription of a drawing [B 48] in Hamburg attests. By 1622, he probably had already reached Rome, where, in Sandrart's words, he adopted «an entirely different manner.» He must have stayed in Rome for a considerably longer period of time than previously assumed, or he would hardly have been admitted to the «Schilderbent,» an association of Northern painters active in Rome.

In the mid- to late twenties (his name only appears on the lists of the painters' guild in 1629), he settled in Venice, possibly in order to execute the famous altar painting [A 39] for the church of S. Nicolò da Tolentino. This is the only painting known to have been officially commissioned from Liss and therefore constitutes the safest point of reference. Soon thereafter, Liss fell victim to the plague, which raged in 1629 but subsided in the following year. Thus, the painter must have died no later than 1630.

In view of the works he left us, one is amazed to realize that his life comprised no more than fifteen productive years as an artist. In this short span, Liss underwent an extraordinary evolution – an evolution which constantly absorbed new impulses and integrated them into his own style. Such an impetuous development remains unparalleled, even among the Netherlandish artists of his generation. The so-called late works of this painter, who died so young, are not only far removed from his own early Dutch style, but also several decades ahead of the style of his contemporaries. He has, therefore, always been judged by his late works which infused new life into the tradition-rich culture of Venetian

painting and which continued to be highly admired by painters who, in the eighteenth century, lived in Italy or traveled there. Sandrart himself, who visited his compatriot shortly before the latter's death, saw in Liss mainly the admirer of Titian, Tintoretto, Veronese, and Fetti. Thus, Germany's first art biographer early coined the image of the Venetian painter from German stock.

The art historical rediscovery of Liss began some sixty years ago, along with the awakening of a general appreciation of Baroque art, and with a stronger interest in national artistic achievements. Thus, Theodor von Frimmel, Wilhelm Bode, and Rudolf Oldenbourg became chiefly responsible for drawing attention to the painterly high qualities of this Holstein artist who had, until then, been taken for a Dutchman.

Works painted in Venice, or kept in Venetian collections, and which had already been described by Sandrart (1675), or were listed in older guide books of the city, constituted the point of departure for research on Liss. It is noteworthy that most Liss paintings recorded in eighteenth-century collections were, at the time, also given their correct attribution, and that they had been erroneously re-attributed at some later date when direct knowledge of Liss's style had become lost. Most Liss paintings which have entered our museums in more recent times were acquired under the names of other Netherlandish or Venetian masters. Our great picture galleries mustered only a reluctant interest in this German master (Budapest 1908, 1916; Berlin 1919; Vienna 1923; Dresden 1925; London 1931). On the other hand, only a very few paintings from Liss's small oeuvre had remained available. Due to the high esteem in which they had formerly been held, many significant Liss paintings had long found their permanent home in the princely collections of old (Florence, Pommersfelden, Kassel, Vienna).

Erroneous attributions of the past mislead the Liss research repeatedly. Already in the seventeenth century, some paintings by Domenico Fetti – including his Vienna *Flight into Egypt* – were mistaken for originals by Liss. The *Lute Player* in Dresden, presently ascribed to Ludovicus Finson, was to play an unfortunate part in this respect. In 1744, this picture came from Venice to Dresden as a work by Liss, and it was long thought to typify the German master's style, even though it pointed in the wrong direction. Based on the proven, or assumed, Liss attributions of the time, all of which documented the painter's late style under the influence of Venice, it was inevitably concluded that «he belonged indeed in Venetian art history, not in the Dutch» (Oldenbourg). This partial truth has obscured the painter's artistic origins up to this day. In his books of 1940 and 1946, Steinbart still adheres to the opinion that almost all known Liss paintings were done in Venice.

In the last three decades, the publication of some unknown or neglected works by Liss has reactivated the inquiry into his artistic beginnings and development. His *Painter in Her Studio* [A 1] pointed to his early period in Haarlem, and the *Satyr and Peasant* [A 9, A 10] to his close relationship with Jordaens; his *Venus and Adonis* [A 25] on copper moved him within the circle of Elsheimer followers; his *Fall of Phaeton* [A 26] and *Bathing Nymphs* [A 27] revealed the little known aspect of his interest in landscape. Of late, two important half-figure paintings have attracted the attention of the researchers – the representations of the dying *Cleopatra* [A 18] and of the youthful *Amor* [A 29].

Although these recently published paintings have been duly acknowledged by scholars, Steinbart's proposed chronology has never been challenged. Yet the Berlin exhibition of 1966, dedicated to German Baroque painters, and including a representative selection of works by Liss, showed clearly that a fresh look at Liss's artistic formation is in order. This realization has prompted the author's attempt to sharpen the formal criteria for his early Netherlandish period, and especially for his activity in Rome, and to use them as a basis for dating. This exhibition affords a first opportunity to examine the new postulates and to discuss the resulting questions of style and chronology.

When young Liss arrived in Amsterdam and Haarlem around 1615/16, his «foundation in the art of painting» (Sandrart) was already laid. We do not know where he had obtained this instruction – presumably in the paternal workshop. The craft-oriented apprenticeship in his native Holstein probably placed emphasis on the careful copying from engraved models. Thus, it is not surprising that several paintings have come to us in which Liss drew inspiration from sixteenth-century prints. The interest in German art of old, which had never faded, saw a revival around 1600. Workshops used to preserve old prints in their pattern books; they may also have encouraged the use of extremely small engravings as models for large compositions. The meticulous line drawing characteristic of engraved miniatures differs oddly from the broadly applied brushstrokes and strongly contrasting colors of the oil paintings. Unlike his Netherlandish contemporaries, Liss rarely painted on wood panels. The relative dryness of his peasant pictures in Bremen, Budapest, and Nürnberg partly results from the coarse canvas primed with dark bolus. Liss may have derived this technique from the painting of banners and decorative ornaments which probably occupied an important place in the workshops of Holstein. The account books at the Court of Gottorf reveal that the painting couple Johann and Anna Liss – the assumed parents of Liss – supplied large amounts of painted banners and escutcheons in the years 1622 and 1649.

The early *Painter in Her Studio*, probably painted in Haarlem, differs from its Dutch models in the paste-like application of paint. Unlike the *Peasant* scenes, it seems to be an attempt at a picture «a la mode,» an allegorical subject which Sandrart would have assigned to the intellectual subjects. Its theme is chiefly inspired by Willem Buytewech; its manner of execution betrays, like no other work by Liss, the sphere of influence of Frans Hals. Yet no one would ever take it for a Dutch painting, perhaps not even for a work by Johann Liss, had his name not been transmitted by a contemporary engraving. The *Gallant Couple*, which exists in two versions and which also represents a Buytewech-inspired subject, indicates a progress in the artist's development; its composition is tighter, the means more subtle. All the same, interior paintings in the Dutch sense never were Liss's strong point. His figures in action always dominate the foreground, and this Flemish-Roman element was to assert itself increasingly.

With the *Satyr and Peasant*, painted in Antwerp and known in two versions, Liss achieved his first important painting composition of entirely individual character. Here he gave monumental form to a classical literary subject, much appreciated among the humanists, which had already found visual expression in sixteenth-century book illustrations. Jacob Jordaens represented this subject repeatedly, but seems to have borrowed the pictorial

invention. On the other hand, Jordaens lastingly influenced Liss's manner of execution, from the fluid application of paint down to characteristic details of brushstroke. This alone would be enough to date the German artist's stay in the city on the Schelde river around 1617/18. The coloring and popular language of the *Satyr* paintings witness Jordaens' proximity more directly than any other work. A chalk drawing, formerly attributed to Jordaens, documents this close relationship. It is a preparatory drawing for the *Satyr* composition and the only known head study by Liss.

Liss compressed the *Satyr* scene into a composition of half-length figures after the fashion of Antwerp's leading artists. In the works of Peter Paul Rubens, Abraham Janssens, and Jacob Jordaens, Liss first encountered the new realism propagated by the Roman painter Caravaggio, and his followers. This confrontation with his Flemish contemporaries prompted Liss's preference for large figure compositions and foreshadowed his development during the Italian years.

We do not know when Liss went to Italy. He seems to have left Antwerp before 1620. According to Sandrart, he first went to Paris before heading for Venice. So far, no evidence has been found for his presence in France. It bears mention, however, that some of Liss's works were reproduced by two engravers active in France, Nicolas de Son and Gilles Rousselet. The style and character of De Son's etching, *The Garden of Love* [C 62], do not exclude the possibility that it reproduces a Liss drawing made in Paris. Upon the arrival of the traveling German in Venice, in 1621, he jotted down a burlesque drawing on an album page which is reminiscent of Jacques Callot's manner. However, at the time, Callot had already been working in Italy for some years.

As far as we know, Venice was the painter's first stop on his way to Rome. The duration of his visit is open to conjecture. Among the few works we connect with this period is the *Morra Game* [A 13] of Kassel. It shows contact with the art of Domenico Fetti, who was active in Venice at about the same time as Liss. Fetti was then a court painter in the service of Duke Ferdinando Gonzaga of Mantua. His style must have impressed the young German at once, as confirmed by Sandrart. This encounter initially suppressed Liss's Jordaens-inspired Flemish realism – an interesting example of the detours possible in an artist's development. Domenico Fetti's gift for naive narrative revived Liss's memories of Haarlem. His *Morra Game* is a successful translation of the moralizing genre paintings of the North into the language of the South. The frivolous pleasures of Haarlem cavaliers turned into popular entertainment under the blue sky of Venice. Here, Liss followed Fetti's style in the formal aspects of composition and of luminous, serene color. Yet, he also integrated into his picture a Dutch content, thus adding a new ingredient to Venetian painting.

After he had settled in Rome, Liss aimed toward finding a new way to interpret the traditional Northern subjects. Undoubtedly, the large composition of *Soldiers and Courtesans* [A 15, A 16] could only have been created on Roman soil; with it Liss sought contact with the circle of Caravaggio followers. This painting, with its erotic candor, went beyond all boundaries of convention, and was probably responsible for his nickname «Pan» under which he entered membership in the Netherlandish «Schilderbent,» an association of Northern painters in Rome, which existed since about 1623.

This provocative picture by the young German, who wanted to exceed the protagonists

of Roman realism, must have created quite a stir. The effect it had on others, particularly in the Netherlands, is readily seen in copies and copper engravings. The painter himself made two versions of this composition, equal in quality, despite the large dimensions, which proves that interest and recognition existed among the collectors and buyers. The few known drawings by Liss convey an impression of how this composition of many figures was created. The composition combines substantial influences from Caravaggio and Valentin de Boullogne, who also influenced the color and painting technique. These influences overshadow the fact that this life-size picture still has its roots in the tradition of the Dutch conversation piece. In the figure of the young man sitting on the table, we recognize the prodigal son who squanders his inheritance with prostitutes.

In Netherlandish painting the artists liked to combine biblical parables with a warning of the dangers of sensual temptations. By dramatizing this aspect in his *Banquet of Soldiers and Courtesans*, Liss refers back to examples from the Haarlem circle. It is probably no coincidence that at least one of the two versions was found in a Dutch art collection only a few years after the painter's death. In the eyes of the Southern countries, the picture must have appeared to be an affront against decorum.

Both versions of *Soldiers and Courtesans* may be counted among the most significant achievements of German Baroque painting. Its close relationship to the Caravaggio circle has always been noted. Sandrart's remark that Liss had «taken on a different manner» was always interpreted in that sense. Steinbart was also of the opinion that it was primarily Caravaggio's realism which was responsible for Liss's development in Rome. Liss's stay in that city could only have been of a short duration since Roman elements otherwise play no part in Liss's oeuvre. Sandrart's remark that the painting had «very soon» returned to Venice was the final contributing factor in the claim that the *Soldiers and Courtesans* was Liss's only Roman achievement. Not only his works, but also the scarce news we have about him, speak against overemphasizing the Venetian aspect of his art. The fact that, on the one hand, Liss was a member of the «Schilderbent» in Rome, and on the other, that his name does not appear in the lists of the Confraternita dei Pittori – the brotherhood of painters in Venice – before 1629, should warn us to be careful. Is it a coincidence that the only patron who is mentioned in early sources was a member of a prominent Roman family? When mentioning Cardinal «Pamphilio,» Feyken Rijp could have meant the art-inclined Giovanni Pamphili, later Pope Innocent X. The exhibition may show that a group of varied works can be defined as a specific Roman phase, which differs clearly from the painter's last period in Venice.

The only documented work he had done in Rome is the *Stammbuch* leaf now in Cleveland, a pen drawing of an *Allegory of Christian Faith* [B 50]. It should be the starting point of all further research. The leaf is signed and the location marked, but unfortunately, the date is no longer legible. Since Liss was in Venice in 1621, the Roman leaf could have been executed in the following years.

The drawing style of the *Allegory* cannot be separated from the *Cephalus and Procris* [B 51] etching. The similarities in the modeling of the figures and the treatment of the draperies are so prominent, down to the singular drawn lines, that the etching could only have been done in Rome, and not, as was previously believed, in the Netherlands. Liss

painted a female figure, similar to that of Procris, in an *Annunciation* picture which is known to us only in an engraving by Abraham Blooteling. The movement of withdrawal, the turn of her head, her splayed hands, as well as the body-hugging drapery, are all echoed in the figure of Mary. However, the curly shapes in the fabric of the garments, so characteristic of Liss, were somewhat lost under the crude hands of the Dutch engraver, who is also responsible for the emptiness of the composition and the wooden stiffness of the figures. And yet, there is no doubt that the engraving goes back to a painting by Liss, and there is just as little doubt that Rome has to be considered as the place where Liss did this lost painting. Iconographically, the *Annunciation* picture is of a type close to Lanfranco's altar picture in S. Carlo ai Catinari in Rome. We cannot determine now whether the lost painting by Liss was also painted for an altar. The rather sparse interior seems to point more to a small painting which would have been more within reach of the engraver, from Amsterdam who obviously never was in Italy.

The lost painting may have had its closest parallel in the *Magdalene* [A 17] in Dresden. The angel approaching from the right may well have been similar to the one in the *Annunciation*. The close relationship of the *Magdalene* to the *Death of Cleopatra* in Munich permits us to count it among the Roman works of the painter.

The painting in Munich, which is close to the characteristic style of the *Allegory* in Cleveland and the *Cephalus* etching, follows the type of the Flemish-Caravaggesque half-figure pictures. His cool and smooth painting technique does not remind us as much of Jordaens as it does of Abraham Janssens and Rubens. Rubens' *Death of Artemisia* in Potsdam could also have influenced the composition. In the elegance of construction and in the fine differentiation of the psychological aspect and subject matter, the *Cleopatra* goes beyond her Flemish prototypes. Only through his Roman experience – and with it the Bolognese element of the Carracci – Liss's style was molded and he reached a new artistic dimension.

The fusion of Roman and Flemish elements mark the style of one of the major works by Johann Liss – his *Judith* [A 19] – which by its form and content has to be linked with the *Cleopatra*. Liss was obviously inspired by a painting by Rubens, now lost, which he could have seen in Antwerp. The painter uses half-figures to carry out the dramatic action and has changed the main character's position to a complete back view. This concentration on the form, characteristic of Liss, without doubt stems from similar depictions from the Caravaggio circle, as is witnessed, for example, in the *Judith* by Artemisia Gentileschi (Florence), where the back view of the maid is the main motif. Liss dares to come up with a rather unconventional solution when he has the heroine turn her back to the viewer, at whom she looks at the same time. In view of the blood-spurting body of Holofernes, her glance seems like a challenge to the viewer whom she invites to witness the deed.

Liss has painted several replicas of this picture in the same format; as far as we know, more than any other composition. The versions in London, Budapest, and Vienna are repeated with amazing exactness, which demands mastery in the technique of transcription. It speaks well for the artist that he did not lose any of the painterly structure or peculiarities of color in the process. According to an account by Sandrart, who lived with him, Liss must have been a loner who painted without a workshop in the traditional sense. The

almost frenzied way in which he worked is described by Sandrart in detail, and not without reproach. Liss was not the only one who repeated his own compositions. Others of his contemporaries are known to have done it too; Domenico Fetti, for instance, was particularly productive in this respect.

Steinbart thought that repeating his own paintings was a peculiarity of Johann Liss. This statement can only be accepted with caution. The same was once said about Adam Elsheimer; however, a critical survey of his oeuvre revealed that no repetitions by his own hand are now known. Many replicas in Liss's name will, in the future, have to be excluded from his oeuvre. In the majority of cases they are copies of the seventeenth and eighteenth centuries which speak for the popularity of the painter. The fame of the large altar painting of the *Vision of St. Jerome* [A 39] in S. Nicolò da Tolentino has been carried further by many artists. We do not have comparable criteria with which to identify the copies done by Liss himself. These can only be established by means of technical examinations, something this exhibition might well inspire. This applies particularly to determining the first version of a given composition. X-ray photographs have been used with success in the past.

The existence of replicas by Liss's own hand, prompted, we may assume, by interested patrons, points not only to the popularity of Liss's compositions, but also to his economic way of working. It even seems, in the case of his *Judith,* that he executed the replicas with greater time lapses in between. Among the few extant drawings by Liss, there are several *ricordi* in which the painter recorded his compositions either for the collector or himself. At times Liss fell back on singular groups or motifs of a certain painting to be used again in a new concept. It can be noted that more than once Liss compressed a composition which originally was arranged in a horizontal format into a vertical picture, which would always bring the image closer. We think that this kind of approach is also recognizable in the relationship of the painter to his artistic prototypes.

Joachim von Sandrart stressed that Liss mastered the old as well as the modern manner of painting and that he seemed «well versed in all.» How should we interpret this comment? No doubt Caravaggio's Roman realism, to which Liss had been exposed in Antwerp, is part of what Sandrart meant by the modern manner. The shocking brutality of his *Judith,* as well as the libertinism of the *Banquet of Soldiers and Courtesans* where they are «amusing themselves each one as he pleases, and living in sin,» document this style. In addition to these examples of Flemish-Roman realism, while in Rome, Liss created a completely different group of pictures, mostly of mythological subjects, nudes in southern landscapes – sometimes with an Arcadian mood. With such depictions, among them the *Cephalus* etching, Liss followed older, more classic traditions. In these paintings the influence from the Carracci circle is evident, as well as the artist's training in Dutch Mannerism. Sandrart probably visualized these paintings when he mentioned the «antique manner» of Liss. «Antique manner» should be understood in the sense of older tradition, since, as Sandrart adds, Liss did not study the art of antiquity.

The picture concept of the famous *Toilet of Venus* [A 28] in Pommersfelden, Liss's only painting on wood, is comparable to that of Goltzius' in, for example, his late drawing *Mars and Venus* in Braunschweig. The figure arrangement and the framing draperies are

similar in both painting and drawing, but compared to the manneristic composition of the drawing, the Pommersfelden painting appears more baroque, particularly by virtue of the dominant motif of the standing nude seen from the back. The figure modeling and brush-stroke echo Jordaens although there is no direct connection to him. Although Dutch and Flemish elements are woven into the picture, they are overshadowed by the Italian character of the painting. The major impression in the South on the Netherlandish-trained Liss must have come from Roman rather than Venetian art. The solid forms and the light color range of the Carracci molded the style of the Pommersfelden *Venus*. The iconographically similar conception by Annibale Carracci in his painting, in the National Gallery in Washington, points in the same direction. We are also reminded of the Carracci frescos, completed in 1604, in the Galleria Farnese in Rome, in which a similar mood prevails.

The subtle modeling of the nudes, and the concentration of diverging figures in a small space, are characteristic of the *Venus* composition which can also be found in a more manneristic work by Liss, the *Fall of Phaeton* [A 26]. When the painting was discovered almost three decades ago, it was attributed to Francesco Albani. In spite of the basically very different arrangements, the close stylistic connection between the two paintings cannot be overlooked. But now a new motif can be observed – a view into the depths of a river landscape. Probably triggered by the natural phenomenon of the waterfalls of Tivoli, Paul Bril and Cornelis van Poelenburg repeatedly painted this subject. The style of the latter particularly has influenced the landscape in the *Fall of Phaeton*. Liss does not seem to have had much experience in landscape painting; at least we do not have any examples from his early Netherlandish period. His mannerist figures do not convincingly tie into the expanse of space. Sandrart very rightly praised the «splendid manner» and the «delicately-painted landscape» of the *Fall of Phaeton,* without elaborating on the circumstances of its origin. Liss painted at least two paintings of this subject, one of which is supposed to have been in the Palazzo Pamphili in Rome. The recently discovered drawing in Braunschweig [B 53] draws our attention again to the significance of this subject in the oeuvre of the artist.

There are other works of his Roman period which reveal his concern with landscapes. A large-sized painting, unfortunately only preserved in a fragment, depicting bathing nymphs in a wilderness setting with groups of trees, points to woodland scenes by Paul Bril. The nudes, reminiscent of Domenichino and Albani, are exceptionally graceful and have some of the elegance of Correggio's figures. Compared to the latter, the *Venus and Adonis* [A 25] in Karlsruhe is more intimate and Netherlandish in its effect. The enamel-like, refined treatment of details again points to Poelenburg, while the composition of this copper panel may be traced back to Elsheimer. Sandrart believed that the small paintings by Liss – of two or three spans – were of superior quality to the others. He may have had the few, small copper panels in mind, in which Liss aligned himself with the famous Elsheimer.

If we draw our conclusions from these observations, we can group together about ten paintings, among these some large ones, and several graphics showing similar stylistic characteristics which are primarily dependent on the art of Rome. On the other hand, there are those paintings, quite different in character, which rather have Venetian traits.

Heretofore, these works, like the *Ecstasy of St. Paul* [A 38] in Berlin and the large altarpiece of S. Nicolò da Tolentino in Venice, have determined the image of this Holstein artist. The works of the Roman years reveal totally different influences. They show his exposure to the followers of Caravaggio, particularly Valentin, and the school of the Carracci, especially Albani, but also to the Northern landscape painters in Rome like Bril and Poelenburg. However, none of these influences replaced the foundations of his Northern schooling entirely. The great number of works of this period, and their Roman connections, prompts us to place greater emphasis on his Roman stay. In light of this, Liss could hardly have left that city much before 1625, leaving only a short span for his activity in Venice until his premature death in ca. 1630.

The paintings of Liss's last years show the loose and fluffy way of painting which characterize not only his mature style, but, in general, that of Venetian painting since Titian. It is only with these works in mind that we can properly interpret Sandrart's comment, namely that Liss followed the manner of Titian, Tintoretto, Veronese, and Fetti, above all the latter's. Fetti's influence asserts itself so strongly in some of his works, such as the *Decision of Hercules* [A 32] in Dresden, that one can almost describe it as a break in style, particularly when one compares these with the refined modeling in his painting during the years in Rome. We don't know when Liss left Rome or when he returned to Venice. Evidently he was considered an artistic follower of Fetti, who had already died in 1624. In Venice, Liss painted the *Ecstasy of St. Paul* as a pendant to a painting by Fetti, perhaps because Fetti died before completing his commission for the two paintings.

During his visit in Venice in 1629, Sandrart, together with Liss and the Flemish painter Nicolas Regnier, toured the churches and palaces in that city in order to see the works by Titian and Veronese. This is the only source which mentions such personal contact between Liss and another painter. Artistic ties have yet to be found between these two painters; Regnier had lived in Venice since 1626. All suggestions pertaining to their relationship do not go beyond features which they have in common that stem from the style of the period.

The *Ecstasy of St. Paul* could have given the monks of Nicolò da Tolentino the idea of commissioning Liss to paint his *Vision of St. Jerome*. This important commission – so we must assume – could only have been given to a Catholic artist. It is possible that the Protestant Holsteiner turned Catholic in Venice, as his compatriot Adam Elsheimer had done before him. This late conversion would explain why Liss appears so late in the list of the Confraternita dei Pittori in Venice. Besides, it is striking that none of his Roman works seem to have been commissioned by a church. Among the paintings of this period, profane subjects are absolutely predominant. Steinbart saw in the *Christian Allegory* album page in Cleveland a confession of the Catholic faith. The inscription rather proves the contrary.

The altarpiece in S. Nicolò da Tolentino in Venice is still in the same place where Sandrart admired and described it. The painting, the largest one Liss ever painted, depicts the saint as the founding father of the church, as the hermit, and the teacher of the doctrine all at once. Seated on a rock, nude, a quill in his hand, St. Jerome looks expectantly at the angel who stands before him. He warms his feet on the coat of the giant lion in front of him. Such realistic elements are in striking contrast to the divine vision and inject a

humorous note to this saintly scene. It is characteristic of Liss, this North German, Netherlandish-trained artist, that this realistic tendency persists, even in his subjects which deal with the irrational. This work, done at the end of his life, seems to advance far beyond his time, and even anticipates the style of the eighteenth century. The many artists who viewed this important work in Venice sensed the surprising newness of Liss's style. No other work of his has been copied as frequently as this one, particularly by painters of the eighteenth century who saw in Liss their spiritual hero, among them the French Jean Honoré Fragonard. Perhaps this very profaneness of a holy subject and the symbiosis of Northern realism and the Italian grand manner, so typical of Liss, fascinated the age of the Rococo. His contemporaries were probably unable to follow the style of the last years of this Holstein painter. In this constellation of history the paintings by Liss pointed the way; «his work open[ed] up a vista on the future of European painting» (Wittkower).

Rüdiger Klessmann

Liss in Venice

Had Rubens died as young as Liss his life would have ended with his return from Italy to Antwerp in 1609, depriving us of the rich harvest of his Italian experience and the culminating works of his mature style. His contemporary, Johann Liss, markedly different in temperament, achieved within the short span of his life not only his artistic climax, but anticipated in his last paintings the style of another century. While Rubens became the major disseminator of the Venetian tradition of painting in Northern Europe, Liss, by adopting Venice as his home, became part of it and contributed to its extension into the eighteenth century.

Liss brought with him to Italy a rich pictorial heritage, from both Haarlem and Antwerp, to which he added the broad spectrum of influences of the early Baroque in Venice as well as Rome, where he spent some years, interrupting his Venetian stay.[1] He never completely gave up his early Haarlem manner, which was transformed and given new impetus by what he absorbed in Venice and, more importantly, Rome. His impressions from the Flemish masters, particularly Rubens, largely influenced his response to the Italian grand manner and the nature of his late Venetian style. When in Antwerp, he shared his admiration for Rubens with the young Jacob Jordaens, and in doing so absorbed influences from both masters at the same time. Jordaens' figures were of a more robust and rustic nature than those of Rubens, and this characteristic rubbed off on Liss.

Liss was a born painter and colorist. Even his early works attract attention through their subtle tonalities with strong accents. His drawings are conceived in color with lines merely assisting his ink washes and adding finishing touches. He rarely used strong chiaroscuro and instead studied his model in the open light in landscapes sparkling with sunshine, or with figures reflecting the setting sun at dusk. Therefore, it seems natural that Liss would choose to live in Venice where painters since Giovanni Bellini had explored colors as they appear in nature, with their interplay of warm and cool hues effecting soft, rather than hard, outlines («tenera, pastosa e sensa terminazione . . .»).[2] Venetians, too, preferred a soft luminosity rather than sharp contrasts of light and dark, placing figures in landscapes rather than indoors. Liss's predilection for Venice is confirmed by Sandrart when he tells us Liss «loved Titian, Tintoretto, Paolo Veronese, Fetti, and the manner of other Venetians . . .»

32

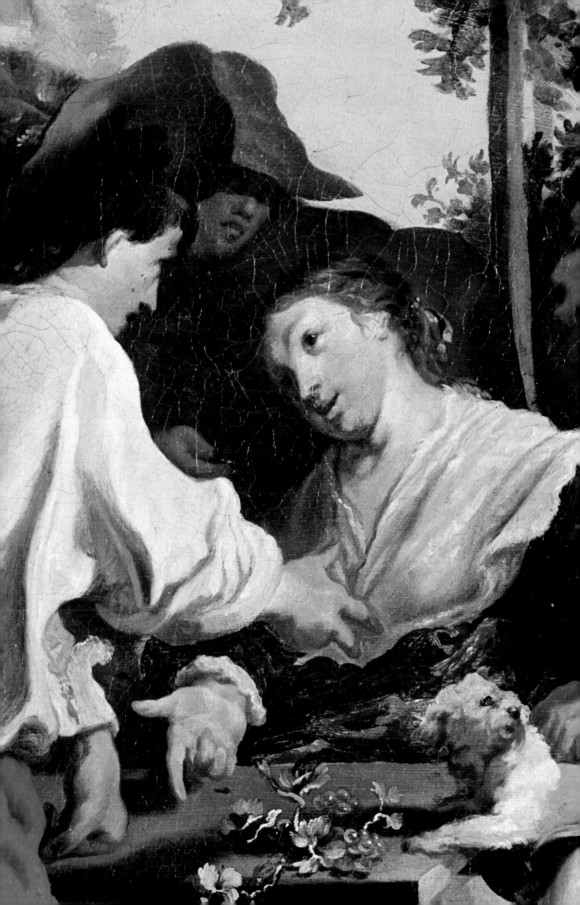

Liss «fared well in Venice,» one of the wealthiest and most attractive art centers in Italy, which granted its citizens a greater freedom of expression, attitudes, and behavior[3] than elsewhere. Artists were not restricted by rules of an all-powerful academy, nor were they solely dependent on church patronage. Paintings in Venetian churches were frequently commissioned by wealthy families for their private chapels rather than by parishes or religious orders. One of the latter, the Theatines, displayed exceptional taste. Their church of S. Nicolò da Tolentino was rich in paintings by well-known artists – Venetians and foreigners alike – among them Palma il Giovane, Luca Giordano, Nicolas Regnier, Bernardo Strozzi, and Johann Liss, represented by one of his climactic works, the *Vision of St. Jerome* [A 39].

Liss arrived in Venice at the time of an artistic decline; the great giants of the High Renaissance, Titian, Tintoretto, Veronese, and Bassano, had died without any comparable masters to take their places. In view of such a glorious past, Venetian painters asked themselves, «Ultra quid faciam» – what else was left to say? Thus, Liss and other foreigners were welcomed like a breath of fresh air. With their own artistic backgrounds as starting points, they approached the great Venetian masters who had inspired them to come, and they reinvigorated the Venetian painting tradition.[4]

Next to Rome, Venice had the largest number of private collections; Venetian families took pride in handing them down to their descendants intact. It followed that their paintings by old masters would be studied by each new generation of artists when they, in turn, were commissioned to paint pictures for the descendants. Thus, Giovanni Guardi undoubtedly saw Liss's *Sacrifice of Isaac* in the Giovanelli collection before painting his own version (now in the Cleveland Museum [E 97]), supposedly also painted for the Giovanelli family.

Liss was probably introduced to Venetian collectors by one of his artist friends who also belonged to the *Confraternita dei Pittori,* where many painters met. It was one of the open studios which existed outside the major guild, the *Arte dei Depentori,* where artists congregated to draw in the preferred Venetian medium, red chalk *(disegni coloriti).*[5] Perhaps this was what Sandrart had in mind when he spoke of «our Academy»[6] where Liss made «many drawings after nude models» (see [B 54]).

By the mid-seventeenth century, collectors had developed an avid taste for Venetian painters, past and present, and Liss was counted among them. Judging from the names of families who owned his paintings,[7] Liss's work had great appeal to Venetians. Sandrart mentions that «lovers of fine art» paid high prices for conversation pieces in which Liss so charmingly transformed his gallant couples from Haarlem into young Venetian lovers under summer skies. His paintings were mentioned and praised in all Venetian guide books; one of their authors, Marco Boschini (*La Carta del Navegar pitoresco*, Venice, 1660), became the adviser and agent for the eminent Florentine art patron, Cardinal Leopold de' Medici. Liss obviously was brought to his attention for we know of at least one painting which he acquired, the *Sacrifice of Isaac*, now in the Uffizi. After the Cardinal's death in 1675, his paintings passed into the hands of the Grand Duke Ferdinand of Tuscany. He, too, became an ardent and discriminating collector of Venetian art, and established his own scouts in Venice to find paintings for him. One was a pupil of

Bernardo Strozzi, Niccolò Cassana (1659–1713), and the other was the well-known Venetian painter, Sebastiano Ricci. In one of Ricci's letters to Ferdinand, we learn that he had been specifically requested to locate some good works by Johann Liss for him – even better than those that were already in Florence. Ricci found two entitled *Paradiso*, but we do not learn whether they were actually acquired; perhaps Ricci advised his patron against the purchase since Ricci did not think they were quite up to Liss's standards.[8]

From the lively exchange of letters which the two Florentine patrons, Cardinal Leopold de' Medici[9] and the Grand Duke Ferdinand of Tuscany, had with their agents, we learn a good deal about the various aspects of collecting in Venice in the seventeenth and eighteenth centuries which sheds some light on problems of Liss's oeuvre. The ever-growing number of collectors, the popularity of Venetian masters, and the reluctance of Venetian families to part with their paintings made it difficult for collectors to buy what they wanted. Therefore, they often had to accept second best, namely a copy of the original. Producing copies became a general practice. Artists specialized in copying certain works, such as Pietro Vecchia (1603–1678), who skillfully imitated Giorgione. Moreover, when a painting was purchased from an impoverished monastery or convent, or was moved from its original site to one of the Medicean residences, a copy was ordered to be hung in its place. We also learn, to our great dismay, that patrons had paintings changed if certain colors or other features were not to their liking. At times paintings were enlarged, or a pendant was ordered to be done by a contemporary artist to match a painting already on hand. We know of at least one copyist who was employed by the Grand Dukes of Tuscany, Francesco Petrucci (1660–1719),[10] who copied originals which were moved from their sites to the Pitti Palace. He was responsible for the design for Mogalli's engraving after the *Sacrifice of Isaac* [A 35] (also see Copies), and, it has been suggested, he may be responsible for one or the other painted copy after this painting.

It followed that artists also developed a great skill in accurately copying their own work on demand; the more popular he was, the more often he had to reproduce his own work. Liss displayed a remarkable talent in repeating his paintings many times, often years apart. Thus those works which existed in several versions were also copied the most, which made for a wider dissemination of the artist's style. This was the case with Liss's *Prodigal Son*, his *Sacrifice of Isaac*, his large *Banquet*, and above all, his *St. Jerome*.

Although a considerable number of Liss's paintings early left Venice for Amsterdam (see under [A 38]), most of his late works remained in Venice, or at least in Italy, and exerted a decisive influence on Italian painters or those who visited Italy during the seventeenth and eighteenth centuries. The dissemination of his style occurred in many different ways. Not only do we find whole compositions by Liss taken over, as in Piazzetta's and Guardi's paintings of the *Sacrifice of Isaac*, or individual elements, such as Bencovich's *Iphigenia*, inspired by the figure of Isaac in Liss's *Sacrifice of Isaac*, but a closeness of style as well. Some artists merely borrowed isolated elements with little correspondence to Liss's style, as with Francesco Maffei's angel in his *Glorification of Alvise Foscarini* [E 105]. Others used whole compositions but translated them into their own styles, as seen in some of the *Prodigal Son* copies done in the eighteenth century. Other artists attempted exact copies but failed to capture the subtleties of Liss's style while exaggerating his idio-

syncrasies, as in some of the copies after the *Vision of St. Jerome* [A 39]. Sebastiano Ricci, who knew Liss's works intimately, in both Florence and Venice, was able to borrow freely in a variety of ways. His figure of Voluptas in his oil sketch for the fresco in the Palazzo Merucelli in Florence echoes the capricious brushwork and exuberant color of Liss's own figure in the *Decision of Hercules* [A 32]. His response to Liss's Jordaenesque robustness and sense of actuality in the *Satyr and Peasant* [A 9, A 10] is witnessed by his two free copies, while Ricci's *St. Peter Freed from Prison*, at S. Stae in Venice, expressed his admiration for Liss's two figures of St. Jerome and the angel in the altarpiece at S. Nicolò da Tolentino. In other instances, artists showed their admiration for one special feature in a specific painting, such as the rich color in Liss's *St. Jerome*, as seen in the colored drawing by Georg Strauch [C 68], or the radiance of light, which is reflected in Michael Herr's drawing [C 66].

One of the most intriguing influences from Liss on eighteenth-century painters came from his *Judith* [A 19, A 20, A 21]. Though strongly dependent on a lost painting by Rubens done while under the influence of Caravaggio, Liss, with comparable Venetian prototypes in mind (such as Titian's *Lucretia* in the Gemäldegalerie in Vienna), unconsciously created a new Venetian courtesan, without losing the psychological intensity so characteristic of Caravaggio. Although *Judith* existed in many versions by Liss's own hand – itself indicative of the appeal she had for Venetian collectors – the striking ambiguity of her expression, the rich and expressive color and texture made it hard for others to copy. (The only existing copies known to us are the engraving by Pietro Monaco of 1739 of the version then belonging to the Vidiman family, see [A 20], and the small anonymous drawing in Stuttgart, see [A 19].) In his painting, Liss filled the whole canvas with her presence, both violent and sensual, defiant and seductive, vividly expressed with an inescapable glance over her shoulder. The memory of this image persisted. Maulbertsch recognized the expressive potential in Liss's color and brush and used *Judith* for his own heroine (Pushkin Museum).[11] Giovanni Guardi captured Judith's seductive look over the shoulder and the richness of her color in his *Woman of Venice* (Cleveland Museum of Art). Piazzetta saw in Liss's figure an intriguing prototype for his young, insouciant temptress, the *Indovina (Fortuneteller*, Galleria dell'Accademia).

Stylistically his most influential paintings were the *Vision of St. Jerome* and the *St. Paul*, both with a large expanse of sun-struck sky, alive with angels and putti. Although they are the only two works presently known with such a setting, the drawing of the *Fall of Phaeton* [B 56] and the three mythological subjects described in Count Algarotti's inventory of 1776 (see Documentation VI 1, 2, 23) indicate that there were others in which the major action took place in the heavens. Liss's exuberant crescendo of light in these two paintings culminates a gradual development in his oeuvre towards an all-embracing luminosity, which anticipates the vast panoramas of Tiepolo's sun-swept skies. It began with the sunny ambiance surrounding Liss's Venus and her nymphs [A 25, A 28], and evolved close to its final conclusion in his *Sacrifice of Isaac* [A 35], with its floating effect of light and color, which particularly intrigued Fragonard, as witnessed in a drawing [C 65] done during his visit to Italy.

The extremely fluent brushwork and the consuming interest in chromatic light in the

upper portions of *St. Jerome* and *St. Paul* affiliates Liss with painters in the following of Correggio, the most important being Federico Barocci (1526–1612) and Ludovico Cigoli (1559–1613). Liss absorbed influences from Cigoli through Domenico Fetti, Cigoli's pupil; but he also could have seen certain Cigoli-inspired works by Rubens while in Antwerp, such as the *Martyrdom of St. Stephen* in Valenciennes. This would explain the intriguing cross references existing between Cigoli's and Rubens' paintings of *St. Stephen* and Liss's *Ecstasy of St. Paul*. All three paintings share the large expanse of luminous sky, teeming with angels, from which Christ and God the Father emerge.[12]

This renewed interest in Correggio's chromatic light and soft flow of color was particularly prominent in the Veneto, stimulated by the Veronese Claudio Ridolfo (1570–1644), who had returned from Urbino in 1617 where he had been in close contact with Barrocci's works.[13] This Correggesque fluency and all-absorbing light gave Liss's two paintings an unprecedented mobility and weightlessness, rendering shadows transparent and colors light and luminous. His shades of turquoise, violet, pink, and yellow anticipate those of the French Rococo and the Italian eighteenth century, represented by Tiepolo and the group of painters whom Engass recently categorized under the term «Barocchetto.»[14] Under this heading are such artists as Francesco Trevisani (1656–1746); Gaetano Gandolfi (1734–1802), who copied Mogalli's engraving after Liss's *Sacrifice of Isaac* in Florence; and Francesco Fontebasso (1709–1768/69), who combined impressions from the *St. Jerome* and the *St. Paul* in a drawing, *The Last Communion of St. Jerome* (private collection, Switzerland).

Painters in Venice of Liss's generation, and those immediately following him, like Bernardo Strozzi (1581–1644), Giovanni Battista Langetti (1625–1676), and Johann Carl Loth (1632–1698), showed strong impressions from his style, but they did not continue from where he had left off. Rather, they followed the weighty and grand manner of the Baroque. The actual heirs to Liss's style were the painters of the eighteenth century. Many ecstasies, visions and glorifications of gods, saints, and monarchs of the Baroque were to include infinite areas of radiant spheres – but not until Tiepolo did any master attain the buoyancy radiance, and delicacy of colors anticipated in *St. Jerome* and *St. Paul*, the paintings which culminated the short career of Johann Liss.

Ann Tzeutschler Lurie

[1] This is not the place to elaborate on the persistence and transformation of Liss's Haarlem manner with which he added an intriguing Venetian epilogue to late Dutch mannerism. It would provide ample material for yet another chapter on this interesting painter.

[2] M. Boschini, *La Carta del Navegar pitoresco*, Venice and Rome, 1966, p. 748.

[3] See the excellent study of O. Logan, *Culture and Society in Venice – 1470–1790, The Renaissance and its Heritage*, London, 1972.

[4] D. Rosand, «The Crisis of the Venetian Renaissance Tradition,» *L'Arte*, N. S., VI, nos. 11–12, 1973, p. 29.

[5] *Ibid.*, p. 41.

[6] M. Vaes suggests, however, that Sandrart founded his own «Academy» – most likely a studio similar to the above-mentioned – in which he, Liss, and their friends congregated. M. Vaes, «Le Séjour de Van Dyck en Italie,» *Bulletin de l'Institut historique belge de Rome*, pt. 1, 1919, p. 213.

[7] See Documentation I 1, 2, 3, 4; IV 12; V 5; VI 1, 2, 23; VII 1, 2, to which should be added the names which appear on Pietro Monaco's engravings after paintings by Liss.

[8] G. Fogolari, «Lettere pittoriche del Gran Principe Ferdinando di Toscana a Niccolo Cassana (1689–1709),» *Rivista del R. Istituto d'archeologia e storia dell'arte*, VI, 1937, p. 161 (see letters no. 56 and 109).

[9] M. Muraro, «Studiosi Collecionisti e Opere d'Arte Veneta Dalle Lettere Al Cardinale Leopoldo de' Medici,» pp. 67–83, and L. and U. Procacci, «Il Careggio di Marco Boschini con il Cardinale Leopoldo de' Medici,» pp. 87–114, *Saggi e Memorie di storia dell'arte*, IV, 1965.

[10] A. T. Lurie, «Luca Giordano, The Apparition of the Virgin to Saint Francis of Assisi,» *The Bulletin of The Cleveland Museum of Art*, LV, 1968, p. 39, n. 8.

[11] See B. Bushart, «Liss and German Art,» in this catalogue.

[12] Concerning the importance of Correggism for the formation of the early Baroque style in general, see the following excellent studies: E. Arslan, *Il concetto di luminismo e la pittura veneta barocca*, Milan, 1946, see pp. 21–33; M. Gregori, «Avantpropos sulla pittura fiorentina del seicento,» *Paragone*, XIII, no. 145, 1962, pp. 21–40; W. Friedländer, «Early to Full Baroque: Cigoli and Rubens,» *Studien zur toskanischen Kunst: Festschrift für Ludwig Heinrich Heydenreich zum 23. März 1963*, Munich, 1964, pp. 65–82.

[13] See M. Vaes, *op. cit.*, p. 205, who mentions that Van Dyck during his visit to Venice ca. 1622 copied works by Correggio in the collections of Luc Van Uffel, Nicolo Grasso, and Daniel Nys.

[14] R. Engass, «Tiepolo and the Concept of the Barocchetto,» *Atti del Congresso internazionale di studi sul Tiepolo con un' appendice sulla Mostra*, Venice, 1971, pp. 81–85.

Johann Liss – Drawings and Prints

The drawings of Johann Liss are arranged in a proposed chronological order which fortuitously places the two signed drawings, the *Fighting Gobbi Musicians* [B 48] and the *Allegory of Christian Faith* [B 50], at midpoint in the sequence. The signed drawings thus provide a central point of reference for the other drawings, a reference that is especially useful since the drawings are dissimilar in subject and drawing style although similar in size and purpose.

The *Gobbi* drawing is a good-humored burlesque, to all appearances swiftly and summarily jotted on the page with a luminous ink-wash modeling that anticipates Tiepolo. The *Allegory of Christian Faith*, which is assumed to date shortly after the *Gobbi*, is meticulously rendered in varied washes, in exquisite and descriptive line, and with a bravura foreshortening of the profile head that displays the virtuosity of a master. Nevertheless, the two drawings demonstrate that in these, as in all of his ink drawings, Liss followed the same procedure. First he indicated the overall placement of forms by a few minimal strokes of black chalk or graphite. Over this scant diagram he brushed in the broad shapes of the subject, usually in two tones of ink wash, a warm brown (light brown or yellowish) and a cooler gray. Where the two tones of ink wash meet they often blend into each other, as in the clouds above Faith, but they may also appear as two distinct, overlapping layers, as in some of the folds of Faith's robe. Over the wash Liss added outlines and finishing details in pen and ink – carefully polished in the *Allegory of Christian Faith*, but with fluid strokes from a broad, flexible pen for the *Gobbi*.

The drawing of the *Merry Company with a Gallant Couple* [B 45] shows an early, comparatively laborious use of this drawing technique. In the *Merry Company* Liss twice added pen and ink accents over the brush drawing. The first pen lines, which trace most of the contours, are lighter. Then followed another layer of wash, on top of which appear the final dark touches of pen and ink. In the background on the right side of the *Merry Company* one can see what Liss's drawing in brush and wash looks like without additions in pen. A youth in a broad-brimmed hat is drawn in brush at the right margin. He is seen from the back and looks over his left shoulder toward the company gathered at the table. Liss followed the same procedure in drawing the *Peasant Wedding* [B 47], again using two layers of pen line but more confidently, with the darkest pen lines used for selectively

placed dark accents and less frequently for contours. The *Merry Company with a Fortuneteller* [B 50a] is also executed in more than one layer of brush and pen, this time in order to portray the subtle and complex pattern of light and shadow that was a major quality of the painting it reflects.

From present evidence it appears that Liss reserved the use of chalk for his preparatory drawings – if one can infer a practice from the small number of drawings so far identified. Two chalk drawings that are unquestionably by Liss are the *Study of a Woman's Head* [B 46], a detail study evidently drawn from life that was used in the paintings of the *Satyr and Peasant* [A 9, A 10], and the *Morra Game Outdoors* [B 49], which is a trial arrangement of figures for a whole composition. In company with these is shown the large drawing [B 54] executed in colored chalks that Michael Jaffé proposes is a life drawing from the model and an example of Liss's working methods as Sandrart has described them (see Documentation).

The wide range of styles to which Liss was exposed during his peripatetic and brief career, and his practice of repeating his images make his drawings as difficult as his paintings to arrange in a clear, logical order. The most thorough study of Liss's drawings, Edmund Schilling's valuable article published in 1954, groups the drawings according to the purpose for which each was made. He described four categories in particular: those drawings made for friendship albums,[1] of which the two signed drawings are the only examples; those made as preparatory studies, like the *Morra Game Outdoors* [B 49]; those that are finished pictures, like the *Brawling Peasants* [B 43]; and those made as *ricordi* or copies of his own paintings to keep as a record when the paintings left his possession.

The latter category is a valuable aid toward the understanding of Liss's drawings, and especially toward arranging them in a coherent sequence. For example, the explanation that some drawings are *ricordi* resolves an otherwise troublesome contradiction between style and chronology for the *Peasant Wedding* [B 47] recently acquired by the Staatliche Graphische Sammlung in Munich. In drawing style the *Peasant Wedding* matches the *Gobbi* drawing of 1621, but its composition is an earlier stage of the Budapest painting [A 5] of around 1617. The contradiction is resolved if we may consider the drawing to be a replica made by Liss in Venice of the design of a painting made a number of years before.

In another instance, the drawing of the *Merry Company with a Gallant Couple* and the existence of a painting [E 92] in San Francisco – the work of a copyist – present a strong argument that Liss's drawing reproduces a lost painting. In the first place, the painting copy does not deviate in the least detail from the drawing, so there is no indication of a development in design between a study and finished painting. Furthermore, the copyist must have had a painting by Liss for his model, rather than the exhibited drawing, since the plants on the wall and the youth at the right are not sufficiently legible in the drawing (even before the top and right sides were trimmed) for it to have served as the copyist's sole guide.

On the other hand, the discrepancies between details of the Uffizi drawing, *Banquet of Soldiers and Courtesans* [D 1], and the Kassel and Nürnberg *Banquet* paintings [A 15, A 16] give weight to the argument that the Uffizi drawing is preparatory to the painted

composition.² If such is the case, then the *Merry Company with a Fortuneteller* [B 50a] and the *Death of Phaeton* [B 53] likewise may have been preliminary composition studies that culminated eventually in the *Banquet* and the *Fall of Phaeton* [A 26] paintings respectively.

Six of the fourteen exhibited drawings contain formal references to identical motifs in existing paintings. This is to be expected of an artist who labored to invent the most perfect arrangement of his figure groups. Once he had found a striking image it remained in his repertory. The Kassel drawing of the *Morra Game Outdoors* [B 49] and the Braunschweig drawing of the *Death of Phaeton* [B 53] in each case link a group of paintings as contemporaneous works – the Kassel drawing by its references to the *Morra Game* paintings [A 13, A 14] and to the *Banquet* paintings [A 15, A 16] as works of Liss's early Roman period, and the Braunschweig drawing as a link connecting three paintings [A 25, A 26, A 28] of about 1625. However, there is the quite different example of the *Merry Company Outdoors* [A 33], a painting of the second Venetian period, that contains a pair of lovers from the *Merry Company with a Gallant Couple* [B 45], a drawing that dates from 1615 or before, and also a pair from the *Fortuneteller* [B 50a], which was executed in Italy close to a decade later.

Schilling published as drawings of Liss's final years the small ink drawing of a *Standing Woman with Drapery* [B 52] (here placed in the Roman period) and the two large drawings, *Manius Curius Dentatus* [B 55] and the *Fall of Phaeton* [B 56]. Recent studies of the numerous drawings produced in Italy in the seicento have greatly furthered knowledge of this complicated period and have succeeded in sorting and identifying ever more individual artists from the mass of available material. Thus we may hope more will be learned of the later drawings of Liss from his active and productive second Venetian period. The artist whose drawing style, and imagination, encompassed the *Fighting Gobbi Musicians* and the *Allegory of Christian Faith*, perhaps within the boundaries of a single year, is still not easily identified. There is no clear stylistic link between the securely attributed drawings of Liss's Roman period and the two large late drawings. The most valid comparison is with Liss's late paintings.

No attempt has been made to mention the many drawings which have been attributed to Liss that are not included in the exhibition. Some were omitted by choice, some were not available for loan. On the whole, the generous cooperation of owners enables us to show most of the drawings that deserve consideration as works by Liss. However, it should be noted at the outset that the choice for the exhibition is necessarily arbitrary; in one or two instances even the organizers were not in agreement, so the ultimate responsibility for the selection, as for the opinions voiced in the entries, rests with the writer.

When one considers that Liss was first and foremost a painter, it is not surprising that he tried his hand at printmaking only twice, even in an age when it was a popular and flourishing branch of the visual arts and could bring an artist widespread recognition. Certainly in Holland Liss must have been aware of the reputation Goltzius gained because of his engravings, and it is of some significance that the *Fool as Matchmaker*, his earlier etching, is strongly influenced by the Haarlem artists Willem Buytewech and Dirck Hals, is stylistically close to the Haarlem etcher Werner van den Valckert (who was in Amster-

dam between 1612 and 1618), and originated at the time Claes Jan Visscher was active as both etcher and print publisher in Amsterdam. And it is equally plausible that his second etching, *Cephalus and Procris,* was made in Rome, another center of etching and print publishing in the seicento. In both Holland and Rome (and indeed in Antwerp) Liss would have found facilities for printing and artists to advise him in preparing an etching plate. Moreover, etching was the logical medium for his two prints. Engraving had become a sophisticated, highly developed craft which necessitated time and practice for mastery of the refined systems of line, stipple, and hatching that had been developed to perfection by Hendrick Goltzius. Etching, however, allowed something closer to the freedom of a pen line on the plate ground and was the preferred medium of the painter. It is notable that Liss's etchings are in the traditional sphere of print subjects, that of instructive moral homilies – one is a comment on the liaison of lust with folly, and the other a lesson in classical dress on conjugal fidelity.

While there are still problems in the attribution of drawings to Johann Liss, his prints number only two etchings, which, as they are signed with his initials, should pose no difficulty. Nevertheless, the earliest print catalogues tended to confuse rather than clarify the identification of Liss's etchings, and, therefore, a short review may be useful. Nineteenth-century print catalogues, which are still basic references for prints by artists who were only occasional printmakers, were apt to credit the etchings signed with Liss's initials to the mythical Jan van der Lys of Breda.[3] Commonly, not two, but three signed etchings were listed: a *Cephalus and Procris* identified by title only, and two untitled etchings which, fully described, are identifiable as the *Fool as Matchmaker* and, once again, *Cephalus and Procris.*[4] However, Wurzbach (p. 77), describes *Cephalus and Procris* and two other signed etchings, both of which are identifiable as the *Fool as Matchmaker.*

Ludwig Burchard's 1912 study of Dutch etchers before the time of Rembrandt resolved these earlier confusions and resulted in a definitive catalogue of the etchings. But even Burchard left one loose end that remains to trip the unwary. Following the two signed Liss etchings in the section of his catalogue that lists works by, rather than after, the artist, he included the *Funeral Pyre of Hercules,* an unsigned etching that had previously occasionally been attributed to Liss.[5] The attribution had been questioned by Nagler as early as 1839, and Burchard mentioned Nagler's doubt. Nevertheless, the most recent general catalogue, that of Hollstein, probably using Burchard as guide, not only perpetuates the misattribution but lists the Hercules subject first under the authentic etchings of Liss.

The section of twelve copies of works by Liss [C 57 to C 68] is exhibited primarily to supply information or pose questions about the fate of the pictures that served as their respective models. Of first importance from this standpoint are the copies of lost works by Liss [C 58, C 60, C 61, C 62]. The other copies were selected because in one way or another they illuminate the subsequent history of the works they reproduce. All of them document the admiration in which Liss's work was held by his contemporaries and by succeeding generations.

Louise S. Richards

[1] See discussion, cat. no. B 48.

[2] Possibly the Uffizi drawing is an expert, close copy of a lost Liss drawing. There are three other drawing

copies in Bassano, Leiden, and the British Museum (Steinbart, 1940, pp. 165, 166), with the identical discrepancies. There is a drawing copy by Dancker Danckerts in Dresden that reproduces the painting versions (Steinbart, 1940, fig. 33).

³ F. Brulliot, *Dictionnaire des monogrammes, ... noms abrégés, etc.*, Munich, 1833, part 2, no. 1566; C. Kramm, *De Levens en Werken der Hollandsche en Vlaamsche Kunstschilders, etc.*, IV, Amsterdam, 1857–1864, p. 1031; Nagler, 1907, IX, p. 132.

⁴ C. Le Blanc, *Manuel de l'amateur d'estampes*, Paris, 1856–88, II, p. 582; Kramm, *op. cit.*; G. K. Nagler, *Monogrammisten*, Munich and Leipzig, 1863, III, no. 2791.

⁵ Attributed to Pierre Brebiette by E. Tietze-Conrat, *Der französische Kupferstich der Renaissance*, Munich, 1925, p. 37.

Liss and German Art

Two questions arise with regard to this exhibition, especially for the German visitor: Should Johann Liss be counted among German painters? Was he ever acknowledged by them? It should be remembered that Liss left his home on Germany's north coast for good when he was not more than eighteen to twenty years old. Where he received his first training remains an open question. Assuming it was in his home town, what could he have learned in the distant, little province of Oldenburg, other than grinding paint and doing apprentice jobs?

His art was molded by impressions received in foreign lands, and he was never active as a painter in Germany. No one knows whether he ever stopped there later, possibly during a trip. Perhaps he had connections to Augsburg, but they, too, cannot have carried much weight. Old inventories usually count him among the artists of Holland, or of Italy, and art historians have done the same.

Extensive travel and sojourns in foreign countries are not sufficient evidence for drawing conclusions; traveling abroad was literally the mark of a modern artist ever since the time of Hans Holbein the Younger. This was not only true in Reformation Germany, where, according to Erasmus, the «arts froze,» but everywhere in culture-conscious Europe. The North Germans were no exception. Melchior Lorck from Flensburg, «without a doubt the most individualistic personality among German graphic artists during the second half of the sixteenth century» (K. Oberhuber), spent his life in Lübeck, Augsburg, Nürnberg, the Netherlands, Venice, Bologna, Florence, Rome, Neuburg, Vienna, Constantinople, Antwerp, Hamburg, and Copenhagen. Ottmar Ellinger from Copenhagen, Wolfgang Heimbach from Övelgönne, Gottfried Kneller from Lübeck, Jürgen Ovens from Tönning, Christopher Paudiss from Hamburg, Carl Ruthart and Pandolf Resch from Danzig, all lived for years, or even died, in the Netherlands, in Italy, in England, or in Southern Germany. Others established families in Italy or the Netherlands and gained fame and wealth, and in the end built up a new life in Germany. That wordy historiographer of German art, Joachim von Sandrart, may be cited as a prime example of such international celebrity. He was, it is true, no less pretentious as a painter than as a *praeceptor artis,* but he was all the more valued as a spokesman who formulated the demands of an ideal artist in this era. Late returnees like Johann Rottenhammer, Christoph Storer, Sebastian Stosskopf, or

Johann Heinrich Schönfeld, prove that artists kept in touch with their mother country over longer periods of time than Johann Liss ever lived. Some died young without a final choice. Adam Elsheimer and Liss belong with these. Others remained in their host country, often highly respected for their artistic contributions. Josef Heintz the Younger, Liss's contemporary in Venice, the Leipzig-born Nikolaus Knüpfer in Utrecht, Johann Carl Loth in Venice, Philipp Peter Roos and Christian Berentz in Rome, to name only a few. Expanding the picture a little further, mention must be made of the equally large number of Dutch, French, and Italian artists who settled in Germany under similar conditions, more or less at the same time.

Above all others, the courts of Prague, Munich, Vienna, Graz, Innsbruck, as well as the imperial cities of Frankfurt, Nürnberg, and Augsburg, offered plentiful work and income. We in our century find it hard to see these facts in a positive light, but the spirit of the maligned – or worse yet – the totally unappreciated century, between the end of the old German art and the general revival of the arts in Germany after the Thirty Years War, was far different from the present conception of it. In thoughts and actions, people of that time revealed their acceptance of the painfully-won European solidarity; their lack of prejudices could still awake our envy today.

In view of such internationalism, we are surprised to find how close Liss is in his early works to the art of the Dürer period, rather than to that of his host country and to his own generation. The coarse figures and subjects of his first pictures, using themes from the life of the farmer or of the simple folk, hark back, as it has long been recognized, to models in the graphics of Hans Sebald Beham, the pupil of Dürer in Nürnberg, and of Lucas van Leyden, Dürer's Dutch admirer. Together with these motifs goes a color scheme that can hardly be described as anything but old German. The saturated yellow, red, and deep black tones, the vivid fleshtones, and the light backgrounds result in a multi-colored palette with pronounced local colors, as was unknown in Netherlandish painting of his time. The fact of his regression, and the question why, become all the more significant. Liss used old German models in his later work, such as the copper engraving with *Hercules and Cacus* [E 48], by Hans Sebald Beham, for the Cursing of Cain [A 34] and for the Apollo of the *Marsyas* picture [A 23]; or the peasant couple from Beham's series of the months for the open demonstrations of love by the soldiers and courtesans [A 15, A 16]; and even the subject of the fool between the two pairs of lovers could have been inspired by Beham's engraving (Bartsch 212). Therefore, we must count him among that circle of German painters in Rome around 1600 who, like Georg Flegel, Adam Elsheimer, or Philipp Uffenbach, consciously concerned themselves with the painting of the Dürer era. If our judgment is correct, it was especially the pronounced coloration, the clarity of the drawing, the unconventional treatment of the themes, and the lively expressiveness of the figures which made Liss and his German contemporaries see and appreciate the works of their great-grandfathers in a new light. This corresponds with the fact that, when he moved to Rome, Liss was drawn to the similarly factual, realistic art of Caravaggio on the one hand, while, on the other, he kept himself open to inspiration from his compatriot, Adam Elsheimer, who also lived in Italy. The poetic fusion of figures with landscape, man and space, the epochal transition from descriptive genre in Netherlandish

art and the actuality of Caravaggio's scenes, to the infusion of spirituality in Liss's mature works occurred not without the influence of the Roman painter from Frankfurt, Adam Elsheimer. Liss's skeptical attitude towards accepting Antiquity as a model and his joining the Netherlandish artists' guild in Rome – to which Elsheimer, Sandrart, Schönfeld, and other Germans also belonged – point in this direction.

The influence of Liss and his art on his German compatriots is more difficult to measure. In Venice, it is true, Sandrart shared his room, but not his views. Johann Carl Loth, whose half- and three-quarter-figure pictures revealed the pronounced influence of Liss in the second half of the seventeenth century, had become too Italian in Rome to be useful as a witness. However, the scenes of Venetian people by Joseph Heintz the Younger, who had emigrated around 1624, reflect Liss's influence. In any case, he could not have known this genre in his hometown of Augsburg. At the same time, Liss, though not the only one among the Northerners, was appreciated precisely because of it. In Johann Heinrich Schönfeld's work, there is only one painting, dated around 1650, *Halt before an Inn* [E 108], whose proximity to Liss was often emphasized. The correctness of this assumption has unexpected support from the recent information that Schönfeld had actually stopped in Venice on his return from Italy to Germany. Whether the old copy of the *Sacrifice of Isaac* in the Barfüsser Church in Augsburg (destroyed during World War II) was done in front of the original in Italy, or whether it was done after an unknown version in Germany, cannot be verified. In the same way, it remains a question as to who procured the model for Johann Melchior Spillenberger's copper engraving. The latter's father, Johann Spillenberger, who had moved from Venice to Augsburg in 1664, has been suggested as the author of a painted copy of a *Prodigal Son* (private collection, Switzerland) which was formerly given to a follower of Domenico Fetti; its colors suggest that the artist was familiar with an original by Liss. There is a page from an *album amicorum* (friendship book), dated 1642, by the Augsburg painter, Matthias Strasser, which, as Heinrich Geissler noticed, combines two motifs – the two lovers from the *Merry Company* [B 45], and a background detail from the *Soldiers and Courtesans* [A 15, A 16]. Strasser was in Verona in 1638, and probably also in Venice; he is documented in Augsburg before 1642, and he died there in 1659 (see *Augsburger Barock*, exh. cat., Städtische Kunstsammlungen, Augsburg, 1968, p. 265, no. 376). The album page interprets the subject of the drawing rather unmistakably in Sandrart's spirit: «Donna bella par / adiso del occhio / inferno del anima / ed purgatorio della / borssa.» Yet another album page by Strasser with a satyr and nymph is inscribed «La Virtu Fugge Del Vicio,» dating from 1650, and which in style, motif, and iconography is undoubtedly related to such paintings as the *Venus and Adonis* [A 25] in Karlsruhe, or the *Fall of Phaeton* [A 26] in London. It is therefore not surprising that the Augsburg etcher, Hans Ulrich Franck, apparently also harked back to Liss's pictures of farmers and soldiers in his series on the war, from 1643 to 1656, even though one is not sure whether he ever went to Italy. Copies in drawings and etchings by Georg Strauch [C 68], Michael Herr [C 66], and Wenzel Hollar [E 107] in Nürnberg point to a limited influence from Liss. Steinbart has already pointed to the thematic and chromatic correspondences with the pictures of outings by Matthias Scheits from Hamburg. «Similar schooling» and «identical dispositions,» by themselves, are not sufficient to explain their

having so much in common. Rather, one must suppose that here, too, there was a direct or indirect influence from Liss's works. One must realize that the only biography extant during the artist's time, Sandrart's oft-cited account in his *Teutsche Academie* of 1675, had not yet appeared at that time. Still, the assumption that is the most plausible is that it was Sandrart (who returned to Frankfurt in 1635, and lived from 1645 in Stockau near Ingolstadt, from 1670 in Augsburg, and from 1674 in Nürnberg), who, at an early time, had spread the fame and work in Germany of his colleague who died an early death.

During the eighteenth century, reminiscences of Liss appear in different places and at different times in German art, at times in the form of etching and drawing copies which occasionally were done, revealing the artists' familiarity with the originals by Liss. In Augsburg, where one was not particular in picking models, Johann Wolfgang Baumgartner borrowed the central group of Liss's painting, the *Prodigal Son,* for his sketch (National Museum, Copenhagen) and his mezzotint-engraving ... and his mezzotint-engraving [E 81], both entitled *Prodigal Son.* One can recognize a copper engraving of Franz Sigrist as a free development of the etching by Melchior Spillenberger; Sigrist's engraving appeared at that time in Augsburg at J. G. Hertel's, and was used with many variations in frescos and oil paintings. Johann Michael Rottmayr's *Klage um Abel* in the Harrach Gallery was also rightly traced back to Liss – this time, presumably, to the original painting in Venice. *The Couple in Love* by Johann Konrad Seekatz from Darmstadt, who was among Goethe's teachers, looks like a contemporary translation of Liss's *Gallant Couple with Cherries,* preserved only in the engraving by Danckerts [C 61]. True, the *galant* and his lady wear Rococo costumes, and the little lap dog has replaced the cherries; nevertheless, the bearing, posture, and meaning follow the older picture.

But none of the German painters of the eighteenth century preoccupied himself so much with Liss – none came so near to him – as Franz Anton Maulbertsch. Although this Viennese, originally from the Lake Constance area, to our knowledge had never been in Italy, and although he could have seen only one work by Liss in Vienna – his *Judith* – his work increasingly shows correspondences to Liss, leading to virtually new creations. There are themes, such as the enamored couples at the fountain (Albertina, Vienna), the open-air concert (Baltimore), the painter's studio (Lawrence), the merry gathering (Stuttgart), or the education of the young gentleman, which are not just similar to Liss, but are also close in spirit. The vibrantly colored oil sketch in Brünn, *Diana's Bath,* is hardly imaginable without Liss's *Toilet of Venus* [A 28]. Despite the different themes, Venus' posture, the nude nymph seen from the back, the way Venus holds the mirror, the curtain, and the exuberant putti seem to stem from a fundamentally common conception. If one considers Maulbertsch's eagerness to conceal the origin of his works, then the extent of the closeness to Liss's work becomes even more surprising. Upon close observation, one will notice that Maulbertsch has borrowed most of the facial traits of the pug-nosed, mouse-eyed girls of his models, including even the main colors that create the impressions. However, this is not the only such case. In the Viennese *Allegory of the Piarist Order,* Maulbertsch has fused the type of the repentant-looking Prodigal with that of the dandy in the *Gallant Couple* into the ideal figure of the sensitive, well-educated, and sheltered young gentleman of the Viennese school. Liss's Judith plays coquettishly as the seductive

Diana, with a turban of feathers, hunting booty, bow and arrows, in the early ceiling paintings by Maulbertsch in Kirchstetten. The weasel-quick *Judith* of the Pushkin Museum in Moscow, a masterpiece of the young Maulbertsch, follows the model of the North German in its entire composition, transposing it, however, into a vision of shimmering color. He used the image a third time, ca. 1765, in the oil sketch in Vienna for an unknown *Judith* painting or fresco which looks like a transformation into the radiance of Liss's late paintings.

Even more particularly, in cases where the relationship is looser, such as in *Abraham's Sacrifice* in the Heiliggrabkapelle of the Pfarrkirche in Sümeg, the profound closeness of the two artists comes forth all the more clearly. It is the special relationship between form and color which ties Maulbertsch to Liss across the centuries. They release both from the constraint of concrete description of the object in the picture, without going to the coloristic virtuosity after the Venetian fashion. Both transform forms and colors into autonomous values as in a musical language – values whose interplay throws the theme into a new light. We are not dealing here with psychological interpretation, nor with that which could be called «mood,» nor even simply with fables or allegories. Rather, the early Maulbertsch and the late Liss assign to their colors the task of expressing the inexpressible: the encroachment of Heaven on the determinism of Earth, the reflection of absolute beauty in the mundane, the glorification of the object in colored light. Thus, the path which Liss walks on in Italy, and follows progressively from year to year, points toward Maulbertsch. As Liss's artistic heir, Maulbertsch continued where Liss left off, but at the same time, actually referred back directly to the past master as well.

From this viewpoint, Liss falls in with the ranks of German painters to the same extent that he is set apart from Dutch or Italian painting. This observation has nothing to do with the nationalistic implications of previous research on Liss. The supra-nationality of a European culture, which was aspired to at the time of Liss, is sufficient in itself to deny Steinbart's claim that Liss was of a «purely German essence.» He was richer in fantasy, more temperamental, and more generous than the Dutch, yet more restrained, more direct, and more subjective than the painters in Rome or Venice, and thus he was able to endow his figures with a «special grace and also a more-than-natural life» (Sandrart). Thus, he builds bridges, not only between the centers of European painting, but also between the old German tradition and the Baroque of Rottmayr, Asam, Baumgartner, Spiegler, Zimmermann, or Maulbertsch. In their contributions to European painting, their exceedingly abundant powers of invention, their apparently easily understood – yet demanding – symbolic language, their realistic representation of reality, their unfathomable light spaces, the musical rhythm of their forms and symphonies of color – all this they shared with Liss to such an extent that even Steinbart, certainly not ignorant, claimed that an oil sketch of 1755, in fact assigned to Johann Baptist Zimmermann (Deutsche Barockgalerie Augsburg), was a work by Liss.

Bruno Bushart

List of Abbreviated Literature

ABBREVIATIONS OF EXHIBITIONS

Berlin, 1966 — Berlin, Orangerie des Schlosses Charlottenburg, 1966: Deutsche Maler und Zeichner des 17. Jahrhunderts. Catalogue, ed. R. Klessmann.

Florence, 1922 — Florence, Palazzo Pitti, 1922: Mostra della pittura italiana del Sei e Settecento. Catalogue.

Nürnberg, 1952 — Nürnberg, Germanisches Nationalmuseum, 1952: Aufgang der Neuzeit. Catalogue by L. Grote and L. von Wilckens.

Paris, 1965 — Paris, Musée du Louvre, 1965: Le Caravage et la peinture italienne du XVIIᵉ siècle. Catalogue.

Venice, 1946 — Venice, 1946: I Capolavori dei Musei Veneti. Catalogue by R. Pallucchini.

Venice, 1959 — Venice, Ca'Pesaro, 1959: La pittura del Seicento a Venezia. Catalogue by P. Zampetti and T. Pignatti.

ABBREVIATIONS OF PUBLICATIONS

Barbieri, 1962 — F. Barbieri. *Il Museo Civico di Vicenza: Dipinti e sculture dal XVI al XVIII secolo.* Venice, 1962

Bartsch — A. Bartsch. *Le Peintre Graveur,* I–XXII. Vienna, 1808–1821.

Benesch, 1933 — O. Benesch. *Beschreibender Katalog Handzeichnungen in der Graphischen Sammlung, Albertina,* IV. Vienna, 1933.

Benesch, 1951 — O. Benesch. «Liss's ‹Temptation of St. Anthony›,» *The Burlington Magazine,* XCIII (1951). Reprinted in *Otto Benesch Collected Writings,* ed. E. Benesch, IV, London, 1973, pp. 3–5.

Bénézit, 1952 — E. Bénézit. *Dictionaire critique et documentaire des peintres, sculpteurs, dessinateurs et graveurs,* V. Paris, 1952.

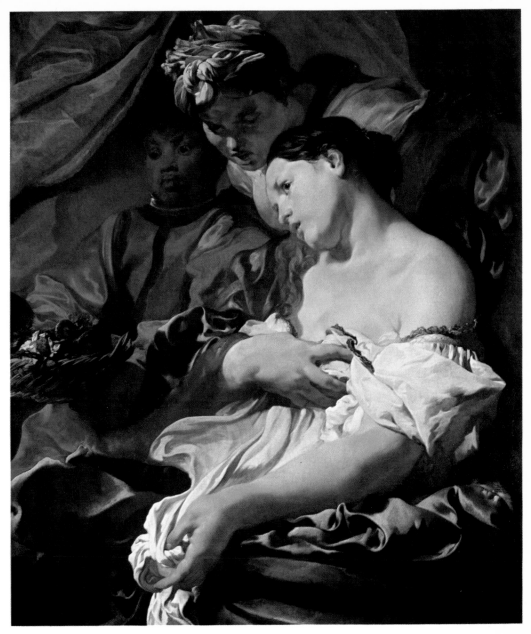

III The Death of Cleopatra · Bayerische Staatsgemäldesammlungen, Munich [A 18]

Bloch, 1942 V. Bloch. «Lissiana,» *Festschrift: Aan Max J. Friedländer.* The Hague, 1942 (in German). Reprinted in Dutch: *Oud Holland,* LXI (1946).

Bloch, 1950 V. Bloch. «Liss and His ‹Fall of Phaeton›,» *The Burlington Magazine,* XCII (1950).

Bloch, 1955 V. Bloch. «Addenda to Liss,» *The Burlington Magazine,* XCVII (1955).

Bloch, 1966 V. Bloch. «German Painters and Draughtsmen of the Seventeenth Century, in Berlin,» *The Burlington Magazine,* CVIII (1966).

Bode, 1919 W. von Bode. «Eine neue Erwerbung der Gemäldegalerie: Vision eines Heiligen von Jan Lys,» *Berichte aus den Preussischen Kunstsammlungen,* XLI, no. 1 (1919).

Bode, 1920 W. von Bode. «Johann Lys,» *Velhagen und Klasing's Monatshefte,* XXXV (1920).

Buberl, 1922 P. Buberl. «Die Ausstellung der italienischen Malerei des 17. und 18. Jahrhunderts im Palazzo Pitti in Florenz,» *Belvedere,* II (1922).

Burchard, 1912 L. Burchard. *Die Holländischen Radierer vor Rembrandt.* Halle a. d. Saale, 1912. Reprinted: Berlin, 1917.

Colasanti, 1921–22 A. Colasanti. «Opere di Jan Lys non ancora identificate,» *Bollettino d'Arte,* XV (1921–22).

De Logu, 1958 G. De Logu. *Pittura veneziana dal XIV al XVIII secolo.* Bergamo, 1958.

Descamps, 1753 J. B. Descamps. *La Vie des peintres flamands, allemands et hollandois.* Paris, 1753.

Donzelli and Pilo, 1967 C. Donzelli and G. M. Pilo. *I pittori del Seicento Veneto.* Florence, 1967.

Ewald, 1967 G. Ewald. «Deutsche Maler und Zeichner des 17. Jahrhunderts, Berlin, Orangerie des Charlottenburger Schlosses, 26. August bis 16. Oktober, 1966,» *Kunstchronik,* XX (1967).

Fiocco, 1929 G. Fiocco. *Venetian Painting of the Seicento and Settecento.* Florence and New York, 1929.

Fokker, 1927 T. H. Fokker. «Nord- en Zuid-Nederlandsche Kunstwerken in de Kerken der drie voormalige Italiaansche Republieken,» *Mededeelingen van het Nederlandsch Historisch Instituut te Rome,* VII (1927).

Frimmel, 1891 T. von Frimmel. «Literaturbericht,» *Repertorium für Kunstwissenschaft,* XIV (1891).

Frimmel, 1892 T. von Frimmel. *Kleine Galeriestudien,* I. Bamberg, 1892.

Frimmel, 1901 T. von Frimmel. »Bilder von seltenen Meistern,» *Monatsberichte über Kunst und Kunstwissenschaft,* I. Munich, 1901.

Frimmel, 1909	T. von Frimmel. «Jan Lys und einige seiner Bilder,» *Blätter für Gemäldekunde*, V (1909).
Frimmel, 1922	T. von Frimmel. *Von alter und neuer Kunst*. Vienna, 1922.
Gelder, 1937	J. G. van Gelder. «Domenico Fettis Vision des Hl. Petrus,» *Die Graphischen Künste*, N. S. II (1937).
Giglioli, 1940	O. H. Giglioli. *La Regia Galleria degli Uffizi*. Rome, 1940.
Goering, 1940	M. Goering. *Deutsche Malerei des 17. und 18. Jahrhunderts*. Berlin, 1940.
Golzio, 1950	V. Golzio. *Storia dell'arte classica e italiana*, Vol. IV: *Il Seicento e il Settecento*. Turin, 1950.
H. de Groot	C. Hofstede de Groot. *Arnold Houbraken und seine «Groote Schouburgh»* («Quellenstudien zur holländischen Kunstgeschichte»). The Hague, 1893.
Heinz, 1965	G. Heinz. *Katalog der Gemäldegalerie*, I. Kunsthistorisches Museum, Vienna, 1965.
Hind, 1931	A. M. Hind. *Catalogue of Drawings by Dutch and Flemish Artists Preserved in the Department of Prints and Drawings in the British Museum*. London, 1931.
Hollstein	F. W. H. Hollstein. *Dutch and Flemish Etchings, Engravings, and Woodcuts*, XI. Amsterdam, 1949.
Houbraken, 1943	A. Houbraken. *De Groote Schouburgh der Nederlantsche Konstschilders en Schilderessen*, I–III. Reprint: Maastricht, 1943.
Immerzeel, 1843	J. Immerzeel, Jr. *De levens en werken der Hollandsche en Vlaamsche Kunstschilders, beeldhouwers, graveurs en boumeesters*, II. Amsterdam, 1843.
Klessmann, 1970	R. Klessmann. In *Schleswig-Holsteinisches Biographisches Lexikon*, I. Neumünster, 1970.
Klessmann, 1970	R. Klessmann. «Johann Liss. Zum Werk der vorvenezianischen Zeit,» *Kunstchronik*, XXIII (1970).
Kohrs, 1956	M. Kohrs. *Nachfolger Caravaggios in Deutschland*, doctoral dissertation. Freiburg i. Br., 1956.
Lanzi, 1853	L. A. Lanzi. *The History of Painting in Italy*, II, transl. T. Roscoe. London, 1853. German translation: Leipzig, 1930–33.
Levey, 1956	M. Levey. *The Eighteenth Century Italian Schools*. London, National Gallery, 1956.
Levey, 1959	M. Levey. *The German School*. London, National Gallery, 1959.
Lieure	J. Lieure. *Jacques Callot*, I–V. Paris, 1927–29.
Lugt	F. Lugt. *Les Marques de Collections de Dessins et Estampes*. Amsterdam, 1921. Supplement: The Hague, 1956.

Lutze, 1934 E. Lutze. *Katalog der Gemälde des 17. und 18. Jahrhunderts im Germanischen Nationalmuseum zu Nürnberg*. Nürnberg, 1934.

Marconi, 1949 S. M. Marconi. *Le Gallerie dell'Accademia di Venezia*. Venice, 1949.

Marconi, 1970 S. M. Marconi. *Gallerie dell'Accademia di Venezia*, Vol. III: *Opere d'arte dei secolo XVII, XVIII, XIX*. Rome, 1970.

Martius, ca. 1955 L. Martius. *Schleswig-Holsteinische Maler in europäischen Museen*. Heide in Holstein, ca. 1955.

McComb, 1931–32 A. K. McComb. «A Saint Jerome by Jan Liss,» *Bulletin of the Fogg Art Museum*, I (1931–32).

Morassi, 1923 A. Morassi. «Un dipinto sconosciuto di Giovanni Lys,» *L'Arte*, XXVI (1923).

Nagler, 1907 G. K. Nagler. *Neues Allgemeines Künstler-Lexikon*, IX. Second edition: Linz, 1907.

Oehler, 1962 L. Oehler. «Unbekannte Vorzeichnungen zu einigen Gemälden der Kasseler Galerie», *Kunst in Hessen und am Mittelrhein*, I–II. 1962.

Ojetti, Dami, Tarchiani, 1924 U. Ojetti, L. Dami, and N. Tarchiani. *La Pittura italiana del Seicento e del Settecento nella mostra di Palazzo Pitti a Firenze, 1922*. Milan and Rome, 1924.

Oldenbourg, 1914 R. Oldenbourg. «Jan Lys,» *Jahrbuch der Königlich-Preussichen Kunstsammlungen*, XXXV (1914).

Oldenbourg, 1918 R. Oldenbourg. «Gemäldegalerie: Neues über Jan Lys,» *Amtliche Berichte aus den Königlichen Kunstsammlungen*, XXXIX (March 1918).

Oldenbourg, 1921 R. Oldenbourg. *Giovanni Lys* (no. 7 in *Biblioteca d'arte illustrata*). Rome, 1921.

Pacchioni, 1955 G. Pacchioni. *The Uffizi Gallery*. Rome, 1955.

Pallucchini, 1934 R. Pallucchini. *L'arte di G. B. Piazzetta*. Bologna, 1934.

Pallucchini, 1960 R. Pallucchini. «La mostra della pittura veneta del Seicento,» XVIII (1960).

Pallucchini, 1960–61 R. Pallucchini. *Storia della pittura veneziano*, Vol. IV: *La pittura veneziano del Seicento*. Anno Accademio, 1960–61.

Parthey, 1864 G. Parthey. *Deutscher Bildersaal*, II. Berlin, 1864.

Pauli G. Pauli. *Hans Sebald Beham, ein kritisches Verzeichnis seiner Kupferstiche, Radierungen und Holzschnitte*. Strassburg, 1901.

Peltzer, 1914 R. A. Peltzer. «Über Jan Lys,» *Studien und Skizzen zur Gemäldekunde*, I (1914).

Peltzer, 1924–25 R. A. Peltzer. «Die Heimat des Johan Lys (Liss) und seine Zeichnungen,» *Zeitschrift für bildende Kunst*, LVIII (1924 bis 25).

51

Peltzer, in Thieme Becker, XXIII, 1929
R. A. Peltzer. In *Allgemeines Lexikon der Bildenden Künstler,* XXIII, ed. Ulrich Thieme and Felix Becker. Leipzig, 1929.

Peltzer, 1933
R. A. Peltzer. «Die musizierende Gesellschaft von Johann Liss in der Alten Pinakothek,» *Münchner Jahrbuch der bildenden Kunst.* N. S., X (1933).

Pevsner and Grautoff, 1928
N. Pevsner and O. Grautoff. *Barockmalerei in den romanischen Ländern* («Handbuch der Kunstwissenschaft»). Wildpark-Potsdam, 1928.

Pieracchini, 1910
E. Pieracchini. *Catalogue of the Royal Uffizi Gallery in Florence.* Prato, 1910.

Pigler, 1956
A. Pigler. *Barockthemen,* I–II. Budapest, 1956.

Pigler, 1968
A. Pigler. *Museum der Bildenden Künste Budapest: Katalog der Galerie alter Meister.* Budapest and Tübingen, 1968.

Posse, 1925–26
H. Posse. «Ein unbekanntes Gemälde des deutsch-venezianischen Malers Johann Liss in Dresdner Gemäldegalerie,» *Zeitschrift für bildende Kunst,* N. S., LIX (1925–26).

Réau, 1958
L. Réau. *Iconographie de l'art Chrétien,* III. Paris, 1958.

Savini-Branca, 1964
S. Savini-Branca. *Il collezionismo veneziano nel '600.* Padua, 1964.

Salvini, 1954
R. Salvini. *The Uffizi Gallery: Catalogue of Paintings.* Florence, 1954.

Salvini, 1965
R. Salvini. *The Uffizi Gallery: Catalogue of Paintings.* Florence, 1965.

Sandrart, 1675
J. von Sandrart. *Teutsche Academie,* I. Nürnberg, 1675.

Scheyer, 1960
E. Scheyer. «Baroque Painting in Germany and Austria,» *Art Journal,* XX (1960).

Schilling, 1954
E. Schilling. «Betrachtungen zu Zeichnungen von Johann Liss,» in *Festschrift für Karl Lohmeyer.* Saarbrücken, 1954.

Schlick, 1973
J. Schlick. *Kunsthalle zu Kiel: Katalog der Gemälde.* Kiel, 1973.

Schneider, 1933
A. von Schneider. *Caravaggio und die Niederländer.* Marburg, 1933. Reprinted: Amsterdam, 1967.

Sobotik, 1972
K. Sobotik. *Central Europe 1600–1800,* exh. cat. John and Mable Ringling Museum of Art, Sarasota, Florida, 1972.

Steinbart, 1940
K. Steinbart. *Johann Liss, der Maler aus Holstein.* Berlin, 1940.

Steinbart, 1942
K. Steinbart. «Johann Liss, der venezianische Maler deutscher Nation,» *Pantheon,* XXX (1942).

Steinbart, 1946
K. Steinbart. *Johann Liss.* Vienna, 1946.

Steinbart, 1958–59
K. Steinbart. «Das Werk des Johann Liss in alter und neuer Sicht,» *Saggi e memorie de storia dell'arte,* II (1958–59).

Suida, 1958 W. E. Suida. «Notes on Old and Modern Drawings,» *Art Quarterly*, XXI (1958).

Voss, 1933–34 H. Voss. «Nicht venezianische Maler im venezianischen Seicento,» in *Sitzungsberichte der Kunstgeschichtlichen Gesellschaft zu Berlin* (1933–34).

Weyerman, 1729 J. C. Weyerman. *De levens-beschryvingen der nederlandsche konst-schilders en konstschilderessen*, I. The Hague, 1729.

Woeckel, 1967 G. Woeckel. In *Kindlers Malerei Lexikon*, IV. Zürich, 1967.

Wurzbach, 1910 A. von Wurzbach, *Niederländisches Künstler-Lexikon*, II. Vienna, 1910.

Zarnowski, 1925 J. Zarnowski. «Zwei unbekannte Werke Jan Lys in Russland,» *Belvedere*, IV (1925).

Zykan, 1947–48 J. Zykan. «Berichte,» *Österreichische Zeitschrift für Denkmalpflege*, I–II (1947–48).

CATALOGUE

A. Paintings

A 1 A PAINTER IN HER STUDIO Fig. 1

Oil on canvas, 81 × 108 cm. (31⁷/₈ × 42⁹/₁₆ inches).

Rijksdienst voor Roerende Monumenten, The Hague.

A woman works at an easel on a painting that represents an elegantly dressed lady sitting in front of her. A cavalier bends over the sitter from behind and places his right hand on her breast. On the left is a young man playing the lute.

This painting, at one time known only from the engraving by Gilles Rousselet [E 71], appeared on the Dutch art market in 1942 under the name of Judith Leyster and was published by Vitale Bloch (1942) as an early painting by Johann Liss. It is very unlikely that Liss painted a portrait of one particular Dutch painter in her studio, as Steinbart assumes. This kind of representation, with its stage-like arrangement, points more to an allegorical concept in which the woman at the easel could be interpreted as the personi-fication of painting – as Pictura. We see her again, also in a similar pose, in a picture by Frans Francken the Younger (private collection) with a lute player next to her in a «Kunstkammer»;[1] however, few Pictura allegories are set in such bourgeois surroundings. Liss's composition follows a type of group portrait in which an artist is shown with family as, for example, in a painting of 1612 by Herman van Vollenhoven in Amsterdam[2] or the well-known group portrait by Otto van Veen in the Louvre.[3]

In this studio picture by Liss a cavalier very demonstratively shows his love for the posing lady; even though no further definition of his role toward either the painter or her model is relayed. A pen drawing by Pieter van Laer in a song book of about 1623 may help to interpret the meaning of the painting: here, the painter interrupts his work on a lady's portrait in order to embrace his model with whom he has fallen in love, and Amor, himself, takes his place at the easel with palette, brush, and «malstock».[4] No literary basis for this representation seems to be known so far, apart from the classic example of Apelles, who also fell in love with his model. If the painting belongs in the same family of subjects as Van Laer's drawing, one would have to identify the cavalier as the painter who, taken by love, is unable to continue his work and leaves his place at the easel to Pictura herself. The lute-playing young man on the left might support such an inter-pretation since he is an often used motif of love symbolism.

The awkwardness of a group picture with an allegorical subject, created in the manner of the Haarlem school, contributes to the difficulty of interpreting this work. Liss visualized interiors with cavaliers similar to those of Willem Buytewech [E 16] and Dirck Hals, whose styles are discernible in the treatment of the figures, particularly the luteplayer on the left; Liss, however, did not achieve the differentiation of the Dutch examples.

Based on this connection with Haarlem, the date of the painting must be around 1615–16, the artist's early Haarlem period.

Within Liss's oeuvre two graphics come closest to the painting: a drawing of a pair of lovers, which is known to us through an etching by Cornelis Danckerts [C61], and the autograph etching, the *Fool as Matchmaker* [B42], in the style of Goltzius. The latter shows that Liss already had considerable ability in drawing, which at the time exceeded his achievements as a painter. Gilles Rousselet did a copper engraving after the painting in which he made slight changes in details of the costume and cited Liss as author. Steinbart (1958–59) mentions a variant of the picture by another hand in a private collection in Brussels.

¹ See R. W. Scheller, «Rembrandt en de encyclopedische kunstkamer,» *Oud Holland*, LXXXIV, 1969, p. 93, fig. 10. With reference to the Pictura allegory see M. Winner, *Die Quellen der Pictura-Allegorien in gemalten Bildergalerien des 17. Jahrhunderts zu Antwerpen*, doctoral dissertation, Cologne, 1957.

² See *Maler und Modell*, exh. cat., Baden-Baden, 1969, no. 42, illus.

³ H. Gerson and E. H. Ter Kuile, *Art and Architecture in Belgium 1600 to 1800*, Harmondsworth, 1960, fig. 40.

⁴ D. P. Snoep; «een 17de eeuws liedboek met tekeningen van Gerhard Ter Borch de Oude en Pieter en Roeland van Laer,» *Simiolus*, III, 1968–69, p. 109, fig. 25.

Collections: The Hague art market; property of German Reich, 1942; since 1945 Dienst voor's Rijks verspreide Kunst voor Werpen, The Hague.

Literature: Peltzer, in Thieme-Becker, XXIII, 1929, p. 285. – Bloch, 1942, pp. 44, 45, 46, illus. p. 42. – Steinbart, 1946, pp. 25–26, 59, fig. 15. – A. Welcker, «Bijdrage tot Lissiana I,» *Oud Holland*, LXII, 1947, p. 136. – Golzio, 1950, p. 568. – Bloch, 1950, p. 278, fig. 5. – Benesch, 1951, p. 379. – Bloch, 1955, p. 323. – Steinbart, 1958–59, pp. 161–62, n. 7, figs. 4, 5. – Bloch, 1966, p. 545.

R. K.

A2 THE DENTIST Fig. 2

Oil on canvas, 129 × 96,5 cm. (50³/₄ × 38 inches).

Kunsthalle Bremen.

A dentist is treating a peasant who winces with pain. A woman standing behind the peasant has seized his purse and extracts a coin.

The painting reproduces, on a vastly enlarged scale, an engraving by Lucas van Leyden, of 1523 [E 12] (Bartsch 157). The artist digressed from his model only in small details. He slightly broadened the picture space on both sides and endowed it with a landscape background. On the table, where instruments and medicaments are spread out, he added a sheet of paper.

Representations of medicine men and quacks are quite frequent in Netherlandish art;

they appear in sixteenth-century prints illustrating allegories of the five senses wherein the suffering of physical pain became a target for derision. The motif of theft is often included in the same context (see a painting by Jan Miense Molenaer, dated 1630, now in Braunschweig, Herzog Anton Ulrich-Museum, their cat. no. 668): for example, a woman exploits a man's weakness to fleece him.[1]

Liss here elaborated upon sixteenth-century prototypes as he had done for the peasant pictures in Budapest and Nürnberg [A 5, A 3], which are most closely related in style. The vigorous colors, with strong accents of red, the dryness of a somewhat heavy-handed brushwork on the red bolus ground are common characteristics of the above Liss paintings. The painterly treatment of the peasant's grey trousers is reminiscent of the grey trousers worn by the man who leads the Budapest *Peasant Dance* as well as the peasant's grey smock in the satyr picture in Berlin [A9]. The satyr painting, however, shows a stylistic distance from the earlier peasant pictures in Bremen, Budapest, and Nürnberg, which date from around 1617, its fluid brushwork already bespeaking an acquaintance with the art of Jordaens.

The Museum of Fine Arts in Budapest has an anonymous seventeenth-century painting which is also a copy of the *Dentist* engraving by Lucas van Leyden.[2]

[1] See Kahr, 1973.
[2] See Pigler, 1968, p. 379, no. 51774.

Collections: Acquired at auction in Paris, 1930, as gift of the Galerieverein dealers.

Exhibitions: Nürnberg, 1952, cat. no. N 1.

Literature: Jahresbericht des Kunstvereins in Bremen für das Jahr 1930–31, p. 12. – E. Waldmann, *Gemälde und Bildhauerwerke in der Kunsthalle zu Bremen.* Bremen, 1935, pp. 7, 56, cat. no. 276. – Steinbart, 1940, pp. 34–36, 161, pl. 9. – Steinbart, 1946, pp. 21, 58, fig. 9. – Golzio, 1950, p. 568. – Nürnberg, 1952, exh. cat., p. 126, no. N 1, fig. 136. – G. Busch and H. Keller, *Handbuch der Kunsthalle Bremen.* Bremen, 1954, p. 26, illus. – Pigler, 1956, II, p. 549. – Steinbart, 1958–59, p. 163. – G. Busch and H. Keller, *Meisterwerke der Kunsthalle Bremen,* Bremen, 1959, fig. 34. – Woeckel, 1967, p. 178. – G. Busch and J. Schultze, *Meisterwerke der Kunsthalle Bremen,* Bremen, 1973, fig. 34. – M. Kahr, «Rembrandt and Delilah,» *Art Bulletin,* LV, 1973, p. 255. – *150 Jahre Kunstverein in Bremen-Jubiläums-Stiftung 1973,* exh. cat., Kunsthalle, Bremen, 1973–74, illus. p. 29.

R. K.

A3 PEASANT BRAWL Fig. 4

Oil on canvas, 67,4 × 83 cm. (26⁹/₁₆ × 32¹¹/₁₆ inches).

Germanisches Nationalmuseum, Nürnberg.

Two fighting men who are about to strike each other with drawn swords are being held back by peasants; behind them an old woman swings a bunch of keys on a chain. In the foreground, a couple lies next to an upset table among plates and dishes; on the left a peasant uses a wood bench for defense.

If one allows for small, not uncommon, inaccuracies in Sandrart's accounts, the description of *Peasant Brawl* apparently refers to the Nürnberg picture. But if the drawing in Ham-

burg [B 43] indicates there was a similar painting, now lost, it would fit Sandrart's description even better. The hoes and forks he mentioned can be found in the drawing but not in the Nürnberg painting.

As a counterpart to the *Peasant Brawl* Sandrart mentions a *Peasant Wedding*, which is most certainly the one in Budapest [A 5]. The two paintings, on the basis of style and measurements, belong together; they represent harmony and discord in the sense of good and bad fortune.

According to Steinbart, the depiction of brawling peasants goes back to an invention by Pieter Bruegel the Elder. The (probably) unfinished painting, now lost, known to us through old copies, was owned by Bruegel's eldest son, Jan, who, with his friend, Rubens, studied the painting.[1] It is uncertain whether and how Johann Liss knew about this composition; Lucas Vorsterman's engraving [E 14], which repeats Rubens' reconstruction of Bruegel's representation, has to be dismissed for chronological reasons. Steinbart (1946) is of the opinion that Liss «must have seen another copy from one of the followers of the elder Pieter.»

Two drawings document Liss's preoccupation with this subject matter and show the development for the Nürnberg painting: a sketch depicting a fighting peasant couple (Steinbart, 1958–59, fig. 9) and the compositional drawing in Hamburg [B 43] – probably done in preparation for the painting – which was engraved by Wenzel Hollar under the name of Bruegel [E 107].[2] It is evident from the Hamburg drawing and the Nürnberg painting that Liss was directly influenced by the artistic strength and dynamic movement that identify Bruegel's figure style. The inspiration for the composition of the *Peasant Brawl*, however, seems to go back to another source, an engraving [E 13] of the subject by Hans Sebald Beham (Pauli 185) from his representations of the months, a series done in 1546–47. Liss also selected motifs from the series for the Budapest *Peasant Wedding*, the counterpart of the *Peasant Brawl*.

Liss's handling of these subjects (which were also painted and distributed by Bruegel copiers in the seventeenth century), along with his competent rendering and the quality of color, make it very probable that both paintings were done in Antwerp. Sandrart did not mention a stay in Antwerp, but we may assume one with some certainty, particularly in view of the strong influence Jordaens had on Liss (see [A 9, A 10]).

The time Liss spent in the Netherlands – determined only on the basis of stylistic evidence – can be set at about 1616–19, a time when his works were extremely heterogeneous. If one uses the few works that were probably done in Haarlem as a point of departure, one might assume that Liss moved to Antwerp in 1617, the year Goltzius died. Keeping in mind the consequent strong influence from Jordaens, we might conclude that Liss painted the *Peasant Brawl*, the *Peasant Wedding*, and related works at the beginning of his Flemish period. There is insufficient evidence for Steinbart's suggestion that Liss could have been in Antwerp twice and, therefore, may have had contact with Bruegel's followers before his Haarlem time.

An old replica of the Nürnberg picture was acquired in Venice and is in the collection of the Ferdinandeum in Innsbruck [A 4]. Since in the replica the picture space is extended to the right and at the bottom, it may be assumed that the Nürnberg canvas was cut.

[1] See in this connection, L. Burchard and R. A. d'Hulst, *Rubens Drawings*, Brussels, 1963, pp. 242 ff.; J. S. Held, *Rubens: Selected Drawings*, London, 1959, p. 58.

[2] Parthey, 1864, no. 599.

Collections: 1928 Berlin art market.

Exhibitions: Nürnberg, 1952, cat. no. N 2.

Literature: Sandrart, 1675 (ed. 1925) p. 187. – Weyerman, 1729, p. 403 (could be either the Nürnberg or Innsbruck version). – Peltzer, in Thieme-Becker, XXIII, 1929, 286. – E. H. Zimmermann, *Neuerwerbungen des Germanischen Museums 1925–29*, Nürnberg, 1929, p. 53, pl. 47. – Lutze, 1934, p. 42, no. 1163. – E. Wiegand, «Deutsche Barockmalerei im Germanischen Nationalmuseum in Nürnberg,» *Bayernland*, XLVI, 1935, p. 51. – Steinbart, 1940, pp. 27–28, 162, pl. 7. – Steinbart, 1946, pp. 19–20, 57, fig. 5. – Bénézit, 1952, p. 600. – Nürnberg, 1952, exh. cat., p. 126, no. N 2. – L. Grote, *Deutsche Kunst und Kultur im Germanischen Nationalmuseum*, Nürnberg, 1952, pl. 167. – Schilling, 1954, p. 37, n. 7. – Martius, 1955, pp. 9, 10, no. 9, pl. 9. – Steinbart, 1958–59, pp. 163, 166. – Scheyer, 1960, p. 12, fig. 5. – Berlin, 1966, exh. cat., p. 47 (R. Klessmann). – Woeckel, 1967, p. 178.

R. K.

A 4 Peasant Brawl Fig. 3

Oil on canvas (mounted on wood), 68,7 × 91,6 cm (27^1/$_{16}$ × 36^1/$_{16}$ inches).

Tiroler Landesmuseum Ferdinandeum, Innsbruck.

This painting, which has its counterpart in the *Peasant Wedding* of the Budapest museum [A 5] deviates only slightly from the Nürnberg *Peasant Brawl* [A 3], mostly in the shapes of trees and clouds and in the slightly wider picture space. Otherwise, the subject and composition are the same.

Compared to the Nürnberg picture, the rendering is smoother and there is less detail. Steinbart (1940) is of the opinion that «the strong chiaroscuro of the Innsbruck *Peasant Brawl* fits in better with the Budapest *Peasant Wedding* than the soft tonalities of the Nürnberg replica [which was] probably done a little later.» The difference in the state of preservation of the two pictures does not permit an objective comparison of color quality or an evaluation of the paintings from the viewpoint of development. However, the paint surface of the Innsbruck *Peasant Brawl* shows evidence of being the second version, probably painted not much later than the Nürnberg picture, which belongs to the artist's Flemish period.

For iconography, style, and dating of the picture see [A 3].

Collections: Legacy Caspar Jele, Innsbruck, 1894 (Netherlandish 17th century); previously acquired in Venice.

Literature: Sandrart, 1675, (ed. 1925) p. 402. – Weyerman, 1729, p. 403 (could be either the Nürnberg or Innsbruck version). – T. von Frimmel, «Ein Bild von Jan Lys,» *Blätter für Gemäldekunde*, IV, 1908, pp. 72–73, illus p. 193. – Frimmel, 1909, pp. 117 ff., illus. p. 115. – Z. von Takács, «Die Neuerwerbungen des Museum für Bildende Kunst in Budapest,» *Der Cicerone*, III, 1911, p. 873. – Peltzer, 1914, p. 163. – Oldenbourg, 1914, p. 144. – Bode, 1919, pp. 5–6. – Bode, 1920, p. 168, illus, p. 164. – Oldenbourg, 1921, p. 16. – Zarnowski, 1925, p. 92. – J. Ringler, *Katalog der Gemäldesammlung des Museums Ferdinandeum Innsbruck*, Innsbruck, 1928, p. 89, fig. 54. – Pevsner and Grautoff, 1928, p. 157. – Peltzer, in Thieme-Becker,

XXIII, 1929, p. 286. – Lutze, 1934, p. 42. – Steinbart, 1940, pp. 27–28, 162, pl. 6. – Bloch, 1942, p. 41. – Steinbart, 1946, p. 56. – Bénézit, 1952, p. 600. – De Logu, 1958, p. 277. – Steinbart, 1958–59, p. 164. – Paris, 1965, exh. cat., p. 173. – Donzelli and Pilo, 1967, pp. 240, 241–42.

R. K.

A 5 PEASANT WEDDING Fig. 5

Oil on canvas, 65,5 × 81,5 cm. (25^{13}/$_{16}$ × 32^{1}/$_8$ inches).

Szépmüvészeti Múzeum, Budapest.

A party of peasants dances to the tune of two musicians standing on an elevation in the background. A young couple, followed by an older couple, leads the dance. The men are looking out toward the viewer; the younger one raises his beer glass. The women carry keys on a chain slung around their waists. To the left, a woman attends to a vomiting youth; to the right, beside three barrels, a man waves at the dancers.

Sandrart described the *Peasant Wedding* in detail and mentioned it as a companion piece to the *Peasant Brawl* [A 3]. Although he identified the first couple of dancers as a «pastor leading the bride by her hand,» there can be no doubt that the painting he saw is the one now in Budapest, or at least a copy thereof.

For the composition of this picture and *Peasant Brawl*, Liss drew ideas from sixteenth-century works. As Takács (1911) noted, similar couples of dancing peasants appear in a series of ten copper engravings (ca. 1546–47), by Hans Sebald Beham, representing the months and feast days (Pauli 177–186). It is there, too, that we find the models for the vomiting youth, the pair of musicians, and the innkeeper waving his hat in greeting. One of these engravings is the source for the composition of the *Peasant Brawl* at Nürnberg [E 15].

The painting has suffered from abrasions, but it is, nevertheless, striking with its strong local colors and red bolus ground. Like its Nürnberg counterpart, it dates from the artist's Flemish period (for discussion of style and date, see under *Peasant Brawl* [A 3]). The letters «JO» at the lower right, applied on top of the original paint, are doubtlessly a later addition (by a former owner?).

A pen drawing by the artists, now in the drawing collection in Munich [B 47], should not be regarded as a study for the painting but rather as a drawing variant which may precede the painting. In the drawing, the dancing men do not turn toward the viewer as they do in the painting.

Collections: Private collection, Venice; Kunsthandlung H. O. Miethke, Vienna.

Literature: Sandrart, 1675, (ed. 1925) p. 402. – Weyerman, 1729, p. 403. – Descamps, 1753, p. 264. – Immerzeel, 1843, p. 181. – T. von Frimmel, «Ein Bild von Jan Lys,» *Blätter für Gemäldekunde,* IV, 1908, pp. 72–73, 193, illus. – Z. von Takács, «Budapest, Museum der Bildenden Künste.» *Monatshefte für Kunstwissenschaft,* I, 1908, p. 666. – Frimmel, 1909, pp. 117 ff. – A. von Wurzbach, *Niederländische Künstler-Lexikon,* III, Vienna, 1911, p. 110. – Takács, «Die Neuerwerbungen des Museums für Bildende Kunst in Budapest,» *Cicerone,* III, 1911, p. 873. – Burchard, 1912, p. 116. – Oldenbourg, 1914, p. 144. – Peltzer, 1914, p. 163. – Oldenbourg, 1918, p. 114. – E. Petrovics, in *Az Országos Szépmüvészeti Múzeum Evkönyvei,* I, 1918, p. 201. – Bode, 1919, pp. 1, 5. – Bode, 1920, p. 168. – Oldenbourg, 1921, pp. 9, 15, fig. VI. – Peltzer,

1924–25, pp. 161, 163. – G. Térey, in *Neue Blätter für Gemäldekunde*, I, 1922, p. 8. – T. Muchall-Viebrook, «Sitzungsberichte der Kunstwissenschaftlichen Gesellschaft in München,» *Münchner Jahrbuch der Bildenden Kunst*, XIII, 1923, p. 171. – Zarnowski, 1925, p. 92. – Fokker, 1927, p. 204. – Pevsner and Grautoff, 1928, p. 157. – Peltzer, in Thieme-Becker, XXIII, 1929, p. 286. – Fiocco, 1929, p. 22. – E. Valentiner, *Karel van Mander als Maler*, Straßburg, 1930, p. 142. – E. Hoffmann, *Magyar Müvészet*, VII, 1931, p. 394. – Benesch, 1933, p. 71. – Lutze, 1934, p. 42. – Steinbart, 1940, pp. 18 ff., 161, pls. 2, 3. – Steinbart, 1942, pp. 171–72. – Steinbart, 1946, pp. 18–19, 57, figs. 3, 4. – Bloch, 1942, p. 41. – Bénézit, 1952, p. 600. – Schilling, 1952, p. 32. – Steinbart, 1959, p. 166. – Venice, 1959, exh. cat., p. 167. – K. Garas, *Meisterwerke der alten Malerei im Museum der Bildenden Künste Budapest*, Leipzig, 1960, p. 23, VIII, pl. 61. – H. W. Keiser, *Gemälde-galerie Oldenburg*, Munich, 1966, p. 105. – Woeckel, 1967, p. 178. – Donzelli and Pilo, 1967, pp. 240–41. – Pigler, 1968, pp. 386–87. – P. Rosenberg, »Twenty French Drawings in Sacramento,« *Master Drawings* VIII, 1970, p. 36, n. 2. – M. Mojzer, *Deutsche und österreichische Gemälde aus dem 18. Jahrhundert*, Budapest, 1975, pls. 2, 3.

COPIES:

Landesmuseum für Kunst- und Kulturgeschichte, Oldenburg. Oil on canvas, 68,5 x 87 cm. (27 x 34-1/4 inches). This is an old copy of the painting. (See H. W. Keiser, *Gemäldegalerie Oldenburg*, Munich, 1966, p. 105.) – *Italian private collection.* This is another painted copy, listed in the Budapest catalogue (see Pigler, 1968, p. 387). – *Sacramento, E. B. Crocker Art Gallery*, Related drawing. – *Budapest Museum of Fine Arts.* Related drawing. – *Breslau Museum* (Wroclaw). Steinbart (1940, p. 26) pointed out that the painter Simon de Vos (1603–1676) of Antwerp partially copied the composition of the *Peasant Wedding*, based on the Munich drawing, for the painting now in Wroclaw. (See Steinborn, *Catalogue Zbiorów malarstva niderlandzkiego*, Wroclaw, 1973, cat. no. 37, illus.)

R. K.

A6 THE GALLANT COUPLE Fig. 7

Oil on canvas, 63 × 49 cm. (24^{13}/$_{16}$ × 19^{5}/$_{16}$ inches).

Dr. Karl Graf von Schönborn-Wiesentheid, Schloss Pommersfelden.

A fashionably dressed young man with sword and plumed hat greets an elegant blond lady. She wears a low-cut gown with a lace collar and gathers her skirt with her left hand. On the left, a man plays the lute; books and musical instruments lie scattered on the floor. Behind the drape on the right, which partly covers a chandelier, is a pair of lovers; the man with his arm around the girl looks outward toward the viewer. Sandrart describes the subject of this painting: «He also did several paintings, in modern manner, of lovers in conversation and of the amorous Venetian girl with music, card games, promenading and of other scenes of courtship . . .»

The picture goes back to the erotic conversation pieces popular among painters of the Haarlem school. During the first quarter of the century, Willem Buytewech and Dirck Hals contributed considerably to the development of this picture type. The original moral purpose, the warning not to spend a loose, luxurious, and godless life, is present in the Dutch conversation pieces (earlier known as «Sittenbild») but in disguise. The *Gallant Couple* by Liss is closely related to a painting by Buytewech, *The Procuress* (Rijksmuseum, Amsterdam), painted ca. 1616–17;[1] however, the motif has not been literally adopted. Steinbart (1940) noted that the cavalier in Liss's painting (who looks out from behind the curtain), could be traced back to a similar figure in an etching by Buytewech, *Lucelle and Ascagnes* (Hollstein 17).

The motif of the *Gallant Couple* relates it to two works by Liss, the well-known pen drawing in the Berlin Kupferstichkabinett [B 45] and the *Garden of Love,* known to us only through an etching by Nicolas de Son [C 62]. The Berlin drawing shows direct parallels to the painting, particularly in the standing couple on the right and the sitting couple on the left. The drawing must have preceded the painting; since the vertical format of the painting offers a «better concentration of the original idea, the composition could only have been developed out of the Berlin drawing» (Steinbart, 1940). The moralizing function of the fool in the background of the drawing, whose eyes fasten on the viewer, has been taken over by the man behind the curtain in the painting. The objects strewn on the ground at the feet of the pair indicate an «untidy» life; this is even more obvious in the Bremen version of the picture [A7], where playing-cards are added.

The etching, *Garden of Love,* can be used as comparison only with reservation, since we cannot be sure whether Nicolas de Son has made changes from the original drawing or painting. If changes were made, these most likely would have been in the background, since the placement and movement of the figures are true to the manner of Liss. One couple stands in the foreground and another lies on the ground, so that the motif of the indoor scene has been transferred to the outdoors.

It is generally assumed, without any cogent reasons, that the painting was done in the 1620's, the Venetian period of the artist. The close relationship of the painting to the art of Haarlem, however, makes it more likely that it was painted earlier, in the Netherlands, particularly if one considers the relationship of the Berlin drawing to the graphic works of the early Netherlandish period of the artist. The large figures, strong color, and relatively broad brushstroke presuppose the artist's contact with Flemish painting. It was characteristic of Liss to transform the subjects of his works from intimate to large form. For these reasons it seems justified to suggest a dating for the *Gallant Couple* of around 1617, close in time to the peasant pictures in Budapest [A5] and Nürnberg [A3].

The replica in the Ludwig-Roselius collection [A7] is a slightly different version acquired from the art market in 1929. Drawn copies are in Paris, Ecole des Beaux-Arts (Steinbart, 1940, p. 167, fig. 18) and in Florence, Uffizi (Steinbart, 1940, p. 166).

[1] See E. Haverkamp Begemann, *Willem Buytewech,* Amsterdam, 1959 no. IV, fig. 35.

Collections: Adriaen Paets, sale, Rotterdam. April 26, 1713(?); Kurfürst Lothar Franz von Schönborn, 1719.

Literature: [J. R. Byss], *Fürtrefflicher Gemähld- und Bilder-Schatz,* Bamberg, 1719, no. 15. – *Beschreibung des ... Bilder-Schatzes ... deren Reichs-Grafen von Schönborn,* Würzburg, 1746, no. 52. – [J. R. Byss], *Verzeichnis der Schildereyen in der Gallerie ... zu Pommersfelden,* Anspach, 1774, no. 199. – J. Heller, *Die Gräflich Schönborn'sche Gemälde-Sammlung zu Schloss Weissenstein,* Bamberg, 1845, p. 24 (as Gerhard Seghers). – *Katalog der Gräflich von Schönborn'schen Bilder-Gallerie zu Pommersfelden,* Würzburg, 1867, no. 579 (as Gerhard Seghers). – Frimmel, 1891, p. 34. – H. de Groot, 1893, p. 143. – Frimmel, *Verzeichnis der Gemälde in Gräflich Schönborn-Wiesentheid'schen Besitze,* Pommersfelden, 1894, p. 115, no. 337. – Frimmel, «Bilder von seltenen Meistern,» *Monatsberichte über Kunstwissenschaft,* I, 1900–1901, p. 218. – Frimmel, 1909, p. 117. – Oldenbourg, 1914, p. 148. – Oldenbourg, 1921, p. 16. – Frimmel, 1922, p. 54. – H. Fischer, *Kurfürst Lothar Franz und seine Gemäldegalerie,* II: *Der Schönborn-Wiesentheid'sche Bilderbesitz,* Dissertation, Freiburg, Schweiz, 1923, no. 426. – Peltzer, in Thieme-Becker, XXIII, 1929, p. 286. – Steinbart, 1940, pp. 37–38, 162–63, pl. 10. – Steinbart, 1942, p. 173. – Houbraken, 1943, I, pp. 342–43. – Steinbart, 1946, pp. 24, 56, colorplate III. – Bénézit, 1952, p. 600 (as *Musicians*). – Steinbart, 1959, p. 168. – Scheyer, 1960, n. l, p. 12. – Woeckel, 1967, p. 178. – Donzelli and Pilo, 1967, p. 242.

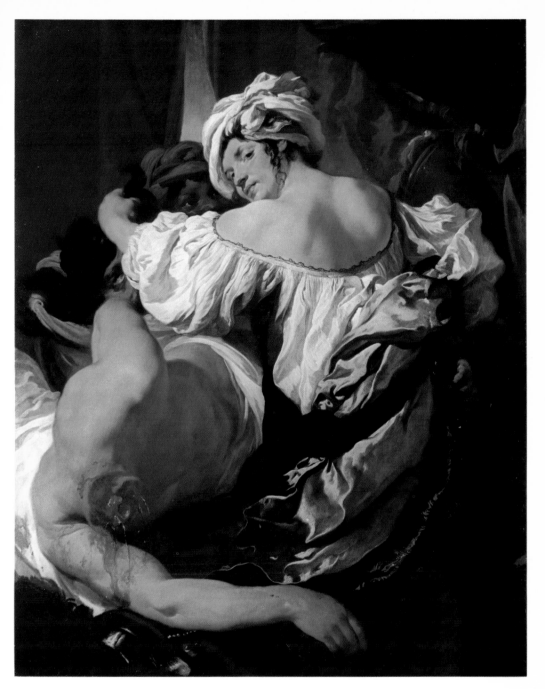

IV Judith · National Gallery, London [A 19]

COPIES:

Formerly Viscount Feilding. Oil on canvas, 63,5 x 48,2 cm. (25 x 18 inches). Sale, Christie's, London, July 1, 1938, no. 88 (to Captain Moore). An inscription on the painting from more recent times reads: Basil Viscount Feilding, Ambassador at Venice in carnival attire with his wife, Lady Anne Weston (see Cecilia Countess of Dembigh, *Royalist Father and Roundhead Son*, London, 1915, illustrated title page). The inscription, which cannot be taken too seriously, is probably based on the story that the painting was purchased in Venice where Viscount Feilding was Ambassador in 1634.

R. K.

A 7 THE GALLANT COUPLE Fig. 8

Oil on canvas, 72,5 × 54,5 cm. (28^9/$_{16}$ × 21^7/$_{16}$ inches).

Ludwig Roselius Collection of Böttcherstrasse, Bremen.

This composition must be considered another original version of the subject represented in the Pommersfelden painting [A6], from which it differs but slightly. Research is still inconclusive as to the chronological order of the canvases, but the close relationship of both to the art produced at Haarlem supports the assumption that they originated in the Netherlands. (For a discussion of iconography, style, and date, see [A6]).

Collections: Berlin, art dealer (Dr. Benedict); acquired by the Roselius Collection in 1929.

Exhibitions: Berlin, Galerie Dr. Schäffer, 1929: Die Meister des Holländischen Interieurs; cat. no. 47. – Nürnberg, 1952, cat. no. N 3.

Literature: Peltzer, in Thieme-Becker, XXIII, 1929, p. 286. – Steinbart, 1940, pp. 38 ff., 161, pl. 11. – K. Bauch, «Beiträge zum Werk der Vorläufer Rembrandts, Haarlemer Figurenbilder aus der Frühzeit Frans Hals,» *Oud Holland*, LVIII, 1941, p. 89, fig. 4. – Steinbart, 1946, pp. 24–25, 56, 58, fig. 11. – Bloch, 1950, p. 281. – Golzio, 1950, p. 568. – Nürnberg, 1952, exh. cat., p. 126, no. N 3. – Venice, 1959, exh. cat., p. 167 (T. Pignatti). – Berlin, 1966, exh. cat., p. 121 (H. Möhle).

R. K.

A 8 DIANA AND ACTAEON Fig. 6

Oil on oak panel, 64 × 49 cm. (25^3/$_{16}$ × 19^5/$_{16}$ inches).

Private collection, England.

> There was a vale in that region, thick grown with pine
> and cypress with their sharp needles. 'Twas called
> Gargaphie, the sacred haunt of high-girt Diana. In its
> most secret nook, there was a well-shaded grotto . . .
> [Here Diana and her nymphs came bathing when weary
> from the hunt.] While the nymph Titania was bathing . . .
> there in her accustomed pool, lo! [Actaeon] Cadmus'
> grandson . . . comes wandering through the unfamiliar
> woods . . . and enters Diana's grove . . . the naked

65

nymphs smote upon their breasts at sight of the man,
and filled all the grove with their shrill, sudden
cries . . . Then they thronged around Diana seeking to
hide her body with their own; but the Goddess stood head
and shoulders over all the rest. And red as the clouds
which flush beneath the sun's slant rays, red as the
rosy dawn, were the cheeks of Diana . . . Then though
the band of nymphs pressed close about her, she stood
turning aside a little and cast back her gaze; and though
she would fain have had her arrows ready, what she had
she took up, the water, and flung it into the young man's
face . . . [and] on the head she had sprinkled she caused
to grow the horns of the long-lived stag . . .[1]

The artist, who, I suggest, was the young Liss, knew Ovid's story[2] intimately, for Diana does stand «head and shoulders over all the rest» *(supereminet omnis)*, turning aside and casting back her gaze. He vividly describes the turmoil caused by Actaeon's entrance into the grotto and the helter-skelter of tumbling bodies just as Ovid described. Diana's open right hand (emptied after flinging water into Actaeon's face) is a gesture which Liss used frequently in his later works.

Typical of mannerist compositions, the main scene (of the metamorphosis) is relegated to the background in small scale. Here Diana appears a second time actually flinging water at Actaeon whose antlers begin to grow. One of his hounds is at Actaeon's feet (later he is killed by his hounds after his transformation into a stag). In the foreground, the large shell and the nymphs create an effective *repoussoir*.[3]

Although reminiscent of many other renderings of the subject by Italianate Dutch artists such as Hendrik van Balen, Joachim Uytewael, Cornelis van Haarlem, and Paulus Moreelse, Liss's *Diana and Actaeon* is a startling departure from their elongated nudes posing in landscapes. Its unusual style and appearance kept the painting in total anonymity until 1973 when it was shown to Denis Mahon by its present owners.[4] Mahon recognized it as a work by the young Liss and believed it was done not long after Liss's arrival in Antwerp from Holland, ca. 1618 to 1619, before his departure for Italy. (The oak panel would fit in with a Netherlandish origin.) Mahon pointed out that the artist was clearly familiar with Dutch mannerism but also revealed knowledge of modern developments by Rubens and Jordaens in Antwerp. At the same time, Mahon commented, the work revealed in embryonic form many highly idiosyncratic characteristics of color, handling, and style which were to become typical of Liss, as his personality developed. Benedict Nicolson and Erich Schleier both agreed with Mahon's attribution and suggested dating.[5] One other record of a *Diana and Actaeon*, attributed to Liss, is a drawing in red chalk, formerly in the Karl Eduard von Liphart collection[6] (sale, Boerner, Leipzig, April 26, 1898, no. 568; 38 × 32 cm. [14^{11}/$_{16}$ × 12^5/$_8$ inches], possibly the same sale in which the drawing, *Allegory of Christian Faith* [B 50], was sold.)

Under the impact of Antwerp masters, the young artist, at least for a while, abandoned his Haarlem manner and vastly enlarged his scale. In his *Diana and Actaeon* he went to

work with the enthusiasm and ambition of a promising young stage director enacting a difficult play with inexperienced actors. No doubt he had just admired Rubens' seaborne nymphs and deities in numerous paintings done around 1615, as well as the luscious *Daughters of Cecrops Discovering Erichthonius* (Liechtenstein).[7] These very same works also impressed the young Jordaens, as we can see in his version of Rubens' *Daughters of Cecrops* [E 17], dated 1617 (Koninklijk Museum voor Schone Kunsten, Antwerp), as well as other works of the period, particularly his *Allegory of Fruitfulness* [E 18][8] (Baye-rische Staatsgemäldesammlungen, Munich). In all these works we find strong echoes of Ru-bens' light tonalities, the sensuous weight of his nudes, and their smooth clinging blond hair. In turn, they affected Liss. For example, one of Jordaens' nudes, standing on the left in both of the above paintings, reappears in slightly varied form in the same place in Liss's *Diana and Actaeon*.[9]

Jordaens' effect on Liss was a lasting one, but in no other work, apart from the *Satyr and Peasant* [A 9, A 10], did Liss come so close to this master. Nor, as far as we know, did he ever again indulge in such a frank display of physical corpulence. This brief lesson in Antwerp influenced his image of female nudes; though slighter in shape and scale, they were – like those of Rubens and Jordaens – both natural and sensuous. Liss added to them his very personal touch of Venetian lustre. Although *Diana and Actaeon* gives the impression of a novice performance, nevertheless, the painting reveals signs of unusual sophistication. Carefully selected diverse accessories give the foreground a cornucopia richness of color, shape, and texture, playing subtly on our senses of sight and touch. Thus Liss has placed the giant shell,[10] with its striking pattern and shiny hard surface below a soft drape of rich satin, whose folds are a prelude to the typical shell-like openings that were to become so familiar in his paintings. The precious silk, wrapped partly around the nymph, intended to cover her nakedness, instead heightens the sensual effect of her nude body. Above all, the subtle gradations of the color and the transparency of the shadows captures the poetry of Ovid's «light from the sun's slant rays» and intimates the promise of an artist who soon was to exult in the rich play of color, texture, and light.

[1] Ovid, *Metamorphoses*, Book III (transl. F. J. Miller; London, 1916), pp. 135, 137, and 139.

[2] The first edition of Ovid's *Metamorphoses* in Holland was published in Arnheim in 1607.

[3] Diana, looking out to the spectator, acts as another *repoussoir* element. There is a close parallel between her and the woman at the extreme right in Cornelis van Haarlem's *Baptism of Christ* in the Kunsthalle, Karlsruhe.

[4] The painting was acquired by its present owners on the London art market in the later 1930's. On the back of the panel is a hand-written inscription: Villa d'Este [below that, two names] Haseltine and Ralph Papé.

[5] Denis Mahon kindly transmitted his cited comments in a letter dated April 25, 1975. We are most grateful for his kind intervention in securing, and arranging for cleaning, the painting for the exhibition through the Leggatt Brothers in London. Mahon also wrote that Gerhard Ewald of Stuttgart, after seeing a transparency of the painting, endorsed the attribution to Liss, and the dating. R. Klessmann, after seeing a transparency, tentatively agreed with the suggestion of Liss's authorship.

[6] This drawing was brought to my attention by L. S. Richards.

[7] Among Rubens' works of about 1615, the following are suggested for comparison with Liss's *Diana and Actaeon*: *Neptune and Amphitrite*, *The Four Quarters of the Globe*, and *Ixion Deceived by Juno* (see A. Rosenberg, *Rubens*, Klassiker der Kunst, Berlin and Leipzig, 1921, pp. 108, 111, and 125).

[8] See M. Jaffé, *Jacob Jordaens 1593–1678*, exh. cat., National Gallery of Canada, Ottawa, 1969, cat. nos, 12 and 14; and L. v. Puyvelde, «Jordaens' First Dated Work,» *The Burlington Magazine*, LXIX, 1936, pp. 225–26.

[9] Jordaens treated the subject of *Diana and Actaeon* at least twice; in a painting in the Musée des Beaux Arts in Besançon, and in a drawing in the Herzog Anton Ulrich-Museum in Braunschweig. Two other mythological scenes by Jordaens lend themselves to further comparison with Liss's *Diana and Actaeon;* one, also in Besançon, is the *Wrath of Juno,* and the other (although a much later work), is a study for the *Triumph of Bacchus* in the Minneapolis Institute of Arts. Both have a close compositional correspondence to the present painting.

[10] Rare shells were much sought after by collectors in the Low Countries in the sixteenth and seventeenth centuries. Liss may have known some of the prominent shell collectors in Haarlem or Amsterdam. His teacher, Hendrick Goltzius, portrayed one of them, Jan Govertsen, holding some of his shells, in 1603 (Boymans-van Beuningen Museum, Rotterdam). The shell in Liss's painting resembles the large *conus marmoreus,* at least in the surface pattern. Liss also displayed some beautiful shells in small scale in the foreground of the *Fall of Phaeton* [A 26].

<div align="right">A. T. L.</div>

A 9 SATYR AND PEASANT

<div align="right">Fig. 9</div>

Oil on canvas, 130,5 × 166,5 cm. (51³/₁₆ × 65⁹/₁₆ inches).

Staatliche Museen Preussischer Kulturbesitz Gemäldegalerie, Berlin.

This painting is one of three known versions of which only two have survived. The other belongs to the National Gallery, Washington [A 10]. The painting that belonged to Max Rothschild (see under Copies) was destroyed in a fire in 1918. There is also a beautiful preparatory study for the head of the peasant woman [B 46].

The painting illustrates a scene from Aesop's fables[1] in which a satyr, befriending a peasant, jumps up from the table in sudden mistrust at the sight of the peasant blowing the soup in his spoon in order to cool it, when just a moment before the satyr had watched him blowing into his hands to warm them. The earlier incident is merely implied in this work; it is depicted in a similar composition of *Satyr and Peasant,* relegated to the background, in a drawing by Paulus Moreelse [E 19] (signed and dated 1611, Rijksuniversiteit, Leiden) which evidently goes back to much the same source as Liss's. Klessmann[2] proposed that one of these earlier models may have been Marcus Gheeraert's etching [E 20] from *De Warachtige Fabulen der Dieren,* which was first published in Brugge in 1567 (and repeated in several later editions).

Klessmann (1965, 1966) drew convincing parallels between Liss's and Jordaens' styles during the period ca. 1616–19, when, he believed, Liss painted his *Satyr and Peasant.* The subject was one of Jordaens' favorites, and he repeated it many times. Klessmann also cited Jordaens' *Holy Family* of 1616 (Metropolitan Museum of Art) for a stylistic comparison of the two masters' works. In support of his early dating, Klessmann also compared the knee-length figures and their arrangement to those in Liss's etching of the *Fool as a Matchmaker* [B 42], and pointed to the resemblance of the luteplayer to the left of the satyr in the painting.

Jordaens' closest compositional parallel with a *Satyr and Peasant* is the version in Brussels, dating from ca. 1619–20, the period when Jordaens, in close contact with Van Dyck, went through a pronounced Caravaggesque phase[3] (no doubt inspired by Rubens' own Caravaggesque compositions of that period in Antwerp). Liss used many features from the Brussels *Satyr and Peasant* but represented the figures in reverse, as they appear in the engraving by Lucas Vorsterman (1595–1675) [E 21]. There are other rather significant changes. Instead of Jordaens' woman and child at the table, Liss's is standing, holding the baby (younger than Jordaens') on her arm. She rejoins the circle through a subtle exchange of glances with the satyr. (This exchange of glances, so typical of Liss, caused his copyists considerable trouble.) Another typical Lissian feature – seen in the pose of the woman – is beginning to evolve in this painting. With her left shoulder slightly pulled up, her head tilted to one side, her glance directed to the other, her face half-smiling, she still reminds us of the woman in Lucas van Leyden's *Dentist*, which Liss copied [A2], and at the same time anticipates the coyly smiling courtesans in his paintings of merry companies in Italy. The fluid brushwork and crowded space on the right, the imposing bulk and heavy folds of the peasant's leather garb, gathered by a belt from which hang his knives, (reminiscent of the swords of Caravaggio's *Bravos*) – all are elements which mark a new cornerstone in his artistic development. By reducing Jordaens' narrative elements to a minimum, enlarging the scale and volume of his figures, and intensifying the chiaroscuro, Liss achieved a convincing unity of design and movement of Baroque amplitude.

For these reasons Steinbart (1958–59) believed that both versions of the *Satyr and Peasant* were painted in Italy – the Washington one before and the Berlin one after Liss's sojourn in Rome. Steinbart recognized the close stylistic ties to Jordaens, but pointed to the example of the Dresden *Magdalene* [A17], a work which was similarly inspired by Jordaens, even though it belongs among Liss's works painted in Italy. Except for Bloch (1966), who expressed doubts about its authorship, scholars have generally accepted the Berlin painting as the work of Liss. Steinbart dealt with the problems of sequence and stylistic relationships between the Berlin and Washington versions but no one else has since taken up the questions because the state of preservation of the Washington painting made a comparison nearly impossible. The painting has been cleaned and X-rayed recently and the problems can now be re-examined. The Liss exhibition will offer a welcome opportunity to come to terms with these questions.

[1] La Fontaine, *Fables,* New York ed., 1954, Book 5, VII.
[2] R. Klessmann «Ein neues Werk des Johann Liss in der Berliner Gemäldegalerie,» *Nordelbingen,* XXXIV, 1965, p. 83, fig. 2.
[3] M. Jaffé, *Jacob Jordaens 1593–1678,* exh. cat., National Gallery of Canada, Ottawa, 1969, pp. 47–48; see also p. 72 where Jaffé points to the close relationship between Jordaens and Liss from 1616 to 1619.

Collections: Acquired in 1962 through the Kaiser Friedrich Museum Association.

Exhibitions: Berlin, 1966, cat. no. 40.

Literature: Peltzer, in Thieme-Becker, XXIII, 1929, p. 286. – Steinbart, 1958–59, p. 204, fig. 2. – I. Kühnel-Kunze, «New ‹Old Masters› for the Picture Gallery,» (transl. M. Kay), *Apollo,* LXXX, 1964, p. 108, fig. 1 – E. Redslob, *Gemäldegalerie Berlin-Dahlem, Ehemals Kaiser-Friedrich-Museum,* Baden-Baden, 1964, pp. 239–40. – R. Klessmann, «Ein Neues Werk des Johann Liss in der Berliner Gemäldegalerie,» *Nordelbingen,*

XXXIV, 1965, p. 83, n. 2. – Berlin, 1966, exh. cat., p. 47 (R. Klessmann). – Bloch, 1966, p. 546. – *Verslagen omtrent 's rijks versammelingen van geschiedenis en kunst*, LXXXIX, 1967, p. 98. – *German Drawings 1400–1700 from Dutch Public Collections*, exh. cat., Museum Boymans-van Beuningen, Rotterdam, 1974, pp. 22–23.

A. T. L.

A10 SATYR AND PEASANT Fig. 10

Oil an canvas, 133,5 × 166,5 cm. (52¹/₂ × 65¹/₂ inches).

National Gallery of Art, Widener Collection, Washington, D. C.

Oldenbourg was the first to publish the painting as by Liss. It was formerly attributed to Velazquez.[1] Perhaps the pronounced monochromatic earth tones and the inclusion of commonplace objects that contribute to the mood of the painting, such as the bowl on the table, reminded the owners of Velazquez. (The *Satyr and Peasant* was formerly in two different Spanish collections in the eighteenth century.) Oldenbourg suggested a plausible comparison between the *Satyr and Peasant* and Velazquez' *Supper at Emmaeus* of 1620–21 (Metropolitan Museum of Art), which in turn pointed to the source of inspiration shared by both painters – Caravaggio's *Supper at Emmaeus* (National Gallery, London).[2]

Oldenbourg (1916) compared the ruddy flesh tones of the satyr and the peasant, the blooming face of the peasant's young wife, as well as the curved fluting of the folds in the peasant's sleeves, to those in the Dresden *Magdalene* [A 17]. Without committing himself to a specific date, Oldenbourg felt that the work should be placed between the two divergent sides of Liss's style – on the one hand, his preference for native peasant types and the Caravaggesque treatment of light, and on the other, his brilliance and refinement of colors inspired by the Venetian High Renaissance masters.

The rediscovery of the well-preserved *Satyr and Peasant* in Berlin in 1962 and its subsequent showing in the Berlin exhibition of 1966 somewhat eclipsed the Washington version, which had turned very dark because of layers of dirty varnishes. Now that it has been cleaned, the Washington *Satyr and Peasant* resumes its previous place of recognition among Liss's oeuvre.

An X-ray examination yielded a number of scattered pentimenti which could shed a new light on the sequence and dating of the two versions.[3] As a rule, pentimenti establish a painting as the first rendering, and help to confirm its authenticity. According to Sandrart, Liss thought long and thoroughly before he began to paint, but once started, he worked fast, without stopping. As far as we know, the only other two paintings which have recently been X-rayed are the Berlin *Satyr and Peasant* and the Cleveland *Amor Vincit* [A29]. Neither reveals any pentimenti. Moreover, the pentimenti in the Washington painting do not effect the design; they are little more than slight outline alterations. Such changes occur in copies and replicas as well as in first renderings, especially when an artist repeats himself as many times and as exactly as Liss did, often with considerable time elapsing between his originals and their replicas. Thus the question remains one of style. The removal of dirty varnishes and occasional overpainting also revealed a quicker pace

of brushwork. Compared to the relatively smooth surface and wide brushstrokes in the Berlin painting, brushwork in the Washington version is more visible and looser, with a greater variety of densities. The texture of the satyr's fur is more tactile, with stronger accents of warm yellow for highlights. The vine leaves, described in greater detail in the Berlin painting, are treated more broadly in the Washington painting. In short, the Berlin version is executed with more restraint (but not less assurance) than the more freely painted Washington version.

Could Liss have painted one version in Antwerp and repeated it – perhaps at the request of an Italian patron? There is pictorial evidence that one *Satyr and Peasant* by, or close after Liss, had been in Italy since the eighteenth century. To prove the point there is a copy by Antoine de Favray (1706–1791 or 1792), signed and dated 1741 (Cathedral Museum, Medina, Malta) [E 74].[4] Since Favray accompanied Jean-François de Troy to Rome in 1738 and stayed there until 1744, he must have painted his copy after a *Satyr and Peasant* by Liss in Rome.

Favray's copy, in certain details is closer to the Washington painting (and to the destroyed Rothschild version) than to the Berlin version. Favray's woman smiles sweetly (no longer establishing contact with the satyr), and her head is smaller. The vine leaves are summarized. The knife is of a slightly different shape than the one in the Berlin version, but it is the same as in the Washington and Rothschild paintings. It is interesting that the latter, like Favray's copy, includes the two peculiar, scallop-edged, overlapping leather patches on the peasant's left shoulder which are not now visible in any other rendering by or after Liss. Favray's copy, and two other paintings by Sebastiano Ricci (1659–1734), also point to an early Italian provenance and are possibly evidence that Liss's painting originated in Italy. Both of Ricci's paintings represent the *Satyr and Peasant;* one is in the Louvre [E 75], and the other (closer in resemblance to Liss's composition) was offered at Agnew's in 1969 [E 76]. Both are free adaptations of the painting; the Agnew version has the same arrangement of figures, with the addition of an old woman and young boy (who echoes the one hidden in the shadow below the right hand of Liss's satyr). Both of Ricci's paintings include the young woman standing behind the table with the baby on her arm. We know that Ricci admired Liss and that he negotiated purchases of Liss's work for the Grand Duke Ferdinand of Tuscany (see Documentation I, 5).[4]

[1] In the Widener catalogue, 1916, it was still listed under Velazquez. Mayer, 1915, dismissed it from the works by Velazquez (or any Spanish master's oeuvre) and was convinced that the painting should be ascribed to Bernardo Strozzi.

[2] It is also possible that the owners of the painting were reminded of Velazquez' *Los Borrachos* (Prado), which also includes satyr and peasant types. Note that a version was reproduced in the Widener collection catalogue of 1916.

[3] There are light changes in the hairline of the peasant, on top of his left hand, on the fifth finger of the satyr's left hand, and on the fifth finger of the baby's right hand. A slight change on the mother's cheek makes it slightly fuller. The white band of light on the window was overpainted, and some of the original white layer is visible beneath it. A dense area on the X-ray suggests that at some point the window extended about two inches further down than it does now. I am grateful to the Conservation Department of the National Gallery for letting me examine the painting while it was being restored and for supplying me with the above information.

[4] The fact that Antoine de Favray died in Malta explains the provenance of his painting. Erich Schleier saw

the painting by Favray when visiting the Cavalieri di Malta exhibition in 1970 and provided Dr. Klessmann with a photograph.

[5] Since Sebastiano Ricci (with his nephew, Marco) also spent some time in England (between 1712–1716), an early English provenance of one of Liss's *Satyr and Peasant* paintings must also be considered.

Collections: Aron de Joseph de Pinto, 1780; Lopes de Laguna, Holland; P. A. B. Widener, Lynnewood Hall, Elkins Park, Pennsylvania, acquired in 1897; Joseph E. Widener, presented by him to the National Gallery in 1942 in memory of his father, P. A. B Widener.

Literature: A. L. Mayer, «Notes on Spanish Pictures in American Collections,» *Art in America*, III, 1915, p. 316. – W. Roberts, *Pictures in the Collection of P. A. B. Widener, Early Italian and Spanish Schools*, Philadelphia, 1916, unpaginated (as *The Satyr and the Traveller*, attributed to Velazquez). – Bode, 1920, p. 172, illus. – Oldenbourg, 1921, p. 10, pl. XVII. – *Paintings in the Collection of Joseph Widener at Lynnewood Hall*, Elkins Park, Pennsylvania, 1923, unpaginated. – Peltzer in Thieme-Becker, XXIII, 1929, p. 286. – J. E. Widener, *Paintings in the Collection of Joseph Widener at Lynnewood Hall*, Elkins Park, Pennsylvania, 1931, unpaginated. – H. Tietze, *Meisterwerke Europäischer Malerei in Amerika*, Vienna, 1935, p. 336, pl. 160. – Tietze, *Masterpieces of European Painting*, New York, 1939, p. 333, pl. 160. – Steinbart, 1940, p. 173 (under wrong attributions). – *Works of Art from the Widener Collection*, National Gallery, Washington, D. C., 1948, no. 635, pl. 35. – *Paintings and Sculpture from the Widener Collection*, National Gallery, Washington, D. C., 1948, no. 635, pl. 35. – Pigler, 1956, II, p. 324. – Steinbart, 1958–59, p. 204. – I. Kühnel-Kunze «New ‹Old Masters› for the Picture Gallery,» (transl. M. Kay), Apollo, LXXX, 1964; p. 108. – E. Redslob, *Gemäldegalerie Berlin-Dahlem, ehemals Kaiser-Friedrich-Museum*, Baden-Baden, 1964, p. 239. – R. Klessmann, «Ein Neues Werk des Johann Liss in der Berliner Gemäldegalerie,» Nordelbingen, XXXIV, 1965, p. 83, n. 2. – Berlin, 1966, exh. cat., p. 47 (R. Klessmann). – *Verslagen omtrent 's rijks versamelingen van geschiedenis en kunst*, LXXXIX, 1967, p. 98.

COPIES:

Formerly Max Rothschild, Sackville Gallery. Destroyed by fire in 1918. Oil on canvas, 133 × 165 cm. (52³/₈ × 65 inches). T. Borenius («Jan Lys,» *Burlington Magazine*, XXXIII, 1918), attributed the painting to Liss. (See also *American Art News*, XVII, no. 6, November 16, 1918, pp. 1–2; Oldenbourg, 1921, pp. 10–16; Steinbart, 1940, p. 178, under «wrong attributions;» Pigler, 1956, II, p. 324; I. Kühnel-Kunze, 1964, p. 180, fig. 1; Klessmann, 1965, p. 82, n. 1; Berlin, 1966, exh. cat., p. 47 (R. Klessmann). – *Brukenthal Museum, Sibin, Hermannstadt*. Oil on canvas. (See the Brukenthal Museum catalogue of 1964, no. 118, illus. as by Liss.) Judging from the illustration it appears to be a fairly competent eighteenth-century copy. Pigler, II, 1956, p. 326, lists this work as «Netherlandish.» – *Formerly Emil Edler von Mecenseffy and Private Property*, sale, Vienna, April 16, 1918, no. 234, pl. XLV, as by Jacob Jordaens. Whereabouts unknown. Oil on canvas, 94 × 112 cm. (37 × 44¹/₈ inches). Formerly collection of Countess Julie Festetics-Hamilton, Baden-Baden. – *Formerly Prince Kaunitz*. (because it bore his stamp). Whereabouts unknown. Oil on canvas, 92 × 116 cm. (36¹/₄ × 45¹¹/₁₆ inches). None of the sales of Prince Kaunitz's collection in the nineteenth century included a *Satyr and Peasant* under any name. Measurements are very close to the preceding copy; perhaps it is the same painting. – *Sale, Dorotheum, Vienna*, December 13–18, 1917, no. 280, pl. 19. This painting has nothing to do with Liss or his compositions. – *Cathedral Museum, Medina, Malta*. Oil on canvas, signed and dated 1741, by Antoine de Favray (1706–1791 or 1792). – *Sale, Fischer, Lucerne*, November 29, 1969. Oil on canvas, 47 × 60,7 cm. (18¹/₂ × 23⁷/₈ inches). (See *World Collectors Annuary*, XXI, 1969, as Jan Lijs, «A Satir with a Peasant Family.» – *Gilberto Algranti, Milan*. Oil on canvas, 47 × 52 cm. (18¹/₂ × 20¹/₂ inches). Possibly the same painting as one now in a private collection in Germany. – *Kupferstichkabinett, Staatliche Museen, Preussischer Kulturbesitz, Berlin*. Drawing copy of one of the versions of *Satyr and Peasant*. 19 × 23,6 cm. (7¹/₂ × 9⁵/₁₆ inches) [E 77].

A. T. L.

A11 THE PRODIGAL SON Fig. 11

Oil on canvas, 115 × 93 cm. (45¹/₄ × 36⁵/₈ inches).

Galleria degli Uffizi, Florence.

The iconography of this painting is discussed under [A 12].

This painting was first mentioned in Zacchiroli's description of the Uffizi in 1783[1] and was listed in the inventory in 1784 (no. 146), both times as a work by Liss; an inscription on the back gives the date of purchase, April 28, 1778, and the name of its previous owner in Venice, Giovanni Antonio Armano.[2] It is one of two versions ascribed to Liss and most likely earlier in date than the one in Vienna [A12].

Frimmel considered one of the copies after the Uffizi version in the Accademia in Venice (discussed under Copies) to be by Liss, and he believed that the Uffizi and Vienna versions were early copies of the Venice painting. Consequently, Frimmel considered the mid-eighteenth century engraving by Pietro Monaco [E 78] to be after the Venetian *Prodigal Son* (which, according to the inscription, then belonged to Constantino Franceschi at S. Giovanni e Paolo in Venice). Fiocco dismissed the *Prodigal Son* in the Uffizi as an inferior copy. Oldenbourg saw it as the earliest of the three above versions and the one that Monaco engraved. Steinbart agreed with Oldenbourg, but claimed that the Uffizi version must have been reduced in size, because the engraving extends further on top and on both sides. A recently discovered early copy, apparently after the Florentine version (see under Copies), corresponds closely to the proportions of the engraving, which would support Steinbart's argument. Since there are slight differences in all three – the Uffizi version, the painted copy in Cronberg, and the engraving – the possibility of yet another version, close to the one in the Uffizi, must be considered. Most likely the *Prodigal Son,* now in the Uffizi, was in Venice when Monaco engraved a painting of the subject by Liss in the collection of Constantino Franceschi. Unfortunately, the link between the ownership of Franceschi and Giovanni Antonio Armano, also a Venetian, is still missing.

Steinbart and Pevsner-Grautoff date the painting in the period when Liss was strongly influenced by Fetti, from 1623–25 (based on the assumption that Liss had already returned from Rome). It is more likely that the present version was painted in Venice – not yet far removed from Haarlem gallantry – in the early 1620's, and that later, after his return from Rome in the mid-twenties, Liss repeated the subject in the much freer rendering of the version in Vienna. Salvini described the painting in Florence as a juvenile work that preceded the more mature work in Vienna, and he pointed to its Northern Caravaggesque influences. No doubt the painting in the Uffizi is much more tightly rendered in comparison to the Vienna one. Although the basic color schemes are the same (vermilion red, ink blues, gold, and white), it seems that in the Uffizi version the sun has nearly set, turning all colors several shades darker and reducing the overall luminosity that characterizes the *Prodigal Son* in Vienna.

[1] Francesco Zacchiroli, *Description de la Galérie Royale de Florence,* Florence, 1783, II, p. 71.
[2] His name is mentioned in an exchange of letters between Sebastiano Ricci and the Grand Duke Leopold of Tuscany with regard to an attribution problem which he was called upon to solve (see G. Fogolari,

«Lettere pittoriche del Gran Principe Ferdinando di Toscana a Niccolò Cassana (1698–1709),» *Rivista del R. Istituto d'Archeologia e Storia dell'Arte,* VI, no. 1–2, 1937, p. 172, n. 1. Sebastiano Ricci refers to him as «Gio. Antonio Armano, giovane Veneziano, gran conoscitore de quadri...» This reputation is confirmed by an epitaph dedicated to him in the Oratory of S. Maurizio (see G. Moschini, *Guida per la città di Venezia all'amico delle Belle Arti,* I, Venice, 1815, pp. 604–605).

Collections: probably Constantino Franceschi, Venice; Giovanni Antonio Armano, until 1778.

Literature: F. Zacchiroli, *Description de la Galérie Royale de Florence,* 1783, II, p. 71. – Lanzi, 1853, p. 257. – *Catalogue de la R. Gálerie de Florence,* Florence, 1882, p. 156, no. 849 (as Jean Van Der Lys, 1600–1657). – Frimmel, 1891, p. 83. – Frimmel, 1892, p. 34, n. 2. – Frimmel, 1901, p. 216. – Nagler, 1907, p. 132. – Wurzbach, 1910, p. 76. – Pieracchini, 1910, p. 164, no. 849 (John Van der Lys). – Oldenbourg, 1914, pp. 142, 144, 165. – Oldenbourg, 1918, p. 115. – Bode, 1920, p. 171. – Oldenbourg, 1921, pp. 8, 16. – Frimmel, 1922, pp. 55, 56. – *Die Gemäldegalerie der Akademie der Bildenden Künste in Wien,* I, Vienna and Leipzig, 1927, p. 237. – Pevsner and Grautoff, 1928, p. 157, pl. VI (color). – Fiocco, 1929, p. 79. – Peltzer, in Thieme-Becker, XXIII, 1929, p. 286. – Schneider, 1933, p. 49. – Steinbart, 1940, pp. 52, 162, pl. 16. – Giglioli, 1940, p. 27. – Bloch, 1942, pp. 48, 49. – Houbraken, 1943, I, pp. 163, 343. – Bloch, 1950, p. 282. – Bénézit, 1952, p. 600. – R. Salvini, *The Uffizi Gallery: Catalogue of Paintings,* Florence, 1953, p. 93, no. 1169. – Salvini, 1954, p. 93, no. 1169. – Pacchioni, 1955, p. 62. – Pigler, 1956, I, p. 362. – De Logu, 1958, p. 144. – Steinbart, 1958–59, pp. 168, 181, fig. 27. – Salvini, 1965, p. 100, no. 1169. – Donzelli and Pilo, 1967, pp. 241–42. – Marconi, 1970, p. 43.

COPIES:

Accademia, Venice. Oil on canvas, 67 × 56 cm. (26³/₈ × 22¹/₁₆ inches). A restoration in 1846 revealed that the painting – a mediocre copy of the Uffizi version – was cut, and that it had been altered in several places by a later hand. Frimmel (*Monatsberichte über Kunst und Kunstwissenschaft,* I, no. 4, 1891, p. 212; 1892, p. 151; 1922, p. 56) believed that it was a work by Liss, though this was contrary to the Accademia's long accepted attributions, first to J. Olis, then to an anonymous follower of Liss. Frimmel also believed that it was the version engraved by Pietro Monaco in the mid-eighteenth century. Steinbart dismissed it as a seventeenth-century, reduced copy. – *Sale, Lepke, Berlin,* March 29–April 1, 1930, no. 136, pl. 14. Oil on panel, 122,5 × 88 cm. (48¹/₄ × 34⁹/₁₆ inches). Whereabouts unknown. In the Lepke sales catalogue it was listed as «Gesellschaft auf einer Gartenterrasse by Jan Lis,» with an expertise by Wilhelm von Bode. This is a copy by an unknown Dutch master of the mid-seventeenth century. (See Steinbart, 1940, pp. 56–57, and 165.) – *Paul Leonhard Ganz, Hilterfingen, Switzerland* [E 80]. Oil on canvas, 93 × 75 cm. (36⁵/₈ × 29⁹/₁₆ inches). Formerly private collection, Berlin(?), 1928. According to Steinbart (1940, pp. 56–57, fig. 24, and p. 165), this is the work of a Venetian artist influenced by Domenico Fetti. It is, perhaps, identical with the painting which Oldenbourg (1914, p. 142, n. 1) referred to as a copy of the version in the Accademia by a Venetian eighteenth-century artist, dating from the time of Monaco's engraving of the *Prodigal Son.* – *Anonymous Collection, Cronberg, Taunus.* Oil on canvas. The painting is poorly preserved and shows extensive overpainting. The background with trees, however, is surprisingly good. Therefore, it remains uncertain whether we deal with a copy or another version of the Florentine painting. The painting corresponds closely to the proportions of the Monaco engraving. See discussion under [A 11]. – *Statens Museum for Kunst, Copenhagen* [E 79]. Oil on canvas, 27,8 × 38 cm. (10¹¹/₁₆ × 14¹¹/₁₆ inches). Inv. no. 6469, pendant to no. 6468. The painting by J. W. Baumgartner is a free adaptation of one of the *Prodigal Sons* by Liss; note especially the main couple, as well as the cardplayers to the left. (This painting was brought to my attention by B. Bushart.)

<div align="right">A. T. L.</div>

A12 THE PRODIGAL SON Fig. 12, Colorplate I

Oil on canvas, 85,6 × 69 cm. (33¹¹/₁₆ × 27⅜ inches).

Gemäldegalerie der Akademie der Bildenden Künste, Wien.

By the early seventeenth century it became increasingly difficult to distinguish paintings
of carousing couples in merry companies from those depicting the parable of the prodigal
son, who, according to the biblical account (Luke 15: 11–24), received his share of the
inheritance from his father and went out into the world to waste it with riotous living.[1]
Dutch artists in particular, with their inherent love for earthy genre, took full advantage
of the thin line existing between the parable and scenes of merry companies.[2] Liss's own
paintings of the *Prodigal Son,* the *Gallant Couple* [A6, A7], the *Merry Company Out-
doors* [A33], the *Banquet* in Kassel [A15] – as well as the Berlin drawing [B45] are per-
fect examples. All include much the same elements – the focus on one particular pair of
lovers, the merry table, the music, the wine – all of which could represent either the story
of the prodigal son or simply a scene of merrymaking.[3] Even Liss's etching of the *Fool as
Matchmaker* [B42] belongs in this ambiguous group (the fool also appears in the Berlin
drawing); one of Liss's early models was Lucas van Leyden's woodcut, the *Prodigal
Son Dissipating has Patrimony* (Unicum, Bibliothèque Nationale; Hollstein 33) which
includes a fool.

Sandrart wisely avoided the issue by summing up all comparable subjects as follows:

«He also did several paintings, in modern manner, of lovers in conversation and of the
amorous Venetian girl with music, card games, promenading and of other scenes of court-
ship . . .»

Moreover, all these works share a general likeness in dress, manner and pose, revealing
their common dependence on prototypes by Haarlem painters such as Hendrick Goltzius,
Willem Buytewech and Dirck Hals in whose circle Liss received his early training. As a
consequence they are very difficult to date.

Even though the two protagonists in this painting still have the air of Haarlem about
them and therefore resemble the pair in the earlier *Gallant Couple,* the ambiance surround-
ing them has changed; they are like young actors in new costumes, on a new stage. The
lustrous colors and fabrics, the *mise en scène,* with the old high wall, and plants and
flower pots, above all the warm glow of a late sun – all indicate that Liss has moved his
stage to a sunnier climate, exchanging the gallantry of Haarlem for that of *Venezia Città
Galante.* Merged with the Haarlem mannerisms are new influences, particularly from
Fetti, whose *Workers in the Vineyard* [E22] in Dresden was cited for comparison (Stein-
bart, 1940). Liss's figures, with seemingly halting movements, their heads tilted, their faces
half smiling, half sad, recall the elegiac and dreamy mood of Fetti's figures, which, in turn,
show their reliance upon Fetti's teacher Ludovico Cardi, called Cigoli (1559–1613).

The cypress trees in the background of the *Prodigal Son* are reminiscent of those in the
Mourning for Abel [A36]; both paintings most likely date from Liss's second Venetian
phase, after he returned from Rome. Pevsner (1928) and Steinbart (1940) suggest that the
Prodigal Son was painted ca. 1623, which they considered a post-Roman date. Since the

drawing of the *Gobbi* [B 48] dates from Venice in 1621; the implication is that Liss spent only two to three years in Rome. As first suggested by Klessmann,[4] the increasing number of paintings revealing direct influences from Rome makes it more likely that Liss did not return to Venice before 1625 (for further discussion supporting this return date, see [A 32]).

The 1889 catalogue of the Akademie attributes the *Prodigal Son* (no. 855) to Giovanni B. Weenix; the edition of 1900 refers to it as «nach Jan Lys,» describing it as a copy after the one in Venice (see under Copies). Oldenbourg (1918 and 1921), Bode (1920), and Fiocco (1929) describe the Vienna version as a good and well-preserved replica after the one in the Uffizi, from Liss's early Venetian period. Zarnowski (1925), who argues for a second sojourn of Liss in the Netherlands interrupting his Italian stay, points to his close adherence to the Haarlem types and manner and votes for placing the painting in this period. Steinbart believed that the Vienna painting, which is more mature, is a reduced replica of the Florentine version. Most likely we deal with a case similar to the two versions of the *Toilet of Venus* [A 28, D 4] and of the *Flaying of Marsyas* [A 23, A 24], where some time elapsed between the first and the second rendering. It is also possible that Liss painted his first *Prodigal Son* (Uffizi) before his stay in Rome and the Vienna one shortly thereafter.

The difficulty in distinguishing prodigal son interpretations from merry companies complicates the documentation of Liss's painting because it is likely to have changed its name several times. Houbraken evidently recognized the subject of the prodigal son in a painting he saw in the house of Gerard van Hoogeveen in Leyden in the beginning of the eighteenth century (Steinbart, 1940). Yet, when Van Hoogeveen's widow sold what was most likely the same painting in The Hague on June 5, 1765 (no. 29), (see Documentation II, 4), it was simply referred to as «Een Stuk verbeeldende en Buitenplaats meet eenige Heeren en Dames, speelende of de Kaart en Cyter» 33 × 27 duims in size (approximately 84,8 × 69,4 cm.).[5] Next, this painting was owned by Johan van der Marck, who in turn sold it as *De Verlooren Zoon (Prodigal Son)* in 1773, now measuring only 32 × 26¹/₂ duims (Documentation II, 4). Thereafter no trace can be found.

If one duim equals 2,57 cm. the size of the Van Hoogeveen painting corresponds more closely to the *Prodigal Son* in Vienna, which measures 85,6 × 69 cm., than it does to the one formerly associated with it – that is, the *Prodigal Son* which appeared in a sale of the combined properties of Vrouwe Maria Beukelaar, the widow of Heer Halungius and Anthony de Waart.[6]

It has been suggested that the figure of the young man on the left (barely discernible in the Uffizi version) may be a self-portrait of the artist (Steinbart, 1940; Klessmann, 1966).

[1] Luke 15: 13 does not mention that riotous living included the company of women. The women are mentioned in verse 30 when the older brother talks with his father about the prodigal son.

[2] Paintings of couples showing their mutual fondness, or raising glasses of wine which at first sight appeared to be double portraits, could in fact be depictions of the *Prodigal Son* (see the so-called *Jonker Ramp and His Sweetheart* by Frans Hals at the Metropolitan Museum of Art; Seymour Slive, *Frans Hals*, I, London, 1970, pp. 72–73). To complicate matters further, such scenes were often coupled with allegories of the five senses, the times of the day, the ages of man, etc.

[3] This fusion of earthy with religious subjects also is revealed in paintings in Protestant Germany – in the

early sixteenth century after the Peasant Wars – especially among the *Kleinmeister* in Protestant Nürnberg, e.g., the Brothers Beham and Georg Pencz (see under [B 47]; Emil Waldmann, *Die Nürnberger Kleinmeister*, Leipzig, 1911, pp. 36–38).

[4] Klessmann, 1970 *(Kunstchronik)*, pp. 292–93.

[5] According to Van der Watering (letter of August 15, 1969) before 1823 «a number of local ‹duimen› and ‹voeten› were used in the Netherlands which were slightly different among themselves. The Amsterdam ‹voet› consisted of 11 ‹duims,› one ‹duim› measuring about 2,57 cm.»

[6] The measurements given in the sale of April 19, 1752 (no. 165) were given as: 2 voet 7 duims × 2 voet 2 duims, equalling about 74,5 × 61,7 cm. Note that this sales catalogue does not separate the two lots and therefore leaves it uncertain whether this painting belonged to Anthony de Waart as was previously assumed (see Documentation II, 3).

Exhibitions: Berlin, 1966, cat. no. 41, fig. 44.

Literature: C. von Lützow, *Katalog der Gemäldegalerie in der k. k. Akademie der Bildenden Künste*, Vienna, 1889, no. 855 (attrib. to B. Weenix). – Frimmel, 1891, p. 83. – Frimmel, 1892, p. 34, n. 2. – C. von Lützow, *Katalog der Gemäldegalerie in der k. k. Akademie der Bildenden Künste*, Vienna, 1900, no. 855 (copy after the original in the Accademia, Venice). – Frimmel, *Kleine Galeriestudien*, III, Leipzig and Berlin, 1898–1901, Chapter IV: «Geschichte der Wiener Gemäldesammlungen,» pp. 32, 188. – Frimmel, 1901, p. 216. – Oldenbourg, 1918, p. 117, n. 1. – Bode, 1920, p. 171. – Oldenbourg, 1921, pp. 8–17, pl. VII. – Frimmel, 1922, pp. 55, 56. – Zarnowski, 1925, p. 92. – O. Benesch, «Seicentostudien,» *Jahrbuch der Kunsthistorischen Sammlungen in Wien*, N. S., I, 1926, p. 251, fig. 176, p. 252, n. 6. – R. Eigenberger, *Die Gemäldegalerie der Akademie der Bildenden Künste in Wien*, I, Vienna and Leipzig, 1927, p. 236, no. 855; Vol. II, pl. 115. – Peltzer, in Thieme-Becker, XXIII, 1929, p. 286. – Fiocco, 1929, pp. 20, 78–79. – Schneider, 1933, p. 49. – Steinbart, 1940, pp. 17, 52, 57, n. 106, 58, 59, pl. 17. – Steinbart, 1942, p. 172. – Bloch, 1942, p. 48. – Steinbart, 1946, pp. 15, 17, 26, 27, 44, 57, pls. 1, 16, 17. – Golzio, 1950, p. 569. – Bénézit, 1952, p. 600. – Martius, ca. 1955, pp. 9, 10, no. 6, pl. 6. – Steinbart, 1958–59, p. 168. – Woeckel, 1967, pp. 176, 178 (colorplate). – Donzelli and Pilo, 1967, pp. 241–42.

<div align="right">A. T. L.</div>

A13 MORRA GAME

Fig. 14, Colorplate II (detail)

Oil on canvas, 75,5 × 56 cm. (29³/₄ × 22¹/₁₆ inches).

Staatliche Kunstsammlungen, Kassel.

A group of young people around a table set up in the open air are enjoying themselves playing the game of morra – a popular Italian pastime from antiquity. In this game the announcer calls out a number as all participants simultaneously thrust out one hand, outstretching as many fingers as they wish; the winner is the one whose number of outstretched fingers coincides with the number called. At left, a seated youth, elbow on the table, pipe and match in his hands, observes the game over his shoulder. In the foreground, a dwarf restrains a dog. Facing each other across the table, the center couple concentrates on the game. Behind them stands a man wearing a broad-rimmed hat.

Though the setting is distinctly Italian, the subject of the painting follows the moralizing tradition of Netherlandish painting, which was particularly characteristic of Haarlem. The game of hazard here implies a gambling with or for love – a metaphor known even from ancient Greek vase painting.[1] This erotic symbolism is quite explicitly stated in one of the supporting scenes: the woman seated on the right holds a little dog on her lap and a lute in her left hand, while a man draws her attention to a pair of birds.

A horizontal chalk drawing, also at Kassel [B 49], was apparently used as a preparatory sketch for the Kassel painting. The painter almost literally took over the middle portion of the drawing but omitted the wine-drinking couple on the left and the maids approaching from the right. The arrangement of figures closely relates the drawing to the *Morra Game* in the Harteneck collection [A 14]), which differs from the Kassel canvas in its nocturnal interior setting and horizontal composition.

Details of the Kassel painting recall the *Gallant Couple* at Pommersfelden [A 6] and the *Prodigal Son* in Vienna [A 12]. The latter shares with the *Morra Game* a Venetian mood and a manner of composition reminiscent of Domenico Fetti. A date for the painting can be established only on the basis of its style, which, as we have said, implies an acquaintance with Fetti's art; on the other hand, reminders of the painter's early period in the Netherlands cannot be ignored. It seems justified, therefore, to suggest a date around 1621, during the artist's first Venetian phase.

[1] See P. F. Perdrizet, «The Game of Morra,» *The Journal of Hellenic Studies*, XVIII, 1898, pp. 129 ff.

Collections: acquired before 1750 by the Landgrave of Hesse.

Exhibitions: Nürnberg, 1952, cat. no. N 6. – Venice, 1959, cat. no. 56. – (Berlin, 1966, cat. no. 42. – Stuttgart, Staatsgalerie, 1971–72: *Bild und Vorbild*, cat. no. 19, illus.

Literature: Parthey, 1864, p. 64. – O. Eisenmann, *Katalog der Königlichen Gemälde-Galerie zu Cassel*, Kassel, 1888, p. 111, no. 169. – Frimmel, 1891, p. 83. – K. Voll, *Die Meisterwerke der Königlichen Gemälde-Galerie zu Cassel*, Kassel, 1904, p. 87, illus. – Wurzbach, 1910, p. 76. – Oldenbourg, 1914, p. 148, fig. 5. – Peltzer, 1914, p. 163, pl. 53. – Oldenbourg, 1918, pp. 115–16. – Bode, 1920, p. 170. – Oldenbourg, 1921, p. 9. – Colasanti, 1921, p. 26. – Peltzer, 1924–25, p. 164. – Zarnowski, 1925, p. 94. – Pevsner and Grautoff, 1928, p. 157. – G. Gronau, *Katalog der Staatlichen Gemäldegalerie zu Kassel*, second edition, Berlin, 1929, p. 45, no. 186. – Peltzer, in Thieme-Becker, XXIII, 1929, p. 286. – Fiocco, 1929, p. 22, pl. 9. – Hind, 1931, p. 151. – Schneider, 1933, p. 50. – Pallucchini, 1934, p. 15. – Steinbart, 1940, pp. 64–65, 162, pl. 23. – Goering, 1940, p. 25, pl. 7. – Steinbart, 1942, p. 172, illus. – Bloch, 1942, pp. 48, 49. – Steinbart, 1946, pp. 27–28, 60, figs. 20, 21. – Bloch, 1950, p. 282. – Golzio, 1950, pp. 568–69. – Bénézit, 1952, p. 600. – Nürnberg, 1952, exh. cat., p. 126, no. N 6. – Schilling, 1954, p. 34. – Martius, ca. 1955, pp. 9–10, fig. 7. – H. Vogel, *Katalog der Staatlichen Gemäldegalerie zu Kassel*, Kassel, 1958, p. 87, illus. – De Logu, 1958, p. 14. – Steinbart, 1958–59, pp. 181, 185. – N. Ivanoff, *I disegni italiani del Seicento*, Venice, 1959, p. 137. – Venice, 1959, exh. cat., pp. 43, 168, no. 56, fig. 56 (P. Zampetti, T. Pignatti). – *Katalog der Staatsgalerie Stuttgart*, I: *Alte Meister*, Stuttgart, 1962, pp. 109–110. – Paris, 1965, exh. cat., p. 173. – Berlin, 1966, exh. cat., pp. 49, 122, no. 42, fig. 43 (R. Klessmann, H. Möhle). – Woeckel, 1967, p. 178. – Donzelli and Pilo, 1967, p. 242. – M. Jaffé *Jacob Jordaens*, exh. cat., The National Gallery of Canada, Ottawa, 1968, p. 72. – P. A. Riedl, *Die Goldene Palette: Tausend Jahre Malerei in Deutschland, Österreich und der Schweiz*, Stuttgart and Hamburg, 1968, p. 245, colorplate. – Klessmann, 1970 *(Kunstchronik)*, p. 293. – *Bild und Vorbild*, exh. cat., Stuttgart, 1971–72, no. 19, pp. 14–15, illus. – Schlick, 1973, p. 133.

COPIES:
Formerly Bremen, Roseliushaus. Whereabouts unknown. (See Steinbart, 1940, pl. 22). – *Kiel, Kunsthalle.* (See Schlick, 1973, p. 133, illus.) – *London, Molsworth Collection.* (See Steinbart, 1958–59, p. 182, fig. 28.) – *Stuttgart, Staatsgalerie.* (See catalogue of the Staatsgalerie. – *Alte Meister*, Stuttgart, 1962, pp. 109 ff. fig. 37.) – *London, British Museum.* Drawing (see A. M. Hind, *Catalogue of Drawings*, IV, London, 1931, p. 151).

R. K.

A14 THE MORRA GAME Fig. 13

Oil on canvas, 74 × 102 cm. (29¹/₈ × 40¹/₈ inches).

Marie E. B. Harteneck Collection, Buenos Aires.

A young man and a girl are playing a game of morra in a dark room (compare with
[A 13]). To their right stands a young Moor with a torch. In the left background, another
couple sits by the chimney drinking wine. Two dogs are discernible in the foreground.
The composition of this painting relates it to the *Morra Game* at Kassel and to a chalk
drawing also at Kassel [B 49]. There is a similar middle group of three figures by the
table in both paintings; the couple sitting by the chimney and the frolicking dogs of the
Harteneck painting correspond to similar representations in the left portion of the
drawing.

The painterly execution of the nocturnal scene is rather summary, and the representation
of interior space is unconvincing; in quality it lags far behind the Kassel canvas. It must,
therefore, be regarded either as a secondary attempt or even as an old copy of a lost
original. In any case, the chalk drawing at Kassel probably served as a preliminary study
for both versions. One suspects that Honthorst's paintings may have inspired the
nocturnal setting (see Schneider, and Steinbart, 1940), yet neither the motifs nor the
manner of painting bear this out. It seems unquestionable, however, that the composition
dates from the beginning of the artist's Roman period (ca. 1622), a dating supported by a
drawing of that time.

Collections: Florence art market, formerly R. Oldenbourg Collection, acquired 1918 in Berlin; Wilhelm
Harteneck Collection, Martinez (Argentina).

Literature: Oldenbourg, 1914, p. 148. – Oldenbourg, 1918, pp. 115–16, fig. 37. – Oldenbourg, 1921, p. 15.–
Peltzer, in Thieme-Becker, XXIII, 1929, p. 287. – Schneider, 1933, p. 50. – Steinbart, 1940, pp. 61–62, 162,
pl. 20. – Steinbart, 1946, pp. 39, 59, fig. 18. – Schilling, 1954, p. 34. – Kohrs, 1956, p. 133. – Steinbart,
1958–59, p. 182. – *Katalog der Staatsgalerie Stuttgart,* I: *Alte Meister,* Stuttgart, 1962, p. 109. – Berlin,
1966, exh. cat., pp. 49, 122 (R. Klessmann, H. Möhle). – Schlick, 1973, p. 133. – *Math. Lempertz'sche
Kunstversteigerung, Auktionskatalog 534,* November 15–19, 1973, no. 99, pl. 29.

R. K.

A15 BANQUET OF SOLDIERS AND COURTESANS Fig. 15

Oil on canvas, 164,2 × 242 cm. (64¹⁰/₁₆ × 95⁵/₁₆ inches).

Staatliche Kunstsammlungen, Kassel.

Soldiers and girls are drinking, playing, and making merry in a tavern. In the center
a soldier sits on the table pouring wine; at both sides and behind him are three amorous
couples, fondling each other, while the soldier's companion, in front, smiles out at the
viewer. At the left are two musicians; in front of them a boy tries to steal a purse. At the
right two maids are arriving with a filled bowl and bottles of wine. In the foreground
a dog scratches himself, and playing cards lie scattered on the floor.

When Johann Liss painted the Kassel *Soldier's Banquet* – there is another version at

Nürnberg [A 16] – he created one of the most important paintings of the German Baroque. Its unusual format and the exuberant vitality of the life-sized figures alone suffice to endow the picture with a peculiar magnetism, and, with existing preparatory studies, lead to the conclusion that this was a masterwork which helped establish the painter's fame among his contemporaries.

Sandrart probably referred to this composition when he wrote: «. . . he has fine revelries to boot, of soldiers in armor, with Venetian courtesans, playing cards to the sweet sound of strings and the refreshment of wine, amusing themselves each one as he pleases, and living in sin, wherein the diversity of individual emotions, gestures, and passions is so sensibly portrayed that these works are not only much acclaimed but are also being purchased at high prices by the lovers of fine art.»

It is highly probable that the Kassel painting belonged to the Dutch merchant Gerrit Reynst (1599–1658), whose renowned collection was known to Sandrart and was comprised chiefly of Venetian works of art – among them Liss's *Ecstasy of St. Paul* [A 38], now in Berlin. A volume of engravings in this collection, unfinished because of Reynst's death, probably published in 1660, includes an engraving of the *Banquet* by Jeremias Falck (Hollstein 160). The painting, however, seems to have come to Amsterdam before 1646, for, as Steinbart (1940) pointed out, some motifs of its composition appear in a painting by Simon de Vos [E 83] of 1646. In all likelihood, the painting «een Bordeel» by Johann Liss, sold in 1704 together with the Pieter Six collection at an auction in Amsterdam, is probably identical with the Gerrit Reynst picture, i. e. the one under discussion (see Documentation IV, 9).

The representation conforms to a type of Dutch genre painting with a moralizing intent, as it had developed – particularly in Haarlem – under the influence of Willem Buytewech and Dirck Hals. This type is more or less closely linked to the pictorial tradition of the «prodigal son among the harlots,» an episode from the familiar parable (Luke 15: 11–24) originally meant to be a warning against the dire consequences of a dissolute life.[1]

In representing these subjects – so popular in the North as collectors' items – on a monumental scale, Liss relied on similarly conceived group paintings by Caravaggio and his followers with which he had become acquainted in Rome. Despite this momentous step in the history of style, a commitment to the Netherlandish tradition of content remains clearly discernible. The central figure of the painting, arm raised and pouring wine, has counterparts in Dutch painting as well as in emblematic literature, where this motif alludes to drunkenness and intemperance *(gula)*.[2] The raised cup is one of the distinguishing marks of vice that characterizes the prodigal son among the harlots,[3] and this is probably the theme of the banquet paintings at Kassel and Nürnberg. Like other painters, Liss, too, shows the prodigal son surrounded by allegories of the five senses, which, due to their abuse by man, were identified with the vices.[4] The musicians represent hearing; the pair looking deep into each other's eyes represent sight; the dog represents the sense of smell; the maids carrying food represent the sense of taste; and, finally, the fondling couple represent touch. This vocabulary is very similar to the one the painter used for his portrayals of the prodigal son in Vienna [A 12] and Florence [A 11].

V The Toilet of Venus (detail) [A 28]
Dr. Karl Graf von Schönborn-Wiesentheid, Schloss Pommersfelden

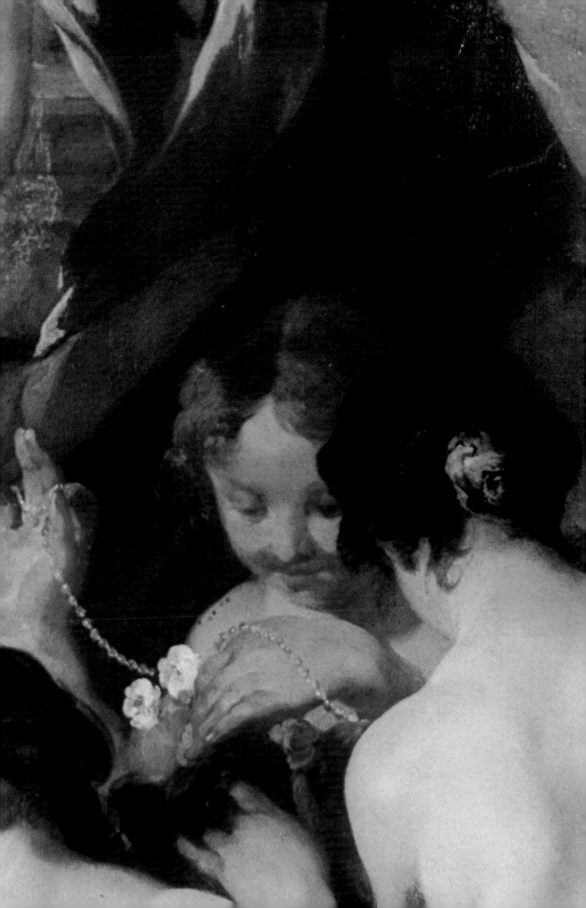

Liss's reliance on works by Caravaggio and, more particularly, by Valentin de Boullogne is immediately apparent in the paintings at Kassel and Nürnberg. The interior lighting effect is similar to that in Caravaggio's *Calling of St. Matthew* [E 23], S. Luigi dei Francesi. For narrative aspects and the treatment of textures, Liss relied on Valentin (see *The Concert* [E 25], Paris, Louvre), although he avoided the negation of distance typical of that painter.

The back view of the man on the bench is a Caravaggesque motif, also observed in Valentin's paintings. Unusual, however, is the main figure of the picture, the prodigal son himself. He sits on the table in such shameless ease that it seems justified to interpret him as a Pan figure. The prevailing opinion was that the impulsive nature of Pan and the licentious life of the prodigal son were closely related; both were considered incarnations of sin. The young man on the bench, propped against the sinner's knee, smiles out at us. As a rule, artists seized upon such figures as opportunities for self-portrayal, and it is entirely possible that such is the case here. It would easily explain why the «Schilderbent» – the association of Northern painters in Rome – bestowed upon Liss the nickname «Pan.»

Two original preparatory studies for this painting are known to exist: a pen drawing of the *Merry Company with a Fortuneteller* [B 50a], with the fortuneteller as the central figure; and a pen drawing in Florence [D 1] that approximates the composition of the painting very closely, although the characteristic iconographical elements are more prominent (the plumed hat and wine cooler, for example). A pen drawing in the collection of Leiden University can only be a copy of the drawing in Florence, contrary to L. Oehler's opinion.

A copy of a drawing by Liss, in Honolulu [C 58], documents a preliminary stage of the composition for the *Soldiers' Banquet*. The game of morra in the central portion recalls paintings of the same subject [A 13, A 14], which are evidently of an earlier date. On the other hand, the drawing reveals essential features of the *Soldiers' Banquet* paintings at Kassel and Nürnberg. It is obvious that the drawing in Honolulu reflects Valentin's influence more strongly than the finished painting.

In no other painting by Liss is the influence of Caravaggio more noticeable than here. It can hardly be doubted that Liss began his activity in Rome (1622) with this painting in order to prove his capability. Too little research has yet been done to establish reliably the chronological order of the paintings at Kassel and Nürnberg. It seems doubtful whether the coloristic differences between the two versions, as described by Steinbart (1940), lead to any such conclusions.

The impressive number of existing copies and reproductions of this composition attest to its popularity and to the admiration in which it was held by contemporaries; it is impossible to determine the model used in each case, however, be it painting, engraving, or drawing.

[1] See K. Renger, *Lockere Gesellschaft*, Berlin, 1970, on the iconography of the prodigal son and of tavern scenes in Dutch painting.

[2] T. de Bry, *Emblemata . . .*, Frankfurt, 1592, No. 14.

[3] See J. Bergström, «Rembrandt's Double Portrait of Himself and Saskia at the Dresden Gallery,» *Nederland Kunsthistorisch Jaarboek*, XVII, 1966, pp. 163 ff.

[4] See K. Renger, *op. cit.*, p. 124.

Collections: Probably in the collection of Gerrit Reynst, Amsterdam, before 1646; known to be in the possession of the Landgrave of Hesse since 1749.

Exhibitions: Vienna, Kunsthistorisches Museum, 1955–56: Gemälde der Kasseler Galerie kehren zurück (and Kassel, Hessisches Landesmuseum); cat. no. 32.

Literature: Sandrart, 1675, (ed. 1925) p. 402. – Parthey, 1864, p. 64. – O. Eisenmann, *Katalog der Königlichen Gemälde-Galerie zu Cassel*, Kassel, 1888, pp. 111–12, no. 170. – K. Voll, *Die Meisterwerke der Königlichen Gemälde-Galerie zu Cassel*, Kassel, 1904, p. 88, illus. – Wurzbach, 1910, p. 76. – A. Bredius, «Eine Zeichnung von Jan Lys,» *Kunstchronik und Kunstmarkt*, XXIV, Leipzig, 1914, p. 660, illus. – Oldenbourg, 1914, pp. 144–45, fig. 4. – Peltzer, 1914, p. 162. – Oldenbourg, 1918, p. 117. – R. Oldenbourg, *Die flämische Malerei des 17. Jahrhunderts*, Berlin, 1918, pp. 145–46. – T. Borenius, «Jan Lys,» *The Burlington Magazine*, XXXIII, 1918, p. 115. – *American Art News*, XVII, no. 6, November 16, 1918, p. 2. – Bode, 1920, p. 170, illus. p. 169. – Oldenbourg 1921, pp. 9, 15, pl. XI. – Zarnowski, 1925, pp. 92, 93, 94. – H. Kauffmann, «Overzicht der Litteratuur betreffende Nederlandsche Kunst. Duitschland,» *Oud Holland*, XLIII, 1926, p. 242. – Pevsner and Grautoff, 1928, p. 157. – Peltzer, in Thieme-Becker, XXIII, 1929, p. 286. – G. Gronau, *Katalog der Staatlichen Gemäldegalerie zu Kassel*, second edition, Berlin, 1929, p. 45, no. 187. – Schneider, 1933, p. 49, pl. 26. – *Katalog der Gemälde des 17. und 18. Jahrhunderts im Germanischen Nationalmuseum zu Nürnberg*, Nürnberg, 1934, p. 42. – Steinbart 1940, pp. 65–66, 162, pls. 27–29. – Bloch, 1942, p. 49. – Steinbart, 1942, pp. 172, 176. – Steinbart, 1946, pp. 28–29, 60, figs. 25–27. – Bloch, 1950, p. 281. – Golzio, 1950, p. 569. – Bénézit, 1952, p. 600. – Schilling, 1954, p. 32. – Kohrs, 1956, p. 133. – H. Vogel, *Katalog der Staatlichen Gemäldegalerie zu Kassel*, Kassel, 1958, p. 87, illus. – De Logu, 1958, p. 277. – Steinbart, 1958–59, pp. 163, 181. – Venice, 1959, exh. cat., p. 168 (T. Pignatti). – Oehler, 1962, pp. 104–105, fig. 6. – *Richard Hamann in Memoriam*, Berlin, 1963, p. 93, fig. 90. – E. Hempel, *Baroque Art and Architecture in Central Europe*, Harmondsworth, 1965, p. 318, n. 19. – Paris, 1965, exh. cat., p. 173. – Berlin, 1966, exh. cat., pp. 49, 54 (R. Klessmann). – Woeckel, 1967, p. 178. – Donzelli and Pilo, 1967, p. 242. – *Augsburger Barock*, exh. cat., Augsburg, 1968, p. 266 (H. Geissler). – E. Herzog, *Die Gemäldegalerie der Staatlichen Kunstsammlungen Kassel*, Hanau, 1969, p. 94, no. 90, pl. 90. – *Schleswig-Holsteinisches Biographisches Lexikon*, I, Neumünster, 1970, p. 186. – *German Drawings 1400–1700 from Dutch Public Collections*, suppl. exh. cat., Museum Boymans-van Beuningen, Rotterdam, 1974, pp. 23–24. – E. Reynst, «Sammlung Gerrit und Jan Reynst,» unpublished dissertation, n. d., pp. 6, 15, 21, 24.

COPIES:
Berlin, Graupe-Ball auction, June 23–24, 1933, no. 319, illus. – Berlin art market, 1938 (Steinbart, 1940, p. 81, 165). – Bologna, *Pinacoteca* (Steinbart, 1940, p. 165). – Florence, *Villa ex Reale della Petraia* (Steinbart, 1940, p. 166). – Graz, *Johanneum* (Steinbart, 1940, p. 166). – Bassano, *Museo Civico*. Drawing (Steinbart, 1940, p. 165; Oehler, 1962, fig. 5). – Braunschweig, *Herzog Anton Ulrich-Museum*. Drawing (as «Dutch, ca. 1625–30, manner of Dirk Hals»). – Dresden, *Kupferstichkabinett*. Drawing (by Dancker Danckerts; Steinbart, 1940, p. 165, fig. 33). – Leiden, *University Library*. Drawing (Oehler, 1962, fig. 1). – London, *British Museum*. Drawing (Steinbart, 1940, p. 166; Oehler, 1962, fig. 4). – *Paris*, auction, April 11, 1924, no. 64. Drawing (attributed to Palamedesz; Steinbart, 1940, p. Oehler, 1962, fig. 3). – *Engraving by Jeremias Falck* (Steinbart, 1940, p. 168; Hollstein, XI, p. 148, no. 8). – *Engraving by Jan van Somer* (Steinbart, 1940, p. 169; Hollstein, XI, p. 148, nos. 21–23).

R. K.

A 16 BANQUET OF SOLDIERS AND COURTESANS Fig. 16

Oil on canvas, 161 × 240 cm. (63³/₈ × 94¹/₂ inches).

Germanisches Nationalmuseum, Nürnberg.

The subject matter and composition of this painting correspond to the one in the Staatliche Kunstsammlungen in Kassel [A 15]. It can be considered another autograph version of this famous Kassel painting, from which it differs very little in measurements. Like the Kassel painting, it came to Germany via the Dutch art market.

Only an examination of both paintings under similar conditions can determine which of the two versions can be considered the first. According to Steinbart (1940), who points out the dark coloring and the «sonorous *tenebroso*» of the Nürnberg painting, «there is a time gap between the Kassel and the Nürnberg *Banquet* paintings, and the Kassel one follows the latter as a later commission within a period when the lightening of [the painter's] temporary Caravaggesque palette to a purely chromatic one had already considerably improved.»

For iconography and dating of the picture see [A 15].

Addenda: The Nürnberg painting, which came into the view of research rather late, was always overshadowed by the replica in Kassel which was in the collection of the Landgrave of Hesse as early as 1749. The state of conservation of the Nürnberg work made a fair judgment even more difficult. A recent restoration of the painting, which had not been completed by the time this catalogue had gone to the printer, revealed heavy overpainting in parts of the picture and several pentimenti. The helmet on the bench at the feet of the soldier sitting on the table, for instance, is painted over a red plumed beret which the painter had originally planned to be there. A preparatory drawing for this picture [D 1] (Uffizi) also shows a beret at the same spot. Because of this evidence, the painting in Nürnberg has to be considered the first version (done in Rome) of this composition and that it preceded the picture in Kassel.

Collections: Sale, Amsterdam, October 14, 1884 (?); Professor J. Marr, Munich; Berlin art market; acquired by the Nationalmuseum in Nürnberg in 1928.

Exhibitions: Nürnberg, 1952, cat. no. 5. – Rome, Palazzo della Esposizione, 1956–57: Il Seicento Europeo, cat. no. 185.

Literature: A. Bredius, «Seltene Niederländer des 17. Jahrhunderts,» *Kunstchronik*, XX, 1884/85, col. 197. – H. Mireur, *Dictionnaire des ventes d'art . . .*, IV, Paris, 1911, p. 387. – Oldenbourg, 1914, p. 144, n. 2. – Oldenbourg, «Neues über Jan Lys», *Amtliche Berichte aus den Königlichen Kunstsammlungen*, XXXIX, 1917–18, p. 117. – E. H. Zimmermann, *Neuerwerbungen des Germanischen Museums 1925–29*, Nürnberg, 1929, pl. 46. – Peltzer, in Thieme-Becker, XXIII, 1929, p. 286. – Lutze, 1934, pp. 42–43. – Lutze, *Malerei des deutschen Barock und Rokoko*, Nürnberg, 1934, p. 5. – Steinbart, 1940, pp. 65–66, 162, pl. 26. – Steinbart, 1946, pp. 28–29, 60. – Nürnberg, 1952, exh. cat. p. 126, cat. no. N 5. – Bénézit, 1952, p. 600. – H. Vogel, *Katalog der Staatlichen Gemäldegalerie zu Kassel*, Kassel, 1958, p. 87. – De Logu, 1958, p. 277. – Steinbart, 1959, p. 163. – Oehler, 1962, p. 104. – P. Strieder, in *Kunstwerke der Welt aus dem öffentlichen bayerischen Privatbesitz*, Bild und Textband zur Sendereihe des Bayerischen Rundfunks, 4, Munich, 1964, p. 140. – E. Hampel, *Baroque Art and Architecture in Central Europe*, Harmondsworth, 1965, p. 61, fig. 28 B. – Berlin, 1966, exh. cat., p. 49 (R. Klessmann). – *German Drawings 1400–1700 from Dutch*

Public Collections, suppl. exh. cat., Museum Boymans-van Beuningen, Rotterdam, 1974, p. 24. – E. Reynst, «Sammlung Gerrit und Jan Reynst,» unpublished dissertation, n. d., p. 21.

R. K.

A 17 THE REPENTANT MAGDALENE Fig. 17

Oil on canvas, 114 × 131,5 cm. (44⁷/₈ × 51³/₄ inches).

*Staatliche Kunstsammlungen, Dresden, Gemäldegalerie Alte Meister,
Deutsche Demokratische Republik.*

The Magdalene carries a precious mantle draped over one arm and with folded hands presses a skull against her body. At left, an Oriental woman bows to offer golden vessels. The Magdalene averts herself and turns toward an angel who gently holds her back by her arm. The young woman's striking clothes and the offered gifts hint at her sinful life. The skull alludes to the futility of worldly pleasures; the palm branch in the angel's hand symbolizes the heavenly reward promised to the repentant sinner.

M. Boschini (1660) mentions a Liss painting on the subject of the Magdalene's repentance, which was at that time in the Palazzo Bonfadina. According to his description, we may assume it is the Dresden picture:

> De Gian Lis Madalena dolorosa
> Che l'Anzolo socore; e in tun canton
> Ghè quela maledeta tentation
> Che studia in darno a farla ambiciosa.
> (By Johann Liss the sorrowful Magdalene / rescued by the
> angel; and in a corner / behold that cursed temptation /
> seeking perniciously to make her ambitious.)

The representation of the saint between angel and pander is unusual and suggests a wilful fusing of diverse iconographic sources on the artist's part. The subject's kinship with genre scenes of matchmaking, so popular in the Netherlands since the sixteenth century, is obvious. [1]

The style of the picture attests to the defining influence of Flemish painting, in particular that of the leading Antwerp masters whom Liss met around 1616–18. Steinbart (1940) indicated the formal parallels with Rubens' *Magdalene* in Vienna. Above all, as Jaffé (1969) observed, the fluid manner of execution of the Dresden painting (which is comparable to the *Satyr and Peasant* in Berlin [A 9]) points to Jordaens, who painted the same subject [E 26] around 1616. [2] This relationship leads Jaffé to believe that the Dresden painting was produced while Liss was still in Antwerp. Yet even in the artist's Roman works the imprint of the Flemish masters remains predominant, especially that of Abraham Janssens, whose characteristic method of composition is recognizable in the Munich *Cleopatra* [A 18] as well as in the painting here discussed. As both pictures are closely related in their color range and in the «ear-conch» movements of the shimmering silk cloths, a date from the artist's Roman period seems justified. The angel of the *Magdalene* picture corresponds in type to that of the *Annunciation* – known to us only through a

84

weak engraving by Abraham Blooteling [C 60] – which probably also dates from the artist's stay in Rome (see Klessmann, 1970).

In 1711, a «life-sized Magdalene by Johann Liss» was found in Sibert van Schelling's collection in Amsterdam,[3] but Steinbart had already speculated on the possibility of a «second and different Magdalene version,» perhaps identical with the painting [D 3] now in Slavkov (Czechoslovakia).

[1] For example, Cornelis van Haarlem, Gemäldegalerie Dresden, inventory no. 850; and an engraving by Jan Saenredam after Hendrick Goltzius, *The Choice between Young and Old* (Hollstein: J. Matham, no. 330).

[2] Jaffé, Ottawa, 1969, exh. cat. no. 7, illus.

[3] *Herrn Zacharias Conrad von Uffenbach Merkwürdige Reisen durch Niedersachsen, Holland und Engelland,* part III, Ulm, 1754, pp. 646–47; see also Documentation III, 2.

Collections: Ca' Bonfadina, Venice, 1660; Gemäldegalerie, Dresden, since 1765.

Literature: M. Boschini, *La Carta del Navegar pitoresco,* Venice, 1660, p. 567. Reprinted: Vol. VII of *Civiltà Veneziana – Fonti e Testi,* Venice and Rome, 1966, p. 604, line 27. – J. A. Riedel and C. F. Wenzel, *Catalogue des tableaux de la Galerie électorale de Dresde,* Dresden, 1765. – Parthey, 1864, p. 64. – K. Woermann, *Katalog der Königlichen Gemäldegalerie zu Dresden,* Dresden, 1896, no. 1840. – T. von Frimmel, *Kunstchronik,* VIII, 1897, column 200 (review of Woermann, 1896). – Woermann, *Katalog der Königlichen Gemäldegalerie zu Dresden,* Dresden, 1902, p. 591, no. 1840. Edition of 1905, p. 589. – Wurzbach, 1910, p. 76. – R. Oldenbourg, «An unidentified picture by Jan Lys,» *Art in America,* IV, 1915, pp. 53–54. – Bode, 1920, p. 176, illus. – Colasanti, 1921–22, p. 25. – Zarnowski, 1925, pp. 94, 96. – Posse, 1925–26, pp. 26–27, illus. – W. Drost, *Barockmalerei in den germanischen Ländern,* Handbuch für Kunstwissenschaft, Wildpark-Potsdam, 1926, p. 91. – Drost, «Motivübernahme bei Jordaens und Brouwer,» *Königsberger Kunstgeschichtliche Forschungen,* I, 1928, pp. 24, 26. – Peltzer, in Thieme Becker, XXIII, 1929, p. 286. – Pallucchini, 1934, p. 15. – Steinbart, 1940, pp. 129–30, 161, pls. 52, 53. – Steinbart, 1942, illus. p. 179 (detail). – Bloch, 1942, p. 128. – Steinbart, 1946, pp. 35, 41, 42, 46–48, 63, figs. 52, 53. – Bloch, 1950, p. 282. – Pigler, 1956, I, p. 454. – Steinbart, 1958–59, pp. 166, 168, n. 29, 170–72, 186, 204, fig. 15. – *Staatliche Kunstsammlungen Dresden, Gemäldegalerie Alte Meister,* Dresden, 1960, p. 55, no. 1840. English edition: Dresden, 1968, p. 69, no. 1840. – *Picture Gallery Dresden, Old Masters,* Dresden, 1962, p. 65, no. 1840. – Berlin, 1966, exh. cat., p. 53 (R. Klessmann). – Donzelli and Pilo, 1967, p. 241. – M. Jaffé *Jacob Jordaens 1593–1678,* exh. cat., National Gallery of Canada, Ottawa, 1969, p. 73. – Klessmann, 1970 *(Kunstchronik),* p. 293.

COPIES:

Edgcote (Northamptonshire), England. See Steinbart, 1958–59, p. 170, n. 33; and H. A. Tippling, *English Homes, Period V,* I, London, 1921, p. 296, pl. 256.

R. K.

A 18 THE DEATH OF CLEOPATRA Fig. 18, Colorplate III

Oil on canvas, 97,5 × 85,5 cm. (38³/₈ × 33¹¹/₁₆ inches).

Bayerische Staatsgemäldesammlungen, Munich.

The Egyptian Queen Cleopatra (69–30 B. C.) sought death in order to escape imprisonment by Octavian, who had defeated her adversary, Anthony (her lover), in the battle to succeed Caesar. The painting shows the young queen supported by a servant after she has received the deadly bite of a viper, while a young Moor, horror-stricken, looks upon the

snake in the basket of flowers he is holding. According to Egyptian belief, death by the bite of a snake would lead to eternal life (Plutarch).

The picture probably came from the Venetian collection of Giorgio Bergonzi in whose inventory of 1709 the painting is described under no. 158: «Due mezze figure con un moreto che tiene una Cesta di fiori, soaza d'intaglio del Giovanni Lis.»

The effective lighting, the strong modeling of the half figures, and the liquid color application of Liss's composition are reminiscent of Flemish examples which the artist could have studied while in Antwerp. His stay in Flanders coincided with the period when the influence of Caravaggio was strongly noticeable in works by Rubens, Jordaens, and Abraham Janssens. Janssens' large forms in particular came close to Liss's own ideas, and it is hardly conceivable that the compositions of Liss's *Cleopatra* could have been done without a knowledge of Janssens' half-figure paintings such as *Meleager and Atalante* [E 27] Berlin (cat. no. 777, destroyed by fire in 1945) and his *Peace* in Antwerp (their cat. no. 5001). However, when Liss painted *Cleopatra* he had reached a new artistic dimension because of his direct contact with the art of Italy. The elegance of the composition, the rich colors, as well as the fine difference in his psychological and physical treatment of the subject of the picture, exceed everything he had done in the Netherlands. It has been overlooked so far, but nevertheless the rendering of the painting, especially the range of colors and the spirit of it, although founded on Flemish training owes more to Roman-Bolognese influences than to Venetian.

The assumption that Liss painted this picture in Rome is supported by two of his prints which were definitely done there. The posture of Cleopatra, the folds of her garment that run against each other, as well as their shell-shaped curves, are in the characteristic style of the *Stammbuch* page in Cleveland [B 50] and the *Cephalus* etching [B 51]. Allowing for the difficulties in comparing paintings with graphic works, there is an observable relationship among these works by Liss, permitting a dating of the painting to about 1622–24. The *Magdalene* of the Dresden museum, which, stylistically, is the painter's closest work to his *Cleopatra*, was – contrary to the assumption of Michael Jaffé[1] – probably painted at about the same time in Rome.

An iconographically related painting by Carl Loth in the Karlsruhe Kunsthalle[2] shows Cleopatra, half nude, with two female servants, one on each side, and a little Moor carrying a flower basket.

[1] M. Jaffé, *Jacob Jordaens 1593–1678*, exh. cat., The National Gallery of Canada, Ottawa, 1968–69, p. 73.
[2] See G. Ewald, *Johann Carl Loth*, Amsterdam, 1965, p. 119, no. 517.

Exhibition: Berlin, 1966, cat. no. 46.

Literature: C. A. Levi, *Le collezioni veneziane d'arte e d'antichità dal secolo XIV ai nostri giorni*, II, Venice, 1900, p. 163. – G. Gronau, «Bilder von Lys und Drost in älteren venezianischen Sammlungen,» *Kunstchronik und Kunstmarkt*, N. S., 1921–22, p. 405. – Steinbart, 1940, p. 172 (under lost paintings). – Savini-Branca, 1964, p. 170, no. 158. – *Münchener Jahrbuch der bildenden Kunst*, XVI, 1965, p. 250. – Berlin, 1966, exh. cat., pp. 52–54 (R. Klessmann). – Bloch, 1966, p. 545. – B. Bushart, *Deutsche Malerei des Barock*, Königstein, 1967, illus. – Ewald, 1967, p. 10. – Woeckel, 1967, p. 178, illus. – Donzelli and Pilo, 1967, p. 242. – E. Pfeiffer-Belli, *Rundgang durch die Alte Pinakothek*, Munich, 1969, pp. 117–18, fig. 64. – Klessmann, 1970 *(Kunstchronik)*, pp. 292–93. – E. Steingräber, *Von Giotto bis Picasso, Meisterwerke aus den Bayerischen Staatsgemäldesammlungen*, Munich, 1972, p. 77. fig. 167 (color). R. K.

A 19 JUDITH (shown in Augsburg only) Fig. 20, Colorplate IV

Oil on canvas, 128,2 × 104,1 cm. (50¹/₂ × 41 inches).

National Gallery, London.

During the siege which Holofernes, commander-in-chief for the Assyrian King Nebuchad-
nezzar, had laid to the Israelite city of Bethulia, the beautiful Hebrew woman Judith
succeeded in gaining entry into the general's tent, then killed the inebriated warrior with
his own sword and, to prove her deed, carried his severed head before the city's elders.
At dawn, the leaderless Assyrian army was put to flight by the Israelites (Judith 13:1–12,
Apocrypha).

There are several known repetitions of the Judith composition, but no other version
equals this painting in quality of execution; it can therefore be assumed that this is the
artist's primary version.

Liss probably drew the inspiration for his subject from a painting by Rubens, now lost,
which has come to us in the form of an engraved copy by Cornelis Galle [E 28] (Holl-
stein 31). It belongs among those of Rubens' paintings which he created shortly after his
return from Italy, with the still fresh impression of the realism practiced in Rome. Liss
may have seen Rubens' painting in Antwerp. Despite formal discrepancies, the similarities
between both representations cannot be overlooked. Both have in common the drastic
grasp of the heroine and the forward plunge of the murdered body, as if tumbling out of
the picture. Liss reduced Rubens' scenic depiction, showing only half-length figures, and
shifted the main figure's position to present a strict rear view. Similar representations by
artists from among the followers of Caravaggio must have encouraged Liss to compose
this picture more compactly; for instance, Artemisia Gentileschi's *Judith*, now at the
Pitti Gallery, Florence, where the figure of the maid, seen from the back becomes the
main motif.[1] Liss went one significant step further, for it is the heroine herself who turns
her back, though still glancing around at the viewer. Steinbart (1940, fig. 54) cites a Vene-
tian painting (Rome, Borghese Gallery) by an artist from among the Pordenone circle as
the prototype for Liss's composition; the comparison, however, applies only in a general
way. In Guido Reni's fresco for the Andreas Oratorium near S. Gregorio Magno al Celio
in Rome, painted 1608 – a noted source of inspiration for many artists – we also encoun-
ter a female figure seen from the back, turbaned and glancing around at the beholder.

The iconography of the painting, its form and colorfulness, all support a date in Rome –
at least for the London version.[2] It was during this period that Liss was greatly preoccu-
pied with the works of Caravaggio and his followers.

Yet in contrast to his crowded *Soldier's Banquet* [A 15]), which shows the Caravaggesque
influence most clearly, Liss's *Judith* attests to his attempt at historical painting by in-
fusing a balanced composition with the specifically Italian vitality of the Baroque, thus
lending new pathos to the pictorial narrative. In this respect, Liss's *Judith* surpasses his
Cleopatra, now in Munich [A 18], which, though darker in color and more Flemish in
concept, dates from approximately the same time. The two paintings share certain
features: the half-length figures, the tent-like enclosure of the picture space reminiscent

of the *Cephalus* etching [B 51], and an action involving three persons. The heroine's white, richly-gathered blouse with its lace-trimmed neckline is identical in both paintings. Based on these observations, it seems justified to assign a date before or around 1625.

Replicas of the painting are at the Budapest Museum of Fine Arts [A 20], the Kunsthistorisches Museum of Vienna [A 21], and the Museo di Ca' Rezzonico of Venice [A 22]. There was also a replica formerly in the Italico Brass collection, Venice (Steinbart, 1940, pl. 46).

An anonymous drawing (12,8 × 10,5 cm.) which copies the *Judith* composition is in the Prints and Drawings collection of the Staatsgalerie Stuttgart.

[1] See A. Moir, *The Italian Followers of Caravaggio*, Cambridge, 1967, II, fig. 128.

[2] It should be noted that after recent cleaning, areas of canvas were reclaimed, changing the size from 128,6 × 99,2 cm. (50^5/8 × 39^1/16 inches) to 128,25 × 104,1 cm. (50^1/2 × 41 inches).

Collections: Venice, auction 1914 (attributed to Domenico Fetti); Munich, Professor F. Naager; acquired by the National Gallery in 1931, presented by John Archibald Watt Dollar.

Literature: Oldenbourg, 1914, p. 150, fig. 7. – R. Baldass, «Neuerwerbungen des Budapester Museums der Bildenden Künste,» *Kunst und Kunsthandwerk*, XX, 1917, p. 393. – Bode, 1919, pp. 1, 2. – Oldenbourg, 1921, pp. 10, 16. – Colasanti, 1921–22, p. 25. – Peltzer, in Thieme-Becker, XXIII, 1929, p. 286. – Goering, 1940, p. 25. – Steinbart, 1940, pp. 119–20, 162, pl. 47. – Steinbart, 1946, pp. 39–40, 62, fig. 46. – Golzio, 1950, p. 569. – Pigler, 1956, I, p. 194. – Kohrs, 1956, p. 133. – Levey, 1959, p. 59. – Venice, 1959, exh. cat., p. 46 (P. Zampetti). – Heinz, 1965, p. 72. – Berlin, 1966, exh. cat., pp. 51–53 (R. Klessmann). – Donzelli and Pilo, 1967, p. 242. – Pigler, 1968, p. 388. – Klessmann, 1970 *(Kunstchronik)*, p. 293. – *The National Gallery, Illustrated General Catalogue*, London, 1973, p. 379, no. 4597, illus.

R. K.

A 20 JUDITH Fig. 19

Oil on canvas, 129 × 104 cm. (50^3/4 × 40^{15}/16 inches).

Museum of Fine Arts, Budapest.

Representation and composition correspond with the painting in London [A 19].

This painting, as well as the version at the Kunsthistorisches Museum in Vienna, is considered to be the artist's own repetition of the picture at the National Gallery in London. Compared to the latter, which is no doubt the first version, the details of the Budapest version are treated more summarily. This difference becomes particularly evident in the execution of drapery folds and the differentiation of textures.

While the invention was probably first conceived in Rome (see [A 19]), it is conceivable that such repetitions as the Budapest painting were painted only after Liss had gone back to Venice. Speculations as to dates and chronology of the various versions are inconclusive without further comparative research and more reliable points of reference.

The Budapest painting may be the same one that once belonged to the Vidiman family in Venice which Pietro Monaco engraved on a title page in 1739 [E 88] (without reversing the image). (See Steinbart, 1940, fig. 52.)

Collection: Venice, Vidiman Family, 1739 (?); bequest of Dr. Ernst Kammerer, 1916.

Exhibitions: Dresden, 1968: Venezianische Malerei 15.–18. Jahrhundert; cat. no. 53. – Bordeaux, 1972: Trésors du Musée de Budapest; cat. no. 43.

Literature: Frimmel, 1901, p. 216. – *Kunstchronik,* XXVIII, 1917, pp. 304, 429. – L. Baldass, «Neuerwerbungen des Budapester Museums der Bildenden Künste,» *Kunst und Kunsthandwerk,* XX, 1917, p. 393. – E. Petrovics, in *Az Országos Szépmüvészeti Múzeum Evkönyvei,* I, 1918, p. 201, fig. 16. – Oldenbourg, 1918, p. 118. – Bode, 1919, pp. 1, 2. – Bode, 1920, pp. 174, 176. – Oldenbourg, 1921, p. 15. – G. Terey, *Neue Blätter für Gemäldekunde,* I, 1922, p. 8. – Frimmel, 1922, p. 55, n. 71. – Peltzer, in Thieme-Becker, XXIII, 1929, p. 286. – Schneider, 1933, pp. 50, 137. – Goering, 1940, p. 25. – Steinbart, 1940, pp. 119–20, 161. – Steinbart, 1946, pp. 39–40, 56. – Bénézit, 1952, p. 600. – Pigler, 1956, I, p. 194. – Levey, 1959, p. 59. – Venice, 1959, exh. cat., p. 46 (P. Zampetti). – Heinz, 1965, p. 72. – Berlin, 1966, exh. cat., p. 51 (R. Klessmann). – Donzelli and Pilo, 1967, p. 242. – Pigler, 1968, p. 388, no. 4913.

R. K.

A 21 JUDITH (shown in Augsburg only) Fig. 22

Oil on canvas, 126 × 102 cm. (49⅝ × 40⅛ inches).

Kunsthistorisches Museum, Vienna.

Representation and composition correspond with the painting in London [A 19].

This painting, as well as the version at the Budapest Museum [A 20] is considered to be the artist's own repetition of the picture at the National Gallery in London. While the London painting has come to be generally accepted as the first version, opinions are divided about the Vienna version. Although it falls behind the London painting in plasticity and coloristic differentiation, doubts expressed by Goering (1940) and Levey (1959) concerning its authenticity are unjustified.

In the Vienna painting, the color is applied fluidly, details are more summarized than in the London painting, and its colors are lighter and more transparent; yet it shows none of the telltale signs of a copy. Its quality is in no way inferior to that of the Budapest version and, like the latter, it was presumably executed during the painter's late Venetian period.

Collection: Formerly Salzburg, Residenzgalerie (on exhibit in the Kunsthistorisches Museum since 1923).

Exhibitions: Nürnberg, 1952, cat. no. N 9. – Berlin, 1966, cat. no. 45.

Literature: Peltzer, in Thieme-Becker, XXIII, 1929, p. 286. – Voss, 1933–34, p. 16. – Goering, 1940, p. 25. – Steinbart, 1940, pp. 119–20, 163, pl. 48. – Steinbart, 1942, p. 176, illus. – Steinbart, 1946, pp. 39–40, 56, fig. 47, pl. V (color). – Bénézit, 1952, p. 600. – Nürnberg, 1952, exh. cat., p. 126, no. N 9. – Pigler, 1956, I, p. 194. – De Logu, 1958, p. 277. – Levey, 1959, p. 59. – Venice, 1959, exh. cat., p. 46 (P. Zampetti). – Steinbart, 1958–59, p. 185. – V. Oberhammer, *Die Gemäldegalerie des Kunsthistorischen Museums in Wien,* II, Vienna, 1961, p. 32. – Heinz, 1965, p. 72, pl. 66. – Bloch, 1966, p. 546. – Berlin, 1966, exh. cat., pp. 51 ff., fig. 46 (R. Klessmann). – Donzelli and Pilo, 1967, p. 242. – Woeckel, 1967, p. 178. – Pigler, 1968, p. 388. – E. Hubala, *Die Kunst des 17. Jahrhunderts,* Berlin, 1970, pp. 205–206 (W. J. Müller), fig. 202.

R. K.

A 22 JUDITH Fig. 21

Oil on canvas, 120 × 172 cm. (47¹/₄ × 67³/₄ inches).

Museo di Ca' Rezzonico, Venice (Dono Volpi, 1950).

The representation and composition correspond to the London painting of the same subject [A 19], except for the nocturnal landscape expanding the picture space to the right.

Steinbart listed this painting whose heroine corresponds to the London, Budapest [A 20], and Vienna [A 21] versions, as Liss's first conception of this subject. Although Steinbart himself remarked on the «meaningless void» of one-third of the picture – the portion on the right – he argued that the nocturne should be seen as a Tintoretto-inspired, typical example of Liss's «Roman-Venetian luminarism,» and as «a very early work created immediately upon Liss's return from Rome,» and he speculated that the painter himself later felt the «impossibility» of the composition, wherefore he omitted the «unimportant right third of the picture space» in his other versions.

This assertion is contradicted not only by the weaknesses of Steinbart's argumentation, but even more so by the weaknesses of the painting itself. One senses in the pictorial expansions toward right and left, a certain helplessness on the painter's part as soon as he goes beyond the original composition by Liss that we know from several versions. If, as Steinbart firmly believes, the full width of the picture is indeed one continuous painting surface, then one must eliminate Liss as the picture's possible author. It seems more likely that it was created by a seventeenth-century copyist who sought to soften the severity of Liss's representation with some novelistic additions.

Collections: Palazzo Vendramin Calergi (formerly Loredan).

Exhibition: Venice, 1959, cat. no. 64.

Literature: C. A. Levi, *Le collezione veneziane d'arte e d'antichità dal secolo XIV. ai nostri giorni*, II, Venice, 1900, p. 76. – Steinbart, 1940, pp. 119–20, 163, pl. 45. – Steinbart, 1946, pp. 39, 62, fig. 45. – G. Lorenzetti, *Ca' Rezzonico*, Venice, 1957, p. 32, pl. XXXVII (detail). – De Logu, 1958, p. 277. – Steinbart, 1958–59, p. 166. – T. Pignatti, *Il Museo Correr di Venezia, dipinti del XVII e XVIII secolo*, Venice, 1960, p. 144. – Heinz, 1965, p. 72. – Berlin, 1966, p. 51 (R. Klessmann). – Donzelli and Pilo, 1967, pp. 241–42. – Pigler, 1968, p. 388 (as a workshop painting).

 R. K.

A 23 THE FLAYING OF MARSYAS Fig. 24

Oil on copper, 49,5 × 37 cm. (19¹/₂ × 14⁹/₁₆ inches).

Pushkin Museum of Fine Arts, Moscow.

When Marsyas lost the musical contest to which he had challenged Apollo, he was flayed by the god in punishment. A goatskin and shepherd's flute (?) are shown at Marsyas' fettered feet; in the foreground lies a violin. According to the Greek legend, as told by Ovid in his *Metamorphoses*,[1] Apollo won the contest playing the Hellenic lyre.

Painted on copper, the Moscow *Flaying of Marsyas* was recorded as a work by Liss as early as the eighteenth century in Dutch auctions of 1734, 1747, and 1749 (see Documentation VI, 3–5). It is more carefully executed, modeled with greater plasticity, and richer in details than the canvas in Venice [A 24], which, for these reasons, must be considered a second version.

From the beginning of the seventeenth century, Italian painters reveal in their work an increasing interest in the subject of Marsyas' punishment. The more frequent form of representation shows him bound head down.[2] Liss's composition follows an older model (see Giovanni Biliverti's painting in the Palazzo Pitti, Florence), yet he seems to have been directly inspired by the work of a contemporary. An etching of *The Martyrdom of St. Bartholomew* [E 29] dated 1624, by Jusepe de Ribera[3] shows such striking iconographic parallels to the composition by Liss that a relationship between the two can be assumed, even though certain details in the Moscow painting are missing from the painting at Venice.

The painting in Moscow belongs among the group of works that Liss probably painted in Rome. These are more precisely executed, more vigorously modeled with light and shadow, and have brighter, cooler color schemes than the works of Liss's later Venetian period (see *Venus and Adonis* [A 25] and *Fall of Phaeton* [A 26]). Given its dependence upon the Ribera etching, the Moscow painting must be dated after 1624.

[1] Ovid, *Metamorphoses*, Book VI.
[2] See E. Schleier, «A Lost Baburen Rediscovered,» *The Burlington Magazine*, CXIV, 1972, p. 787, fig. 67.
[3] See J. Brown, *Jusepe de Ribera, Prints and Drawings*, Princeton, 1973, no. 12, fig. 15.

Collections: Amsterdam, sale, May 12, 1734; The Hague, sale, May 23, 1747; Amsterdam, sale, April 22, 1749; J. S. Ostrouchow, Moscow; in the Pushkin Museum since 1929.

Literature: G. Hoet, *Catalogus of Naamlyst van Schilderyen*, The Hague, I, 1752, p. 416, no. 116; II, 1752, p. 252, no. 207; III, 1770, p. 48, no. 32. – P. P. Weiner, «Notizie di Russia,» *L'Arte*, XII, 1909, p. 225. – A. Benois, *Les anciennes écoles de peinture dans les palais et collections privées russes*, Brussels, 1910, p. 107. – Oldenbourg, 1914, p. 156, fig. 11. – *American Art News*, XVII, no. 6, November 16, 1918, p. 2. – T. Borenius, «Jan Lys,» *The Burlington Magazine*, XXXIII, 1918, p. 115. – Oldenbourg, 1921, pp. 12, 16, pl. XXVI. – Colasanti, 1921–22, p. 25. – Peltzer, in Thieme Becker, XXIII, 1929, p. 286. - Steinbart, 1940, pp. 95–96, 162, pl. 37. – Steinbart, 1946, pp. 34, 61, fig. 34. – Italian Paintings of the XVII and XVIII Centuries from the Museum Collection, Pushkin Museum, Moscow, 1961, pp. 41–42. – Berlin, 1966, p. 55 (R. Klessmann). – Marconi, 1970, p. 42.

R. K.

A 24 THE FLAYING OF MARSYAS Fig. 23

Oil on canvas, 59 × 51 cm. (23¼ × 20¹/₁₆ inches).

Gallerie dell'Accademia, Venice.

The representation and composition correspond to the painting in Moscow [A 23], which is a qualitatively superior version. *The Flaying of Marsyas* in Venice is characterized by a broader, softer brushwork and a predominantly earthy brown tonality. Unfortunately, the abraded surface somewhat impairs its effectiveness. In this second version, forms and

objects are but summarily developed, and the painter completely relinquished some details of the Moscow painting – such as Apollo's tied sandals, or the satyrs appearing from behind a tree. These differences, however one may explain them, imply a change of concept and indicate that the painting is a late work from the artist's Venetian period, when he also painted the stylistically related *Mourning for Abel* [A 36] and *The Sacrifice of Isaac* [A 35].

Collections: Contarini Bequest, 1838.

Exhibition: Venice, 1946, cat. no. 267.

Literature: Pinacoteca Contarini aggiunta a quella dell' J. R. Accademia delle Belle Arti, quest' anno 1841, Venice, 1841, p. 11. – G. Fiocco, *Le Regie Gallerie dell'Accademia di Venezia: Catalogo a cura della Direzione,* Venice, 1924, p. 129. – Fiocco, 1929, p. 19. – Steinbart, 1940, pp. 96–97, 163, pl. 36. – Steinbart, 1946, pp. 34, 61. – Marconi, 1949, pp. 57–58. – F. Valcanover, *Die Galerie Accademia in Venedig,* Munich, 1956, p. 122, illus. – Steinbart, 1958–59, p. 199. – Marconi, 1970, p. 42, no. 88, illus.

R. K.

A 25 Venus and Adonis

Fig. 25

Oil on copper, 52,5 × 69 cm. (20^{11}/$_{16}$ × 27^{3}/$_{16}$ inches).

Karlsruhe, Staatliche Kunsthalle (loan of the Federal Republic of Germany).

Venus tries in vain to prevent Adonis' departure for the hunt which will end in his death. One of Amor's arrows had accidentally injured the goddess and thereby caused her to love Adonis.[1] The picture shows Amor on a red cloth where he has just fallen asleep next to Venus. Several putti bring flowers. One of them attempts to pull an arrow out of Amor's quiver. On the shore of the lake in the background dance the three graces who, in the company of Venus, represent beauty and joy.

The composition of the picture and the treatment of the subject reveal Liss's Italian influence. The lively activity of the putti and the figures of the lovers in particular remind us of the famous paintings by Titian, the *Bacchanal* and *Offering to Venus* (Madrid), which until 1638 hung in the Palazzo Ludovisi in Rome. A similar embrace can be found in a charcoal drawing by Titian, formerly in the collection of C. Ricketts, London.[2] On the other hand, the refined rendering and the choice of color in this Karlsruhe painting are closer to the works of Northern painters living in Rome – Adam Elsheimer, Cornelis van Poelenburg – than to Venetian art.

Steinbart, who did not accept the attribution to Liss first made by Voss, pointed out the relationship of the painting to Elsheimer's *Coronis* composition, engraved by Magdalena de Passe.[3] It is possible that Liss wanted to continue in the tradition of the popular copper paintings of his countryman from Frankfurt when he made his small paintings that were so much admired by Sandrart, but he could not hide his mannerist-Netherlandish training. The style of his figures reminds us of Cornelis van Haarlem's figures. The way Adonis bends over his beloved from behind, shading her face, is similar to a representation by Cornelis formerly in the collection of Schtschawinsky in Leningrad.[4] The relationship to works by Cornelis van Poelenburg, who was active in Rome at the same time

as Liss, cannot be overlooked either; an example is the drawing in Munich of a reclining nymph, which perhaps also goes back to Elsheimer's *Coronis* picture[5] [E 30]

Stylistically, the Karlsruhe painting is closely related to Liss's *Fall of Phaeton* [A 26], and, together with the *Bathing Nymphs* [A 27], belongs to the artist's Roman phase. The Venus motif can be found again in the reclining Heliade. The wooded landscape, rendered in the manner of Paul Bril, with the Triton blowing into a shell, is comparable to Liss's landscape with nymphs. The Karlsruhe picture was probably painted before or around 1625 in Rome.

[1] Ovid, *Metamorphoses*, Book X.
[2] See H. Tietze, *Tizian*, Vienna, 1936, pl. 236.
[3] H. Weizsäcker, *Adam Elsheimer, der Maler von Frankfurt*, part II, Berlin 1952, no. 49.
[4] Catalogue of 1917, no. 69; photograph RKD, The Hague.
[5] See W. Wegner, *Die niederländischen Handzeichnungen des 15.–18. Jahrhunderts*, Berlin, 1973, no. 831, pl. 155.

Collections: Count Algarotti, Venice, 1776; Sterbini collection, Rome, 1874; since 1941 property of the German Reich.

Exhibitions: Berlin, 1966, cat. no. 43, fig. 42.

Literature: G. A. Selva, *Catalogo dei quadri ... della galleria del fu Sig. Conte Algarotti in Venezia*, Venice, 1776, p. XIII. – A. F. Bartholomäi, *Beschreibung der Gräflich Algarottischen Gemälde- und Zeichnungs-Gallerie in Venedig*, Augsburg, 1780, p. 32. – D. Farabulini, *Galleria del Cavaliere Giulio Sterbini*, Rome, 1874, p. 39 (as Rubens). – A. Venturi, *La Galleria Sterbini in Roma*, Rome, 1906, p. 258, no. 65 (as French 1800). – Voss, 1933–34, p. 16. – Steinbart, 1940, p. 182, fig. 75 (as unknown Dutch or German painter). – Steinbart, 1946, pp. 33–34, fig. 35. – Bloch, 1950, p. 278. – Bloch, 1955, p. 323. – Pigler, 1956, II, p. 241. – Steinbart, 1958–59, p. 187, fig. 39. – Berlin, 1966, exh. cat., pp. 50, 55, no. 43, fig. 42 (R. Klessmann). – Donzelli and Pilo, 1967, p. 241 (formerly Dresden). – Ewald, 1967, p. 10, fig. 3. – *Jahrbuch der Staatlichen Kunstsammlungen in Baden-Württemberg*, IV, 1967, p. 125–26, fig. 81 (J. Lauts). – Klessmann, 1970 *(Kunstchronik)*, p. 293. – J. Lauts, *Neuerwerbungen alter Meister 1966–1972*, Karlsruhe, 1973, pp. 27–28, illus. p. 28, and colorplate.

R. K.

A 26 THE FALL OF PHAETON Fig. 26

Oil on canvas, 128 × 110 cm. (50³/₈ × 43⁵/₁₆ inches).

Denis Mahon, London.

Helios, the god of light, gives in to his son Phaeton's urging and yields the sun chariot to him for one day. Yet Phaeton does not know how to keep the winged horses in check, and the incandescent carriage veers too closely to the earth. When scorching heat threatens to destroy the earth and all its living creatures, Jupiter throws his thunderbolt and hurls Phaeton into the depths.[1]

Representations from the legend of Phaeton occupy a conspicuous place in the sparse oeuvre of Johann Liss (see [B 53]) and show various phases of the dramatic action. One such painting – probably identical with the one here on exhibit – is described by Sandrart: «In equally brilliant manner he painted the fall of Phaeton, with his chariot / and beneath

on earth the water nymph looking up so terror-stricken / with which beautiful nude nymphs, as well as with the graceful landscape and flaming clouds / Lys proved / that he was a master of color / and of charming hues.»

At the left the painting shows three nude nymphs mourning over the drying of wells in the searing heat: «Rivers even, broadly rolling in their mighty beds, are not spared.»[2] In the foreground, sea animals languish on dry soil. On the right, Neptune, the sea god, looks at the sky in alarm. On the rock behind, Phaeton's sisters, the winged Heliades, become witnesses of the divine judgment.

Feyken Rijp, author of a chronicle of the Dutch town of Hoorn, published in 1709, mentions two Liss paintings on this subject: one, six feet high, owned by the Dutch collector Hooft; the other, «even bigger,» at the Palazzo Pamphili in Rome. Judging from these proportions, the picture in this exhibition could conceivably be the first of the two. Another painting on the subject, at the time in Count Algarotti's collection in Venice, corresponds to none of the aforementioned pictures, if the catalogue information is correct.[3]

The *Fall of Phaeton* painting is of particular significance for our understanding of Liss. It is the earliest example of his preoccupation with landscape, and therefore it points back to the sources from which he drew. Since there are no known landscape paintings from his Netherlandish period, it may well be that his interest in this theme was awakened in Rome. The meandering mountain river splashing over rocks was a favorite motif of Netherlandish painters working in Rome around and after 1600, and was evidently inspired by the waterfalls of Tivoli. Paul Bril and Cornelis van Poelenburg repeatedly used and modified this motif in their landscapes; Poelenburg's Tivoli painting at the Pinakothek in Munich is a case in point.[4] This painter from Utrecht, a co-founder of the «Schilderbent» – an association of artists from the Netherlands – lived in Rome from around 1617 to 1625 and was certainly a close acquaintance of Liss. Poelenburg's style of this period must have exerted some influence on the landscape of Liss's *Fall of Phaeton,* for the way Liss represents the river with glittering clarity finds its closest parallel in the enamel-like smoothness of Poelenburg's refined manner.

Liss was apparently still inexperienced in landscape painting; the figures in the *Fall of Phaeton* are not yet convincingly incorporated into the picture space as they move about in manneristic fashion. Poelenburg had skirted this problem by reducing his figures to a small scale, whereas Liss probably sought to combine the monumental figure style of the Carracci circle with a Netherlandish feeling for landscape. He later integrated this monumental figure style far more convincingly into his highly individualistic compositions (see *The Toilet of Venus* [A 28] and *Bathing Nymphs* [A 27]).

Steinbart rightfully stressed the importance of the Phaeton cycle created in 1609 by Francesco Albani for the Palazzo Giustiniani-Odescalchi of Bassano di Sutri, in the vicinity of Rome. Presumably, Liss knew these frescoes as well as Annibale Carracci's wall paintings of 1595–1605 for the gallery of the Palazzo Farnese in Rome. This classically decorative figure style made a strong enough impression on Liss to reduce the influence of the harshly realistic Caravaggio school, as becomes obvious, at the latest, in his *Bathing Nymphs.* Although the nymphs in the *Fall of Phaeton* are, as Bloch (1950) pointed out,

still ensconced in the mannerism of a Cornelis van Haarlem, they also betray the plasticity and fluid brushwork of the Antwerp Baroque.

It may be assumed that the exhibited painting, dated around 1624, marks the beginning of the painter's interest in landscape, and that this interest also made him revise the Netherlandish character of his figure style. The *Fall of Phaeton* is stylistically related to the *Venus* painting in Karlsruhe [A 25]; the elongated female figure type of the *Venus* work can be compared to the Heliades in the *Fall of Phaeton*.

The group of plastically conceived nymphs clinging to one another is, as Steinbart noticed, reminiscent of Bernini's *Proserpina* sculpture of 1622. It finds its closest parallel in the *Toilet of Venus* of Pommersfelden, probably also painted in Rome at a slightly later date. Both pictures have in common the interaction between female nudes studied from various angles. It is characteristic of Liss's working method to isolate certain figure groups from their larger context and to further develop them for re-use in new compositions, as can be observed in the case of the morra game motif [A 13, A 14]. The recent discovery of a *Death of Phaeton* drawing at Braunschweig [B 53] reconfirms the close stylistic connection between the *Fall of Phaeton* and the *Toilet of Venus*.

[1] Ovid, *Metamorphoses* II, pp. 238–39.

[2] Ovid, *op. cit.*

[3] G. A. Selva, *Catalogo dei quadri ... della Galeria del fu Sig. Conte Algarotti in Venezia*, Venice, 1776, p. XIII; see also Documentation.

[4] *Alte Pinakothek München Katalog I, Deutsche und niederländische Malerei zwischen Renaissance und Barock*, Munich, 1963, pp. 47–48, no. 5273; *Italianiserende Landschapschilders*, exh. cat., Centraal Museum, Utrecht, 1965, p. 70, no. 18, fig. 19.

Collections: M. A. W. Swinfen-Broun, Swinfen Hall, Lichfield; sale, Christie's, London, December 10, 1948, cat. no. 76 (as Albani).

Exhibitions: London, Hazlitt Gallery, 1952: Vasari to Tiepolo, cat. no. 5, illus. – Zürich, Kunsthaus, 1956: Unbekannte Schönheit, cat. no. 156. – Venice, 1959, cat. no. 58. – Manchester, City Art Gallery, 1961: German Art 1400–1800, cat. no. 186, pl. XI. – London, Thomas Agnew, 1965: Art Historians and Critics as Collectors, cat. no. 8, illus. – Berlin, 1966, cat. no. 44.

Literature: Sandrart, 1675, (ed. 1925) p. 187. – Steinbart, 1940, p. 171 (under lost works). – Bloch, 1950, pp. 278 ff., figs. 1, 6. – Benesch, 1951, p. 376. – G. Briganti, «The Mahon Collection of Seicento Paintings,» *The Connoisseur*, CXXXII, 1953, pp. 12, 18, no. 35. – Schilling, 1954, p. 37. – Bloch, 1955, p. 323. – Pigler, 1952, II, p. 208. – R. Wittkower, *Arts and Architecture in Italy 1600–1750*, Harmondsworth, 1958, p. 67. – Steinbart, 1958–59, pp. 192 ff., figs. 37, 38. – Pallucchini, 1960, p. 5. – B. Nicolson, «The Mahon Collection,» *Great Private Collections*, ed. D. Cooper, 1963, p. 120, illus. p. 125. – Paris, 1965, exh. cat., p. 173. – Berlin, 1966, exh. cat., pp. 50–51, no. 44 (R. Klessmann), p. 123 (H. Möhle), fig. 45, and color-plate. – Donzelli and Pilo, 1967, p. 242, fig. 260. – Ewald, 1967, p. 10. – E. Hubala, *Die Kunst des 17. Jahrhunderts*, Berlin, 1970, p. 206 (W. J. Müller), XLI (color). – Klessmann, 1970 *(Kunstchronik)*, p. 293. – H. Pée, *Johann Heinrich Schönfeld, die Gemälde*, Berlin, 1971, p. 94, fig. 15. – *Sztuka Baroku w niemczeck*, exh. cat., Warsaw, Muzeum Narodowe, 1974, p. 62 (R. Klessmann). – *Deutsche Kunst des Barock*, exh. cat., Braunschweig, Herzog Anton Ulrich-Museum, 1975, p. 56 (R. Klessmann).

R. K.

A 27 BATHING NYMPHS Fig. 27

Oil on canvas, 104,5 × 95 cm. (40¹⁵/₁₆ × 37⁷/₁₆ inches).

Georg Schäfer Collection, Schweinfurt.

Several nymphs are resting and bathing in the shadow of a forest through which a brook is running from left to right. In the left background, a shepherd (Mercury?) sits by his flock playing the shawm; two satyrs accompany his music. A goat looks on from a high rock.

Only a fragment of the painting has survived. Approximately one-third of the origi- nally horizontal format is missing at the left. The original composition, as noted by Stein- bart (1958–59, fig. 19), is reproduced in a pen drawing at the Louvre, attributed to Aegidius Sadeler [E 89].[1] It shows an additional nymph, sleeping at the foot of a tree in the left foreground.

The type of landscape painting as a setting for nude figures developed independently in Flanders and culminated in Rubens' lost painting from the Aguado collection which is documented in an engraving by J. Louys.[2] Its pedigree can be traced back through Abra- ham Janssens (*Diana and Callisto*, 1601, Budapest Museum) to the Floris circle. Rubens' paintings on the subject are no doubt related to works by Titian, among them the *Bacchanal* and the *Offering to Venus* (Prado), copies of which were probably available in Antwerp.[3] Liss, too, may have seen compositions of this kind while in the Netherlands; yet it was probably later on in Rome that he first became interested in landscape painting. Liss's composition and painterly treatment of the forest derive from similar represen- tations by Paul Bril (see Bril's drawing of 1604, at the Louvre),[4] while the relatively large nudes are rather more Italian-oriented. The bodies are modeled by a mellow light that reveals a familiarity with the art of Domenichino and Albani, especially so in the case of the nymph in the foreground whose sleeping pose is surprisingly relaxed. None of Liss's other paintings exudes such an arcadian mood, none other attests so clearly to Liss's contact with the Carracci circle.

The Bril-like execution of the landscape, tuned to dark colors, relates closely to the Karls- ruhe *Venus and Adonis* [A 25]. Both paintings presumably originated in Rome at roughly the same time, in or around 1625.

[1] F. Lugt, *Musée du Louvre, Inventaire Général des dessins des écoles du Nord, Ecole flamande*, II, 1949, p. 62, no. 1280, illus.

[2] M. Rooses, *L'Oeuvre de Rubens*, III, Antwerp, 1890, no. 599; see also Rubens' drawings in L. Burchard and R. A. d'Hulst, *Rubens Drawings*, Brussels, 1963, nos. 85, 86.

[3] See J. Held, *Rubens, Selected Drawings*, London, 1959, p. 113.

[4] A. Mayer, *The Life and Works of the Brothers Matthäus and Paul Bril*, Leipzig, 1910, pl. 49).

Collections: Paris, auction (attributed to Vermeer); Julius H. Weitzner, New York.

Literature: Bloch, 1950, p. 278. – Schilling, 1954, p. 37, n. 2. – Bloch, 1955, p. 323, fig. 26. – Steinbart, 1958–59, pp. 175, 176, fig. 18. – C. Sterling, «Les peintres Jean et Jacques Blanchard,» *Art de France,* I, 1961, p. 89. – Donzelli and Pilo, 1967, p. 242. – Klessmann, 1970 *(Kunstchronik)*, p. 293.

R. K.

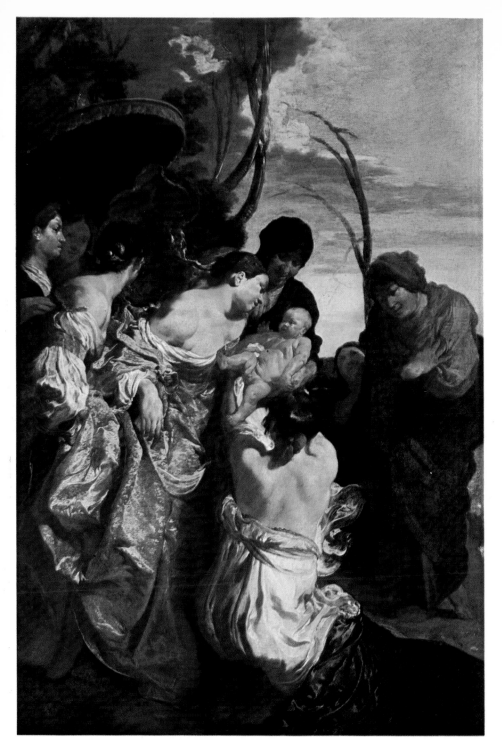

VI The Finding of Moses · Musée des Beaux-Arts, Lille [A 30]

A 28 THE TOILET OF VENUS Fig. 28, Colorplate V (detail)

Oil on poplar panel, 80 × 59,5 cm. (31¹/₂ × 23⁷/₁₆ inches).

Dr. Karl Graf von Schönborn-Wiesentheid, Schloss Pommersfelden.

Venus, «the Goddess of Love and Beauty who laughed sweetly or mockingly at those her wiles had conquered,» [1] is seen in the company of her nymphs preparing for the arrival of Adonis. It is spring, the season when Adonis is to return to her from Persephone, the Queen of the Dead, with whom he had spent the autumn and winter according to the decree of Zeus. [2]

In this version two amorini play about in the sky, and two on the ground. One, with his bow and quiver cast aside, helps Venus to hold up the ornately framed mirror, tumbling backwards under its weight; another, partly hidden in the wrap cast off by Venus, looks out to the spectator. The eye moves to the softly undulating lines of the young nymph to the right of Venus, who gently shifts her weight from one leg to the other as she helps her mistress with her toilet. In contrast to the Titian-red hair of Venus, the nymph's is dark, adorned with a vibrant red ribbon. The calm which her figure exudes is contrasted with the subtle urgency in Venus' pose as she strains to hold up her mirror.

Undoubtedly, this is one of the paintings which Sandrart had in mind when he praised that special grace inherent in Liss's nude figures, and at the same time, said they appeared to him more natural than life itself. It is that subtle balance between the natural, unposed body and the studied ease of the model, that Liss was able to achieve, as were Rubens and, often, Jordaens. Though the body is full, the head is smaller and the skin less dimpled than is characteristic of Rubens' figures. Rubens' nudes seem to personify autumn's abundance and fullness, [3] whereas Liss's nymphs, with their very young faces, seem like tender buds in spring. With their resilient contours and soft colors, fused with bright sunlight they are precursors of Watteau's Venus in his *Judgment of Paris* (Louvre). [4]

By Liss's time, the image of the Venetian High Renaissance Venus – whether reclining, standing, or seated – was firmly imprinted in artists' minds on both sides of the Alps. Thus Liss could have gathered impressions for his *Toilet of Venus* even before he left the Netherlands. [5] Once in Venice, he had access to an overwhelming wealth of images, among these, Titian's *Toilet of Venus* [E 31] (Washington), which Rubens copied ca. 1613–15 (Liechtenstein). Liss was particularly impressed with the composition of Titian's *Diana and Callisto* (Bridgewater Collection), a replica of which hung in the Accademia di S. Luca in Rome when Liss was there. [6] His impressions from Venice merged in Rome with those of classical antiquity; such images as the *Three Graces* and reliefs of the *Judgment of Paris* helped to shape his own idea of standing nymphs. [7] One other decisive influence came to him from Annibale Carraci's *Venus Adorned by the Graces* [E 32] (National Gallery, Washington), although supposedly it was painted in Bologna. [8]

In painting his own *Toilet of Venus*, Liss reversed the direction of Annibale's scene (perhaps working from an engraving) and changed it from a horizontal to a vertical composition; nevertheless, he retained Annibale's basic arrangement of figures. The nymph on the left in Annibales's painting is turned around in Liss's, but her stance is much the same.

Each painting shows a companion of Venus dressing her hair – the two very closely resembling each other. Liss's figures are reduced in scale compared to those of Annibale's painting, but not to the extent of Francesco Albani's figures in another work inspired by Annibale, a tondo [E 33] (Galleria Borghese, Rome) painted in 1622.[9] Like Annibale, Liss focused on the dressing of Venus' long stream of hair and used this occupation to weave together the three main figures.[10] The Pommersfelden version, like Annibale's, shows corpulent amorini in full view in the immediate foreground; and both Liss versions, like Annibale's, have one amorino eagerly helping Venus to hold her mirror. Even the light purple curtains behind Annibale's figures reappear in Liss's painting. These relationships suggest that Liss may have painted his first version of the *Toilet of Venus* when still in Rome or shortly after his return when the memory of Annibale's work was still fresh in his mind.

Similar direct impressions from the Carracci-Albani circle are observed in the painting, *Fall of Phaeton* [A 26]. The newly discovered drawing by Liss, *The Death of Phaeton* [B 53], most likely a *ricordo* of another painting of the Phaeton subject, ties a neat ribbon, as it were, around this group of works that share Roman recollections. The resemblance between the drawing and the painting is self-evident. Moreover, the groups of nymphs in both *Phaeton* works corresponds to Venus and her nymphs in the Pommersfelden panel. The nymphs of the drawing, with their arms tenderly interlocked, echo in the young graces dancing around in the distant background of the Karlsruhe *Venus and Adonis* [A 25]. In turn, one nymph in the drawing and the central nymph in the Phaeton painting are direct relatives to the nymph holding the curtain above Venus in the Pommersfelden and Uffizi paintings. Their yearning look – a reminder of Liss's Haarlem schooling – recalls the theatrical expression of Procris in Liss's earlier etching [B 51].

Of these works most likely dating from Liss's Roman sojourn, the Pommersfelden panel stands out as the most Venetian. And yet, compared with the *Toilet of Venus* in the Uffizi [D 4], the Pommersfelden version is more tightly executed, the forms are more solid, and there is a greater interest in still-life details. Although Steinbart (1940) implied that the Uffizi painting was the earlier of the two versions, a stylistic comparison suggests the opposite. In the Pommersfelden version the paint was more firmly and carefully applied on a panel (the use of a panel could in itself indicate an earlier date); in the Uffizi version it was loosely brushed on a Venetian canvas, allowing the red bolus ground to bleed through in several areas. The forms of the Uffizi painting are modeled more sketchily, and colors and outlines are more diffused. To de-emphasize the pronounced outline of the Pommersfelden nymph, seen from the back, set against a dark shadow, Liss has draped a white sheet over her arm. The mossy stone ballustrade in the Pommersfelden panel has been removed, clearing the view into the landscape (where Adonis appears in hazy outlines), and in the foreground, the plate, ewer, and doves have been omitted so that the eye focuses on the cascading rich drapes of carmine and purple-reds. In short, details of the Pommersfelden version have been sacrificed in favor of an overall richness of texture and color in the Uffizi version, all of which supports the argument that the Pommersfelden version precedes the one in the Uffizi, which could be dated around 1626.

Tracing the history of the *Toilet of Venus* beyond its first mention in the Pommersfelden

inventory of 1719 is difficult enough without exact description or measurements; for other reasons, it becomes virtually impossible. There is the familiar difficulty in distinguishing between the paintings of Liss and Dirck van der Lisse (died 1669, a pupil of Cornelis van Poelenburg, 1586–1667). Both painted nudes in landscapes; both spent time in Rome. To complicate things further, the story of Venus, goddess of love, is often confused with that of Diana, goddess of the hunt. Both involve female nudes in a landscape setting. The story of Diana, as told in Ovid's *Metamorphoses,* enjoyed particular popularity during the seventeenth and eighteenth centuries; in the Netherlands (Arnheim) it was published as early as 1607. It is quite possible, therefore, that the *Toilet of Venus* which appears in the inventory of 1719 may well have been listed in earlier sales as a representation of Diana (not including those which specifically mention Actaeon, the nymph Callisto, or those simply referring to bathing women).[11] The earliest known mention of a nude Diana, by «Jan Liss,» is made in an inventory of the painter Jacob Loys, in Amsterdam, October 30, 1680, no. 92 (see Documentation VI, 11). A *Bath of Diana* by «Jan vander Lis» appeared in the Johan van Marselis sale in Amsterdam, April 25, 1703, no. 20 (see Documentation VI, 13), according to Mireur[12] it was sold again in *Vente* X in Amsterdam on May 18, 1707 (see Documentation VI, 14). Prior to the Pommersfelden inventory of 1719, another Diana – described as «Het Badt van Diana, in een konstig Landschap, door J. vander Lis» (Documentation VI, 17) – was mentioned in an anonymous sale in Amsterdam, July 13, 1718. The inconsistency in the spelling of Liss's name in just these four cited sales catalogues demands that we exercise caution in attributing works to Liss or Van der Lisse. So it remains uncertain whether any, all, or none of the paintings mentioned in reality refer to the Pommersfelden *Toilet of Venus.*

As Charles Sterling pointed out, Jacques Blanchard paid tribute to Liss's Venus paintings in *Bacchanale* [E 90] (Musée des Beaux-Arts, Nancy). A tambourine-playing nymph in the background, who appears in a flood of sunlight, corresponds very closely to Liss's nymph who holds the curtain over Venus. Blanchard could have seen the painting either in Rome, where he arrived in 1624, or in Venice, where he arrived in 1626.[13]

[1] E. Hamilton, *Mythology,* New York, 1942, p. 33.

[2] W. Brewer, *Ovid's Metamorphoses in European Culture,* Francestown, New Hampshire, 1949, p. 359.

[3] K. Clark, *The Nude,* New York, 1959, pp. 131–33. The comparison of Rubens' and Liss's nudes is underlined when one notes that although two inventories of the Uffizi, of 1753 and 1769, list their painting under its proper attribution, «Van Lys» and «Giovanni Van Lys» respectively, in 1784 it was changed to Rubens. In 1825 it appeared under the name of Jordaens, an attribution which remained unchanged until Bode visited the Uffizi (with Alexander von Frey) in 1912 or 1913 and recognized it immediately as a work by Liss.

[4] Oldenbourg, 1921, p. 9.

[5] See, e. g., Cornelis Cornelisz' *Bath of Bathsheba* painted in Haarlem in 1616 (Rheinisches Landesmuseum, Bonn).

[6] See Steinbart, 1940, pp. 89–95, where there are extensive discussions of inspiration for Liss's paintings.

[7] See the Braunschweig drawing of *Phaeton* [B 53], which most certainly documents Liss's knowledge of this or comparable images. Jordaens' *Judgement of Paris,* of ca. 1620–25, in the Samuel H. Kress Collection of the Lowe Gallery of the University of Miami, Coral Gables, Florida (M. Jaffé, *Jacob Jordaens 1593–1678,* exh. cat.; Ottawa, 1969, no. 32) (one of Jordaens' most self-consciously classical performances), shows that Northern artists had access to classical models without ever visiting Italy. Jordaens' painting probably goes back to a model similar to Marcantonio's engraving after Raphael.

[8] See F. R. Shapley, *Paintings from the Samuel H. Kress Collection, Italian Schools XVI–XVIII Century,* London, 1973, pp. 73–74, fig. 132.

[9] Albani's tondo is closely related to an intermediary version, following Annibale Carracci's, which Donald Posner suggests was done with the collaboration of Annibale Carracci. See Posner's *Annibale Carracci,* II, National Gallery of Art, Kress Foundation Studies in the History of European Art, London, 1971, p. 35, no. 85.

[10] One may wonder whether Pierre Brebiette's etching of the *Toilet of Thétis* (Bibliothèque Nationale, Paris) indicates an admiration for this very group in either Annibale's or Liss's works. Incidentally, Steinbart, 1940, p. 90, in his description of the nymphs in the Pommersfelden *Toilet of Venus,* mistook the nymph's rather large left hand for a hat. The nymph is actually holding two small flowers, ready to be braided into Venus' hair, together with a string of pearls.

[11] See Documentation VI for a complete listing of all the works involving Venus, Diana, and bathing women attributed to Liss.

[12] H. Mireur, *Dictionnaire des Ventes d'Art,* IV, Paris, 1911, p. 345.

[13] C. Sterling, «Peintres Jean et Jacques Blanchard,» *Art de France,* I, 1961, 93, fig 55.

Exhibitions: Rome, 1956–57: Il Seicento Europeo; cat. no. 186, pl. 59. – Nürnberg, 1952, cat. no. 7, illus. p. 137.

Literature: [J. R. Byss], *Fürtrefflicher Gemähld- und Bilder-Schatz,* Bamberg, 1719, no. 25. – *Beschreibung des ... Bilder-Schatzes ... deren Reichs-Grafen von Schönborn, Bucheim, Wolfsthal ...,* Würzburg, 1746, Audienzzimmer, no. 38. – [J. R. Byss], *Verzeichnis der Schildereyen in der Gallerie ... zu Pommersfelden,* Anspach, 1774, no. 199. – *Beschreibung des Fürtreflichen Gemähld- und Bilder-Schatzes ... in dem Hochgräflichen Schloss ... Weisenstein ob Pommersfelden ... deren Reichs-Grafen von Schönborn, Bucheim, Wolfsthal ...,* Aschaffenburg, n. d., no. 38. – *Katalog der gräflich von Schönborn'schen Bilder-Gallerie zu Pommersfelden,* Würzburg, 1857, no. 67 (Johann van der Lys). – Parthey, 1864, p. 64, no. 3. – Frimmel, 1892, pp. 34–35. – Frimmel, *Verzeichnis der Gemälde in gräflich Schönborn-Wiesentheid'schem Besitze,* Pommersfelden, 1894, no. 338. – Frimmel, 1901, p. 218. – Oldenbourg, 1914, p. 158, n. 2. – *Amtliche Berichte aus den preußischen Kunstsammlungen,* XXXIX, March 1918, pp. 113 ff. – Frimmel, 1922, pp. 54, 56. – W. Drost, *Handbuch der Kunstwissenschaft: Barockmalerei in den germanischen Ländern,* Potsdam, 1926, pp. 91, 95, 101, 107 119, 125. – Peltzer, in Thieme-Becker, XXIII, 1929, p. 286. – Steinbart, 1940, pp. 89, 90, 91, 163, pl. 35, and frontispiece (color). – Bloch, 1942, p. 49. – Steinbart, 1942, p. 176, illus. opp. p. 171 (color). – Steinbart, 1946, pp. 32–34, 46, 47, 56, 61, figs. 31–33, colorplate I. – Bénézit, 1952, p. 600. – Schilling, 1954, p. 34. – De Logu, 1958, p. 277. – Suida, 1958, p. 397. – Steinbart, 1958–59, pp. 182, n. 56, 185, 187, 189, fig. 36, 205. – Venice, 1959, exh. cat., p. 44. – Scheyer, 1960, n. 1, p. 12. – Paris, 1965, exh. cat., p. 173. – Donzelli and Pilo, 1967, pp 241–42, fig. 259 (detail). – Woeckel, 1967, p. 178. – J. Held and D. Posner. *17th and 18th Century Art: Baroque Painting, Sculpture, Architecture,* New York, 1971, pp. 103, 111, colorplate 10.

COPIES:

Dr. Robert Purrmann, Starnberg. Oil on canvas, 47,5 × 57,5 cm. (18[11]/16 × 22[5]/8 inches). Formerly Professor Purrmann, Langenargen. Comparing photographs of this painting with one of the painting formerly in the collection of Dr. Richter, Florence, seems to confirm Steinbart's (1940, p. 162) suggestion that the two are one and the same – a late and much abraded copy of the Pommersfelden *Toilet of Venus.* – *Academia de los Nobles Artes de San Carlos, Mexico City.* Oil on canvas, 87 × 68 cm (34[1]/4 × 26[3]/4 inches). *Tocador de Venus* (Inv. no. 308) is a signed copy after the Uffizi version, by Alberto Fuster, a Mexican painter and student of the Academy of San Carlos who died in 1930 (according to a letter dated August 27, 1974, from Teresa M. de Ruiz-Funes, Assistant Director of the Academy of San Carlos. (See Steinbart, 1940, p. 162 [as lost].) – *Formerly Dr. A. Grabowski, Berlin.* Measurements and whereabouts unknown. (See Steinbart, 1940, p. 161; Peltzer, in Thieme Becker, XXIII, 1929, p. 286, [lists it as a replica after the Uffizi version].) – *Formerly Leopold Peill, Düren.* Oil on canvas, 82 × 67 cm (32[5]/16 × 26[3]/8 inches). Whereabouts unknown. Exhibition: Düsseldorf, 1904, Kunsthistorische Ausstellung, cat. no. 339 (See Steinbart, 1940, p. 161.) – *Vienna, Art Market.* Whereabouts unknown (see Steinbart, 1940, p. 163). There are

photographs of two copies after Liss's *Toilet of Venus* in the files of the archives in The Hague: one is label-ed with the name K. Monred (Manred?) Nansen, Copenhagen, as the source of the photograph; the other, described as a «bad copy,» appeared on the Zürich art market in 1943.

<div style="text-align: right">A. T. L.</div>

A 29 AMOR VINCIT Fig. 29, Colorplate frontispiece

Oil on canvas, 87,7 × 65,7 cm. (34¹/₂ × 25⁷/₈ inches).

The Cleveland Museum of Art, Purchase, Leonard C. Hanna Jr. Bequest.

The painting was first published as a work by Liss by Morassi in the exhibition catalogue *Mostra della pittura del seicento in Liguria* held in Genoa in 1947; it was then on loan from the Genoese collector, Alessandro Basevi, the only known previous owner.[1] Bloch (1955) included the painting in his «Addenda to Liss»[2] with the suggestion that the paint-ing might have had a symbolic connotation stemming from Liss's notoriously Bohemian life.

Although this image of Amor recalls Caravaggio's *Amor Vincit* in Berlin [E 39] and re-veals Liss's familiarity with this master's early genre paintings such as the *Boy with a Bas-ket of Fruit* (Galleria Borghese) and the *Lute Player* (Hermitage [E 35], the *Amor Vincit* reveals yet another link between himself and Domenico Fetti. We know of no painting on this subject by Fetti, but Liss's painting may well suggest the existence of one, for it shares an unmistakable relationship with a drawing of *Cupid* by Fetti [E 36] in the Count Seilern collection (dated ca. 1618 on the basis of its obvious relationship to the *Guardian Angel* in the Louvre).[3] Fetti's *Cupid* and Liss's *Amor* both have curly hair, extended little fingers, one wing held high with only a small portion of the other one showing, and a long scarf elaborately draped over an arm. Both exhibit a certain youthful sweetness, and both are placed on a round base – Amor's of stone, Cupid's of clouds.

Bloch's hint of a symbolic connotation for the painting leads to a tempting hypothesis. Liss's nickname among the members of the «Schilderbent,» an association of Northern artists in Rome founded in 1623,[4] was «Pan,» after the close relative of Cupid. Are we dealing with an anthropomorphic self-portrait?

Disguised or undisguised, self-portraits were favored among the Caravaggisti in Rome who were inspired by Caravaggio's own striking examples. Since most of these were nar-cissistic in nature and were characterized by handsome physiognomies and a melancholic mood, they often show a remarkable sameness. Thus many a «Bacchus,» «Cupid,» or «Amor» – and even undisguised self-portraits – still await identification (for example, the anonymous *Apollo Coronato d' Accaro,* Museo Civico d'Arte Antica, Turin [E 37]).[5]

Unfortunately, we have neither portraits nor self-portraits by Liss to compare with the *Amor Vincit*[6] except for the early lute player in the *Painter in Her Studio* [A 1] in which Steinbart and Bloch[7] saw the young Liss, and the tucked-away, small-scale, indis-tinct face on the left side of the *Prodigal Son* [A 11, A 12], which several times has been suggested to be that of the artist. Liss's faces, like those of Rubens, all have a certain family resemblance; compared with these, *Amor* shows more distinct features and a cer-

tain portrait likeness. Moreover, the subject of the painting, like those in known self-portraits, has an attentive yet uncommunicative gaze and is modeled in the slightly diffused light typical of mirrored images. There is also the tucked-away hand,[8] the artist's right hand, with which he executed his work (in the mirror, and hence in the picture, it appears as his left hand). Amor holds the arrow in his right hand – a reflected left hand – as a painter would hold his «malstock.» The arrow draws attention to the brilliantly rendered drape over Amor's arm, arrow and drapery bringing into striking focus the two essential things in Liss's life – love and painting, so we are told by Sandrart. Cupid, Amor, or Johann Liss, the painting shows all the artist's stylistic earmarks.[9]

At the risk of falling into a bottomless pit with art historians who hear the grass grow, the reader is asked to stretch his imagination yet one point further; could not one decipher a *J. Liss* in the curled vine sparkling with highlights at the bottom of the painting?[10]

[1] Unfortunately, an inquiry addressed to the daughter of Alessandro Basevi yielded no further information as to the previous history of the painting (letter from Enrica Basevi, no date, received in 1972).

[2] Previously, Bloch, 1950, before he had seen the original, rejected Morassi's attribution.

[3] See A. Seilern, *Corrigenda and Addenda to the Catalogue of Paintings and Drawings at 56 Princes Gate, London SW 7*, London, 1971, p. 72, pl. LXXV.

[4] G. J. Hoogewerff, *De Bentvueghels*, The Hague, 1952, p. 139.

[5] See A. B. de Lavergnée and J.-P. Cuzin, *I Caravaggeschi Francesi*, exh. cat., Accademia di Francia, Villa Medici, 1974, no. 73.

[6] There is, however, mention of several portraits in early sources (see Documentation V).

[7] Bloch, 1942, p. 45, illus. p. 44. Steinbart (1958–59, p. 162 fig. 5) suggested that the lute player in the *Painter in Her Studio* also represents the young Liss at about twenty years old. See also Klessmann's suggestion that the young man seated on the bench in the Kassel *Banquet of Soldiers and Courtesans* [A 15] is possibly a self-portrait.

[8] See Vouet's *Bravo* in the Herzog Anton Ulrich-Museum in Braunschweig. Many artists avoided painting hands altogether.

[9] It is also typical in all technical aspects. A recent examination in our laboratory, including x-rays, gave us a clear idea of how Liss built up his painted surface. The report by Ross M. Merrill, Paintings Conservator of The Cleveland Museum of Art follows: The support is a single piece of plain woven brown linen fabric of moderately fine weight, with the tacking margins present along all four edges. The painting still has the original dimensions and it appears to be on the original four-member, single fork mortise stretcher. The warm brown ground layer is a single opaque layer of moderate thickness. The binder is estimated to be an oil-type. The ground fills the fabric but does not obscure the fabric texture. Large red agglomerates of an iron oxide earth in a matrix of warm gray-brown are apparent under the stereo-microscope. The oil-type paint was applied as an opaque brushmarked paste. Although the background is applied in a single opaque layer directly on the warm ground, the flesh tones and proper left wing were underpainted with a cool gray tone. The lighter, warmer fleshtones were thinly applied over this gray, resulting in cool half tones in the modeling of the flesh. The red drapery was underpainted in a very fluid manner with warm pink highlights and cool blue-green shadows. These cool shadow tones are composed of white lead, smalt, blue verditer, and yellow iron oxide earth. Over this underpaint, a thin transparent glaze of reddish-brown lake was applied in a rich oil medium. This transparent red glaze becomes much thicker in the shadow areas. The above pigments were identified by microscopic examination. The general application of the paint was a rapid, fluid procedure of brushing of wet paint into wet paint such as is evident in the raised proper right hand. Aside from moderate abrasions of the paint layer, especially in the background, the general condition of the painting is good. There are two large vertical tears through the original support in the upper right quarter which have been repaired in the old glue lining. Although the painting was retouched and revarnished before acquisition, there is an

incompletely removed, fragmentary yellowed varnish in the texture of the paint in some areas which alters the contrast of the painting and minimizes the subtle cool tones of the flesh.

[10] I am grateful for having been able to share this notion with other scholars who visited the Cleveland Museum. Similar curled vines illuminated with salmon-pink highlights are also found in the *Sacrifice of Isaac* in Venice [D5]. Rubens, copying Parmigianino, did an *Amor* (Alte Pinakothek, Munich, of 1614) sharpening an arrow, also with vine leaves in the background and curled vines on the ground. In the seventeenth century «cursive brush signatures» (either in full or with linked initials) became popular, particularly among painters in the Netherlands.

Collections: Alessandro Basevi, Genoa.

Exhibitions: Genoa, Palazzo Reale, 1947: Mostra della pittura del Seicento e Settecento in Liguria; cat. no. 146, illus. – Venice, 1959, cat. no. 63, illus. – The Cleveland Museum of Art, 1971–72: Year in Review 1971; catalogue, *The Bulletin of The Cleveland Museum of Art,* January 1972, no. 54.

Literature: Bloch, 1950, p. 282, n. 22. – Bloch, 1955, p. 324, n. 6, fig. 27. – Donzelli and Pilo, 1967, p. 241. – *La Chronique des Arts,* February 1972, p. 82, no. 290, illus. – *La Chronique des Arts,* July–August 1972, p. 9.

<div align="right">A. T. L.</div>

A 30 THE FINDING OF MOSES Fig. 30, Colorplate VI

Oil on canvas, 155 × 106 cm. (61 × 41³/₄ inches).

Musée des Beaux-Arts, Lille.

Among many stories from the Old Testament the finding of Moses (Exodus 2:5–6), in particular, gave artists free range to depict female beauty, oriental splendor, drama, and human compassion, all in an outdoor setting.

> And the daughter of the Pharaoh came down to wash herself at the river; and her maidens walked along by the rivers side: and when she saw the ark among the flags, she sent her maid to fetch it.
>
> And when she had opened it, she saw the child and, behold, the babe wept. And she had compassion on him, and said, This is one of the Hebrews' children.

Since the story carried a strong moral message, it became one of the favorite subjects of Counter Reformation painters.[1] Paolo Veronese (ca. 1528–1588) had left splendid renderings of the subject (Prado [E38], and also one in the Staatliche Gemäldesammlungen, Dresden) which helped inspire the magnificent painting by Orazio Gentileschi (of ca. 1630, now in the Prado) and, quite evidently, also the *Finding of Moses* by Liss. The work is a telling example of Liss's affinity for Veronese's richness of color. Like Veronese, Liss lavished his brushwork on the description of shimmering gold brocade, satin, and silk dresses. Scarfs billow and cascade from the shoulders and backs of his foreground figures, which he has described with his usual fondness for transluscent skin and undulating lines. Zigzag touches of yellow-gold highlights give vibrance to his colors and texture to his surfaces, simulating impasto. However, unlike Veronese and Gentileschi, whose brilliant colors and precious surfaces pervade the whole picture, Liss combines his with an earthy naturalism close to Jordaens. Dark and muted colors describe the rough clothes worn by the peasant women who appear in the shadowed middle ground. While the one group is

bundled up in the scarfs and wraps customary in northern climates, the bare shoulders and backs of Pharaoh's daughter and her companions reflect the warm Venetian sun. Both groups are bound together by their interest in the infant Moses, an adorable baby whose creamy-pink complexion is close to the coloring in Jordaens' work, and to the baby in Liss's earlier, Jordaenesque *Satyr and Peasant* [A 9, A 10]. Unlike Veronese's proud and erect daughter of the Pharaoh, Liss's lowers her head, her glance resting tenderly on the child. The group of women, like Venus and her nymphs in the *Toilet of Venus* [A 28], are anxiously preoccupied with what they are doing, a convention typical of Northern painting.[2] The intensity of feeling which pervades the whole group transforms their courtly outing into a scene kindred to Northern adoration scenes. Pharaoh's daughter, with her head slightly tilted and her face turned to the side, is reminiscent of Cleopatra [A 18]. Klessmann[3] convincingly points out that the same sitter may have been used for both paintings, suggesting a closeness in their dates, shortly after Liss's return from Rome ca. 1625. The hooded peasant woman behind the Pharaoh's daughter reveals Liss's continuing kinship with Jordaens even in this advanced stage. She is a recollection from such figures as Jordaens' *Magdalene* [E 26] of ca. 1616, a painting which Jaffé believes inspired Liss's composition of the Dresden *Decision of Magdalene* [A 17].[4] In the immediate foreground, Liss displays – as he so often does – one piece of drapery with his typical shell-like folds, rich in surface excitement. We find a similar rendering in the Cleveland *Amor Vincit* [A 29].

Although the catalogue of the Camille Rogier sale of 1896 states that *The Finding of Moses* (as by Bernardo Strozzi) once belonged to Count Algarotti, the Algarotti inventories of 1776 and 1780 list no *Finding of Moses* by Strozzi, Liss, or any other artist.[5] Oldenbourg (1914, 1921) saw a plausible comparison between the rustic types common to both painters, but he argued against the old attribution to Strozzi because of the lighter colors and smaller scale more typical of Liss. In the Lille catalogue of 1932, Leblanc again listed the work as by Strozzi. Steinbart listed the painting under wrong attributions and maintained that it was a work by Strozzi inspired by Veronese's *Finding of Moses* (Prado).[6]

The listing of a «quadretto con la rittrovata di Moisé nel fiume soaze intagliate dorate opera di Giovanni Liss» in the inventory of Giovan Maria Viscardi of 1674[7] indicates that a second, smaller version of the subject existed. A drawing somewhat reminiscent of Castiglione, in the British Museum [C 57] appears to be an early shorthand *ricordo* of the Lille painting.

[1] For some unexplainable reason, Pigler's very comprehensive and valuable book *Barockthemen* omits the subject altogether.

[2] A. T. Lurie, «Gerard van Honthorst: Samson and Delilah,» *The Bulletin of The Cleveland Museum of Art*, LVI, 1969, p. 342.

[3] Berlin, 1966, exh. cat. no. 46 (R. Klessmann).

[4] M. Jaffé, *Jacob Jordaens, 1593–1678*, exh. cat., The National Gallery of Canada, Ottawa, 1968–69, no. 7.

[5] Selva, *Catalogo dei quadri . . . della galleria del Sig. Conte Algarotti in Venezia*, Venice, 1776; Bartholomäi, *Beschreibung der Gräflich Algarottischen Gemälde- und Zeichnungs-Gallerie in Venedig*, Augsburg, 1780.

[6] Steinbart recently agreed orally with the attribution to Liss.

[7] Savini-Branca, 1964, p. 153; see Documentation I, 2.

Collections: Galerie Algarotti (?); Camille Rogier, sale, Hotel Drouot, Paris, May 26–28, 1896, no. 27 (as Strozzi).

Exhibitions: Valenciennes, 1918: Kunstwerke aus dem besetzten Nordfrankreich; cat. no. 212. – Ghent, 1950: Quarante chefs-d'oeuvre du Musée de Lille; cat. no. 29, pl. XXIV. – Berlin, Orangerie Schloß Charlottenburg, 1964: Meisterwerke aus dem Museum in Lille; cat. no. 28, illus. – Berlin, 1966, cat. no. 48.

Literature: J. Lenglart, *Catalogue des tableaux du Musée de Lille*, Lille, 1893, suppl. 3, no. 1139 (as Strozzi). – Oldenbourg, 1914, p. 159, fig. 13. – R. Oldenbourg, «An Unidentified Picture by Jan Lys,» *Art in America*, IV December 1915, p. 57. – E. Gavelle and P. Turpin, *Cent tableaux du Musée de Lille,* Lille, 1920, p. 12. – Bode, 1920, p. 176. – Oldenbourg, 1921, pp. 11, 16, pl. XIX. – Posse, 1925–26, p. 27. – Pevsner and Grautoff, 1928, p. 157. – Fiocco, 1929, p. 11. – Peltzer, in Thieme-Becker, XXIII, 1929, p. 286. – Hind, 1931, p. 151. – M.-L. Leblanc, *Le Musée de Lille collections publiques de France*, Paris, 1932, p. 27. – Pallucchini, 1934, p. 15. – Steinbart, 1940, p. 178. – Pallucchini, «Opere del Museo di Lilla esposte a Gand,» *Arte Veneta*, IV, 1950, p. 179. – Bloch, 1955, p. 324, fig. 24, n. 7. – De Logu, 1958, p. 277. – Bloch, 1966, p. 546, fig. 84. – Donzelli and Pilo, 1967, pp. 241–42, fig. 261, pl. V (color). – Ewald, 1967, p. 10. – A. Châtelet, *Cent chefs-d'oeuvre du Musée de Lille*, Lille, 1970, p. 47, no. 29, illus. p. 75. – Klessmann, 1970, p. 186.

A. T. L.

A 31 DAVID WITH THE HEAD OF GOLIATH Fig. 31, Colorplate VII

Oil on canvas, 161 × 121 cm. (63³/₈ × 47⁵/₈ inches).

Palazzo Reale, Naples.

Young David returns in triumph after killing the giant Goliath with a sling and stone, thus terminating the battle between the Philistines and the Israelites. In the painting by Liss, David is seen carrying the head of Goliath on the tip of his sword in the midst of the «Women [who] came out of all cities of Israel, singing and dancing . . . with tabrets, with joy, and with instruments of music.» [1]

Liss painted one other subject from the life of David, entitled *David Before King Solomon,* which appears in the 1674 and 1763 inventories of Giovan Maria Viscardi, Venice, along with a small version of the *Finding of Moses.* [2] Both are lost.

The *David with the Head of Goliath* is the third largest canvas in Liss's known oeuvre, [3] most likely commissioned by an important noble or patron of a church. The painting was first registered in the inventory of the Palazzo Reale in 1907 (as no. 171), among the «oggetti di privata spettanza di S.M. il Re» (at the time the reigning monarch was Umberto I di Savoia), as «Davide con la testa di Golia,» attributed to Andrea Vaccaro. An inventory of the House of Savoy in 1632 lists a *David* but without an attribution to a specific artist; the painting is described as «Davide con la testa di Golia di bona mano.» [4] It is not known when the *David* in Naples was acquired by the House of Savoy, or if it was actually commissioned by a member of that House.

According to Steinbart (1958–59), Sergi Ortolani changed the attribution from Vaccaro [5] to Liss in 1951. Undoubtedly, Vaccaro's name was attached to the painting because it

shared certain features with his two known compositions on the subject, one at the Musée d'Art et d'Histoire, Geneva, but especially with another in the collection of Baronessa Colleta de 'Peppe. [6]

The overall impression of Liss's *David* is totally different from Vaccaro's (in the Baronessa Colleta de 'Peppe collection). Liss has placed his two main figures compactly in the foreground of a vertical composition; Vaccaro spread a great number of figures out into a horizontal, dance-like arrangement. Nevertheless, the main figures in the two paintings bear a certain resemblance to their counterparts. In both paintings, the hero carries at the end of a long sword, the giant head of Goliath topped with bushy black hair, his face in profile. In both, David is met by one girl, who stands out through her special charm and grace and beautiful attire; Liss, however, shows her in front view, while Vaccaro turns her the other way. Both look at David. In both paintings, the daughters of Israel are silhouetted against dark, stormy clouds relieved with occasional glimpses of moonlight. The features shared by the two paintings may lead to a common source, that is, Lucas van Leyden's *David Entering Jerusalem with the Head of Goliath*, which, incidentally, once belonged to Rubens, [7] and was engraved by Saenredam [E 39]. [8] (In the case of Liss, at least, this connection does not come as a surprise. See his *Dentist* [A 2].) Van Leyden's figures, too, like Liss's and Vaccaro's, stand out against a dramatic, cloudy sky, and his David, too, is greeted by one of the girls as he carries a long sword with the dark-haired giant's head at the top.

By the time Liss painted his *David* he had been in Rome and in touch with the Caravaggisti. David's pose is a direct impression from Bartolomeo Manfredi's *Bacchus* [E 40] (Steinbart, 1958–59) in the Palazzo Corsini, though they are totally different in spirit – one is bucolic, the other lyrical. Like Manfredi's *Bacchus*, David holds his arm above his head. Both figures have a bare right shoulder (Liss was obviously intrigued by the subtly undulating shadows effected by this pose). And while the face of Manfredi's *Bacchus* appears in full light, exaggerating his satyric grin, David's face is withdrawn into the shadow cast by his arm and the giant's head, with only one fleck of light on his forehead. Ultimately, both figures go back to Roman statuettes of Bacchus and satyrs, [9] which Liss, like other Northern artists, could have known through engravings and drawings without ever going to Italy [E 41]. [10]

The slightly melancholic note in Liss's painting recalls Renieri's *David* [E 42], Galleria Spada in Rome, which is in turn indebted to Caravaggio. [11] Liss, who later was closely acquainted with Renieri in Venice, could have known this work. In both paintings David's figure is seen in three-quarter length, the head tilted slightly to the left, looking out to the spectator with an unfocused, sad gaze. Both paintings are distinguished by soft modeling and a lively pattern of light and shadow. But here the comparison ends for, although Renieri's *David* reveals the far stronger links with Rome and Caravaggio of Liss's *Amor Vincit* [A 29] in Cleveland, by contrast it brings into clear focus the Venetian elements in the *David*.

The young black servant proudly displaying David's golden slingshot, barely emerges from the mass of drapery spilling into the foreground. The red of his robe nearly matches his master's, and we catch sight of him only through the shimmer of his white satin lapel

and his shiny brass collar. He closely resembles the horror-stricken young black servant in the Munich *Cleopatra* [A 18]. The female figure holding a tambourine, belongs to Liss's family of *femmes fatales*, following his *Magdalene* [A 17] and his *Judith* paintings in date; like them, she has heavy eyelids, fleshy cheeks and lips, and a rounded forehead. The exuberant display of rich brocade and cascading drapery in the immediate foreground, and the female profiles in the back, reminiscent of Jordaens' peasant types, have their parallels in the *Finding of Moses* [A 30]. Although the compact crowding of figures in the foreground echoes not only the *Finding of Moses* but also earlier works such as the *Decision of Magdalene* and the *Satyr and Peasant* [A 9, A 10], the *David* bears witness to a maturing of Liss's Flemish Venetianism. His brush has gathered momentum, creating a surface of rich and vibrant colors, while his drapery curves in rhythms which anticipate the capriciousness of the rococo.

[1] I Samuel 18:6. The biblical description continues, showing how the women came to meet their king, Saul, but David stole the show: «The women answered one another as they played, and said, Saul hath slain his thousands and David his ten thousands. And Saul was very wroth, and the saying displeased him . . .» (I Samuel 18:7–8).

[2] Most likely not the large one in Lille [A 30]. Savini-Branca, 1964, p. 153.

[3] The largest is *St. Jerome* [A 39]; the second largest, the horizontal version of *Judith* in the Ca' Rezzonico [A 22].

[4] N. XI. A. 1632. Inventario dei quadri nel Palazzo del Duca di Savoja in Torino, in G. Campori, *Raccolta di Cataloghi ed Inventarii inediti . . .*, Modena, 1870, p. 83. The House of Savoy also patronized Simon Vouet (see A. Moir, *The Italian Followers of Caravaggio*, Cambridge, Massachusetts, 1967, p. 275) and Nicolas Regnier (or Renieri) whom Liss knew in Venice (see A. B. de Lavergnée and J.-P. Cuzin, *I Caravaggeschi Francesi*, exh. cat., Accademia di Francia, Villa Medici, Rome, 1974, p. 80).

[5] In view of the attribution to the Neapolitan painter, Andrea Vaccaro, one should take note of another early inventory listing – of the famous Ruffo collection of 1649: «Scuola napolitano, Il *David*, di palmi 8 e 5, regalato allo zio don Antonio del Priore di Bagnara . . .» (see *Bollettino d'Arte*, X, 1916, pp. 30, 36, and 42, no. 2).

[6] M. Marcangoni, «Un Domenichino di meno e un Vaccaro di più,» *Bollettino d'Arte*, I, 1923–24, 228 ff., illus. pp. 228 and 229.

[7] J. Denucé, *De Antwerpsche «Konstkamers,» Inventarissen van Kunstverzamelingen te Antwerpen in de 16e en 17e Eeuwen*, Vol. II: *Bronnen voor de Geschiedenis van de Vlaamsche Kunst*, Amsterdam, 1932, p. 64, no. 176. See article by Franz Wolter, «A Rediscovered Original Painting by Lucas van Leyden,» *Oud Holland*, XLIII, 1926, pp. 228–34.

[8] Bartsch, III, p. 254, no. 109 (dated 1600). Van Leyden himself engraved one other version of the subject (Hollstein 26) in which he focused on David and one girl. In that version, David carries the sword with one hand and holds the head of Goliath with the other.

[9] For example, compare the figure of Bacchus holding a bunch of grapes over his head (see *Katalog der Sammlung Antiker Skulpturen, Staatliche Museen zu Berlin*, IV, pl. 38, K. 153).

[10] See Hendrick Goltzius' drawing of the *Satyr of the Villa Albani* (Rome), in E. K. J. Reznicek, *Die Zeichnungen von Hendrick Goltzius*, I, Utrecht, 1961, no. 245, brought to my attention by R. Klessmann.

[11] R. E. Spear, *Caravaggio and His Followers*, exh. cat., The Cleveland Museum of Art, 1971–72, no. 53.

Collection: Umberto I, House of Savoy.

Literature: Unpublished Inventory of 1907 (mentions the painting for the first time among «ogetti di privata spettanza di S.M. il Re» [Umberto I of Savoy]). – Steinbart, 1958–59, pp. 204, 205, fig. 3. – Donzelli and Pilo, 1967, p. 242.

A. T. L.

A 32 THE DECISION OF HERCULES Fig. 32

Oil on canvas, 61 × 75 cm. (24 × 29⁹/₁₆ inches).

Staatliche Kunstsammlungen Dresden, Gemäldegalerie Alte Meister,
Deutsche Demokratische Republik.

No examples of the story of *Hercules' Decision* remain from classical art although we
find it fully described in Philostrates the Elder's *Vita Apollonii Tyanei* (A.D. third cen-
tury). Translated from Greek into Latin by Alemanus Rinuccinus in Venice and Florence,
edition of 1501, in English it reads as follows: «You have also at some time seen in paint-
ings the same account of the *Hercules* of Prodicus, a mere youth and unable to make
the choice, whom Virtue and Vice were striving to lay hold of and draw each to herself.
Now Vice was in fact adorned with gold and jewels, and gleaming moreover in purple
clothes and beauty of countenance, with her hair bound in various separate knots and her
eyebrows painted, wearing golden shoes, she advanced with pretentious and elevated
tread. But the other [Virtue] was like someone worn with toil, rough in appearance, far
gone in thinness and filth, with bare feet and wrapped in a mean garment, so that she
looked as if she would have been naked, if she had not recognized what modesty requires
in women.» [1]

It seems artists portrayed the three characters of the story from their own imagination,
and, lacking classical prototypes in paintings and sculpture, they drew upon other useful
images. The young Annibale Carracci, for example, borrowed his three protagonists
– including the seated Hercules receiving the Golden Apples [2] – directly from the *Relief
of Hesperides* in the Villa Albani for his *Decision of Hercules* [E 43] (now in the Museo
Nazionale in Naples) for the Camerino Farnese in 1595. Carracci's painting provided a
prototype which many artists were to consult, among them Liss: whose figure of Virtue
as well as the attributes of his Voluptas – masks and musical instruments – in his *Decision
of Hercules* are clearly indebted to Carracci's painting. Dal Pozzo's drawing [E 44]
after a relief of the story of *Bacchus and Ariadne* [3] also demonstrates how easily the
Mainad on the right of this frieze could be turned into a Voluptas, Bacchus into a Her-
cules, and Ariadne into the figure of Virtue. Like Dal Pozzo's Bacchus, Liss's Hercules
is standing, leaning with his left arm on a wooden club – instead of sitting, like Anni-
bale's. Liss has put Hercules' weight on the right foot, leaving the left foot free to take
the decisive step, but the charming Voluptas, whom Liss has substituted for Annibale's
statuesque figure, makes it convincingly difficult for Hercules to choose the right direc-
tion! Unwinding herself from silken covers, one foot out of bed, she beckons with a
beguiling smile, her right arm outstretched to emphasize her plea. [4]

Such figures as Voluptas in seventeenth-century paintings – with smiling faces, one foot
out of bed, and the other entangled in bedcovers – directly or indirectly depend upon
Caravaggio's *Amor Vincit* (Staatliche Museen, Berlin-Dahlem) [E 34]. Liss's own *Amor
Vincit* [A 29] confirms his knowledge of Caravaggio's painting.

The lost *Lucretia* by Simon Vouet, engraved by Claude Mellan in Rome [E 45] – stylisti-
cally very close to Vouet's *St. Catherine*, another lost painting engraved by Mellan in

Rome in 1625 – offers an interesting link between the *Amor* image of Caravaggio and Liss's figure of Voluptas, especially when seen in reverse.[5] Although Lucretia lacks the Bacchanalian spirit of Liss's figure (which one would expect considering the difference in their roles), she does have Voluptas' forward thrust and determination.

When the *Lucretia* and *St. Catherine* were painted, Vouet held the position of *Principe* of the Accademia di S. Luca in Rome. One would expect that young foreigners, whether affiliated with the Academy itself or, like Liss, with the «Schilderbent,»[6] would pay close attention to what Vouet was doing. On the other hand, while in Rome Vouet himself kept a very open mind to a great variety of influences, often bringing about a chameleon-like change in the style of his paintings. Compared with his weighty and severe Lucretia, the figure on the right in his *Allegory of Time Vanquished by Hope, Love and Beauty* (Prado), which he painted shortly before departing for Venice in 1627,[7] exhibits a gaiety that is even more Lissian than Liss himself would have portrayed it – a strong suggestion that the two artists were in touch and occasionally looked over each other's shoulders. Therefore, if Liss's Voluptas is a direct recollection of Vouet's original *Lucretia*, dating ca. 1624–25, we have found a convenient, if tentative, *terminus post quem* for Liss's departure from Rome.

The landscape with its hilly distance and dark screen of trees against which pearly whites of flesh and satin stand out, as well as the disposition of figures in a row near the front, their scale and unheroic stances, with heads coyly tilted – all reveal Liss's close contact in Rome with Northern landscape painters in the following of Elsheimer and Poelenburg. The work of Moyses van Uyttenbroek [E 46], who came to Rome in the early 1620's suggests itself most strongly for comparison.[8]

The theatrical masks and the disposition of the two main figures in Liss's *Hercules* still echo his earlier etching of *Cephalus and Procris* [B 51], while the Dresden painting reveals the widening gap between Haarlem and Italy. If the figures of Hercules and Virtue are rooted in Rome and Northern mannerism, Voluptas is an open declaration of Liss's love for Venice; she reminds one of Veronese's freshly bathed *Susanna* (Prado), although the roles are paradoxically reversed. Voluptas' Bacchanalian spirit is derived from Titian's painting of *Bacchus and Ariadne*, which was in the Aldobrandini Palace in Rome when Liss was there (it is now in the National Gallery, London). The sunlit palatial facade behind her often appears in Veronese's paintings (e. g., in one of the same subject as Liss's painting, *El Joven entre la Virtud y el Vicio*, Prado). But, above all, the very opulence surrounding her figure, the sensual effect of contrasting nude flesh and sumptuous stuffs, the exuberant display of pearly whites and luminous reds – vibrant with small dashes of highlights – all reflect the artist's growing affinity for the Venetian way of handling color and paint, and suggest a date soon after his return from Rome.

According to the Dresden inventories (listed as no. 696) between 1874 and 1945, the *Decision of Hercules* by Liss was acquired from the collection of Dr. Karl Lilienfeld in Dresden through exchange of a painting by Philips Wouverman – not, as Posse maintains,[9] from the London art market in 1925 and attributed to Adriaen van der Werff. Van der Werff did actually paint a *Decision of Hercules*[10] which was sold publicly in London in 1925, but his Hercules is seated and therefore not easily mistaken for Liss's.

[1] Translated from Latin into English by Professor Charles H. Reeves, Case Western Reserve University, Cleveland. See E. Panofsky, *Herkules am Scheidewege*, Studien der Bibliothek Warburg, Leipzig, 1930, p. 108, for the original Greek and Latin text. His book is a comprehensive study of the iconographical evolution of the subject.

In addition to the sixteenth-century translation of Philostrates' book, the Dutch poet Daniel Heinsius, alias Caspar Schoppe wrote two books on the subject, most likely based on the above literary source, one in 1608 – *Hercules tuam fidem* – the other in 1617 – *Satire due, Hercules tuam fidem* . . . (Both books are in the British Museum Library.)

[2] See Panofsky, 1930, fig. 66.

[3] Dal Pozzo Album I, British Museum, fol. 27, no. 27. See pl. XLV, fig. 104 in P. P. Bober, *Drawings After the Antique by Amico Aspertini Sketchbooks in the British Museum*, London, 1957, p. 77.

[4] The gesture of Voluptas' outstretched right arm is obviously a vestige from the original iconography as it is expressed in the Latin text: «adprehensum ad se trahere» (and draw [him] each to herself).

[5] W. R. Crelly, *The Paintings of Simon Vouet*, New Haven, 1962, p. 252, cat. no. 227, fig. 35. See also G. Dargent and J. Thuillier, «Simon Vouet en Italie,» *Saggi e Memorie di storia dell'arte*, IV, 1965, pp. 46–47, A 27.

[6] G. J. Hoogewerff, *De Bentvueghels*, The Hague, 1952, p. 139: «Lis (Liss or Lys), Jan alias Pan.» Hoogewerff suggests ca. 1625 for the end of Liss's Roman sojourn.

[7] Charles Sterling first suggested the stylistic resemblance of Vouet's *Allegory* in the Prado with Liss's work (letter, July 2, 1973).

[8] This suggestion was made independently by several scholars with whom I discussed the painting. See U. Weisner, «Die Gemälde des Moyses van Uyttenbroek,» *Oud Holland*, LXXVIII-LXXIX, 1963–64, pp. 189 ff.

[9] H. Posse, «Ein unbekanntes Gemälde des deutsch-venezianischen Malers Johann Liss in der Dresdener Gemäldegalerie,» *Zeitschrift für bildende Kunst*, N.S. LIX, 1925–26, pp. 24–27.

[10] A photograph is in the Rijksbureau voor Kunsthistorische Dokumentatie, The Hague. See C. Hofstede de Groot, *Beschreibendes und kritisches Verzeichnis der Werke der hervorragendsten holländischen Maler des XVII. Jahrhunderts*, X, 1928, p. 265. Dr. Lilienfeld owned another work attributed to Liss, entitled *Youthful Bacchanale with Donkey* which he acquired from Sir Henry Hosworth at Christie's in London on 14 December, 1923 (no. 103). Whereabouts are unknown.

Collection: Dr. Karl Lilienfeld, Dresden.

Exhibitions: Dresden, Albertinum, 1968: Venezianische Malerei 15.–18. Jahrhundert; cat. no. 54. – Kunsthaus Zürich, 1971: Kunstschätze aus Dresden; cat. no. 25.

Literature: Posse, 1925–26, pp. 24–27. – Pevsner and Grautoff, 1928, p. 157. – Fiocco, 1929, p. 79. – Posse, *Die Staatliche Gemäldegalerie zu Dresden, Katalog der alten Meister*, Dresden, 1930, cat. no. 1841 A. – E. Panofsky, *Herkules am Scheidewege*, Leipzig and Berlin, 1930, pp. 122, n. 2, 130, nn. 3–5, 131, pl. LI, fig. 76. – Posse, «Johann Liss, Herkules am Scheidewege,» *Deutsche Kunst*, V, no. 6, Bremen and Berlin, 1935–45, pl. 6a (color). – Steinbart, 1940, pp. 85–89, 161, pls. 32 and 33 (detail). – Bloch, 1942, p. 49. – Steinbart, 1946, pp. 31, 32, 34, 41, 45–48, 56, 61, pl. IV, fig. 29 (detail). – Bloch, 1950, p. 282. – Schilling, 1954, p. 34. – Pigler, 1956, II, p. 117. – Steinbart, 1958–59, pp. 181, 185, 186, 187, fig. 34. – *Gemäldegalerie Dresden Alte Meister*, Staatliche Kunstsammlungen Dresden, 1960, p. 55, no. 1841 A (English edition, 1968, p. 69, cat. no. 1841 A). – *Picture Gallery Dresden: Old Masters*, Dresden, 1962, p. 65, no. 1841 A. – Berlin, 1966, exh. cat., p. 53 (R. Klessmann). – Donzelli and Pilo, 1967, p. 241.

A. T. L.

A 33 MERRY COMPANY OUTDOORS (PRODIGAL SON ?) Fig. 33

Oil on canvas, 49,5 × 68,5 cm. (19¹/₂ × 27 inches).

Private collection, England.

In Netherlandish painting of the early seventeenth century, the subject of merry com-
panies in or out-of-doors was much in vogue in the North, where artists drew only a fine
line – or no line at all – between depictions of the prodigal son dissipating his inheritance
and scenes of pure genre. (See also the discussions under [A 12] and [A 15].) A typical
example, comparable to Liss's *Merry Company,* is the *Outdoor Party (The Prodigal Son?)*
by Gerrit Pietersz Sweelinck (1566-before 1616), in the collection of Sydney J. Freed-
berg. The inscription on the engraving by Cornelis Galle I (Hollstein 376) which cor-
responds closely to the painting[1] indicates that it is not meant to be a prodigal son but a
music party outdoors. However, the preparatory drawing (Herzog Anton Ulrich-Museum,
Braunschweig) for the painting includes in the background the expulsion of the prodigal
son. The engraving omits several figures that appear in the painting, most significantly
the tall couple linked together in mutual affection and wearing costumes different from
the others – are they the prodigal son and his female companion?[2] Is the couple in the
foreground in Liss's *Merry Company Outdoors* also the prodigal son and his lover?

Merry companies occur like a theme with many variations throughout Liss's stylistic
development. Because he uses figures and groupings interchangeably in these works, and
all of them strongly reflect their Haarlem background, it is extremely difficult to arrive
at a safe stylistic chronology. For example, the two seated couples on the left and behind
the table in the *Merry Company Outdoors* are close to those in the earlier Berlin drawing
of the *Merry Company with a Gallant Couple* [B 45] (which documents a lost painting
known through the San Francisco copy [E 92]). For another example, the main couple in
the present painting resembles the couple in the background of the later drawing, *For-
tuneteller* [B 50a].

Still closer parallels can be drawn between the *Merry Company* and Vienna's *Prodigal
Son* [A 12]. The sketchily rendered young servant boy on the right in the *Prodigal Son,*
resembles the even sketchier figure in the same spot in the *Merry Company Outdoors.*
A dog is at the feet of the main protagonists in the *Merry Company*; the *Prodigal Son*
has two dogs. The man seen in profile in both paintings (to the right of the main couple)
closely resembles his counterpart.

Stylistic ties also link the *Merry Company* and the *Temptation of St. Anthony* [A 37].[3]
Comparing these with the first *Prodigal Son* in the Uffizi [A 11] we note that Liss's man-
ner of execution has become even quicker, his modeling softer, and his brushwork more
fluid and open. Although the dressfolds of the woman seated in the foreground of the
Merry Company Outdoors are more tightly rendered than those of the young temptress
in *St. Anthony,* there are enough close parallels between the paintings to support the
arguments for Liss's authorship and for their proximity in date.[4] Both scenes take place
in an arbor-like enclosure with a landscape opening to the right. Although she is smaller
in scale, the young woman in the limelight of the *Merry Company Outdoors* – motioning

theatrically with one open hand and glancing upward with yearning – anticipates St. Anthony, who gestures widely with both hands opened, arms outstretched, and whose broad, strongly illuminated face looks imploringly to heaven. The faces looming from the shadow in the *Merry Company Outdoors*, with their mask-like grins, are not far removed from St. Anthony's satanical aggressors. Moreover, the lecherous expression on the face of the man behind the couple to the right in the *Merry Company Outdoors* makes him a perfect male counterpart to the witch-faced gypsy in the *Temptation of St. Anthony*. (He still looks like an ordinary chap in the *Prodigal Son*.)

Thus, the *Merry Company Outdoors* may be dated close to the second version of the *Prodigal Son* in Vienna and before the Cologne *Temptation of St. Anthony* – that is to say, from the artist's second Venetian period.

¹ «Tranquillam esepertes curarum ducere vitam . . .»
² *Dutch Mannerism. Apogee and Epilogue*, exh. cat., Vassar College, Poughkeepsie, New York, 1970, no. 95.
³ Unfortunately the *Merry Company Outdoors* has some serious restoration problems in the entire left background, and one must approach a study of the painted surface with considerable caution.
⁴ There is another similar composition of nude figures in a painting (*Bacchanale*, 35 × 26 cm, private collection, England) which Steinbart (1958–59, p. 203, fig. 1) published as by Liss. However, none of the exhibition committee members found Steinbart's attribution convincing.

Collections: Old Masters Galleries, Ltd., London; Julius Böhler, Munich; Brod Gallery, London.

Exhibition: Bregenz, Künstlerhaus, Palais Thurn und Taxis, 1965: Masterpieces from Private Collections; cat. no. 58, pl. VIII (color).

Literature: Weltkunst, October 1953, p. 3, illus. – Schilling, 1954, p. 37, n. 2. – Steinbart, 1958–59, p. 181, fig. 26. – Donzelli and Pilo, 1967, p. 242.

A. T. L.

A 34 THE CURSING OF CAIN

Fig. 35

Oil on canvas, 86,4 × 71,1 cm (34 × 28 inches).

M. Knoedler & Co., New York.

The story of Cain and Abel was traditionally represented in Northern art as a series of three works: the first, the slaying of Abel (Genesis 4:8); the second, Adam and Eve mourning for Abel (there is no biblical account of this); and the third, the cursing of Cain (Genesis 4:10–15).¹ Often several scenes were presented in one work, the main scene taking up the largest space in front, with other, smaller scenes in the background. Liss's *Mourning for Abel* [A 36] reveals his familiarity with Saenredam's engraving of the story, after Bloemaert, and most likely also with Jan Sadeler's three engravings, after Michiel Coxcie, which included *The Cursing of Cain* in addition to *The Mourning for Abel* and the *Slaying*. One may almost certainly assume that Liss also painted a slaying of Abel (which is now lost), to complete his cycle of the story.²

If he had, most likely it would have shown impressions from Titian's *Slaying of Abel* [E 47] in the church of S. Spirito (now in the S. Maria della Salute), where Liss conceived his idea for the *Sacrifice of Isaac* [A 35] after Titian's work on that subject. Liss's figure

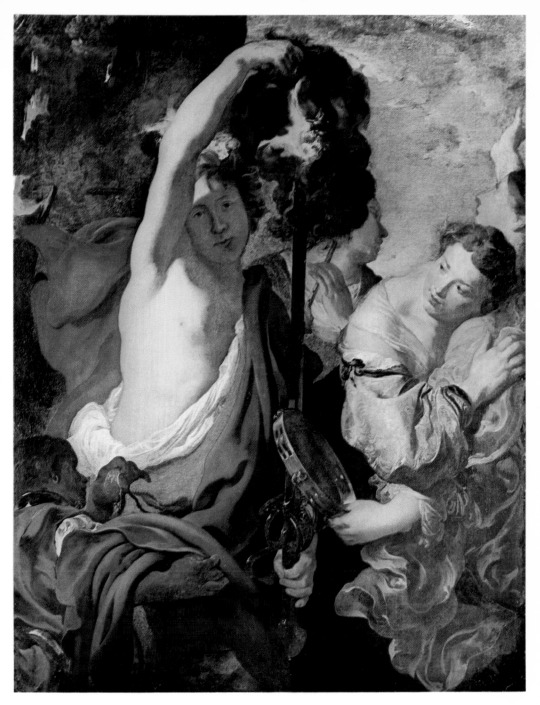

VII David with the Head of Goliath · Palazzo Reale, Naples [A 31]

of Cain in his *Cursing* unmistakably reflects Titian's own Cain from the *Slaying*.[3] Liss's version of the figure is charged with unresolved energy, its thrust expressing both the fury of the slayer and the horror of the damned. As if struck by a thunderbolt, Cain shields his eyes against the light and sight of God (we are reminded of the falling Phaeton holding his head [A 26]); with his other hand outstretched, he desperately implores mercy. Taking a giant step backwards, he stands with the full weight of his muscular body on the right foot, the left foot caught high in the air in mid-step. With the sudden movement his loin cloth has slipped, exposing his back; Liss has exaggerated the muscular strain and contortion. The frenzy of his pose closely resembles the figure of *Hercules Killing Cacus* [E 48] in the engraving by Hans Sebald Beham of 1545 (Pauli 102), which in turn is surprisingly close to a furious demon (in the reverse) in one of Rubens' early drawings for an engraving designed for the book *Vita Ignatii*, published in Rome in 1609.[4]

The figure of Abel belongs to another world. While on Cain's body we see both the reflected brightness of God and the blackness of the clouds below, Abel – just slain – lies in a pool of dazzling light that isolates him from the darkness surrounding his brother. The tree nearby forms a link between Abel and heaven. The ambitious pose and proportions of Liss's Abel recalls Michelangelo's nudes in the Sistine Chapel, especially the figure of Adam. Painted on the ceiling, the figures can be viewed from any angle. Thus Liss saw in Adam's pose the inspiration for his slain Abel; with an ingenious stroke of imagination he transformed Adam into Abel, slipping downhill headfirst, his legs propped against the slope at the same angle as Adam's. With just a small change the restful pose of Adam became one of helplessness and defeat for Abel.

God the Father cursing Cain, with his right arm raised in reprimand, was inspired by another figure in Michelangelo's ceiling which Liss saw right next to the *Creation of Adam,* God emerging from the clouds, dividing heaven from the waters with a gesture Liss was to adapt for his own painting.

This comparison with the Michelangelo figure is even more clearly demonstrated in the two copies now in the Pitti Palace and in the Schleswig Museum (see under Copies), where the figure of God is more clearly delineated than in this painting by Liss. It is possible, therefore, that Liss painted an earlier (larger) version in Rome, which may be documented by the copies in the Pitti Palace and in Schleswig (the latter has similar measurements).

At any rate, in the present small version, the figure of God emerging from sunstruck clouds, enveloped in a garment of intense purple, compares very closely with the diaphanous and luminous figure of Liss's angel in the *Sacrifice of Isaac* in Venice [D 5], and, like it, should be dated ca. 1626–27, at the beginning of the master's last Venetian phase.

[1] See the iconographical discussion under [A 36].

[2] A *Death of Abel* was included in the Seicento exhibition in Venice in 1959 (cat. no. 62, illus.) when the painting belonged to the Fiocco collection in Padua. Present whereabouts unknown. The attribution to Liss cannot be accepted without further careful study of the painting. A small tondo (24,1 cm. [9½ inches] in diameter) of a *Slaying of Abel* was offered on the London art market in 1965 as a work by Liss. While it could be based on a composition by him, the style does not resemble his. See *Apollo,* LXXXI, 1965, p. xlvi.

[3] It also inspired Rubens' Goliath in his *Slaying of Goliath* (Norton Simon Collection).

⁴ The Beham engraving was brought to my attention by Bushart. Concerning the Rubens drawing, see J. S. Held, «Rubens and the Vita Beati P. Ignatii Loiolae of 1609,» *Rubens before 1620*, ed. J. R. Martin, The Art Museum, Princeton University, 1972, p. 11, fig. 53.

Collections: Capt. Wentworth, Wentworth Castle, near Barnsley, York, England; David Koetser, New York; Walter P. Chrysler, Jr., New York.

Exhibitions: Venice, 1959, cat. no. 65. – Brunswick, Maine, Bowdoin College Museum of Art, 1963: Baroque Paintings from the Collection of Walter P. Chrysler, Jr.; cat. no. 15, illus. – New York, Finch College Museum of Art, 1964: Venetian Baroque Painters; cat. no. 15. – The Detroit Institute of Arts, 1965: Art in Italy; cat. no. 193, illus. – Norfolk, Virginia, Norfolk Museum of Arts and Sciences, 1967–68: Italian Renaissance and Baroque Paintings from the Collection of Walter P. Chrysler, Jr.; cat. no. 29, illus.

Literature: Donzelli and Pilo, 1967, p. 242. – Klessmann, 1970, p. 186.

COPIES:

Schleswig-Holsteinisches Landesmuseum, Schleswig. Oil on canvas, 90 ½ 72,5 cm. (35⁷/₁₆ × 28⁹/₁₆ inches). Formerly P. Cassirer until 1921 or 1923; Dr. H. Baer; Otto Wagner, Bern, until 1940; Helmut Zwez. Steinbart (1940, pp. 99 and 161, pl. 38) accepted the painting as by Liss, dating it from ca. 1623–24. While the painting is close to Liss's *Cursing of Cain* at Knoedlers, it lacks its subtle nuances of light and shade, the modeling, and the sparkling highlights. – *Palazzo Pitti, Florence.* Oil on canvas, 87 × 69 cm. (34¹/₄ × 27³/₁₆ inches). Judging from a photograph, the painting appears to be in poor condition, but it seems to have more of the mobility of light and shade, the vaporous quality of the clouds than the Schleswig verson, to which it is close in measurements. M. Cochin (*Voyage d'Italie*, II, Paris, 1758, part III, p. 81) mentions two paintings, both subjects of Liss, without knowing who painted them, in the collection of Marquis Capponi in Florence; one, *Apollo and Marsyas,* and opposite from it, «Cain et Abel & le Pere eternel interrogeant Cain: il est de bon ton & de bonne maniere quoiqu'indecis dans les formes.»

A.T.L.

A 35 SACRIFICE OF ISAAC

Fig. 36

Oil on canvas, 88 × 70 cm (34⁵/₈ × 27⁷/₁₆ inches).

Galleria degli Uffizi, Florence.

The drama and compositional complexity of a scene describing the last-minute descent of the angel who came from heaven to prevent Abraham from sacrificing his son Isaac (Genesis 22:1–13) presented a welcome challenge to the great spatial composers of the Venetian High Renaissance. Their powerful compositions in turn inspired a host of comparable paintings by Seicento artists both north and south of the Alps. Liss, like the young Rubens during his visit to Venice in 1600, must have stood spellbound below Titian's paintings on the ceiling of the church of S. Spirito [E 49].¹ The titanic thrust and daring foreshortening of Titian's figures – linked through dynamic interaction, dramatically silhouetted against a storm-torn sky – evidently inspired Liss to paint his own *Sacrifice of Isaac.* He painted two versions, a horizontal one for the Giovannelli family (now in the Accademia, Venice [D 5]) – a pendant to their *Mourning for Abel* [A 36] – and a vertical one that came from the legacy of Cardinal Leopoldo de Medici in 1675 (Guardaroba no. 826) and hung in one of the Medicean residences, the Villa di Poggio a Caiano in Florence, until 1836. Cosimo Mogalli (1667–1730) engraved it [E 93] for the Medici after the design of Francesco Petrucci (1660–1719), which may account in part for the many copies of this painting (see under Copies).

Both versions of the *Sacrifice* anticipate the mobility of brushwork, the color, and light in the slightly later *St. Paul* [A 38] and *St. Jerome* [A 39]; the figures of Abraham and the angel, especially in the Uffizi version, prepare, as it were, for St. Jerome and his angel in the Tolentino altarpiece. Although St. Jerome was inspired by Tintoretto's prototypes, Liss's figure of Abraham strongly recalls Rubens' Titian-inspired counterpart in his *Sacrifice of Isaac* [E 50] in Kansas City (Nelson Gallery and Atkins Museum) dating from 1614. [2] Liss's angel, too, was inspired by Rubens – particularly the angel appearing in the midst of his *Four Evangelists* (Sans-Souci), another early post-Italian work. [3]

Liss seems to have been intrigued with Rubens' *Sacrifice of Isaac*, especially by the way Abraham's arm was blocked in movement by the angel. He ingeniously adapted Rubens' device (inspired by Tintoretto's *Sacrifice* in the Scuola di San Rocco) to suit his own compositional needs: instead of crossing the angel's right hand over and in front of Abraham's arm, as Rubens did, Liss placed his angel in a face-to-face confrontation with Abraham, and in so doing thrust Isaac into the principal focal position. Abraham is turned to the side, creating a deep shadowed area in the center of the group to further dramatize the pallor of the terrified Isaac. Although Rubens' (and Titian's) Isaac is kneeling, Liss's is precariously seated on the altar with his hands bound behind his back, a placement that as Steinbart suggested (1958–59, p. 168, fig. 12) may have been derived from a similar figure in a *Sacrifice of Isaac* attributed to Ludovico Carracci [E 51], in the Vatican. The peculiar placement of the waiting ass, whose back is lined up with the low horizon on the right, recalls yet another Venetian prototype, Veronese's *Sacrifice of Isaac* (Prado).

The pathetic pose and the pallor of Isaac's youthful body especially impressed Liss's admirers, and it is not surprising to find similar representations in a number of eighteenth-century paintings of the same or comparable subjects. Thus, the figure of Iphigenie in Bencovich's *Sacrifice of Iphigenie* (Pommersfelden) and of Isaac in Piazzetta's *Sacrifice of Isaac* (Academy of Yugoslavia, Zagrabia) are undoubtedly indebted to Liss. [4] Indeed, Piazzetta has relied on Liss for the composition of two other versions of the *Sacrifice of Isaac* (one in London in the Owen Fenwich collection, the other in Dresden, Staatliche Gemäldesammlungen [E 96]). [5] As one would expect, Fragonard, one of Liss's admirers, not only faithfully copied in his drawing [C 65] the intriguing poses of Liss's three figures in the Florentine *Sacrifice*, but also delineated in chalk the independent and lively patterns of light and shade.

Although the divine presence could be symbolized by storm-torn skies, as in Titian's *Sacrifice of Isaac*, or by the mysterious shafts of light that penetrated Caravaggio's dark interiors, Liss felt that the radiance of sunlight could provide an even more glorious link between heaven and earth. His angel owes his visual existence to the sun that breaks through the clouds on which he descended, and the radiance of the angel envelopes the whole group in transparent shades of color. The angel's wings shimmer in pearly greys, pinks, and turquoise where touched by the sunlight. The blues and mauves in Abraham's garments and the sky on the right are balanced by subtle shades of vapory yellows in the clouds behind the angel. In the foreground, Liss has once again displayed an array of crumpled and cascading materials, carefully chosen for their texture and color, picking

up the predominant note of golden yellows and blues. Sunshine breaking through fast-drifting clouds forms shifting patterns of light and color that anticipate the mobility of Liss's *St. Paul* and *St. Jerome* and predict the jubilant spectacles of Tiepolo's sunny skies.[6]

[1] Since 1656 in the church of S. Maria della Salute.

[2] The painting was in Amsterdam from the very beginning and Liss could have been familiar with the original or the engraving by Andreas Stock (1580–1668). See R. T. Coe, «Rubens in 1614: The Sacrifice of Abraham,» *The Nelson Gallery and Atkins Museum, Bulletin*, IV, no. 6, December 1967, pp. 1–23, illus. between pp. 12 and 13 (color).

[3] One may speculate that Liss's lost *Lot and His Daughters* (see Documentation I, 3 and I, 4) also could have been inspired by Rubens' painting of the same subject and same period (see A. Rosenberg, *Rubens*, Klassiker der Kunst, Stuttgart, 1921, p. 105). It, too, included an angel which one could easily see transformed into a Lissian figure.

[4] Formerly also attributed to Bencovich. See R. Pallucchini, *Piazzetta*, Milan, 1956, pl. 14.

[5] The latter was at times attributed to the young Tiepolo; see Levey, 1956, pp. 86–88 and Pallucchini, 1934, p. 35.

[6] The figure of the angel in the horizontal version, in the Giovanelli collection before it came to the Accademia in Venice [D 5], carries Liss's color luminescence yet one step beyond that of his Florentine *Sacrifice*. Whereas in the latter painting the angel has actually arrived, in the Venetian version he is still swirling through the air at great speed with his arms outstretched like an eagle's wings, his garments totally integrated in the luminous vapors of the clouds. There seems little doubt that Giovanni Antonio Guardi (698–1760) was intrigued with this image; see his angel in the *Sacrifice of Isaac* [E 97] (The Cleveland Museum of Art), which supposedly was also in the collection of the Principe Giovanelli in Venice (see Levey, 1956, p. 86).

Collections: Cardinal Leopoldo de Medici (legacy of 1675); in the Villa di Poggio a Caiano in Florence until 1836.

Exhibitions: Florence, 1922, cat. no. 618.

Literature: Pieracchini, 1910, p. 161, no. 1052. – Oldenbourg, 1914, pp. 162, 163, 164, fig. 16. – Peltzer, 1914, p. 163. – Bode, 1920, p. 176, illus. p. 175. – Oldenbourg, 1921, pp. 12, 16, pl. XXIII. – Colasanti, 1921–22, pp. 28–29. – Zarnowski, 1925, pp. 94, 95, 96. – Peltzer, in Thieme-Becker, XXIII, 1929, p. 286. – Pallucchini, 1934, p. 35. – Giglioli, 1940, p. 27. – Steinbart, 1940, pp. 111, 113, 161–162, 166, pl. 43. – Steinbart, 1942, pp. 173, 176, illus. – Steinbart, 1946, pp. 37–3̍8, figs. 43, 44. – Golzio, 1950, p. 569. – Bénézit, 1952, p. 600. – R. Salvini, *The Uffizi Gallery: Catalogue of Paintings*, Florence, 1953, p. 93. – R. Salvini, *Musei e Pinacoteche: Uffizi*, Novara, 1954, p. 90. – Salvini, 1954, p. 93, no. 1376. – Pacchioni, 1955, p. 62. – Levey, 1956, pp. 86, 88. – Salvini, 1965, p. 100, no. 1376. – Woeckel, 1967, p. 178. – Donzelli and Pilo, 1967, p. 241, fig. 262.

COPIES:

Formerly Anna Moffo Sarnoff, New York, Oil on canvas, 86,5 × 71,5 cm. (34¹/₁₆ × 28¹/₈ inches). This painting was brought to my attention by Richard Spear at the time it belonged to the Lanfranchi-Moffo collection in Rome. It is a close and competent repetition of the *Sacrifice of Isaac* in the Uffizi, although the figures are slightly larger. Abraham's hand with the knife is skillfully reproduced, as is the exchange of glances between him and the angel. The sky on the right appears rubbed, even thought it was thinly painted originally – similar to the one in the Uffizi – allowing the red bolus ground to bleed through. – *Museum Bredius*, *The Hague*. Oil on canvas, 100 × 76 cm. (39³/₈ × 29⁹/₁₆ inches). Steinbart (1940, pp. 111 and 162) accepted this painting, which was acquired from the Amsterdam art market in 1937, as an autograph work by Liss, and, because of the pronounced chiaroscuro, dated it before the version in the Uffizi. He also claimed that the *Sacrifice of Isaac* from the collection of Mrs. Mewes, Berlin (present whereabouts unknown), was a slightly modified and inferior variant after the above (Steinbart, 1940, p. 11, pl. 42; on canvas, 77,5 × 95,5 cm. 30¹/₂ × 37⁵/₈ inches, formerly Friedrich Back, Darmstadt). Note that this is the only version or copy that has a broken tree stump in the right middle ground. In the Bredius painting, modeling of all

forms and figures is weak, and the foreshortening of faces is incompetently copied. The full foliage of the trees that frame the landscape opening on either side (resembling to some extent the tree branches in the Mogalli engraving) adds to the decorative effect of the painting, which is most likely an eighteenth-century copy after Liss. – *Museo Stibbert, Florence.* Oil on canvas, 38,5 × 31 cm. (15³/₁₆ × 12³/₁₆ inches), attributed to Giovanni Van Hus Hoorn (?). (See Giuseppe Cantelli, *Il Museo Stibbert a Firenze*, Milan, 1974, II, part 1, p. 74, no. 604; II, part 2, fig. 141.) – *German private collection.* Oil on canvas, 86 × 73 cm. (33⁷/₈ × 28³/₄ inches). The painting shows more pronounced contrasts of light and shade than the one in the Uffizi of which it is a copy. It seems related to the version formerly in the collection of Anna Moffo Sarnoff (compare the treatment of the clouds). The angel's right sleeve lacks the diaphanous quality of the original in the Uffizi. The artist has slightly altered the foreshortened face of the angel by turning his face further to the front. – *Formerly Barfüsserkirche, Augsburg.* Whereabouts unknown. Attributed to a member of the Spillenberger family (seventeenth century). This is a painted variant (see Steinbart, 1940, pp. 115–16), close to the Uffizi *Sacrifice*. Spillenberger went from Hungary to Augsburg via Venice ca. 1660 and remained in Augsburg from 1664 to 1671. His son, Johannes Melchior Spillenberger (whose exact dates are not known), made an etching [C 67] of Liss's Uffizi *Sacrifice*. – *Formerly Imperial Rumyantzov-Museum, Moscow.* Measurements and whereabouts unknown. Oldenbourg (1914, p. 164, n. 1) described it as an identical replica of the Florentine version. Zarnowski (1925, p. 96) dismissed it as an inferior variant. Judging from the photograph from the files of the Courtauld Institute, details, which are missing or indistinct in the Uffizi *Sacrifice of Isaac,* correspond closely to those in the engraving by Mogalli after Francesco Petrucci's design. Note, for example, the two lower buttons on Abraham's vest, the ass resting his nose on the tree, pronounced highlights on the piece of fabric, and the careful description of folds and creases in the foreground drapery, as well as the more distinct tree branch behind the angel. Since Petrucci copied paintings for the Grand Dukes of Tuscany on other occasions (see M. Gualandi, *Nuova raccolta di lettere sulla pittura ed architettura scritte de'pui celebri personaggi dei secoli XV–XIV con note ed illustrazioni,* III, Bologna, 1844–56, pp. 113–14, and 126, n. 3), and because the painting is close to the engraving for which he supplied the design, it is quite possible that Petrucci painted this, or even some of the other copies, after the *Sacrifice of Isaac* in the Uffizi.

A. T. L.

A 36 ADAM AND EVE MOURNING ABEL'S DEATH

Fig. 34

Oil on canvas, 67,5 × 89 cm. (26⁹/₁₆ × 35¹/₁₆ inches).

Galleria dell'Accademia, Venice.

Sandrart's description of this small painting revealed his appreciation for its inherent poetry and the simple seriousness with which Liss had told the story. Three lonely figures are seen in a landscape, Adam and Eve, old and alive, and Abel, young and dead. (Only very sketchily on the right is another figure, Cain, fleeing into the distance.) Without pathos, Adam and Eve express bewilderment and grief over their son's death. Their rough clothes, their old and weathered faces and bent backs offer a startling contrast to the pale young body of Abel, who lies stretched out before them. A warm orange glow illuminates the faces af Adam and Eve, while Abel's reflects the pale yellow light that follows sunset. In the foreground, to the right is a large pumpkin plant with three fruit, their number matching the tragic threesome on the left; the leaves and fruit of this plant are fast growing and perishable, symbolic of the brevity of life.[1] In the hilly distance two tall cypresses (often used to symbolize mourning) stand against a sky aglow with the light of the setting sun. The whole landscape expresses the stillness that follows death.

The unusual iconography of the scene – not recorded in Genesis but described later in a pseudepigraph (Steinbart, 1940, p. 103 n. 196) – had a well-established tradition in Netherlandish art. Lucas van Leyden included it among a series of six plates depicting the history of *Adam and Eve*, dating from 1529 (Hollstein 6). Saenredam, too, engraved six scenes of the *Story of Adam* after Bloemaert, one of which was the *Mourning for Abel* [E 52] (Hollstein 6).[2] In turn Jan Sadeler copied these and engraved six plates of the *History of Cain and Abel* (Hollstein 14–19), after Michiel Coxcie (1499–1592), among them the *Lament of Adam and Eve over Abel's Body*. Coxcie also depicted the story in a tapestry and in a painting closely related to it in the Prado,[3] which Rubens copied in two drawings, *Cain Cursed by the Lord* (British Museum) and *Abel Slain by Cain* (Fitzwilliam Museum, Cambridge).[4] Of these depictions Liss certainly knew Saenredam's engraving of the *Mourning for Abel*, on which his grouping of the three figures depends. The pose of Abel, on the other hand, reveals Liss's awakening interest in heroic nudes of the High Renaissance, such as Tintoretto's slave in the foreground of his *Miracle of St. Mark* [E 54] (Venice, Accademia). There is also a striking resemblance between the pose of Liss's Abel and his counterpart in Ruben's Cambridge drawing of 1604 [E 53], after Coxcie.[5]

The crumpled clothes and soft turban, the scale and stance of Liss's Adam and Eve, reveal the artist's affinity for Fetti's work (see, for instance, Fetti's *Multiplication of the Fishes*, Palazzo Ducale, Mantua, and *The Workers in the Vineyard*, [E 22] Staatliche Kunstsammlungen, Dresden). Both artists shared an admiration for Elsheimer's landscapes with figures: Liss's charming *Venus and Adonis* [A 25] painted on copper, clearly shows his knowledge of and fondness for this master's *Death of Procris*. Similarly, the *Mourning for Abel* recalls the simple poetry of Elsheimer's *Good Samaritan* [E 55] (Louvre).[6]

The painting, which is a pendant to the horizontal *Sacrifice of Isaac* [D 5], was engraved by Pietro Monaco [E 100] when both were in the possession of the Giovanelli family in the mid-eighteenth century.[7] No other version is known except for the painting in the collection of Dr. Schäfer, Obbach, which once belonged to Dr. Capparoni in Rome (see under Copies).

Sandrart described the *St. Jerome* in the church of S. Nicolò da Tolentino [A 39], and immediately thereafter described this work, *Mourning for Abel;* it could, therefore, be interpreted that this painting, too, was in that church. «Wie alda» («also there»), translated by Houbraken into «als ook» («as also») led Fokker (1927) to believe there had, indeed, been a *Mourning for Abel* in that church and that it was probably the one belonging to a private collector in Rome (he did not mention his name). Fokker believed further that the painting in Venice was a «gewijzigde copie» after the one from Rome. Oldenbourg (1914), unaware of another version, assumed Sandrart was referring to the painting in the Giovanelli collection, although he felt it gave the impression of a quickly dashed-off replica of an earlier version – like the *Sacrifice of Isaac*,[8] also in the Giovanelli collection. Steinbart (1940) suggested that, because of its more pronounced chiaroscuro, the *Mourning for Abel* formerly in the collection of Dr. Capparoni preceded the Giovanelli version, although he admitted that the former was poorly preserved and inferior by comparison.

The sketchy quality of the two pendants in Venice suggests a slightly later date than the *Sacrifice of Isaac* in the Uffizi [A 35]. The clouds, fused with sunset colors, lend a mood to the painting and reveal Liss's admiration for the warm, glowing skies that illumined the fleshtones of Titian's figures.[9] Liss's clouds, like wind-rippled water, vibrate through continuous shifts of luminosity, the warm yellows and orange-reds relieving the cool twilight down below.

[1] Similar fruits (*curcurbita* in Latin) are mentioned in the Bible twice, once in Numbers 11:5, once as a nourishment of the Israelites when in Egypt and, secondly, in Jonah 4:6–7, where the Lord made a gourd grow to give shade to Jonah, but it soon withered because of a worm in the fruit. A pumpkin serves as a lamp in Dürer's engraving, *Der heilige Hieronymus in der Zelle*. Another later example is Jan Wynant's *Vertumnus and Pomona*, signed and dated 1679 (Coll. Victor Spark, New York, in which a large pumpkin grows in the foreground.

[2] This included a distant scene of the Offerings of Cain and Abel (Genesis 4:3–5).

[3] There attributed to Frans Floris (?). See A. F. Calvert, *The Spanish Royal Tapestries*, London and New York, 1921, pl. 129.

[4] L. Burchard and R.-A. d'Hulst, *Rubens Drawings*, I, Brussels, 1963, pp. 58–60; and II, pls. 32 and 33.

[5] Brought to my attention by Klessmann; see also Burchard and d'Hulst, *op. cit.*, p. 59. A similar pose is given the dead Phaeton in the foreground of the Braunschweig drawing by Liss [B 53].

[6] The left foreground group of Elsheimer's *Good Samaritan* is similar to the figures in *The Good Samaritan* by Ribera, once in the Palais Ranuzzi, Bologna, which was copied by Fragonard in a drawing formerly in Washington (see R. T. Coe, «A Problem in Ribera Studies: The Good Samaritan,» *The Nelson Gallery and Atkins Museum Bulletin*, IV, no. 12, 1971, pp. 1–14). Ribera also painted a *Mourning for Abel*, formerly in the Ruffo collection, now lost (see *Bolletino d'Arte*, X, 1916, p. 313). The painting, if found, could reveal interesting cross-references between Ribera's and Elsheimer's *Good Samaritan* paintings and Liss's *Mourning for Abel*. Incidentally, Elsheimer's *Good Samaritan* also resembles Carlo Saraceni's *Good Samaritan* (Museum für Bildende Künste, Leipzig). Saraceni was born in Venice in 1585 and early in life (ca. 1602–1604) went to Rome where he was in close touch with Elsheimer. He returned to Venice in 1618 and he died there in 1620.

[7] The engraving brings out details which are no longer clearly visible in the painting such as the wood pile on the rock in the left background, the large wide-brimmed hat behind Adam and Eve, the tree stump (no doubt alluding to the slain figure of Abel right next to it). The fleeing Cain, too, is more easily discernible, and the pumpkins on the right have been brought into startling prominence. The engraving is slightly lower on top and extends more to the left than does the painting.

[8] Oldenbourg (1914, p. 164, n. 2) mentions a *Mourning for Abel*, presumably from the collection of Cardinal Leopold de 'Medici in the Pitti Palace (brought to his attention by Dr. Poggi, director at that time). This was most likely the picture attributed to Carlo Loth, related to Liss's *Mourning* from the collection of the Grand Duke Ferdinand of Tuscany, since 1698 in the inventory of the Pitti Palace and since 1773 in the Uffizi.

[9] Steinbart (1940, pp. 107–108, fig. 45) suggested that Liss's interest in skies reflects his familiarity with paintings by Lodewyck Toeput (ca. 1550–ca. 1603–5).

Collection: Family of Prince Giovanelli, Venice.

Exhibitions: Florence, 1922, cat. no. 622, pl. 108. – Venice, 1946, cat. no. 268, illus. – Venice, 1959, cat. no. 59, illus.

Literature: Sandrart, 1675, (ed. 1925) p. 187. – Weyerman, 1729, p. 403. – Descamps, 1753, p. 264. – *Blätter vermischten Inhalts*, 5, Oldenburg, 1792, pp. 505, 516. – G. Nagler, *Allgemeines Künstler-Lexikon*, IX, Munich, 1840, n. 43. – Immerzeel, 1843, p. 181. – Blanc, *Manuel d'histoire de l'art*, III, 188, n. 169. – H. de Groot, 1893, p. 143. – Frimmel, 1901, p. 215. – Oldenbourg, 1914, p. 164. – Bode, 1920, p. 176. – Oldenbourg, 1921, p. 17. – Colasanti, 1921–22, p. 28. – Frimmel, 1922, pp. 53, 54. – M. Nugent, *Alla Mostra della pittura italiana del '600 e '700*, exh. cat., San Casciano Val di Pesa, I, 1925, pp. 69, 72. –

Fokker, 1927, p. 204. – *Mostra di capolavori della pittura olandese*, exh. cat., Rome, Galleria Borghese, 1928, p. 58. – Fiocco, 1929, p. 20. – Peltzer, in Thieme-Becker, XXIII, 1929, p. 286. – G. Fogolari, *Le R. Gallerie dell' Accademie di Venezia* (Itinearo dei Musei e Monumenti d'Italia), Rome, 1938, pp. 9, 15. – Steinbart, 1940, pp. 102, 109, 163, 169, pl. 40. – Steinbart, 1942, p. 173. – Houbraken, 1943, I, p. 162. – Steinbart, 1946, pp. 34, 36, 37, 47, 61–62, fig. 40. – Marconi, 1949, p. 58. – Golzio, 1950, p. 569, fig. 607. – F. Valcanover, *Gallerie dell' Accademia di Venezia*, Novara, 1955, p. 122, illus. – De Logu, 1958, pp. 144, 277. – Steinbart, 1958–59, p. 199. – Bloch, 1950, p. 282. – V. Moschini, *The Galleries of the Academy of Venice*, 6th edition (Guidebook to the Museums and Monuments of Italy, no. 40), Rome, 1958, pp. 12, 23. – Pallucchini, 1960–61, p. 16. – L. Burchard and R.-A. d'Hulst, *Rubens Drawings*, Brussels, 1963, p. 61. – Donzelli and Pilo, 1967, pp. 241–42. – Marconi, 1970, pp. 42–43, fig. 91.

COPIES:

Georg Schäfer, Schweinfurt. Oil on canvas, 104,5 × 95 cm. (41¹/₈ × 37⁷/₁₆ inches). Formerly Dr. Capparoni, Rome (see Steinbart, 1940, pp. 102 and 163, pl. 39). This painting appears throughout most of the Liss literature as an autograph version preceding the horizontal one in the Accademia [A 36]. Parallels have been drawn to the horizontal *Sacrifice of Isaac* in the Accademia for which there also exists a vertical version [A 35]. After a recent careful examination, the painting proved to be a horizontal copy after the one in the Accademia, which was cut on the right, changing it from a horizontal to a vertical composition.

A.T.L.

A 37 THE TEMPTATION OF ST. ANTHONY Fig. 37

Oil on copper, 23,3 × 17,8 cm. (9³/₁₆ × 7 inches).

Wallraf-Richartz-Museum, Cologne.

St. Athenasius' *Vita Antonii*, popularized by the *Golden Legend*,[1] has provided artists since the Middle Ages with rich material for scenes from the life of St. Anthony. The visit of St. Paul the Hermit and the temptation of St. Anthony were among the favorites. Two great early sixteenth-century Northern masters, Matthias Grünewald (ca. 1470/80–1528) and Hieronymous Bosch (died 1516), left powerful examples of St. Anthony's temptation which were to haunt the imaginations of generations of later artists. Liss could actually have studied two renderings of Bosch in Venice in the possession of the famous collector Giovanni Grimani,[2] as well as any one of the many Bosch-inspired versions of the *Temptation of St. Anthony* by David Teniers the Elder (1582–1649). The young temptress on Anthony's left in Liss's painting appeared as early as 1509 in an engraving by Lucas van Leyden [E 56] (Hollstein 139). Her presence adds carnal temptation to the torment inflicted by the demons. Tintoretto's *Temptation of St. Anthony*, in the church of S. Trovaso in Venice – and thus accessible to Liss – also combined the tormenting by demons with the carnal temptation.[3]

Like Liss, Tintoretto depicted the scene described in the *Legenda Aurea* (Vol. XXI, p. 1) in which St. Anthony, close to despair in his attempts to ward off his demonic attackers, perceives a bright ray of light emanating from heaven in which Christ appears to reassure him that he has not been forsaken. While Tintoretto – as well as Annibale Carracci in his *Temptation of St. Anthony* [E 57] (National Gallery, London), which may also have been known to Liss – represented Christ's physical presence, Liss represented the divine intervention symbolically with a beam of light that magically fills the dark enclosure,

focusing on the saint's face and on the young temptress, bringing out with sparkling highlights monsters' eyes and teeth and the cross on St. Anthony's lap. The broad, soft face of the saint is bathed in the heavenly light; his look and gesturing hands anxiously implore the help of Christ. St. Anthony is the spiritual center of the picture; his extreme confidence and human warmth convincingly disarm his aggressors, who become mere spectators of the divine miracle. Behind the temptress entering from the right, a burning city is visible in the distance, the rising smoke coloring the sky blackish purple.[4]

The young woman who interrupts Anthony's studies and contemplations visually links this painting with other depictions of saints absorbed in writing or reading but interrupted by the entrance of an angel. Caravaggio's first *St. Matthew* [E 65] (lost, formerly Kaiser-Friedrich-Museum) began the tradition and such scenes grew in popularity, extending to other saints as well (see Liss's *St. Jerome* [A 39]).

Steinbart (1958–59, p. 186) drew a convincing parallel between Liss's young woman and Caravaggio's angel in his *Rest on the Flight to Egypt* [E 58] (Galleria Doria Pamphili), but visually – in looks, manner, and dress – St. Anthony's temptress is most closely related to the figure of *Helen of Troy* [E 59] painted by Liss's teacher Hendrick Goltzius in 1615 (collection of Mr. and Mrs. David G. Carter, Montreal).[5] The saint, on the other hand, in type and gestures, is reminiscent of Honthorst's ascending *St. Paul* in the church of S. Maria della Vittoria in Rome, the painting cited earlier for comparison with the Berlin *St. Paul* [A 38].

In spite of Liss's increasingly quick brushwork and the exuberance of his colors, particularly in describing the young temptress, the jewel-like quality of this small panel and the sparkling light of the scene, contrasted with the dense mossy greens and browns, reflects Liss's lasting kinship with Elsheimer, whose small works were also painted on copper. The luxuriance of nasturtium reds[6] in the drapery of the young woman recalls the intensity of the colors surrounding the young Voluptas in Liss's *Decision of Hercules* [A 32], which dates from the years close to his return from Rome, ca. 1625–26.

The work was acquired in 1937 from the Vienna art market. Robert Eigenberger first attributed it to Liss in 1930,[7] a conclusion which Benesch (1933) arrived at independently when he saw it on the Vienna art market (in a 1951 *Burlington Magazine* article he discussed it among Liss's late works). Bloch (1955) included it among Liss's oeuvre. Steinbart (1940, p. 177) at first rejected the attribution, but in 1958–59 (p. 186) counted it among Liss's works of the mid-1620's.

Since all existing copies of the *Temptation of St. Anthony* (see under Copies) basically repeat the Cologne picture, and since no variant has been found in which the saint is depicted bald-headed, Sandrart may have been thinking of St. Paul [A 38] when he described a bald St. Anthony. Until another version fitting Sandrart's description turns up, we may assume that the Cologne picture, unquestionably a very fine work by Liss himself, is the one he described.

[1] Réau, 1958, p. 108.
[2] O. Logan, *Culture and Society in Venice 1470–1790*, London, 1972, p. 156.
[3] Note that Tintoretto's temptress also brings gold and jewels with her (Réau, 1958, p. 109).
[4] The burning city could be symbolic of the presence of hell.

⁵ Liss's transformation of a figure of Helen of Troy into St. Anthony's temptress suggests an interesting parallel between the temptation of St. Anthony and the temptation of Dr. Faustus by Helena and Mephistopheles. The drawing (now in Rijksprentenkabinet, Amsterdam) by Adriaen Matham (born 1599 in Haarlem, died 1660 in The Hague) visually proves this close relationship between the two subjects (see P. Leendertz, Jr., «Nederlandsche Faust-Illustratie,» *Oud Holland*, XXXIX, 1921, pp. 130 ff., illus. p. 132). According to Leendertz, the drawing was inspired by one of the scenes in Marlowe's *De Hellenvaart van Doktor Faustus*, which English actors *(toneelspelers)* brought with them to the Netherlands and Germany. Unfortunately, the date of the drawing is not known.

ᴶ Even though darkened by retouchings in the garment and the red scarf of the temptress, the similarity is clear.

⁷ Dossier on file at the Wallraf-Richartz-Museum.

⁸ Descamps (1753), curiously enough, speaks of several subjects representing the *Temptation of St. Anthony*, but his account is very chatty and is merely based on the earlier accounts of Sandrart and Houbraken, neither of whom mention several versions.

Collection: Vienna art market, 1937.

Exhibitions: Cologne, Wallraf-Richartz-Museum, 1937: Neuerwerbungen deutscher Künstler 1933–37; cat. no. 21. – Berlin, 1966, cat. no. 47, fig. 40.

Literature: Sandrart, 1675, (ed. 1925) p. 187. – Weyerman, 1729, p. 404. – Descamps, 1753, p. 264. – Frimmel, 1909, p. 116. – Bode, 1920, p. 176. – Benesch, 1933, p. 71, no. 625. – *Gemälde-Galerie, Wegweiser und Verzeichnis*, Wallraf-Richartz-Museum der Hansestadt, Cologne, 1938, p. 64. – O. H. Förster, «Wallraf-Richartz-Museum der Hansestadt Köln,» *Wallraf-Richartz-Jahrbuch*, X, 1938, p. 267. – *Die Gemälde der altdeutschen Meister*, I, Wallraf-Richartz-Museum der Hansestadt, Cologne, 1939, p. 93, illus. – Steinbart, 1940, pp. 129, 171, 177, 178. – *Meisterwerke aus den Kölner Museen und der Württembergischen Staatsgalerie Stuttgart*, Tübingen, 1946, no. 31. – *Meisterwerke aus neun Jahrhunderten*, Stuttgart, 1948, p. 80, illus. – Bloch, 1950, p. 282. – Benesch, 1951, pp. 376, 379, fig. 10. – Schilling, 1954, p. 37, n. 2. – Bloch, 1955, p. 323. – Pigler, 1956, I, p. 416. – *Führer durch die Gemäldegalerie*, Wallraf-Richartz-Museum, Cologne, 1957, p. 74. – Steinbart, 1958–59, pp. 159, n. 3, 185, 186, fig. 31. – *Verzeichnis der Gemälde*, Wallraf-Richartz-Museum der Stadt, Cologne, 1959, p. 98. – *Verzeichnis der Gemälde*, Wallraf-Richartz-Museum der Stadt, Cologne, 1965, p. 98. – Woeckel, 1967, p. 178. – Donzelli and Pilo, 1967, p. 241. – *Katalog der deutschen Gemälde von 1550 bis 1800 im Wallraf-Richartz-Museum und im öffentlichen Besitz der Stadt Köln*, Wallraf-Richartz-Museum der Stadt, Cologne, 1973, p. 60, no. 2592.

COPIES:

National Picture Gallery, Athens (acquired through bequest of a private collection in 1911). Oil on copper, 25 × 22 cm. (9⁷/₈ × 8⁵/₈ inches). This painting was brought to my attention by Pierre Rosenberg. The attribution to Liss was made by M. Lebel of the Louvre (letter from Dr. Dimitrios E. Papastamos, August 21, 1973). It lacks the crispness and sparkle of the Cologne panel which it copies closely. Like the other two copies, the painting stems from a Northern admirer who shared Liss's affinity for Elsheimer but had trouble with Liss's Venetian touch. (See *Katalog der deutschen Gemälde von 1500–1800 im Wallraf-Richartz-Museum und im öffentlichen Besitz der Stadt Köln*, Cologne, 1973, p. 60.) – *Bayerische Staatsgemäldesammlungen, Munich* (inv. no. 6759). Oil on wood, 24 × 19 cm. (4⁷/₈ × 7¹/₈ inches). This is a reduced copy after the Cologne version, attributed to Nicolaus Knüpfer (born in Leipzig in 1603, died in Utrecht in 1660). – *Bayerische Staatsgemäldesammlungen, Munich* (inv. no. 6010). Oil on copper, 24 × 18 cm. (9⁷/₈ × 7¹/₈ inches). The painting is attributed to a copyist of Rubens' work after the Cologne painting. – *Formerly Frau Soyka, Baden near Vienna.* Oil on paper, mounted on canvas; measurements and present whereabouts unknown. According to Benesch (1951, p. 377), this is a second version, slightly larger and earlier in date than the painting in Cologne. (See R. Klessmann, in Berlin, 1966, exh. cat. no. 47.) – *Formerly Weenen collection* (sale, Dorotheum, Vienna, September 9–10, 1948, no. 27, illus. as by Ambrosius Francken). Whereabouts unknown. Oil on copper, 23,5 × 18,5 cm. (9¹/₄ × 7¹/₄ inches). Perhaps this is the same one mentioned in the *Katalog der Handzeichnungen der Albertina: Die Deutschen Schulen*, Vienna, 1933, p. 71.

A. T. L.

A 38 ECSTASY OF ST. PAUL Fig. 38, Colorplate VIII (detail)

Oil on canvas, 80 × 58,5 cm. (31¹/₂ × 23¹/₁₆ inches).

Staatliche Museen Preussischer Kulturbesitz, Gemäldegalerie, Berlin.

While most Seicento artists such as Domenichino, Poussin, and Honthorst depicted St. Paul tall and robust, with bushy hair and beard, being carried to heaven by angels,[1] Liss portrayed him seated in a chair, old and bald (though also bearded), overcome by the vision of his own ascension into heaven. Liss's interpretation is probably more in keeping with the saint's own description of the event (II Corinthians 12:1–4) in which he tells the story in the third person as though it had happened to someone he knew.[2] Liss's characterization, too, more closely resembles St. Paul's description of himself, according to which he was small, puny, with rheumy eyes and an aquiline nose.[3]

In Liss's painting, St. Paul, engaged in his studies, looks up, suddenly stricken by the vision and sound coming from above: «How that he was caught up into paradise and heard unspeakable words, which it is not lawful for a man to utter» (II Corinthians 12:4). The unspeakable words arrive at St. Paul's ears as heavenly music from a chorus of angels. As in the two paintings of the *Toilet of Venus* [A 28, D 4], a curtain is drawn, this time by an angel, revealing a veritable *Barockhimmel* (baroque heaven).[4] Awestruck by the sound and light, gesturing with his index finger as though straining to hear, St. Paul has dropped his book, and in leaning back in his chair, his robe has slipped off his left shoulder (Liss never missed a chance to expose one, young or old). The pale skin and fine wrinkles gleam in the light from above, which also brings into focus a beautifully modeled ear and the bony structure of his bald head.

Not long before Liss's arrival in Rome, Honthorst had painted his *Ecstasy of St. Paul* [E 60] for the church of S. Maria della Vittoria; the angelic chorus in the Honthorst painting may have nourished Liss's inspiration for his own musician angels.[5] In the upper left, emerging from sun-drenched clouds, appear the figures of Christ (clad in a robe of light pink), God the Father (with a turquoise-colored globe), and, hovering over them, the Holy Dove. (A similar Trinity group is portrayed in Cigoli's *Stoning of St. Stephen* in the Pitti Palace.)[6] Kneeling before the Trinity with his back bent low is the figure of St. Paul; barely visible in the painting, the figure is more clearly defined in the engraving after the painting by Jeremias Falck [C 63], as well as in an anonymous eighteenth-century drawing after *St. Paul* [E 102]. The angel on the left plucking the strings of his cittern, has the strength and conviction of comparable figures by Rubens, which also tune and play instruments (see, for example, one of the *Musician Angels* [E 61] in the Liechtenstein collection, dating from ca. 1611–13).

The history of Liss's *St. Paul* is sketchy, but it obviously was caught up in the maelstrom of art moving from Venice to Amsterdam during and after Liss's lifetime. Many art treasures from Venice – including the present painting, the *Banquet of Soldiers and Courtesans* [A 15] as well as a large part of the famous Vendramin collection – were acquired by the two brothers Gerrit and Jan Reynst who were wealthy merchants and art collectors from Amsterdam and kept in close touch with Venice.[7] On one of the pages

of the Gerrit Reynst collection catalogue is the *St. Paul* engraved by Jeremias Falck.[8] Other than the appearance of the painting in the Van de Amory sale in Amsterdam on 23 June 1722,[9] and its rediscovery by Alexander von Frey[10] at an English art dealer's in Florence, ca. 1913 (Bode, 1919) no other provenances are known.

The *St. Paul* was first published by Oldenbourg (1914) and has been accepted by subsequent scholars as an autograph work by Johann Liss of ca. 1627–29, close in style to the *Vision of St. Jerome* [A 39]. No other version of the painting is known.

Another of Falck's engravings, the *Dream of St. Peter* [C 64] in the catalogue of the Reynst collection has been the subject of considerable scholarly debate because of stylistic similarities to Liss's *St. Paul*. According to the inscription added later, the *Dream of St. Peter* was also done after a painting by Liss. There is, however, no doubt that the engraving is closely related to a painting by Domenico Fetti of the same subject [E 62], known to us through the drastically cut version in the Kunsthistorisches Museum in Vienna. Some believe the *St. Peter* documented in the Falck engraving and the Berlin painting of *St. Paul* were pendants or companion pieces. Klessmann (1971) suggested that after Fetti's death in 1623 his patron may have asked Liss to paint the *St. Paul* as a companion picture to Fetti's *St. Peter*, but Van Gelder (1937) dismisses the idea of pendants because of the difference in the scale of the two saints.

A comparison with Fetti's *Dream of St. Peter* in Vienna reveals undeniable evidence linking the engraving with another copy or version by or after Fetti.[11] The major difference between the *St. Peter* engraving and the Fetti painting is the setting; in the painting, St. Peter sits on a terrace or rooftop; in the engraving he sits in a landscape.[12] This is explained by a study of pentimenti in the painting, which reveals some of the features of the Falck engraving and leads to the conclusion – accepted by many scholars – that Fetti painted an earlier version. It was this version, rather than the one in Vienna, that was documented by the Falck engraving. If Falck did engrave his *St. Peter* after a painting by Fetti, why then do the faces of his angels so closely resemble those in Liss's painting of *St. Paul*? The Vienna painting offers no clues, for the faces of the angels are cut off. Van Gelder offered the suggestion (emphatically rejected by Steinbart, 1940, p. 172) that the earlier version of *St. Peter's Dream*, which is documented by the Falck engraving, may have been painted by Liss, who may have copied Fetti's (Vienna) painting while it was temporarily in Venice in ca. 1627.[13] If we accept this argument, how then do we account for the change in setting from the rooftop with ballustrade to the landscape? Is it possible that Liss knew the earlier version by Fetti and copied that?[14] Pamela Askew actually found another version of a *Dream of St. Peter* by Domenico Fetti listed in the collection of Cardinal D'Este in Rome in 1624.[15]

A typical Lissian mannerism in the *St. Peter* engraving supports the argument that Liss actually painted a *St. Peter*: the widely spread index finger and thumb of one of the angels is an echo of St. Paul's gesture in the painting. Still, if Liss did paint a *Dream of St. Peter*, it does not necessarily follow that the two paintings were pendants. The similarities, nevertheless, indicate that the *St. Peter*, inspired by Fetti, in turn inspired the painting of *St. Paul*. When we compare Liss's *St. Paul* and *St. Jerome*, we note even stronger compositional resemblances than those linking his *St. Paul* with the *St. Peter*

engraving. In both paintings our eye is led into the composition from below, across a front stage scattered with props, to the main figure on the right, to the angel diagonally across from him, over and up to the group of angels on the right, going further and deeper into the mass of clouds enlivened with putti. *St. Paul* and *St. Jerome* share a Correggesque crescendo of light; in both, figures and forms are conceived in color and light, decreasing in solidity as they move towards the lights of heaven. In both, iridescent silks and satins vibrate with zig-zag dashes of yellow and salmon pink highlights. If color can describe the beauty of Paradise, Liss has done that in his painting of *St. Paul*. From the dark purples and ink blues in the foreground, to opalescent sea-greens, to tender hues of lavender and pink, to a vast range of ochre-yellows and yellow-whites, his colors increase in luminosity until dissolving in a burst of light in the upper left where the Holy Trinity is revealed. Significantly, in a later state of Falck's engraving (see [C 63] state II) God and Christ, who played too prominent a part in the earlier print were replaced by a bright sun which the small figure of St. Paul is left to worship. Thus a transcriptive print was made into one that was interpretive of Liss's painting in which the radiance of the sun plays such a prominent role. No wonder Fragonard was attracted by these two late paintings by Liss, the *St. Jerome* and *St. Paul*, whose heavenly visions virtually anticipated his own in *Dream of a Warrior* [E 101] (Louvre) of nearly a century and a half later.

Except for the previously mentioned drawing by an anonymous master of the eighteenth century there seems to be no copy of this impressive painting.

[1] Domenichino's and Poussin's *St. Paul* in the Louvre; Honthorst's in the S. Maria della Vittoria, Rome.

[2] Biblical scholars agree that when Paul says «I knew a man . . . [who was] caught up to the third heaven,» his is speaking of himself. He does not want to boast, as he says later in the chapter, except in his infirmities, because it is through his weakness that God's strength is made manifest in him.

[3] Also see Réau, 1958, pp. 1038–39.

[4] See B. Bushart (*Der Barocke Himmel*, exh. cat., Stuttgart, 1964, pp. 9–11) who elaborated on the importance of the celestial sphere in Southern Baroque paintings.

[5] See also comparison between *St. Paul* and Liss's *St. Anthony* under [A 37].

[6] Cigoli's painting inspired Rubens' own rendering of the subject in Valenciennes, which Liss could have known before leaving Antwerp.

[7] E. Jacobs, «Das Museo Vendramin und die Sammlung Reynst,» *Repertorium für Kunstwissenschaft*, XLVI, 1925. One other important Dutch art collector residing in Venice in Liss's time was Daniel Nys, who negotiated the large sale of the Gonzaga collection to Charles I of England in 1627–28. Another collector, one of Van Dyck's patrons, the wealthy Luc van Uffel, also lived in Venice. Sandrart visited and admired his collection in Venice in 1627–28, prior to its transfer to Holland before and after Van Uffel's death (1637). See *Bulletin de l'Institut historique belge de Rome*, Ier Fascicule, Rome, 1919, pp. 178–79 and 205.

[8] Gelder, 1937, p. 91, n. 4: *Variarium imaginum a celeberrimis artificibus pictarum caelaturae, elegantissimis tabulis representatae. Ipsae picturae partim extant apud viduam Gerardi Reynst . . . Amstelodami, Nr. 18.*

[9] Hoet, 1752.

[10] During a visit with Bode to the Uffizi, Frey admired the *Toilet of Venus* [D 4] so much that he decided to acquire a Liss painting of his own. Shortly thereafter he purchased the *Ecstasy of St. Paul*, now in Berlin.

[11] *Katalog der Gemäldegalerie*, part I, Vienna, Kunsthistorisches Museum, 1965, pp. 52 and 53.

[12] Van Gelder, *op. cit.*, p. 93, suggests that Fetti in his second version adhered more strictly to the iconography of the story, according to which St. Peter climbed to a rooftop of a house in the city of Joppe where he supposedly had his dream of the unclean animals (Acts 10:9–12).

[13] Gelder, *op. cit.*, p. 92. Fetti's painting was in the house of the Flemish art dealer Daniel Nys in

Venice in 1627–28, coinciding with Liss's stay there. It was one of the many paintings the Duke of Mantua sold to Charles I of England (See Gelder, p. 91).

[14] It is interesting to note that the lower part of Falck's *St. Peter* engraving resembles two of Ribera's etchings of 1621: the *Penitence of St. Peter* and the *Poet* (both in the British Museum). The latter also is related to Fetti's *Melancolia* in the Louvre in which there is a dog strongly resembling the one in Fetti's *St. Peter* in Vienna.

[15] Mrs. Askew was kind enough to send me a copy of her entry on the *St. Peter* panel from her forthcoming monograph on Domenico Fetti in which she cites G. Campori, *Raccolta di cataloghi ed inventarii inediti,* Modena, 1870, p. 68.

Exhibitions: Florence, 1922, cat. no. 617. – Nürnberg, 1952, cat. no. N 8. – Berlin, 1966, cat. no. 49, illus.

Literature: G. Hoet, *Catalogus of Naamlyst van Schilderyen,* I, The Hague, 1752, p. 264, no. 82. – J. Wussin, *Conrad Vischer,* Leipzig, 1865, pp. 273, no. 18 (?), and 274. – Nagler, 1907, p. 132. – Oldenbourg, 1914, p. 162, fig. 15. – Peltzer, 1914, p. 163. – E. Plietzsch. «Die ‹Ausstellung von Werken alter Kunst› in der Berliner Kgl. Akademie der Künste,» *Zeitschrift für bildende Kunst,* N. S., XXV, 1914, p. 232, illus. (as *Vision of St Peter*). – Bode, 1919, pp. 3–5, fig. 1. – Bode, 1920, p. 176, illus. – Oldenbourg, 1921, p. 12, pl. XXII. – A. Morassi, «Dipinto sconociuto di Giovanni Lys,» *L'Arte,* XXV, 1922, p. 117. – Buberl, 1922, p. 27. – Morassi, 1923, pp. 115, 117. – Ojetti, Dami, Tarchiani, 1924, p. 189, illus. – W. Weissbach, *Die Kunst des Barock in Italien, Frankreich, Deutschland und Spanien,* Berlin, 1924, p. 50, pl. XXV (color). – Zarnowski, 1925, pp. 93, 95, 96. – Posse, 1925–26, p. 27. – Pevsner and Grautoff, 1928, pp. 157, 158. – Peltzer, in Thieme-Becker, XXIII, 1929, p. 286. – Fiocco, 1929, p. 20. – Gelder, 1937, pp. 91–95, fig. 3. – Steinbart, 1940, pp. 126–28, 161, 168, pls. 50–51. – Steinbart, 1942, p. 176, illus. p. 178 (detail). – Bloch, 1942, p. 50. – Steinbart, 1946, pp. 41, 43, 46, 47, 57, 62, 63, figs. 50–51, colorplate VI. – Golzio, 1950, p. 569. – Bénézit, 1952, p. 600. – Pigler, 1956, I, p. 392. – De Logu, 1958, p. 144. – Steinbart, 1958–59, pp. 186, 197, 198, fig. 48 (detail). – I. Kühnel-Kunze, «New Old Masters for the Picture Gallery» (transl. M. Kay), *Apollo,* XXC, 1964, p. 108. – R. Klessmann, »Ein neues Werk des Johann Liss in der Berliner Gemälde-galerie,» *Nordelbingen,* XXXIV, 1965, p. 83. – Paris, 1965, exh. cat., p. 173. – Bloch, 1966, p. 546, fig. 86. – Ewald, 1967, p. 10. – Woeckel, 1967, p. 178. – Donzelli and Pilo, 1967, p. 241. – R. Klessmann, *The Berlin Museum,* New York, 1971, pp. 188–89, illus. – E. Reynst, «Sammlung Gerrit und Jan Reynst,» unpublished dissertation, n. d., pp. 7, 13, no. 16, 20, nos. 11 and 12. – J. B. Knipping, *Iconography of the Counter Reformation in the Netherlands,* II, Nieukoop, 1974, p. 436.

A. T. L.

A 39 VISION OF ST. JEROME

Fig. 40, Colorplate IX

Oil on canvas, 225 × 175 cm. (88⁹/₁₆ × 68⁷/₈ inches).

S. Nicolò da Tolentino, Venice.

It is not surprising that an altarpiece for a church in Venice would feature St. Jerome – the subject of Liss's only known altarpiece in Venice in S. Nicolò da Tolentino. One of the four Fathers of the Latin Church, this prominent saint was born in Stridon, a town near Venice, in 347. He wrote the life of St. Paul the Hermit, among other subjects, during his three years in the Syrian desert, and, before his death in Bethlehem in 420, translated the *Vulgata.*[1] In the sixteenth century the city of Venice founded a *scuola* in St. Jerome's name,[2] for which Tintoretto was commissioned to paint the two key pictures; one, *The Virgin Appearing to St. Jerome* (now lost), was engraved by Agostino Carracci [E 63].[3] Liss obviously knew and admired Tintoretto's painting in the *Scuola di S. Girolamo,* for it inspired his own composition. But the idea of the lion serving the saint as a

footrest (to prove their complete confidence in each other) was derived from yet another painting of *St. Jerome* by Tintoretto [E 64], known to us through the version in the Kunsthistorisches Museum in Vienna. [4]

Like many Seicento artists, Liss treated the subject of St. Jerome freely, making use of the imagery provided by the *Golden Legend* [5] and by the iconography prescribed by the Bolognese scholar Giovanni di Andrea (Johannes Andreas) in his book *Hieronymianus*, written in the fourteenth and published in the sixteenth century. [6] Liss, in his painting, combined three major roles of St. Jerome: the penitent in the desert (hence the rugged outdoors, the body with only the loins covered, the skull); the scholar absorbed in studies (hence the books and quill); and the Doctor of the Latin Church (hence the cardinal's purple and hat). The saint is traditionally shown with a lion, who according to the legend, came to live with him in the desert after he had pulled a thorn out of his foot. Liss expanded his iconography to include an angel drawing St. Jerome's attention to another angel about to blow the «last trumpet.» The image of a saint engaged in scholarly pursuits, visited by an angel, became extremely popular after Caravaggio painted his first *St. Matthew with an Angel* [E 65] (formerly Kaiser-Friedrich-Museum, Berlin, now lost), a painting which also must have made its impression on Liss. Including an angel with a trumpet, as Ribera did in his two versions of *St. Jerome,* shows once again that Liss knew Ribera's etchings [E 66] of the early 1620's. [7]

In style, the *St. Jerome,* together with *St. Paul* [A 38], predict in full measure what the eighteenth-century Venetians and their followers were to bring to fruition. Even though St. Jerome's weighty and muscular figure firmly holds its ground, his diagonal thrust and upward glance lead swiftly heavenwards where forms and colors become increasingly buoyant and vibrant. Even though St. Jerome's wrap is of the traditional cardinal's purple, its brilliance is dulled by pale shadows which also absorb foreground details, including the beautiful lion. Modeled with great skill, the lion's head and mane were described with a very soft and wet brush, much like Goliath's head on David's sword (see [A 31]).

Liss's *St. Jerome* in the church of S. Nicolò da Tolentino never left its original site. In all the guidebooks from 1664 [8] on it was mentioned for its beauty, and it became the most widely admired and copied work in his oeuvre (see Copies). When Sandrart arrived in Venice, ca. 1628, the painting was already *in situ,* but judging from its advanced style, it could not have been painted earlier than 1627. Steinbart (1958–59) suggested that the Netherlandish painter Nicolas Regnier (ca. 1590–1667), whom Liss knew (Sandrart, p. 25), may have been instrumental in securing for Liss the commission for the church of Tolentino – dedicated to Nicolò, Regnier's name saint – for which Regnier, himself, had painted a *St. Kajetan.* Unfortunately, no documents support this tempting hypothesis.

The version in the Museo Civico di Vicenza [D 6] has long been considered a *bozzetto* for the altarpiece in Venice (most recently Mariacher [1971] referred to it as an autograph *bozzetto* by Liss), but scholars do not all agree that it is. Oldenbourg (1914, p. 162) considered it a replica by Liss, although criticizing its somewhat compressed and confusing chiaroscuro. Steinbart (1940, pp. 135–37) used Oldenbourg's criteria for dating the painting slightly earlier than the large altarpiece in Venice, suggesting a date of ca. 1624–25.

He dismissed the idea of a *bozzetto*, believing that the version in Dublin [A 40] (nearly twice the size of the Vicenza version) preceded the final painting in Venice and may have given the Fathers of the church of Tolentino the idea for their commission.

Pietro Monaco's engraving of the mid-eighteenth century, after Liss's *St. Jerome*, contributed largely to the widespread knowledge of the painting. Another eighteenth-century artist who admired the *St. Jerome* was Fragonard; his etching of the subject [E 103] (it is hoped his drawing will be found some day) was made during his visit to Venice in 1761 and was, in turn, copied in an etching-aquatint by Saint-Non [E 104], who traveled with Fragonard in Italy.

The paintings listed under Copies do not include variants such as Giulia Lama's *Vision of St. Jerome* (Galeria Campori, Modena),[9] although it, too, is a work directly inspired by Liss's *St. Jerome*. Nor does the list include those paintings that have borrowed isolated elements from Liss's painting, such as Maffei's *Glorification of Alvise Foscarini* [E 105], in the Pinacoteca, Vicenza (Steinbart, 1940, pp. 139–41, fig. 64), in which the angel, though seen in reverse, echoes Liss's angel to the left of St. Jerome. Nor does it include those works by eighteenth-century Venetians whose own saints visited by angels leave no doubt that Liss's *St. Jerome* served as one source of their inspiration – for example, Sebastiano Ricci's *St. Peter Freed from Prison* [E 106] in the church of S. Stae in Venice.

[1] Réau, 1958, p. 740.

[2] G. Moschini, *Guida per la città di Venezia*, I, 1815, pp. 40 ff.

[3] *Ibid.*, p. 629. In February and March 1975 the Herbert E. Feist Gallery, New York, exhibited a drawing (no. 20) after the engraving which was attributed to Giulio Cesare Procaccini.

[4] H. Tietze, *Tintoretto*, London, 1948, pp. 379–80. Liss's *St. Jerome* recalls yet another saint by Tintoretto, *St. Anthony*, from the altarpiece in the church of S. Trovaso in Venice (see also under *St. Anthony* [A 37]). Note that the version of *St. Jerome* [D 6] in the Museo Civico di Vicenza was listed as «copia dal Tintoretto» in the *Inventario dei dipinti di proprieta del comune di Vicenza esistenti nella Pinacoteca Comunale, alla data del 14 Novembre 1854*, no. 63.

[5] *Legenda Aurea*, compiled and put into form about 1275 by Jacobus de Voragine, Archbishop of Genoa.

[6] Réau, 1958, p. 742.

[7] J. Brown, *Jusepe de Ribera, Prints and Drawings*, exh. cat., Princeton, 1973, pp. 92–93, figs. 4 and 5. See also *Apollo and Marsyas* which was inspired by Ribera's etching of *St. Bartholomew* [E 29] Note: Vouet in his *St. Jerome and the Angel* (Samuel H. Kress Collection) went yet one step further in the iconographical fusion; he has the angel who visits St. Jerome bring his trumpet with him.

[8] Boschini, 1664, p. 384; 1674, pp. 34 and 57.

[9] R. Pallucchini, «Di una pittrice veneziana del settecento: Giulia Lama,» *Rivista d'Arte*, V, 1933, pp. 410–11 fig. 8.

Exhibitions: Florence, 1922, cat. no. 616, pl. 61. – Venice, Procuratie Nuove, 1945: Cinque Secolo di pittura Veneta; cat. no. 117. – Venice, 1959, cat. no. 61, illus. – Venice, Procuratie Nuove, 1971: Arte a Venezia dal Medioevo al Settecento; cat. no. 33, illus.

Literature: M. Boschini, *Le minere della pittura*, Venice, 1664, p. 384. – Boschini, *Le ricche minere della pittura*, Venice, 1674, pp. 34, 57. – Sandrart, 1675, (ed. 1925) p. 187. – D. Martinelli, *Il ritratto di Venetia*, Venice, 1684, p. 312. – Martinelli, *Il ritratto ovvero le core più notabili di Venezia*, Venice, 1705, p. 354. – Weyerman, 1729, p. 402. – A. M. Zanetti, *Descrizione di tutte le pubbliche pitture . . . o sia rinnovazione delle Ricche Minere di Marco Moschini*, Venice, 1733, p. 360. – Descamps, 1753, p. 264. – C. N. Cochin, *Voyage d'Italie on recueil de notes sur les ouvrages de peinture . . .*, II, Paris, 1758, p. 96. – Zanetti, *Della Pittura veneziana*, 1771, p. 508. – *Blätter vermischten Inhalts*, 5, Oldenburg, 1792, pp. 502, 513–516. – Zanetti, *Della Pittura veneziana . . .*, Venice, 1792 and 1797, p. 657. – G. Moschini, *Guida per la città*

VIII Ecstasy of St. Paul (detail) [A 38]
Staatliche Museen Preussischer Kulturbesitz, Gemäldegalerie, Berlin

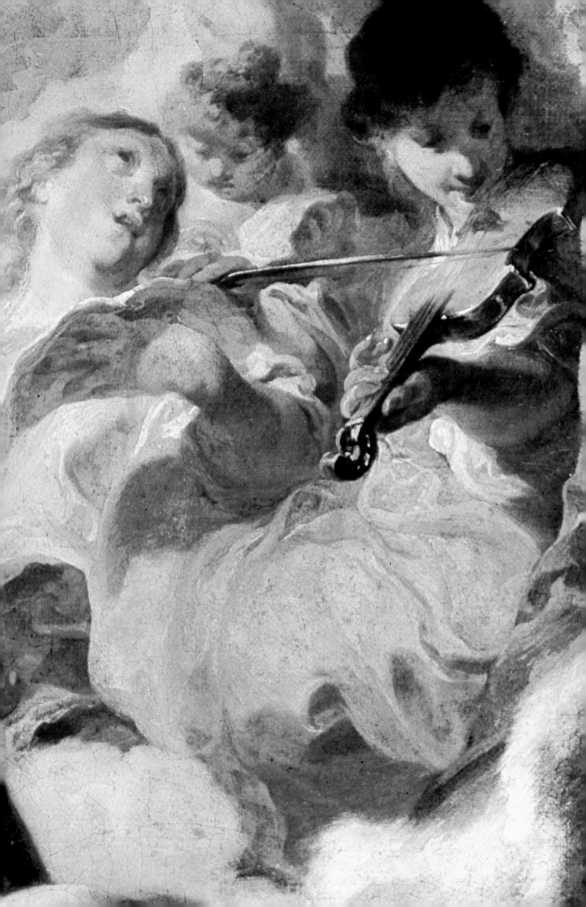

di Venezia all'amico delle Belle Arti, II, Venice, 1815, p. 91. – Moschini, *Itinaraire de la ville de Venise et des iles circonvoisines*, Venice, 1819, p. 233. – S. Ticozzi, *Dizionario degli architetti, scultori e pittori*, II, Milan, 1831, p. 363. – Moschini, *Nuova Guida per Venezia . . .*, 1834, p. 141; 1840, p. 86. – E. Paoletti, *Il Fiore di Venezia . . .*, III, 1840, p. 169. – Immerzeel, 1843, p. 181. – Lanzi, 1853, p. 257. – Frimmel, 1891, p. 83, n. 12. – *Il Gazettino*, February 28 and March 1, 1895. – Frimmel, 1901, pp. 215, 216, 218. – Nagler, 1907, p. 132. – Frimmel, 1909, p. 114. – Würzbach, 1910, p. 77. – P. Molmenti, *Tiepolo la vie et l'oeuvre du peintre*, Paris, 1911, p. 223. – Peltzer, 1914, p. 164. – Oldenbourg, 1914, pp. 160–62, fig. 14. – T. Borenius, «Notes on Giovanni Battista Piazzetta,» *The Burlington Magazine*, XXX, 1917, p. 15. – Borenius, «Jan Lys,» *The Burlington Magazine*, XXXIII, 1918, P. 115. – Oldenbourg, 1918, p. 122. – Bode, 1920, p. 177, illus. – Oldenbourg, 1921, pp. 11, 17. – Buberl, 1922, p. 27. – Frimmel, 1922, p. 55. – *Münchner Jahrbuch der bildenden Kunst*, XIII, 1923, p. 171. – Morassi, 1923, pp. 115, 117. – Ojetti, Dami, Tarchiani, 1924, p. 188, illus. – Zarnowski, 1925, pp. 92, 93, 95. – Posse, 1925–26, p. 27. – G. Lorenzetti, *Venezia e il suo estuario*, Rome, 1926, (ed. 1956) p. 477. – Fokker, 1927, p. 221. – Pevsner and Grautoff, 1928, pp. 157, 160. – Fiocco, 1929, p. 20, pl. 10. – Peltzer, in Thieme-Becker, XXIII, 1929, p. 286. – McComb, 1931–32, p. 33. – Voss, 1933–34, p. 16. – Pallucchini, 1934, pp. 14, 45, fig. 6. – *Exhibition of 17th Century Art in Europe*, exh. cat., London, Royal Academy of Arts, 1938, p. 122. – Steinbart, 1940, pp. 134, 142, 163, pl. 56. – Steinbart, 1942, p. 179. – Bloch, 1942, p. 50. – Houbraken, 1943, I, p. 162. – Steinbart, 1946, pp. 42, 47, fig. 54. – Zykan, 1947–48, p. 190. – Golzio, 1950, pp. 569, 572, fig. 609. – Bloch, 1950, pp. 281–282. – Schilling, 1954, p. 37. – A. M. Matteucci, «L'Attività Veneziana di Bernardo Strozzi,» *Arte Veneta*, 1955, p. 153, n. 1. – Réau, 1958, p. 748. – Suida, 1958, p. 398. – De Logu, 1958, pp. 147, pl. 89 (color), 277. – Steinbart, 1958–59, pp. 178–79, 197, 199, n. 80. – Venice, 1959, exh. cat., p. 45 (P. Zampetti). – A. Morassi, «Considerazioni sulla Mostra di Pittura Veneta del Seicento,» *Arte Veneta*, XIII–XIV, 1959–60, p. 272. – Pallucchini, 1960, pp. 5, 7, illus. (detail). – Pallucchini, 1960–61, part 2, p. 17. – Barbieri, 1962, pp. 89, 91. – E. Waterhouse, *Italian Baroque Painting*, London, 1962, pp. 125, 129, fig. 106. – *National Gallery of Ireland Centenary Exhibition 1864–1964*, exh. cat., Dublin, 1964, p. 27. – *Reclams Kunstführer, Italien*, Vol. II: *Oberitalien Ost*, Stuttgart, 1965, p. 919. – Paris, 1965, exh. cat., p. 173. – Bloch, 1966, p. 545. – Ewald, 1967, p. 10. – Woeckel, 1967, pp. 176, 178. – Donzelli and Pilo, 1967, pp. 241–42, figs. 263, 264 (detail). – *Die Goldene Palette – Tausend Jahre Malerei in Deutschland, Österreich und der Schweiz*, Stuttgart-Hamburg, 1968, p. 246. – Klessmann, 1970, p. 186. – T. Pignatti, *Venice* (World Cultural Guides), English translation, London, 1971, p. 277. – Sobotik, 1972, pp. 12–13. – Schlick, 1973, p. 134. – R. Wittkower, *Art and Architecture in Italy 1600–1750*, Harmondsworth, 1973, pl. 34. – *Deutsche Kunst des Barock*, exh. cat. Herzog Anton Ulrich-Museum, Braunschweig, 1974, p. 56. – *Sztuka Baroku w Niemczech*, exh. cat., Warsaw Nationalmuseum, 1974, p. 62.

COPIES:

John and Mable Ringling Museum of Art, Sarasota, Florida. Oil on canvas, 205 × 157 cm. (81 × 62 inches). Formerly Thomas Thompson, Boston. This painting cannot be the lost version from Pommersfelden as was suggested by Sobotik (1972, p. 12), since the measurements given in the 1746 inventory (121,9 × 96,5 cm., 48 × 38 inches; see Documentation III, 1) differ from those of the Ringling painting. Voss attributed the Ringling painting to Liss in the late 1920's; Suida (1949, p. 259, no. 311) called it an early copy after Liss, an attribution with which E. Waterhouse (letter of November 22, 1972) agreed. After a recent cleaning, Sobotik (*op. cit.*) believed it to be a work by Liss close to the version in Vicenza, which, he suggested, served as a *modello* for the Ringling picture. It is more likely a competent eighteenth-century copy, perhaps by a contemporary of Fragonard. – *Kunsthalle zu Kiel* (acquired in 1957). Oil on canvas (relined), 89 × 67,5 cm. (35¹/₁₆ × 29⁹/₁₆ inches). Formerly private collection, Munich; Dr. Hans Fetscherin, Munich; G. Scharnowski. Steinbart, after first ascribing the painting to Liss himself in an expertise in 1956, two years later (1958–59, p. 103, n. 80) called it a reduced variant, perhaps by a South German painter of the eighteenth century. This is a plausible attribution. – *Private Collection, c/o Heim Gallery, London.* Oil on canvas (relined), 140,3 × 88,6 cm. (55¹/₄ × 34⁷/₈ inches). Formerly private collection, England; sale, Sotheby's, London (from various properties), August 28, 1971, no. 27 (Peretti). Exhibition, Heim Gallery, London, 1971: *Faces and Figures of the Baroque*, cat. no. 3. This is a largely reduced eighteenth-century copy. Since the canvas has been relined its original size cannot be established. It certainly included all of the lion and the trumpet-playing angel in the upper right (note his foot emerging

from the clouds). – *Formerly Schloss Schleissheim.* Measurements and whereabouts unknown. Formerly attributed to a German copyist of Ribera, the painting was possibly in the Nürnberg Rathaus in 1711. (See Peltzer, 1914, p. 164.) – *Franziskanerkloster, Vienna.* Oil on canvas, 218 × 150 cm. (85¹³/₁₆ × 59¹/₁₆ inches). I am grateful to Pater Berthold for supplying detailed color photographs of this painting from which one gains at least the impression that it is a competent copy by a late seventeenth-century admirer of Liss, possibly of Austrian origin. The painting is reduced on the right, left, and top. This could be one of the intermediaries between the altarpiece in Venice and some of the other copies after Liss. (See Zykan, 1947–48, p. 190.) – *Kiew State Museum of Western Art* (since 1926). Oil on canvas, 211 × 143 cm. (83¹/₁₆ × 56⁵/₁₆ inches). Formerly B. I. and V. N. Khanenko. It has been attributed to Luca Giordano (after Liss). (See *Kiev State Museum Catalogue,* 1927, no. 224, and 1931, no. 273; *Catalogue of West European Painting and Sculpture,* Moscow, 1961, no. 27.) De Logu (1958, p. 277) believes the painting to be a replica by Liss such as the one in Dublin. – *Fogg Art Museum, Harvard University, Cambridge, Massachusetts.* Oil on canvas, 144,9 × 112,1 cm. (57 × 44¹/₈ inches). This painting is close in date but inferior to the copy in Sarasota. It is slightly narrower on the right and at the bottom and wider on the left than the Sarasota copy. Part of the cardinal's hat is cut off, as in the painting at Vicenza [D 6]. Steinbart (1940, p. 138, n. 286, and p. 165) listed it as a copy, which is the way it is now catalogued by its owner. (See McComb, 1933, pp. 32 ff., illus.) – *Sale, S. Kende, Vienna,* November 25, 1920, no. 18. Whereabouts unknown. Oil on canvas, 146 × 100 cm. (57¹/₂ × 39³/₈ inches). Judging from the illustration in the sales catalogue this is a poorly rendered and preserved copy, with slightly more space on top than the original in Venice. – *Okresni Museum, Kroměříž (Kremsier), Czechoslovakia.* Oil on canvas, 197 × 152 cm. (77⁹/₁₆ × 59¹³/₁₆ inches). This appears to be a poorly preserved and inferior copy. (See Steinbart, 1940, p. 138, n. 286, and p. 166) – *Stift Strahow, c/o National Gallery, Prague.* Oil on canvas, 57 × 46,5 cm. (22⁷/₁₆ × 18⁵/₁₆ inches). This appears to be a small and crude, late copy. (See Steinbart, 1940, pp. 138, 167.) – *Schlesisches Museum, Breslau.* Oil on canvas, 70,5 × 55 cm. (27³/₄ × 21⁵/₈ inches). (See Steinbart, 1940, pp. 138, 165.) – *Formerly Uffizi, Florence.* No measurements are available. Whereabouts unknown. Buberl (1922, p. 27) mentions the painting as one of the two sketches for the altarpiece in Venice; the second is from Vicenza, and was exhibited at the Pitti Palace in 1922. (See Peltzer, in Thieme Becker, XXIII, 1929, p. 286; and Barbieri, 1962, p. 89.) – *Sale, Anderson Galleries, New York,* April 9, 1929, no. 122, illus. (as «St. Peter in Prison»). Whereabouts unknown. Oil on canvas, 101,6 × 81,2 cm. (40 × 32 inches). Formerly Norton; sale, Clarke's Art Room, New York, April 4, 1912, no. 25, illus. (as Peter Lastman); Rosenberg; Stoke; The Kesto Corporation, New York. (See *Art Prices Current,* VIII, 1928–29, p. 184, no. 9170.)

A. T. L.

A 40 THE VISION OF ST. JEROME

Fig. 39

Oil on canvas, 112 × 90 cm. (44¹/₈ × 35⁷/₁₆ inches).

National Gallery of Ireland, Dublin.

The painting was accepted by Steinbart (1940) as an original variant by Liss similar to the one in Vicenza [D 6]. Steinbart rejected the idea that the latter served as a *bozzetto* for the large altarpiece in Venice [A 39]. He believed that the Dublin version, which is twice the size of the one in Vicenza, was later in date and may have been the painting that inspired the Fathers of the Tolentino church to commission Liss to paint their large altarpiece. Pallucchini and Zykan referred to the Dublin painting as a replica; De Logu did the same in a discussion of the painting in Kiev (see under Copies), which he and Steinbart also believed to be by Liss. Mariacher described it as a minor replica without mentioning Liss's name.

Unfortunately, this is one of the few paintings the author did not see in person; it would

seem, however, from comparison with the original in Venice and with other paintings which are undoubtedly copies, that the Dublin painting gives the impression of a replica – quickly executed like the two pendants, the *Sacrifice of Isaac* [D 5] and the *Mourning for Abel* [A 36], with a free and wet brush, leaving a number of loose ends. This is one of the paintings which will be subjected to a careful examination in the exhibition by those scholars who are not totally convinced that the work is by Liss.

Collection: Rev. Father John Shine (1936).

Exhibitions: London, Royal Academy of Art, 1938: Exhibition of 17th-Century Art in Europe; cat. no. 302. – Dublin, National Gallery of Ireland, 1964: 1864–1964 Centenary Exhibition; cat. no. 67.

Literature: An Illustrated Souvenir of the Exhibition of 17th-Century Art in Europe, Royal Academy of Art, London, 1938, p. 76, no. 302. – Steinbart, 1940, pp. 135, 137, *passim*, 161, pl. 55. – Steinbart, 1946, pp. 42, 47, 63. – R. Pallucchini, *Cinque Secoli di Pittura Veneta*, exh. cat., Venice, Procuratie Nuove, 1945, p. 104. – Zykan, 1947–48, p. 190. – De Logu, 1958, p. 277. – Réau, 1958, part 2, p. 748. – *Illustrations of the Paintings*, National Gallery of Ireland, Dublin, 1963, pl. 981. – *Catalogue of the Paintings*, National Gallery of Ireland, 1971, p. 103, no. 981. – G. Mariacher, *Arte a Venezia dal medioevo al settecento*, exh. cat., Venice, Correr Museum, 1971, p. 72. – Sobotik, 1972, p. 12. – Schlick, 1973, p. 134.

A.T.L.

A 41 CHRIST IN THE GARDEN (shown in Augsburg only) Fig. 41

Oil on copper, 28 × 20,5 cm. (11 × 8¹/₁₆ inches). Signed in lower left corner: Joañes. Liss: F. A: D: 162 – [last digit is illegible; 8 or 9?].

Private collection, Switzerland.

During the night in which He is to be taken prisoner Christ prays in the Garden. His glance is directed toward the cup – the symbol of his sacrificial death – which appears in front of him in a ray of light. An angel supports the collapsing Christ. In the dark background one can recognize the armed men with torches who will take Him prisoner (Luke 22:39–43).

Only the gospel according to St. Luke tells about the angel who appears to Jesus on the Mount of Olives when He is in agony. Liss combines the motif of comfort, which corresponds to a more recent iconographical conception of the subject, with the representation of the cup which stems from the older symbolic picture tradition (C. Tümpel, 1968). It is probable, however, that Liss used the cup as a metaphor for Christ's suffering, as it is written in the gospel («... remove this cup from me»). The painter's literal interpretation of the text is supported by a detail so far overlooked: the drops of blood which are recognizable on the head of Christ, according to the words of the gospel, «And His sweat became as it were great drops of blood falling down upon the ground.» Jesus has slid down onto the red cloak lying on the ground which resembles a pool of blood.

In this composition Liss follows a Venetian example which can also be found in paintings by Veronese. [1] However, similar figure groups were also known in the Caravaggio circle. Orazio Gentileschi, for example, painted the fainting St. Francis supported by an angel in a similar compositional arrangement (Rome, Galleria Nazionale).

131

The small picture painted on copper is of special significance since it is the only signed and dated painting by Liss. Even the back of the panel is signed, Johann Liss (obviously by the artist himself). The last digit of the year, which unfortunately is damaged, seems to be an 8. Stylistically the picture corresponds to the works of the artist's last years of life in Venice, although, because it is a nocturnal picture, it cannot be compared directly. In painting technique it is closest to the *Ecstasy of St. Paul* [A 38] in Berlin. The head of the angel is reminiscent of the one in the *Sacrifice of Isaac* [A 35] in Florence.

[1] Steinbart, 1940, p. 125, fig. 55.

Collections: A. Berlan, Triest (before 1923); Rome art market (Ugo Jandolo); Professor Hans Purrmann, Zürich.

Exhibitions: Berlin, Akademie der Künste, 1925: Gemälde alter Meister aus Berliner Besitz, cat. no. 224. Berlin, 1966, cat. no. 50.

Literature: Morassi, 1923, pp. 115 ff., fig. 1. – G. J. Hoogewerff, «Verslag van verrichte studien en belangrijke voorvallen op kunstwetenschappelijk gebied,» *Mededeelingen van het Nederlandsch Historisch Instituut te Rome,* IV, 1924, pp. XLIV f., pl. 2. – *Gemälde alter Meister aus Berliner Besitz,* exh. cat., Akademie der Künste, Berlin, 1925, p. 39, no. 224. – Pevsner and Grautoff, 1928, pp. 156–57, fig. 124. – Peltzer, in Thieme-Becker, XXIII, 1929, p. 286. – Fiocco, 1929, pp. 20, 78. – Steinbart, 1940, pp. 124–25, 163, pl. 49. – Bloch, 1942, p. 50. – Steinbart, 1946, pp. 40, 62, figs. 48, 49. – Bloch, 1950, p. 281. – R.Wittkower, *Art and Architecture in Italy 1600 to 1750,* Harmondsworth, 1958, p. 67. – Steinbart, 1959, p. 199. – Berlin, 1966, exh. cat., p. 55, no. 50, fig. 48 (R. Klessmann). – Donzelli and Pilo, 1967, p. 242. – Bloch, 1966, p. 546 – C. Tümpel, «Ikonographische Beiträge zu Rembrandt,» *Jahrbuch der Hamburger Kunstsammlungen,* XIII, 1968, p. 99, n. 13.

<div align="right">R. K.</div>

B. Drawings and Etchings

B 42 THE FOOL AS MATCHMAKER

Etching, plate 16,8 × 21 cm. (6⁵/₈ × 8⁵/₁₆ inches).
Signed with monogram on chair back at right: J L fecit [initials linked].

State I/II Fig. 42

Rijksprentenkabinet, Rijksmuseum, Amsterdam.

Provenance: Acquired from F. Muller, Amsterdam, 1899.

State II/II Fig. 43

The Art Institute of Chicago, The Stanley Field Fund.

Collections: A. P. F. Robert-Dumesnil, Paris (Lugt 2200, sale: London, Phillips, 1837, no. 557);
mark of unidentified collector. Purchased from C. G. Boerner, Düsseldorf, 1971.

In the second state, «Mariette excud.» is added at the upper left, and there is additional
work on the plate: some shading lines on the face of the standing woman – to the left of
her mouth – have been burnished out; there is considerable additional shading over the
figure of the fool and some on the curtain fold beside his head; a floral pattern has been
added on the underskirt over the knee of the seated woman; and a dot marks the pupil of
the dog's eye.[1]
The association of lust with folly was a traditional subject of popular art in the Nether-
lands. The fashionably dressed couples are oblivious of the fool who lurks by a curtain
in the background, his hand to his face, spying between his fingers. His central position
points the moral that, in a brothel, folly is the pander. The setting and the arrangement of
the figures show correspondences to *The Painter in Her Studio* [A1]: the chair in the
etching is the same, as is the lute; and the costumes of both men are identical with the
suit worn by the lute player in the painting.[2]
This is unquestionably the earlier of Liss's two etchings. The elaborate clothes and sump-
tuous materials bear comparison with those in the paintings of the *Gallant Couple* [A6,
A7], but in his attempt to duplicate in the etching the variety of textures that could be

portrayed in paint, Liss reveals himself a novice printmaker. The diversity of etched lines is so great that the differences in size and weight tend to fragment the image, and the lack of a uniform system for shading distorts the intended light and dark pattern. As is often the case in early attempts, the etching style is over-descriptive and over-complicated.

Probably all the second state changes in the plate were made after it came into the hands of Pierre Mariette I, the noted publisher, who was active in Paris from about 1630 until 1657. Because the plate was printed by Mariette, it has been surmised that Liss etched it in Paris.[3] However, as print seller and print publisher, Mariette was in frequent communication with art centers in the Netherlands and in Italy;[4] he commissioned works by foreign artists; and he also purchased the contents, including print plates, of two other great publishing houses – that of Jean Messagier in 1637, and that of Melchior Tavernier in 1644.[5] In addition, his son, Pierre Mariette II, married the widow of Ciartes in 1655 and in consequence brought to the family business the holdings of this other successful publisher, who had traveled extensively and had particularly strong ties with Italy.[6] Thus, the fact that Mariette eventually published the plate for the *Fool as Matchmaker* in Paris, casts no light on its place of origin.

[1] The second state impressions in the Albertina, Vienna (Knab, pl. 8), and in Berlin (Steinbart, 1946, fig. 22) have all the additions but the last; the dog's eye remains blank. According to a kind communication from Dr. J. W. Niemeijer, the third state with the address of Franciscus van Wijngaert, described by Steinbart (1940, p. 164), does not exist. The error originated in a misinterpretation of Van der Kellen's description of a copy of the etching by Cornelis Galle II (Hollstein 309).

[2] Rousselet changed the collars to conform to French fashion in the 1630's. The same suit appears in Danckerts' and de Son's prints (see cat. nos. C 61 and C 62).

[3] Peltzer, 1933, p. 33, fn. 4. Weigert, p. 175, but with the remark that the costume is foreign. Steinbart (1940, p. 60) understood the likelihood that the plate came to Mariette from another locality, but thought it originated in Liss's late Venetian period.

[4] Weigert, pp. 176–77.

[5] Weigert, pp. 169–70.

[6] Weigert, pp. 177–78.

Literature: Burchard, 1912, pp. 48–51, 146, no. 2. – Oldenbourg, 1914, p. 139. – Bode, 1919, p. 2. – Peltzer, in Thieme-Becker, XXIII, 1929, p. 285. – Peltzer, 1933, p. XXXIII, fn. 4. – Steinbart, 1940, pp. 60–61, *passim*, p. 164, pl. 19. – Bloch, 1942, p. 41. – Steinbart, 1946, pp. 26, 30, 44, 60, fig. 22. – Hollstein, p. 147 no. 3. – Bloch, 1950, p. 281. – R. A. Weigert, «Le Commerce de la gravure au XVIIe siècle en France; les deux premiers Mariette et François Langlois, dit Ciartres,» *Gazette des Beaux-Arts*, XL, March 1953, p. 175, fig. 5. – Steinbart, 1958–59, pp. 159–61, fig. 1. – Klessmann, 1965, p. 86, fig. 4. – Berlin, 1966, exh. cat., pp. 47–48 nos. 40–41 (R. Klessmann). – E. Knab, *Jacques Callot und sein Kreis*, exh. cat., Vienna, Albertina, 1968–69, p. 93, no. 213, pl. 8.

L. S. R.

B 43 BRAWLING PEASANTS Fig. 44

Pen and brown ink over brown and light brown wash, white ink wash, opaque white highlights (watermark: initials VB over shield with griffon rampant, close to Briquet 1918 and Eineder 329, 331), 22,6 × 33,3 cm. (8¹⁵/₁₆ × 13¹/₈ inches).

Hamburger Kunsthalle, Kupferstichkabinett.

The motif of the drawing is related to Liss's paintings of peasant subjects [A3, A4, A5]. Perhaps inspired by the 1546–47 engravings of Hans Sebald Beham [E 13, E 15] (Pauli 177–186), Liss's interpretation relies upon figures derived from Bruegel. (For discussion of subject see cat. no. A3.) The bulky, rounded forms, the grotesquely exaggerated features of the few profiles visible to us, the heavy swollen hands, explain the mistaken attribution of Hollar's etched copy[1] of the drawing to Pieter Bruegel. In Hollar's etching, playing-cards on the ground indicate the roots of the quarrel. The drawing, however, contains no such hint of a card game; like the later paintings, it may instead show quarrel-some peasants as the converse of merrymaking peasants. The tightly knit, spatially complex groups at right and left, punctuated by the diagonals of tools and bench, show the young artist's mastery of composition. The drawing bursts with full-blooded life; not only the struggling yet tightly restrained combatants but the outward springing, upward thrusting plants, grasses, and tree branches – even the hat feathers – fairly quiver with exuberant vitality.

As Steinbart (1940, p. 32) noted, the drawing is executed almost as a little painting. The ink washes in warm brown and tan are heightened with both transparent and opaque white ink and are sufficient in themselves for a finished picture; the pen lines merely add descriptive details. It is more sensitively executed than those drawings that appear to serve as *ricordi* [B45, B47, B53]. The heavy, prominent pen and ink lines here add finishing touches but are subordinated to, and work in harmony with, the ink washes. Whether an identical painting of the subject – and perhaps a counterpart feast – preceded the drawing is a moot question. The existence of another drawing, of a fighting peasant couple, in a later drawing style (Schilling, fig. 1; Steinbart, 1958–59, fig. 9), attests to Liss's continuing fascination with the subject.

The Hollar etching [E 107], which reproduces the Hamburg drawing in reverse, shows that the drawing margins are intact, except for the possible loss of a thin strip trimmed from the left side. In 1646, when he copied the drawing, Hollar was in Antwerp; his model had not traveled far since Liss drew it some thirty years earlier, perhaps in the same city. The watermark indicates that the paper was probably manufactured in Upper Austria some-time before 1618.[2]

According to Steinbart (1940, p. 32), Friedrich Winkler first attributed the drawing to Liss. Benesch expressed doubt, but the attribution is now generally, and rightfully, accepted.

[1] G. Parthey, *Wenzel Hollar,* Berlin, 1853, p. 128, no. 599.
[2] According to G. Eineder (*The Ancient Paper-Mills of the Former Austro-Hungarian Empire and Their Watermarks,* Hilversum, 1960, p. 64), the initials VB stand for Valentin Brämer (or Prämer), who in 1569 married the widow of Balthasar Fischer, owner of the mill of Steyr-Altmühl. Before 1599, Brämer bought the mill from his stepson, Wolf Fischer, and thus was sole owner until sometime before 1618, in which year Brämer's widow remarried.

Collection: JD (Lugt 1436), mark of unidentified collector.

Exhibitions: Nürnberg, 1952, cat. no. W 163. – Berlin, 1966, cat. no. 158 (H. Möhle), fig. 161.

Literature: Steinbart, 1940, pp. 32–33, *passim*, 164, pl. 5. – Steinbart, 1946, pp. 20–22, *passim*, 57, fig. 5. – Benesch, 1951, p. 376. – Schilling, 1954, p. 33. – Steinbart, 1958–59, pp. 163–65, fig. 8. – *German Drawings 1400–1700 from Dutch Public Collections,* exh. cat., Rotterdam, Museum Boymans-Van Beuningen, 1974, p. 23, no. S 28.

L. S. R.

B 44 STANDING PEASANT SEEN FROM BACK Fig. 45

Pen and dark brown ink over yellow-tan and gray-tan wash; backed (watermark: part of four-wheeled wagon, close to Zonghi 1389), 16,7 × 10 cm. (6^9/₁₆ × 3^{15}/₁₆ inches).
Inscribed verso, on backing paper, in pencil: 2019 A / 563 / C[G?]al . . .

Georg Schäfer collection, Schweinfurt.

Like several of the figures in the drawing of the *Brawling Peasants* [B 43] the man here portrayed is no more than a bundle of clothes. Nothing is revealed of face, head, or even hands. His clothes and his stance are the sum of the man. This drawing and that of the *Brawling Peasants* were attributed to Liss by Friedrich Winkler (Steinbart, 1940, pp. 32, 33). The figure and clothes are reminiscent of the *Naer het leven* drawings by, or after, Bruegel, though the means of drawing – in ink wash with accents and finishing details in pen – conforms to Liss's practice. Benesch doubted the attribution, Steinbart accepted it, Schilling did not mention the drawing. The execution relies more on pen and ink delineation than one expects of Liss, though the mixture of a warm yellow-brown with a grayer tone in the ink wash is typical of his drawings.

There can be no doubt the exhibited drawing belongs to the beginning of the seventeenth century, but it is a curious circumstance that the paper, and the sketches on the verso of the page (visible through the backing paper when held toward a strong light), appear considerably older. The verso sketches, in pen and ink, consist of a stylized profile face, a thistle-like flower with stem and four leaves, and two small drawing notations cut off at the margin, one of which seems to be a figure with one arm raised and the other the outline of a viol. The wagon watermark in the paper is of a type found in Italian paper made no later than the end of the fifteenth century.

Collection: Prince of Liechtenstein, Vienna.

Literature: Steinbart, 1940, pp. 33–34, 164, pl. 8. – Steinbart, 1946, pp. 21, *passim*, 58, fig. 10. – Benesch, 1951, p. 379.

L. S. R.

B 45 MERRY COMPANY WITH A GALLANT COUPLE Fig. 46

Pen and brown ink over brush with light brown and gray wash, slight black chalk indications, backed; 19,1 × 27,3 cm. (7¹/₂ × 10³/₄ inches).

Staatliche Museen Preussischer Kulturbesitz, Kupferstichkabinett, Berlin.

The *Merry Company with a Gallant Couple* is the earliest of Liss's drawings which Schilling categorized as *ricordo* drawings, that is, made not as studies for paintings but as

records of completed paintings. There is a painting in San Francisco [1] [E 92] of the identical composition which is probably a copy of a lost Liss painting. Every important element of the picture is recorded in the drawing. Details of dress and accessories of the two foreground couples are drawn with some precision; the couple behind the table is treated more summarily; and the fool is set apart from the background wall only by a few thin pen outlines. Thus the drawing serves as an efficient diagram of a painting by distinguishing the areas of main emphasis and by mapping the overall play of light through the ink washes. The theme of heedless, amorous adventure is repeated in the paintings of the *Gallant Couple* in a more abbreviated form (see discussion, cat. no. A6). The standing couple of the drawing is the centerpiece in the paintings, and there are only minor variations of pose and costume. The drawing also treats the subject of Liss's etching, the *Fool as Matchmaker* [B 42], but without so obviously pointing the moral; and it combines the delightful surroundings of the lost painting of the *Garden of Love,* reproduced in Nicolas de Son's etching [C 62], with the close intimacy of the *Fool as Matchmaker.* The setting for the supper party – in the corner of a wall out-of-doors – appears again in the *Prodigal Son* [A 11, A 12], even to the urns and plants along the top of the wall, which, though barely indicated by strokes of wash in the drawing, can be distinguished in the San Francisco painting. Comparison with the painting also clarifies the figure of the boy drawn only with brush and wash at the right edge of the page. Evidently the right side of the drawing has been cut so that only part of the figure remains.

[1] M. H. de Young Memorial Museum. Published *Weltkunst,* XXIII, December 1, 1953, p. 9, illus.; Steinbart, 1958–59, p. 80, fig. 25.

Collections: Marquis Charles de Valori, Paris (Lugt 2500, sale: Paris, Drouot, November 25–26, 1907, p. 42, no. 182 [Palamedes], illus. p. 50); Louis Deglatigny, Rouen (Lugt 1768a, sale: Paris, Drouot, November 4–5, 1937, no. 291 [attributed to Palamedes]). Purchased in Paris, 1938.

Exhibitions: Nürnberg, 1952, cat. no. W 194. – Venice, 1959, (Disegni) cat. no. 31 (T. Pignatti), illus. – Berlin, 1966, cat. no. 160 (H. Möhle), fig. 159.

Literature: Steinbart, 1940, pp. 38, *passim,* 163, pl. 12. – Steinbart, 1942, p. 172, illus. p. 173. – Steinbart, 1946, pp. 24, *passim,* 58, fig. 12. – H. Möhle, *Deutsche Zeichnungen des 17. und 18. Jahrhunderts,* Berlin, 1947, pp. 27–31, pl. 29. – Schilling, 1954, pp. 31–33. – Steinbart, 1958–59, pp. 180, *passim,* fig. 24. – Oehler, 1962, p. 105.

L. S. R.

B 46 STUDY OF A WOMAN'S HEAD Fig. 47

Black chalk with traces of white chalk, on blue Venetian paper (watermark: anchor in circle), 29,8 × 19,8 cm. (11³/₄ × 7¹³/₁₆ inches).

Rijksprentenkabinet, Rijksmuseum, Amsterdam.

This beautiful, large drawing, which was discovered under the name of Jordaens, was correctly identified as by Liss and purchased by the Rijksprentenkabinet in 1967. It adds another dimension to our knowledge of the artist's work, as it is the only detail study drawn from life for a known painting by Liss. It doubly confirms the strong influence of

Jacob Jordaens' style on the young Liss, first, as a study for the most Jordaens-like of Liss's subjects, the *Satyr and Peasant* [A9, A10], and second, by having been attributed to the Flemish master as an isolated drawing before its connection with the painting by Liss was recognized. It is drawn on a sheet of the manufactured blue paper that was a Venetian specialty, prized by artists from the sixteenth through the eighteenth centuries for studies that are intended, like this one, to be carried out in the wider spectrum of paint. The blue paper serves as a middle tone for Liss's painterly drawing, which is executed in terms of the modeling light. The darkest accents (on one nostril, under the lower lip, the pupil of one eye) are of softer black chalk. Only faint traces remain now of white chalk highlights on the tip of the nose and on the temple. The light that reflects from the blouse onto the shaded side of the face and the right contour of the chin enlivens Liss's drawing; it is reproduced in the painted face as it was observed and recorded in this study.

Collections: Jonathan Richardson, Sr., London (Lugt 2184); Jonathan Richardson, Jr., London (Lugt 2170); J. A. van Dongen, Amsterdam.

Exhibition: Rotterdam, Museum Boymans-van Beuningen, 1974: German Drawings 1400–1700 from Dutch Public Collections, no. S 28, illus.

Literature: Verslagen omtrent's Rijksverzamelingen van geschiedenis en kunst, LXXXIX, The Hague, 1967, p. 98, illus. p. 104.

L. S. R.

B 47 PEASANT WEDDING Fig. 48

Pen and brown ink, light brown wash, over black chalk (watermark: crown with star and crescent, similar to Heawood 1132), 20,5 × 31,2 cm. (8¹/₈ × 12⁵/₁₆ inches).
Verso: figure studies in graphite.

Staatliche Graphische Sammlung, Munich.

A 1974 acquisition for the Munich graphic collection, this is one of the recognized Liss drawings and one of those that Schilling considered to be a record by Liss of one of his own paintings. There are differences, however, between the drawing and the Budapest painting (see discussion, cat. no. A5): notably, the two men in the center of the painting turn their heads toward the observer, whereas in the drawing all four dancers – men and women – are seen in profile. This and the oblong proportion of the page place the drawing slightly closer than the painting to Beham's engraved suite of the months [E 15, E 67] (Pauli 177–186). The difference in proportion is not solely a matter of additional space beyond the figures at either end; the dancers are spaced slightly farther apart so that they have a little more the aspect of a linked sequence, a little less that of a compactly interwoven cluster. The lively motif of the outflung legs and feet of a pair of half-hidden dancers at the right suggests the sequential movement of a single dancer and is patterned on the dancing couple in Beham's engraving of *July and August* [E 67], which in turn depends directly on Dürer's 1514 engraving of a *Peasant Couple Dancing* [1] [E 68].

The *Peasant Wedding* is executed in ink wash with final details added in pen and ink, like the Berlin *Merry Company* [B45], but the drawing style, with its more relaxed and free-flowing outlines and less insistent description of detail, approaches the fluid ease of the Hamburg *Gobbi* [B48].

According to Schilling, the drawing was formerly bound in an eighteenth-century album where it was attributed to Jakob Weyer (active from 1648, died 1670 in Hamburg). There is a fairly faithful copy of this drawing in the Crocker Art Gallery, Sacramento, and another drawing copy in Budapest.

[1] J. Meder, *Dürer-Katalog*, Vienna, 1932, p. 106, no. 88.

Collections: 18th-century album of drawings on art market, Wiesbaden (source: Schilling, 1954, p. 37, fn. 5); Gilhofer and Ranschburg, Vienna (source: Benesch, 1951); J. W. Zwicky, Freiburg.

Exhibition: Venice, 1959, (Disegni) cat. no. 30 (T. Pignatti), illus.

Literature: Benesch, 1933, p. 71, no. 625. – Steinbart, 1940, pp. 19–20, *passim*, 164, pl. 1. – Steinbart, 1946, pp. 18–20, *passim*, 57, fig. 2. – Benesch, 1951, p. 376. – Schilling, 1954, pp. 31–33, 37, n. 5. – Steinbart, 1958–59, p. 166. – Oehler, 1962, p. 105. – Berlin, 1966, exh. cat., p. 121, no. 160 (H. Möhle). – Pigler, 1968, p. 387, no. 3844. – P. Rosenberg, «Twenty French Drawings in Sacramento,» *Master Drawings*, VIII, 1970, p. 36, n. 2. – R. Müller-Mehlis, «Für München gewonnen, Neuerwerbungen der Staatlichen Graphischen Sammlung,» *Die Weltkunst*, XXa, 1974, p. 1789, illus, p. 1788.

L. S. R.

B48 FIGHTING GOBBI MUSICIANS Figs. 49, 50

Brush and brown ink over brush with light brown and gray wash, black chalk indications (verso: red chalk), 9,6 × 13,1 cm. (3³/4 × 5¹/8 inches).
Signed and dated in brown ink: Johan Liss. Holsacia. A 1621. / a: VEN–.

Hamburger Kunsthalle, Kupferstichkabinett.

This little page is from an *album amicorum*, or «friendship book,» in which were collected drawings, poems, mottoes, autographs – tokens of friendship or souvenirs of an acquaintance. Judging by the number of such drawings still extant, they were popular from the late sixteenth century onwards, especially among artists from Germany and the Netherlands. In a period when artists traveled frequently from city to city and from country to country, the *album amicorum* drawing provided the alien artist with a means of presenting his credentials to fellow artists and of advertising his skill to a foreign community.[1] The drawings were signed by the artist donor, and usually the date and city were added. It is thanks to this custom that we have a unique record in Liss's own hand of his exact location in a stated year. The inscription documents Liss's arrival in Italy in 1621, when he first stayed in Venice, and before he traveled on to Rome.[2]

The subject of the drawing is a stock character of *commedia dell' arte*, the *gobbo* or hunchback clown. Here two besotted *gobbi* musicians battle each other with their lutes as weapons, and a third lies *hors de combat* in the background. An empty canister lies in the foreground, and an object has been flung into the tree – possibly a hoop with attached bells. It is astonishing to encounter this humorous trio in a drawing dated a year before

Callot returned to France and there published his well-known series of etchings in which the antics of the *gobbi* are immortalized.[3] Two alternative explanations given by Steinbart (1940, p. 21) are plausible: either that Liss saw, and was moved to imitate, early trial impressions printed in Florence of some of Callot's plates (or drawings for them) before the series was completed for publication as a whole, or that Callot and Liss independently were attracted to a subject of widespread interest at the time. The verve and energy, not to mention the wit, with which Liss sketched the furious combatants suggests that this drawing was made for a close friend, perhaps a drinking companion.

The red chalk sketch on the verso is a copy of a boy and dog from the lower left corner of a wall painting in the Doge's Palace, the *Doge Receiving the Persian Ambassador*, by Gabriele and Carlo Caliari.[4] Probably a notation made in front of the painting, the sketch is so brief as to leave little imprint of its author. As the reverse of an *album amicorum* drawing, it could have been done by someone else after the page left Liss's hands. There are two points of similarity to drawings by Liss, however, that bring it into the range of his style: the drawing of the page boy's right leg resembles the summarily outlined leg of the man at the far left in the Berlin *Merry Company* [B45];[5] and the occasionally wavering, irregular outline can be compared to a characteristic meandering line that is found especially in Liss's early ink drawings. On the recto of this page it profiles the tree trunk.

[1] See W. Schade, *Dresdener Zeichnungen 1550–1650*, Kupferstichkabinett der Staatlichen Kunstsammlungen, Dresden, 1969, pp. 13, 18.
[2] Both the date and the city were misread when the drawing was first published («1629 a Neap,» Koopman), probably because the city is rewritten in capital letters over writing incompletely effaced beneath.
[3] J. Lieure, *Jacques Callot*, 5 vols., Paris, 1927–29; vol. II, 1927: *Catalogue de l'oeuvre gravé*, nos. 407–426. Two plates of the *Caprices* published in Florence are *gobbi* subjects (Lieure, vol. I, nos. 246–47), but they correspond much less in form and costume to Liss's drawing than the later series.
[4] Discovery of Ann Tzeutschler Lurie. [E 69]
[5] Observation by Konrad Oberhuber (verbal communication, January 1975).

Collections: Ernst Georg Harzen Bequest, 1863.

Exhibitions: Nürnberg, 1952, cat. no. W 166. – Venice 1959, (Disegni) cat. no. 29 (T. Pignatti), illus. – Berlin, 1966, cat. no. 160 (H. Möhle), fig. 159.

Literature: W. Koopman, «Einige weniger bekannte Handzeichnungen Raffaels,» *Jahrbuch der Königlich Preußischen Kunstsammlungen*, XII, 1891, p. 42. – H. Schmidt, «Gottorfer Künstler,» *Quellen und Forschungen zur Geschichte Schleswig-Holsteins*, V, 1917, p. 311, illus. – Peltzer, 1924–25, pp. 161–64, illus. p. 162. – Posse, 1925–26, p. 24. – Fokker, 1927, p. 204. – Pevsner and Grautoff, 1928, p. 156. – Peltzer, in Thieme-Becker, XXIII, 1929, p. 285. – Benesch, 1933, p. 71, no. 625 – Steinbart, 1940, pp. 21–22, *passim*, 164, pl. 4. – Bloch, 1942, p. 45. – Steinbart, 1946, pp. 22, *passim*, 58, fig. 6. – Bloch, 1950, p. 281. – Benesch, 1951, p. 379. – Schilling, 1954, pp. 30–31. – Steinbart, 1958–59, pp. 165, 197. – W. Stubbe, *Hundert Meisterzeichnungen aus der Hamburger Kunsthalle 1500–1800*, Hamburg, 1967, p. 32, no. 40, pl. 44. – R. Klessmann, «Ein neues Werk des Johann Liss in der Berliner Gemäldegalerie,» *Nordelbingen*, XXXIV, 1965, p. 84. –Klessmann, 1970, p. 185.

L. S. R.

B 49 Morra Game Outdoors Fig. 51

Graphite, black chalk, faint white chalk highlights on heavy tan paper, 22,4 × 34,2 cm. (18^{13}/$_{16}$ × 13^{7}/$_{16}$ inches).
Inscribed lower right in ink: Quellinus.

Staatliche Kunstsammlungen, Kassel.

The subject of this beautiful study by Liss is discussed under cat. no. A13. It is his only
extant preparatory drawing for an entire picture. It is the best example of Liss's method
of composing a painting; that is, in Sandrart's words, of «thinking a long time before he
started on his work.» Liss invented figure groups which, rearranged and modified, could
be used and reused. Yet they always appear spontaneous, for he animated each figure
within a group – with the gesture of a hand, the turn* of a head, or the angle of a hat
brim – thus cunningly interrelating them and uniting them in a single cohesive pattern.
The central group from this drawing, including the man with a pipe at the left, the girl
with the lute, and the boy pointing upward behind her at the right, is repeated in the
painting, *Morra Game* [A13]. In order to accommodate a horizontal format, Liss placed
at the left end of the table the two men of the Harteneck *Morra Game* [A14], and because
of the greater width of his projected painting, he added the pipe smoker to fill the inter-
vening gap and link the two groups. Two serving women occupy the extra space at the
right and are attached to the central group by the adroit invention of a lolling reveler
lifting his wine glass to be filled. The serving women and the reveler appear again in the
paintings of the *Banquet of Soldiers and Courtesans* [A15, A16] where the man, in
slightly altered pose, becomes the central figure. Possibly the otherwise unexplained form
that extends in the drawing from the reveler's hat to the wine jug is an unexpunged
remnant of a trial of his arm in the position it holds in the Banquet paintings. There is no
known painting of the Morra Game that corresponds exactly with the Kassel drawing.
The drawing was not sold at the auction sale of the Habich collection in 1899. Sub-
sequently, according to a memorandum in the Kassel collection archives dated June 6,
1899,[1] it was presented by Edward Habich to the Kassel painting gallery.

[1] Kind communication from Lisa Oehler.

Collections: J. A. G. Weigel, Leipzig (sale: Stuttgart, Gutekunst, May 15 and ff. days, 1883, p. 99, no. 793
[E. Quellinus der Vater], sold to Edward Habich); Edward Habich, Kassel (sale: Stuttgart, Gutekunst,
no. 51, April 27 and ff. days, 1899, p. 47, no. 415).

Exhibitions: Nürnberg, 1952, no. W165. – Washington, National Gallery of Art, 1955–56: German
Drawings, Masterpieces from Five Centuries (also The Cleveland Museum of Art; Boston, Museum of Fine
Arts; San Francisco, M. H. de Young Memorial Museum); catalogue by P. Halm, no. 100. – Munich, Staat-
liche Graphische Sammlung, in Haus der Kunst, 1956: Deutsche Zeichnungen 1400–1900 (also Ber-
lin–Dahlem, Kupferstichkabinett der ehem. Staatlichen Museen; Hamburg, Kunsthalle); cat. no. 113. –
Venice, 1959, (Disegni) cat. no. 35 (T. Pignatti), illus. – Berlin, 1966, cat. no. 161 (H. Möhle), fig. 158.

Literature: Aehrenlese auf dem Felde der Kunst, Erste Abtheilung: Originalhandzeichnungen [J. A. G.
Weigel collection] (Leipzig, 1836), p. 105, no. 706 (as E. Quellinus the elder). – *Catalog einer Sammlung
von Original-Handzeichnungen der deutschen, holländischen, flandrischen, italienischen, französischen, spa-
nischen und englischen Schule, gegründet und hinterlassen von J. A. G. Weigel in Leipzig* (Leipzig, 1859),
p. 140, no. 986. – O. Eisenmann, *Katalog der Kgl. Gemäldegalerie zu Cassel* (Kassel, 1888), p. 111, under
no. 169. – O. Eisenmann, *Ausgewählte Handzeichnungen älterer Meister aus der Sammlung Edward Habich*

141

zu Kassel, Lübeck, 1890, part III, pl. 11 (2nd ed., Leipzig, 1891, pl. 43). – Wurzbach, 1910, p. 76. – Peltzer, 1924–25, pp. 163–64. – Peltzer, in Thieme-Becker, XXIII, 1929, p. 286. – R. Hallo, «Die Geschichte des Kupferstichkabinetts und sein heutiger Bestand,» *Das Kupferstichkabinett und die Bücherei der Staatl. Kunstsammlungen zu Kassel . . .,* Kassel, 1931, p. 21. – E. Preime, «Das Kasseler Kupferstichkabinett (Übersicht über seine Bestände),» *Die Graphischen Künste,* N.S. IV, 1939, p. 148. – Steinbart, 1940, pp. 63–64, 146, *passim,* 164, pl. 21. – Steinbart, 1946, pp. 28, *passim,* 60, fig. 19. – Schilling, 1954, p. 34. – Martius, ca. 1955, pp. 9–10, no. 8, fig. 8. – N. Ivanoff, *I disegni italiani del seicento,* Venice, 1959, p. 137, pl. 12. – Steinbart, 1958–59, pp. 182–85, fig. 29. – F. G. Grossmann, *German Art 1400–1800 from Collections in Great Britain,* exh. cat., City of Manchester Art Gallery, 1961, no. 187.

L. S. R.

B 50 ALLEGORY OF CHRISTIAN FAITH Fig. 53

Pen and brown ink over brown and gray-brown wash, scant graphite indications (watermark: fragment), 15,3 × 9,4 cm. (6 × 3^{11}/$_{16}$ inches).

Signed, dated, and inscribed by the artist in ink: [above right] Alle Kunst undt widtz ist / eitel staub. / Hoch wiesheidt ist ann. / Christum gelaub (All art and cleverness are mere dust. The height of wisdom is to believe in Christ.); [lower right] Johan Liss / Mahler zu / Holsati[a], [bottom margin] Zu Rom den 19 martis A° 16 – [final numerals effaced] (Johan Liss, painter of Holstein / in Rome, 19 March, year 16 –). The cross, above left of center, and numerals along the upper right margin are later.

The Cleveland Museum of Art, Dudley P. Allen Fund.

Faith is personified as a woman with bared breasts and bare feet, symbolizing the message of the true faith, which is plain and pure and has no need to be clothed in devious phrases.[1] The crown, scepter, and book perhaps symbolize worldly power and knowledge lying, scorned, at her feet as she looks up to an urn from which smoke rises toward heaven.

Liss's Faith is an ideal woman of the robust Rubensian type. She is seated in front of an Italian landscape, with cypress trees, in a pose derived from Veronese's painting, *Vision of St. Helena* in the National Gallery, London. Veronese's painting was in turn based on an engraving by a follower of Marcantonio Raimondi, which was a copy of a drawing by Raphael.[2] The ornamental convolutions of Faith's robe, however, are in the Northern graphic tradition. The «pot-hook» form of the fold above her knee, which is an early sixteenth-century graphic convention, reminds us that Liss would have known Goltzius' engravings in the manner of Lucas van Leyden and Dürer. This mixture of elements from Italy and the Netherlands supports Steinbart's date of 1622, shortly after Liss's arrival in Rome. That Liss was then currently interested in etching (see cat. no. B 51) is indicated by his use here of strong, regular cross-hatchings to darken the shadows on the stone bench and on the ground behind Faith's foot; this graphic formula is not found in his other drawings. On the other hand, Liss's use of two different layers of ink in brown and gray, and the brilliant alternations of light and shadow, give the drawing the finished jewel-like quality of a little painting, even without the full range of color.

Steinbart[3] suggested that the drawing commemorates Liss's conversion in Rome to the Catholic faith on the date inscribed on the drawing. But, given the convention of the *album amicorum* drawing (see cat. no. B 48), Liss may well have chosen his subject not to

express a personal conviction but rather to dazzle an influential recipient with his ability and invention in a traditional subject of «high art.»

[1] *Art in Italy 1600–1700,* Detroit Institute of Arts, 1965, exh. cat. no. 194 (B. S. Manning).
[2] Prasse, 1953, p. 216; Manning, 1965, p. 170.
[3] Steinbart, 1940, pp. 11–12; 1946, pp. 13–14; 1958–59, p. 166.

Collections: Karl Eduard von Liphart (?); Freiherr Reinhold von Liphart, Dorpat (Lugt 1758); Dr. O. Feldmann, Brünn; Edmund Schilling, London; Purchased from Herbert Bier, 1953.

Exhibitions: The Cleveland Museum of Art, 1956: The Venetian Tradition, cat. no. 24. – Venice, 1959, (Disegni) cat. no. 33 (T. Pignatti), illus. – The Detroit Institute of Arts, 1965: Art in Italy 1600–1700, catalogue by B. S. Manning, *et al.,* no. 194, illus. – Washington, National Gallery of Art, 1974–75: Venetian Drawings from American Collections (also Fort Worth, Kimbell Art Museum; The St. Louis Art Museum), catalogue by T. Pignatti, no. 37, illus.

Literature: Benesch, 1933, p. 71, no. 625. – Steinbart, 1940, pp. 83, *passim,* 163–64, pl. 30. – Bloch, 1942, p. 45. – Steinbart, 1946, pp. 35, *passim,* 61, fig. 36. – Bloch, 1950, p. 281. – Benesch, 1951, pp. 376, 379. – L. E. Prasse, «A Drawing by Johann Liss,» *Bulletin of The Cleveland Museum of Art,* XL, 1953, pp. 215–16, illus. p. 219. – *The Cleveland Museum of Art Handbook,* Cleveland, 1958, illus. no. 583. – Schilling, 1954, pp. 30–33. – Steinbart, 1958–59, p. 166. – *Handbook of The Cleveland Museum of Art,* Cleveland, 1966 and 1968, illus. p. 114. – Klessmann, 1970, *(Kunstchronik),* p. 293.

L. S. R.

B 50a MERRY COMPANY WITH A FORTUNETELLER Fig. 52

Pen and brown ink, brush with ink washes, black chalk indications (holes and abrasions in paper, some pen restoration), 22,5 × 33,5 cm. (8⁷/₈ × 13³/₁₆ inches).

Lent by N. N. Collection, the Hague.

Despite its damaged surface this is one of the finest surviving drawings by Liss. It is comparable in the breadth and complexity of its composition, as well as in subject, to the paintings of the *Banquet of Soldiers and Courtesans* [A 15, A 16]. Attention centers on the ritual gesture of the gypsy fortuneteller who is reading the palm of the bearded soldier at the right. While the other soldier is engrossed in the account of his companion's hypothetical fortune, his own tangible fortune is stolen by the fortuneteller's light-fingered accomplice.

A Caravaggesque diagonal shaft of light divides the background more sharply than in the *Banquet* paintings, but the carefully modulated, varied ink washes describe an ambiance of shimmering highlights and luminous half-lights, accented by scattered dark shadows, that is quite unlike Caravaggio's distinct chiaroscuro. Liss repeated the embracing couple behind the table in the forefront of his later painting of the *Merry Company Outdoors* [A 33]. There is a pen and wash copy of the drawing in the Vienna Academy (Steinbart, 1940, p. 167).

Literature: A. Bredius, «Eine Zeichnung von Jan Lys,» *Kunstchronik,* N.S. XXIV, 1913, pp. 660–61, illus. p. 661. – Oldenbourg, 1914, p. 148. – Peltzer, 1914, p. 161. – Peltzer, 1924–25, p. 163. – Steinbart, 1940, pp. 71, 164, *passim,* pl. 24. – Steinbart, 1946, pp. 30, 60, fig. 23. – Schilling, 1954, p. 31. – Oehler, 1962, p. 105.

L. S. R.

B51 CEPHALUS AND PROCRIS Fig. 54

Etching (only state), 17,6 × 24,3 cm. (6¹⁵/₁₆ × 9⁹/₁₆ inches).
Signed with initials on the basket, lower right: J. L. fecit.

Hamburger Kunsthalle, Kupferstichkabinett.

This incident from the story of Cephalus and Procris[1] is rarely illustrated and therefore much less readily recognized than the frequently illustrated death of Procris from the same legend. Eos, goddess of the dawn, who was in love with Cephalus, told him his wife Procris was unfaithful. The goddess disguised Cephalus, who then wooed Procris by offering her costly presents. Thus tempted, Procris yielded, whereupon Cephalus revealed his true identity. Liss shows the moment of revelation in which Cephalus removes the mask and Procris reacts in anguish.

A comparison of this etching with the *Fool as Matchmaker* [B42] shows a decided advance in etching technique. Liss has learned to use a uniform etched line; he controls the degree of light and shadow by varying the space between the lines instead of varying the line itself. The effectiveness of this change is seen in a comparison of the curtains in the two etchings, or in the texture of the masonry wall near the curtain in *Cephalus and Procris* compared to the ambiguous shaded area behind the standing woman in the *Fool as Matchmaker*.

This is perhaps the most consciously Roman of Liss's works. It corresponds in many details to the drawing, *Allegory of Christian Faith* [B50] – the carefully finished hands and feet, for instance, and the shape of the balustrade – so that both clearly belong to the same time and place. Liss not only chose a classical subject for his second etching, but his composition takes a completely new direction. He seems to have embraced the concept of the symmetrical balance of contrasting forms of equal weight which Annibale Carracci perfected in his Galleria Farnese paintings (1597–1604) of the amorous adventures of the classical gods – one of which portrays Cephalus with Eos. Liss's protagonists are shown full-length, their gestures parallel to the picture plane, each occupying half of the page; the agitated outline of Cephalus is backed by angular masonry, and the static form of the seated Procris is set against background draperies.

In spite of its greater technical proficiency *Cephalus and Procris* is a less successful image than the *Fool as Matchmaker*. Nevertheless, it is fascinating as one experimental step toward the «ganz andere Art» (Sandrart) which Liss was to develop from his immersion in the art of Italy.

[1] Ovid, *Metamorphoses*, Book VII.

Literature: Burchard, 1912, p. 145, no. 1. – Oldenbourg, 1914, p. 139. – Peltzer, in Thieme-Becker, XXIII, 1929, p. 285. – Peltzer, 1933, p. XXXIII, fig. 3. – Steinbart, 1940, pp. 84–85, 164, pl. 31. – Bloch, 1942, p. 41. – Steinbart, 1946, pp. 31, *passim*, 61, fig. 28. – Schilling, 1954, p. 34. – Steinbart, 1958–59, p. 159. – F. G. Grossmann, *German Art 1400–1800 from Collections in Great Britain*, exh. cat., Manchester, 1961, no. 212. – Klessmann, 1970 *(Kunstchronik)*, p. 293.

 L. S. R.

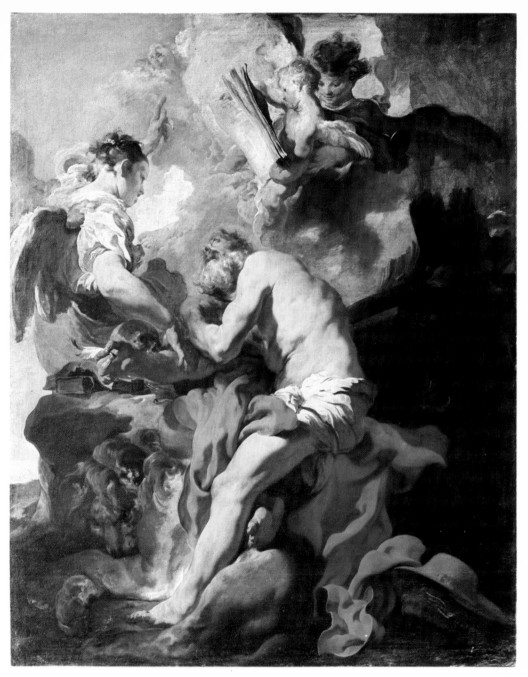

IX Vision of St. Jerome · S. Nicolò da Tolentino, Venice [A 39]

B 52 STANDING WOMAN WITH DRAPERY Fig. 55

Pen and brown ink over pale tan and grayish wash, graphite indications, 15 × 9,5 cm. (5⁷/₈ × 3⁷/₈ inches).
Inscribed on verso «Gaetano Gandolfi» and «Caro Arpinus» as well as other notations.

Dr. Efim Schapiro, London and Paris.

This is one of a pair of small drawings of artfully posed figures clothed in floating drapery
which remained together until they were dispersed from the Witt collection. The counter-
part of the exhibited drawing is a male figure.[1] The pair have been described as allegorical
personifications, and this drawing is sometimes identified as Spring. Schilling pointed out
the resemblance of the woman's costume to that of Cephalus in Liss's etching [B 51], and
he noted the similar poses of the nymphs in the *Toilet of Venus* [A 28]. Steinbart called
attention to the similarities of the graceful nymphs in *Venus and Adonis* [A 25] and the
Fall of Phaeton [A 26] and suggested an influence from the drawings of Ludovico
Carracci (1555–1619). All of these suggestions combine to place the drawing in Liss's
Roman period.

[1] Reproduced, Schilling, fig. 2, and Steinbart (1958–59), fig. 33.

Collections: Rudolf Philip Goldschmidt, Berlin (Lugt 2926; sale: Frankfurt, Prestel, October 4–5, 1917,
no. 121 [two drawings]); Dr. Benno Geiger, Vienna; Sir Robert Witt, London.

Exhibitions: Manchester, City of Manchester Art Gallery, 1961: German Art 1400–1800 from Collections
in Great Britain, cat. no. 213. – Berlin, 1966, cat. no. 162 (H. Möhle), fig. 157.

Literature: Schilling, 1954, p. 34, illus. p. 32, fig. 3. – Steinbart, 1958–59, pp. 186–87, fig. 32. – L. Borgese,
Disegni italiani e stranieri del cinquecento e del seicento, Milan, 1960, p. 75.

 L. S. R.

B 53 THE DEATH OF PHAETON Fig. 56

Pen and brown ink over brush with brown and gray wash, over graphite sketch, 19,7 × 29,6 cm.
(7³/₄ × 11¹¹/₁₆ inches).
Inscribed in pen on verso in seventeenth-century handwriting: Z gl 6 ch [2 gulden, 6 pfennig].

Herzog Anton Ulrich-Museum, Braunschweig.

In this important, newly discovered drawing, the goddess of earth still stands as a
petitioner in the clouds before Jupiter although the god has already cast his thunderbolt
and hurled down the reckless Phaeton from the sun chariot. Weeping putti stand over the
smoking corpse in the foreground. Naiads cling to each other below at the left, and Nep-
tune (or perhaps the personification of the river Eridanus) is seated on the right.

> Here lie the reins, there the axle torn from the pole . . . and fragments of the
> wrecked chariot are scattered far and wide. But Phaeton, fire ravaging his ruddy
> hair, is hurled headlong and falls . . . far from his native land . . . The Naiads
> in that western land consign his body, still smoking with the flames of that
> forked bolt, to the tomb . . .[1]

The swan reined by a putto at the left may have been suggested by earlier illustrations of

the legend, which showed either Ovid's Cygnus – who became a swan while mourning Phaeton's death[2] – or the flock of swans which Philostrates[3] described as setting out from the river Eridanus to sing of Phaeton throughout the earth.

We owe the recovery of this charming composition to Rüdiger Klessmann, who found it in the Braunschweig collection under the name of Johann Wilhelm Bauer.[4] The drawing has the static appearance of a *ricordo,* and therefore presupposes a painting which, because of its composition, must be considered earlier than the *Fall of Phaeton* [A 26]. The trio of naiads – or water nymphs – is a first formulation of the beautiful group Liss developed in the *Fall of Phaeton.* They appear to be related as well to the dancing naiads in the background of *Venus and Adonis* [A 25] and to Venus with her attendants in the *Toilet of Venus* [A 28]. The fallen Phaeton and the two putti bending over him presage the *Mourning for Abel* [A 36].[5]

The composition of the *Death of Phaeton* is open and spacious compared to the Berlin [B 45], and Munich [B 47] *ricordo* drawings. The figures are relatively smaller and share the picture space equally with great spirals of smoke and clouds that, at the right, open dramatically to a vista curtained by rainfall. With the existing, later Phaeton painting in mind, one cannot but wonder what glowing colors may be represented by the swirling ink washes filling fully half the page.

[1] Ovid, *Metamorphoses,* Book II, transl. F. J. Miller, New York and London, 1916, lines 316–325.
[2] Ovid, Book II.
[3] Philostrates, Book I, Chapter 11.
[4] Born in Strassburg 1600, lived in Italy ca. 1626 to 1637, died in Vienna 1640.
[5] Observation of Ann Tzeutschler Lurie.

Collection: In Braunschweig before 1806, taken to Paris for Musée Napoleon, returned to Braunschweig after 1816 (Paris inventory, H80, no. 144, «Wiliam Baur, Venus demandant une grace à Jupiter»).

Exhibitions: Warsaw, National Museum, 1974: Sztuka Baroku w Niemczech, ze Zbiorów Herzog Anton Ulrich-Muzeum w Brunszwiku; catalogue by R. Klessmann, no. 74, fig. 34. – Braunschweig, Herzog Anton Ulrich-Museum, 1975: Deutsche Kunst des Barock; catalogue by R. Klessmann, no. 86.

Literature: R. Klessmann, publication in preparation.

L. S. R.

B 54 NUDE WOMAN STANDING Fig. 61

Black and red-brown chalk with yellow, green, and white (?) wash on buff paper (watermark: oval enclosing monogram of Christ surmounted by cross), 39,2 × 25,3 cm. (15⁷/₁₆ × 9¹⁵/₁₆ inches).
Inscribed in pencil, lower left corner, a monogram of the initials AP, and at the lower right: 10.

Fitzwilliam Museum, Cambridge, England.

This drawing which previously had been ascribed to Watteau and to Rubens, was recently attributed to Liss by Michael Jaffé. As the two black chalk drawings [B 46, B 49] by Liss differ from the Fitzwilliam drawing and from each other in purpose, it is difficult to find a basis for comparison. The *Nude Woman Standing* is proposed as one of the life drawings that from Sandrart's account (see Documentation) we know Liss made at the artists'

academy in Venice, drawings on which he based the graceful and life-like nymphs and goddesses of his paintings. The plump fist of the model can be compared to the hand of the angel in the *Decision of Magdalene* [A 17]. The pink coloring of the woman's cheeks, hands, and chest conform to Liss's paintings, where we often see a similar realism in the coloring of skin normally exposed to sunlight and weather. The pale green wash used for half-shadows on the legs, and the observation of light and reflected light as modeling agents, accord with Liss's use of color and light in his paintings. As a proposed addition to Liss's oeuvre the drawing should appear early in the second Venetian period, close to the *Finding of Moses* [A 30].

Collections: Leo Franklyn, London; Kurt Meissner, Zurich. Purchased 1973.

L. S. R.

B 55 MANIUS CURIUS DENTATUS REFUSING THE SAMNITE TREASURE Figs. 57, 58

Pen and brown ink over brush and warm brown wash shading to gray, with touches of brush and gray-brown ink (yellow-green on plant upper left added by another hand);
35,4 × 54 cm. (13¹⁵/₁₆ × 19⁷/₈ inches).
Inscriptions top right in pen and brown ink, the name JLis(s?) with the two capital letters combined, various trials of the monogram J L, and some illegible words in cursive script.
Verso (not exhibited): *The Elephant of Pyrrhus in Battle Against the Romans*. Pen and brown ink over brush and pale brown wash. In pencil upper right, 2.

Graphische Sammlung Albertina, Vienna.

Though it is undoubtedly from Roman history, the subject of the exhibited drawing is not clear. The verso scene can be more easily identified because it includes Plutarch's terrible war elephant of Pyrrhus.[1] As the subject for the recto, two other stories from Plutarch have been suggested: the consul Manius Curius Dentatus refusing gold from the defeated Samnites, saying that he would rather rule those with gold than own it himself;[2] and the dictator Camillus, who, finding the tribunes about to ransom Rome from Brennus and the besieging Gauls, ordered the Gauls away with their scales and measures, saying Rome should be delivered not by gold but by iron.[3] The peculiarly shaped box in the background might even contain Pyrrhus' elephant, according to yet another subject from Plutarch in which Caius Fabricius, after a defeat at the hand of Pyrrhus, was negotiating an exchange of prisoners on behalf of the Romans and in the process refused a large bribe. Pyrrhus arranged for an elephant to be hidden and to roar suddenly behind Fabricius, who merely smiled and said that he was not moved by either Pyrrhus' gold or his beast.[4]
The page corresponds in size to the drawing of the *Fall of Phaeton* [B 56], suggesting that the two sheets came from the same album.[5] In both drawings, figures appear in extreme foreshortening, animated by expressive hand gestures as in such paintings of Liss's second Venetian period as *St. Paul* [A 38] and *St. Jerome* [A 39], and both show the artist experimenting with designs for ceiling decoration. The wall and ceiling paintings of the Doge's Palace, many of which date from the decade following the disastrous

147

fires of 1574 and 1577, when the Venetian painters of that splendid generation were engaged for the renovátion, may have served as models for the drawings. The great horse in the Vienna drawing is not unlike the one in the foreground of Veronese's *Venice Triumphant,* which dominates the ceiling of the Sala del Maggior Consiglio. A prototype for the bizarre costume of Liss's soldiers may be found on the north wall in Federico Zuccaro's painting, the *Emperor Barbarossa Kneeling Before the Pope;* the standing soldier at the right wears similar, late mannerist armor with the same fish-scale coat of mail. On the other hand, the pictorial schemes of both recto and verso most resemble the battle scenes by Tintoretto and his studio that decorate the ceiling soffits of the same great hall.

The drawing was attributed to Liss by Benesch (1928) when he acquired it for the Albertina. Steinbart (1940) rejected the attribution but was won over (1958) by Schilling's essay on the drawings of Liss. Benesch (1933) had attributed the drawing on the basis of the inscription, the modeling in washes – which he compared to the *Fighting Gobbi Musicians* [B 48], the *Allegory of Christian Faith* [B 50], and the *Peasant Wedding* [B 47] – and the similarity of the forms to those in the paintings, *Cursing of Cain* [A 34] and *Temptation of St. Anthony* [A 37]. Benesch read the name in the inscription as «Lys» and indicated the anomaly of the Dutch form of the name in Liss's Italian period. Schilling pointed out that the spelling must be read as Lis or Liss because of a dot clearly inscribed over the vowel.

[1] Plutarch, *Lives:* Pyrrhus.
[2] Benesch, 1933, p. 71. Plutarch, *Essays:* Roman Apothegms.
[3] O. Benesch, *Meisterzeichnungen der Albertina,* Salzburg, 1964, p. 346. Plutarch, *Lives:* Camillus.
[4] Plutarch, *Essays:* Roman Apothegms.
[5] Schilling, p. 35.

Exhibitions: Venice, 1959, (Disegni) cat. no. 36 (T. Pignatti), illus. (recto and verso). – Berlin, 1966, cat. no. 163 (H. Möhle), fig. 163. – Vienna, Albertina, 1968–69: Jacques Callot und sein Kreis, catalogue by E. Knab, no. 767, pl. 53.

Literature: O. Benesch, [Albertina, recent acquisitions], *Pantheon,* I, February, 1928, p. 114. – Peltzer, 1933, p. XXXIII, fn. 4. – Benesch, 1933, no. 625; illus, vol. V, pl. 177. – Steinbart, 1940, p. 186. – Schilling, 1954, pp. 34–35, fig. 4 (verso). – Steinbart, 1958–59, pp. 196–97, figs. 43, 44. – Janos Scholz, «Notes on Old and Modern Drawings, Sei- and Settecento Drawings in Venice: Notes on Two Exhibitions and a Publication,» *The Art Quarterly,* XXIII, 1960, p. 54. – O. Benesch, *Meisterzeichnungen der Albertina,* Salzburg, 1964, [English edition: *Master Drawings in the Albertina,* Greenwich, Conn., n. d.], pp. 346–47, no. 105, fig. 105 (recto). – W. Stubbe, *Zeichnungen alter Meister aus Deutschem Privatbesitz,* exh. cat., Hamburg, Kunsthalle, 1965, no. 73.

L. S. R.

B 56 THE FALL OF PHAETON Figs. 59, 60

Pen and brown ink over gray ink wash and faded color washes, 33,5 × 52,8 cm. (13³/₁₆ × 20⁷/₈ inches). Inscribed in pen and brown ink, Alexander (?) and letter trials, including several of the letter Y; in another hand, top center, «55.»
Verso: Another version of the same subject in pen and brown ink over slight graphite indications. Inscribed: [lower left corner] jfl (1 florin); [above left] 55.

Private collection.

Two versions of the *Fall of Phaeton* (see also cat. nos. A 26 and B 53) are tried on the two sides of this large page, which may come from the same album as the large Albertina drawing [B 55] (Schilling, p. 35). In both drawings Phaeton is shown in the careening sun chariot, the bottom of the page is filled with the suffering inhabitants of the earth, and Jupiter appears at the upper left. The verso drawing also includes a figure who may be Tellus, goddess of earth, who gestures imploringly toward Phaeton. The drawing on the recto is an amalgam of circular forms that combine to suggest a spinning vortex, surrounded by billowing clouds. The *Phaeton* drawings on both sides of the page, even more than the Albertina drawing, seem to be designed as ceiling decoration. It would not be surprising that an artist so adept at foreshortening would try his hand at this challenging compositional problem, if only on paper, although no ceiling designs by Liss are anywhere recorded or even mentioned. There is, however, the description by Selva of a horizontal *Phaeton* painting in the Algarotti collection (Documentation VI, 23)[1] which, although it fits neither side of the exhibited drawing exactly, might have evolved out of such preliminary drawings and certainly suggests the artist's continuing interest in the subject.

According to Edmund Schilling, who first published this *Phaeton,* it was attributed to Liss by Otto Benesch.

[1] Selva also describes two unknown paintings by Liss of mythological subjects, Apollo in his chariot, and a Venus and Mars discovered by Vulcan.

Exhibitions: Hamburg, Kunsthalle, 1965–66: Zeichnungen alter Meister aus deutschem Privatbesitz (also Stuttgart and Bremen), cat. no. 73, fig. 121. – Berlin, 1966, cat. no. 164 (H. Möhle), fig. 162.

Literature: Schilling, 1954, pp. 35–37, figs. 5a (recto), 5b (verso). Steinbart, 1958–59, pp. 197–98, figs. 45 (recto), 46 (verso). – Venice, 1959, exh. cat., p. 169, no. 36 (T. Pignatti). – E. Knab, *Jacques Callot und sein Kreis,* exh. cat., Vienna, Albertina, 1968–69, p. 238, no. 767.

L. S. R.

ADDENDUM

B 56 a Life Study for a Nymph in THE FALL OF PHAETON (shown in Cleveland only) Fig. 61 a

Black chalk heightened with white on gray paper, 25,3 × 18,3 cm. (10 × 7¼ inches).

Private collection, Paris

This drawing was identified by its owner on viewing the exhibition in Augsburg.

C. Selected Drawings and Prints after existing or lost works by Johann Liss

Late seventeenth-century imitator of Castiglione

C57 THE FINDING OF MOSES (copy of a painting by Johann Liss) Fig. 63

Pen and brown ink with brush and oil, 27,1 × 17,8 cm. (10^{11}/$_{16}$ × 7 inches).

Trustees of The British Museum, London.

This drawing is the only known replica in any medium of Liss's painting in Lille [A 30]. The copyist elongated the proportions of the figures, omitted the women at the right, and concentrated his attention on facial expressions and on such surface delights as the hair, the soft skin, and the rich clothing of the princess and her court attendants. The use of brush and oil color for the drawing suggests that the artist was an admirer of the drawings of Giovanni Benedetto Castiglione (ca. 1610–1663/5), to whom the drawing was once attributed. K. T. Parker considered the drawing to be a study by Liss for the Lille painting, and Hind so published it in the British Museum drawing catalogue. Steinbart (1940) rejected the attribution.

Ann Percy (correspondence, Fall 1974) agrees that the drawing might be by an imitator of Castiglione,[1] though the use of pen and ink for isolated details in combination with the brush and oil is an unusual feature.

[1] From a photograph Percy suggests the copyist found in Milan and Boston (A. Percy, *Giovanni Benedetto Castiglione*, Philadelphia Museum of Art, 1972, exh. cat., p. 66, no. 8).

Collection: Bequest of George Salting, 1910.

Literature: Hind, 1931, p. 151, Add. 1, pl. LXXV. – Steinbart, 1940, pp. 185–86.

L. S. R.

ANONYMOUS, early seventeenth century

C58 MORRA GAME IN THE GUARD ROOM (copy of a drawing by Johann Liss) Fig. 64

Pen and brown ink over brown and gray ink wash, backed; 20,6 × 32,7 cm. (8¹/₈ × 12⁷/₈ inches).

Honolulu Academy of Arts, Purchase C. Montague Cooke Jr. Fund, 1956.

This drawing lacks the confident execution of Liss's own works, but the similarity to Liss's subjects and drawing style supports the argument that it is a close copy of one of his drawings. Sandrart in his description of Liss's paintings of «soldiers in armor, with Venetian courtesans,» implied more than one rendering of the subject, of which, as Klessmann points out, the *Banquet of Soldiers and Courtesans* [A 15, A 16] exemplifies the masterwork. The number of drawing copies of the *Banquet* attests to its popularity, as does the preservation of two large paintings of the subject which, as Klessmann reveals, incorporates traditional moral and religious iconography in its joyfully sensual tableau.

As there are fewer figures in the *Morra Game in the Guard Room,* the drawing may represent a variation of the subject devised by Liss for a cabinet-size painting. The drawing of the *Merry Company with a Fortuneteller* [B 50a] – a drawing of such confidence and authority, despite its damaged surface, that Liss's authorship is beyond question – is a third variation of the soldiers and courtesans theme. The tilted head of the seated soldier with a wine glass in the Honolulu drawing corresponds to the head of the soldier in a plumed hat in the *Fortuneteller,* and the dogs in the two drawings are similar. But in execution, the Honolulu drawing lacks vitality; there is an oversimplification on the one hand and a fussy, layered hatching on the other, whereby it suffers in a comparison with the *Fortuneteller.*

Literature: Art Quarterly, XIX, 1956, p. 422, illus. p. 423. – Steinbart, 1958–59, pp. 179–80, fig. 23. – Berlin, 1966, exh. cat., p. 122 (H. Möhle).

L. S. R.

ANONYMOUS, seventeenth century

C59 THE TOILET OF VENUS (copy after Johann Liss) Fig. 62

Pen and black ink, gray wash (watermark: grapes), 40,2 × 26,2 cm. (15¹³/₁₆ × 10⁵/₁₆ inches).

Trustees of The British Museum, London.

This is a drawing copy of a version of the *Toilet of Venus* which is otherwise unknown. The head of the putto below is hidden in the shadow of the drapery as in the Uffizi painting [D 4], and a pair of doves is seen in the foreground as in the Pommersfelden version [A 28]; but here the lower of the two flying putti face frontwards and a girl

with a flower basket (reminiscent of the basket in *Cleopatra* [A 18]) appears under Venus' outstretched arm. Steinbart (1940, p. 41) suggests that the drawing may have been done after a preparatory study by Liss which was modified in the final painted version. On the other hand, it may be a copy of another painting by Liss, now lost.

Collection: Sir Hans Sloane, London.

Literature: Hind, 1931, p. 151. – Steinbart, 1940, pp. 91, 166, fig. 36. – Steinbart, 1956, p. 56.

L. S. R.

ABRAHAM BLOOTELING Born in 1640 in Amsterdam, died there in 1690. Blooteling was a pupil of Cornelis van Dalen and worked in both engraving and mezzotint. He was in England between 1672 and about 1676, but is not otherwise known to have traveled beyond the Netherlands.

C 60 THE ANNUNCIATION (copy of a lost painting by Johann Liss) Fig. 67

Engraving, 33,6 × 26,2 cm. (13^{1}/$_4$ × 10^5/$_{16}$ inches).
Inscribed in plate: [bottom margin, six lines of Latin verse] Salve Virgo Maria, parens . . . hic quod agat: R. W.; [bottom margin, at right] J. Lis. pinx / A. Blooteling.

Staatliche Museen Preussischer Kulturbesitz, Kupferstichkabinett, Berlin.

As Oldenbourg (1914) and Peltzer (1929) noted, the lost original must have been painted during Liss's Roman period, a judgment which the composition and the strong, simple architecture of the setting confirm. Steinbart (1940, p. 168) expressed doubt that the lost painting was by Liss, then (1946, p. 40) reversed his earlier opinion, noting that behind the conventional appearance of Blooteling's engraving Liss's style can be recognized. Steinbart cited the angel as a forerunner of the angel in the *Vision of St. Jerome* [A 39]. One can imagine that the Virgin in Liss's *Annunciation* resembled the Magdalene of the Dresden painting [A 17], with the dark curl of hair over her shoulder and the characteristic tilt of the head. Liss's own etching of *Cephalus and Procris* [B 51] offers sufficient formal correspondence to the engraving to confirm that the *Annunciation* is based on a work of Liss's Roman period (Klessmann).

Literature: J. E. Wessely, «Abraham Blooteling, Verzeichnis seiner Kupferstiche und Schabkunstblätter,» *Archiv für die Zeichnenden Künste*, R. Naumann, ed., XIII, 1867, p. 30, no. 58. – Oldenbourg, 1914, p. 150. – Peltzer, in Thieme-Becker, XXIII, 1929, p. 286. – Steinbart, 1940, pp. 124, 167–68, pl. 70. – Steinbart, 1946, p. 40. – Hollstein, II, p. 204, no. 62, repr. – Hollstein, p. 148, no. 1. – Steinbart, 1958–59, pp. 177–78, fig. 22. – Klessmann, 1970 *(Kunstchronik)*, p. 293.

L. S. R.

CORNELIS DANCKERTS Born ca. 1603, died in Amsterdam before 1656. Danckerts was a printmaker and publisher, and frequently reproduced the work of others in his prints. Jakob von Sandrart, nephew of Joachim von Sandrart, studied engraving under him for four years.

C 61 GALLANT COUPLE WITH CHERRIES (copy of a lost drawing by Johann Liss) Fig. 66

Etching, 27,7 × 19,2 cm. (10⁷/₈ × 7⁹/₁₆ inches) to borderline
Inscription in plate: Johan: Lis jnv. / C. Danckertz fecit / et excud.

Graphische Sammlung Albertina, Vienna.

The three-quarter-length, close-up view of the couple indicates a work of Liss's Haarlem period, and the blank background suggests that the original was a drawing. The woman's gesture of half-hearted rebuff is similar to that of the seated woman in the *Fool as Matchmaker* [B 42] (Steinbart, 1940); indeed, the same woman appears to have served as model for both Liss's own etching and for the drawing copied in this etching.

Literature: G. K. Nagler, *Die Monogrammisten . . .*, V, Munich and Leipzig, 1879, p. 396 (Valckert). – Würzbach, 1910, p. 77, no. 11. – Burchard, 1912, p. 50, fn. 3, p. 146, no. 2. – Peltzer, in Thieme-Becker, XXIII, 1929, p. 285. – Peltzer, 1933, pp. 33–34, fig. 2. – Steinbart, 1940, pp. 48–49, *passim*, 168, pl. 14. – Steinbart, 1946, p. 25, *passim*, 59, fig. 14. – Hollstein, p. 148, no. 2. – Steinbart, 1958–59, p. 159.

L. S. R.

NICOLAS DE SON Two etchings by De Son made from his own drawings of the church of St. Nazaire and the cathedral in Reims, both dated 1625, are the only documentation of where and when he lived. Most of his etchings reproduce works by Callot and Vignon.

C 62 THE GARDEN OF LOVE (copy of a lost work by Johann Liss) Fig. 65

Etching, 18,3 × 26,6 cm. (7³/₁₆ × 10¹/₂ inches) to borderline.
Inscribed in plate, lower left corner: I. L. Jnv. N. de Son Sc.

Graphische Sammlung Albertina, Vienna.

The Garden of Love had become a popular subject of secular painting by the end of the sixteenth century. Its antecedents are found in decorative arts and prints from the fifteenth century onward and encompass both scenes of courtly love and portrayals of the fountain of youth. Rubens' painting of the *Garden of Love* in the Prado[1] is the culmination of the tradition, and Steinbart (1946, p. 25) notes that both Rubens and Liss drew their subject from the same source, that is, the school of Haarlem. An interesting parallel in the work of a Haarlem contemporary is a vignette in the background of Frans Hals's *Married Couple in a Garden*,[2] which also shows a couple promenading in the hedged garden of a villa with a second couple standing behind a baroque fountain nearby.

153

Steinbart (1940, p. 45) suggested that the setting of the etching reflects the Venetian enclosed pleasure garden. If so, the garden was not yet known to Liss at first hand, for the lost model, whether a painting or perhaps a *ricordo* drawing of a painting, belongs with the drawing of the *Merry Company with a Gallant Couple* [B 45], and the *Fool as Matchmaker* [B 42], close to Liss's Haarlem experience and probably before the paintings of the *Gallant Couple* [A 6, A 7]. Besides, as Klessmann states (cat. no. A 6), the building and landscape may not copy Liss's original so faithfully as do the figures, which reveal Liss's hand in spite of the intervention of De Son's own style.

The lack of biographical information for De Son makes speculation about his contact with Liss's work pointless. Furthermore, as Steinbart says (1940, p. 8), it is reasonable to suppose that a Liss painting or drawing could have been brought by someone else to the location where it was seen and copied by the French artist.

[1] A. Rosenberg, *P. P. Rubens, des Meisters Gemälde*, «Klassiker der Kunst,» Stuttgart and Berlin, 1921, p. 348.

[2] Amsterdam, Rijksmuseum. About 1622. Reproduced S. Slive, *Frans Hals*, II, London, 1970, plates 33 and 35.

Literature: C. LeBlanc, *Manuel de l'amateur d'estampes*, III, Paris, 1888, p. 566, no. 17. – Burchard, 1912, pp. 51, 146, no. 1. – Peltzer, 1933, p. XXXIII, n. 4. – *Allgemeines Lexikon der Bildenden Künstler*, XXXI, ed. U. Thieme and F. Becker, Leipzig, 1937, p. 274. – Steinbart, 1940, pp. 45–47, *passim*, 168, pl. 13. – Steinbart, 1946, pp. 24–25, *passim*, 59, fig. 13. – Bloch, 1950, p. 281. – Steinbart, 1958–59, p. 160. – Berlin, 1966, exh. cat., p. 121, no. 160 (H. Möhle).

L. S. R.

JEREMIAS FALCK Born in Danzig about 1620, died there in 1677. During Falck's active years as an engraver of portraits, reproductions, and fashion plates, he moved frequently in search of employment. Around 1640–45 he was in Paris, from 1649–55 he worked in Stockholm, and he had been in Hamburg and Copenhagen before working on the *Cabinet Reynst* in Amsterdam. How long he stayed in Amsterdam and how soon he left after Reynst's sudden death in 1658 is not known. Falck worked again in Hamburg before returning to Danzig in the final decade of his life.

C 63 THE ECSTASY OF ST. PAUL (copy of the painting by Johann Liss)

Engraving and etching.
State I. 41,9 × 29,1 cm. (16¹/₂ × 11⁷/₁₆ inches).
State II. 41,2 × 28,8 cm. (16¹/₄ × 11⁵/₁₆ inches). Fig. 68
Inscribed in plate: [bottom margin, two lines of Latin text] Paulus raptus in tertium usque Coelum . . .
2 Corint: 12 2.; [at left] Johannes Lis pinxit.; [at right] Nichol: Visscher excud.; [bottom center] Cum Privilegio Ordinum Hollandiae et Westfrisiae.

Rijksprentenkabinet, Rijksmuseum, Amsterdam.

Falck's engraving reproduces the Liss painting [A 38] in reverse. In the second state, not only was the explanatory text added in the bottom margin,[1] but the upper right corner

of the plate was reworked, perhaps because the exact copy of Liss's painting seemed over-crowded when translated into engraving in the first state.

The engraving was made for the wealthy Amsterdam merchant, Gerrit Reynst,[2] who had an ambitious plan to publish his extensive private collection of paintings, sculpture, and antiquities in engraved reproductions, a project on which several artists were at work when Reynst drowned in an Amsterdam canal in 1658. Eventually, however, between 1660 and 1671, engravings for the *Cabinet Reynst* were published in two sections, one of sculpture and another of paintings. It can be assumed that the editions of the prints with the marginal text were printed toward the end of this period and that the upper right corner of the plate of *St. Paul* was altered on instructions from the publisher, Nicolas Visscher, to enhance the appearance of the print.

[1] Block quotes a different text for this engraving, which in another catalogue would suggest the existence of an additional state, but unfortunately, Block's catalogue is highly unreliable.

[2] See also under cat. no. A 15.

Literature: J. Wussin, *Cornel Visscher,* Leipzig, 1865, p. 273, no. 18. – J. C. Block, *Jeremias Falck, sein Leben und seine Werke,* Danzig, 1890, pp. 43–44, no. 26. – Oldenbourg, 1914, p. 162. – Peltzer, 1914, pp. 163–64. – Peltzer, in Thieme-Becker,XXIII, 1929, p. 286. – Gelder, 1937, pp. 91–95, fig. 2. – Steinbart, 1940, pp. 128, 168, fig. 56. – Steinbart, 1946, p. 63. – Hollstein, VI, p. 211, no. 26. – Hollstein, p. 148, no. 4. – E. Reynst, «Sammlung Gerrit and Jan Reynst,» unpublished dissertation, n. d. p. 13, no. 16, p. 20, n. 12. – Berlin, 1966, cat. no. 49 (Klessmann).

L. S. R.

C 64 DREAM OF ST. PETER Fig. 69
 (copy of a painting by Domenico Fetti, or of a lost painting by Johann Liss)

State II. Engraving and etching (watermark: Strassburg lily), 41,2 × 28,8 cm. (16¹/₄ × 11⁵/₁₆ inches).
Inscribed in plate [bottom margin, two lines of Latin text] Petrus in mentis excessu vidit . . . Coeli consideravit. Actorum 11.5.6; [at left] Johannes Lis pinxit.; [at right] Nicol: Visscher excud.; [bottom center] Cum Privilegio Ordinum Hollandiae et Westfrisiae.

Rijksprentenkabinet, Rijksmuseum, Amsterdam.

The design of the Fetti painting is reversed in this engraving which was made for the *Cabinet Reynst* as a pendant to cat. no. C 63. This is the second of a probable three states. The first state has no text; an impression in Zurich[1] has the marginal text and also the signature, «J. Falck sculp.,» engraved on the light patch of ground under the open book. No changes were made in the image, which even in the first state differs from the Fetti painting in important background details, thus suggesting it might reproduce a lost painting (see cat. no. A 38). On the other hand, errors of information commonly occur in the text of reproductive engravings, and the interruption of the *Cabinet Reynst* publication in 1658 resulted in a more than ordinary opportunity for error by the time the text was engraved on the plates.[2]

[1] Graphische Sammlung der Eidgenössischen Technischen Hochschule.

[2] Another Reynst collection engraving by Falck (Block 156) on which Liss is named as the painter, reproduces a Strozzi painting *(Old Woman Before a Mirror)* now in the Pushkin Museum, Moscow.

Literature: J. Wussin, *Cornel Visscher,* Leipzig, 1865, p. 274, no. 1. – J. C. Block, *Jeremias Falck, sein Leben und seine Werke;* Danzig, 1890, p. 45, no. 29. – Oldenbourg, 1914, p. 162. – Peltzer, 1914, p. 164. – Peltzer, in Thieme-Becker, XXIII, 1929, p. 286. – Gelder, 1937, pp. 91–95, fig. 1. – Steinbart, 1940, pp. 128, 168, fig. 57. – Hollstein, VI, p. 211, no. 26. – Hollstein, p. 148, no. 5. – E. Reynst, «Sammlung Gerrit und Jan Reynst,» unpublished dissertation, n. d., p. 12, no. 15, p. 20, fn. 11. – *Katalog der Gemäldegalerie,* Vienna, Kunsthistorisches Museum, 1965, p. 53, no. 531.

L. S. R.

JEAN HONORÉ FRAGONARD Born in Grasse, 1732, died in Paris, 1806. Fragonard was a student at the French Academy in Rome, 1756–1761. He traveled with the Abbé de Saint-Non in 1761, drawing Italian views and sculpture and paintings in Italian collections, some of which were etched by Saint-Non for publication in *Fragments choisies dans les peintures . . . de l'Italie* (1771–74) and *Griffonis . . .* (1790).

C65 SACRIFICE OF ISAAC (copy of the painting by Johann Liss) Fig. 71

Black chalk, 29,4 × 20,3 cm. (11⁹/₁₆ × 8 inches).
Inscribed lower left in pencil: Livio meus. Palais Pitti. In another hand (?): Florence / Giov. Lys –. At right in pencil by a third hand: Jean Lys.

Trustees of The British Museum, London.

The inscription indicates that either Liss's painting, the Uffizi version [A 35], was attributed to Livio Meus (Lieven Mehus, Oudenaarde 1630–Florence 1691) in the eighteenth century or that there was a copy of the painting by Mehus and Fragonard did not have access to the original. On the whole the drawing is a faithful reproduction but it is nevertheless filtered by Fragonard's perception. Like other copyists, Fragonard ignored the asymmetry of the painting, with the distant vista on the right weighed against the figures on the left, and made the drama central. He loosened the compositional bond between Isaac and the other two figures by shifting him toward the right, so that Isaac's head no longer lies below Abraham's outstretched hand. Fragonard took pains to interpret textures and to indicate how forms emerge through nuances of light, and by means of the patches of shading in varying density of chalk to give an indication of the richness of the painted surface. The *Sacrifice of Isaac* is not one of the subjects reproduced in etching by Saint-Non.

Collection: Sir Samuel Rush Meyrick (1783–1848) and heirs. Gift of Mrs. Spencer Whatley, 1936.

Literature: E. Senior, «Drawings Made in Italy by Fragonard,» *The British Museum Quarterly,* XI (1936), pp. 5–9 (describes gift of seventy-one drawings).

L. S. R.

MICHAEL HERR Born in Menzingen (Württemberg) in 1591; died in Nürnberg in 1661. Herr was probably trained in Nürnberg, traveled early to Venice and Rome, and returned to Nürnberg by 1620.

C 66 THE VISION OF ST. JEROME (copy of a painting by Johann Liss) Fig. 72

Pen and black ink, gray wash, on yellow tinted paper, white (oxidized) highlights; 25,2 × 19,5 cm. (9^{15}/$_{16}$ × 7^{11}/$_{16}$ inches).
Lower right corner, remains of monogram: MH. Inscribed on verso: [left] Schitza vom Cardinals . . . (?) / auf d. Rathauss, [right, in another hand] St. Hieronymus vom Sing . . . zu Venedig / 485.

Herzog Anton Ulrich-Museum, Braunschweig.

It is probable that Michael Herr did not travel a second time to Venice and that his drawing is not of the S. Nicolò da Tolentino painting [A 39] but of a version in Nürnberg. The first inscription of the back of the drawing may refer to the lost painting once owned by Sandrart that hung in the Nürnberg Rathaus in 1711[1] [A 39: Copy, Schloss Schleissheim]. The two heads sketched at the top left of the page, unrelated to the subject and quickly noted in the only blank space available, add an unexpected note of spontaneity.
Christian von Heusinger assigned the drawing to Michael Herr and discovered the remaining trace of Herr's monogram. A pen and ink paraph on the back of the drawing also appears on two other drawings by Herr in the Braunschweig collection.

[1] Peltzer, 1914, p. 164.

L. S. R.

JOHANN MELCHIOR SPILLENBERGER Active in Augsburg in the late 17th century. Almost nothing is known of the artist's life. It is assumed he was the son of the Hungarian-born painter and etcher, Johann Spillenberger (ca. 1628–1679) who came to Augsburg by way of Venice between 1660 and 1664.

C 67 THE SACRIFICE OF ISAAC (copy of the painting by Johann Liss) Fig. 70

Etching, 31,4 × 20,5 cm. (12^{3}/$_{8}$ × 8^{1}/$_{16}$ inches).
Inscribed in plate in lower right margin: Joh. Lys inv. et pinx. M. Spln. fec.

Städtische Kunstsammlungen, Augsburg.

According to Steinbart (1940, p. 116), Johann Melchior Spillenberger modeled his etching on a painted or drawn copy his father had made in Venice of the Liss painting [A 35]. The etching, in which the image is reversed, is a simplified but comparatively accurate transcription of Liss's picture. Steinbart is also of the opinion that it was the younger Spillenberger who painted an adaptation of the subject that was formerly in the Barfüsserkirche in Augsburg.[1] In the painted version the artist placed the angel so high above Abraham that he was unable to duplicate the expressive motif of the crossed arms;

nevertheless, following Liss's painting he positioned the figures toward the left side. In the etching he placed the figures in a more conventional central position. Neither the etching nor the painting includes the ass seen in the right background of Liss's painting. Presumably this detail was overlooked by the elder Spillenberger when he made the copy that he brought to Augsburg.

[1] Illus., Steinbart, 1940, fig. 49.

Literature: Wurzbach, 1910, no. 1 (after Liss). – G. K. Nagler, *Neues allgemeines Künstler-Lexikon*, XIX, second edition, Linz, 1912, p. 222, no. 7. – A. Hämmerle, *Das Schwäbische Museum*, 1929, p. 184, no. 18, fig. 19. – *Allgemeines Lexikon der Bildenden Künstler*, XXXI, ed. U. Thieme and F. Becker, Leipzig, 1937, p. 378. – Steinbart, 1940, pp. 115–16, *passim*, 170, fig. 48. – Steinbart, 1946, p. 62. – Hollstein, p. 148, no. 25.

L. S. R.

GEORG STRAUCH Born in Nürnberg in 1613, died there in 1675. Strauch worked primarily as a designer for enamels, enameled glass, and book illustrations; he also painted small portraits and portrait miniatures. Apparently he remained in Nürnberg throughout his life.

C 68 VISION OF ST. JEROME (copy of a painting by Johann Liss) Fig. 73

Pen and dark brown ink and watercolor over graphite, 22,3 × 16,2 cm. (8³/₄ × 6³/₈ inches).
Signed, dated, and inscribed in pen and brown ink: [lower left] G. Strauch fec. 1657; [center, above margin] Joh: Liss.

Staatliche Graphische Sammlung, Munich.

This copy of Liss's *St. Jerome* [A 39] by a Nürnberg artist reinforces the evidence of the inscription on the back of the Michael Herr drawing (see cat. no. C 66) that there was once a version of Liss's painting in Nürnberg. Furthermore, the date of Strauch's drawing places the painting in Germany within thirty years of Liss's death.

Strauch's drawing is more summary than Herr's copy; the two drawings show no peculiarities of detail in common that might serve to identify a painted version. Indeed, Strauch not only omitted the rolled mat behind the saint but he also either overlooked the hindquarters of the lion or deliberately changed it into a mound of earth. Herr's drawing seems to be a more reverent copy of the painting, whereas Strauch was evidently more interested in an overall impression. The remarkable fresh condition of the paper and unfaded colors of Strauch's drawing have preserved the nuances of light that he copied from Liss's painting, such as the shadow cast by the angel over St. Jerome's head and arm, and the reflected light that illuminates the angel's profile.

Collection: Herzog Carl Theodor, Mannheim; (acquired by Munich before 1794).

Literature: H. Mahn, «Lorenz und Georg Strauch,» *Tübinger Forschungen zur Archäologie und Kunstgeschichte*, VIII, Reutlingen, 1927, no. (A I, 1) 11, fig. 70. – Steinbart, 1940, pp. 138, *passim*, 166. – Steinbart, 1946, pp. 49, 63.

L. S. R.

D. Desiderata

D 1 BANQUET OF SOLDIERS AND COURTESANS Fig. 74
Pen and dark brown ink, brown ink wash, on pink washed paper;
23,1 × 33,9 cm. (9¹/₁₆ × 13³/₄ inches).
Gabinetto dei disegni degli Uffizi, Florence (Santarelli gift, 1866)

D 2 JUDITH Fig. 75
Oil on canvas, 112 × 88 cm. (44¹/₈ × 34⁵/₈ inches).
Private collection

D 3 THE REPENTANT MAGDALENE Fig. 76
Oil on canvas, 90 × 80 cm. (35⁷/₁₆ × 31¹/₂ inches).
Muzeum ve Slavkově u Brna, Slavkov, Czechoslovakia

D 4 THE TOILET OF VENUS Fig. 77
Oil on canvas, 82 × 69 cm. (32¹/₄ × 27³/₁₆ inches).
Galleria degli Uffizi, Florence

D 5 SACRIFICE OF ISAAC Fig. 79
Oil on canvas, 66 × 88 cm. (26 × 34⁵/₈ inches).
Galleria dell'Accademia, Venice

D 6 ST. JEROME IN THE DESERT COMFORTED BY AN ANGEL Fig. 78
Oil on canvas, 70 × 56 cm. (27⁹/₁₆ × 22¹/₁₆ inches).
Museo Civico d'Arte e Storia, Vicenza

E. Study Exhibition

His Life and Time

Gerardus Mercator (1512–1594)

E 1 MAP OF HOLSTEIN Fig. 80
from: Atlas sive cosmographicae le fabrica mundi . . . Duisburgii 1595
Engraving, hand colored, 35,4 × 47,8 cm. (13¹⁵/₁₆ × 18¹³/₁₆ inches)
Schleswig-Holsteinisches Landesmuseum, Schleswig

Nicolas Joannis Visscher (ca. 1550–1612)

E 2 MAP OF HOLSTEIN
published in Amsterdam 1659.
Engraving, 44,3 × 54,8 cm. (17⁷/₁₆ × 21⁹/₁₆ inches)
Schleswig-Holsteinisches Landesmuseum, Schleswig

Philipp Kilian (1628–1693)

E 3 PORTRAIT OF JOACHIM VON SANDRART Fig. 81
from: J. von Sandrart, «Teutsche Academie»
Engraving, 32,9 × 21,4 cm. (12⁷/₈ × 8⁷/₁₆ inches)
Städtische Kunstsammlungen, Augsburg

Jacob Matham (1571–1631)

E 4 PORTRAIT OF HENDRICK GOLTZIUS Fig. 82
Engraving, 57,6 × 42,6 cm. (22¹¹/₁₆ × 16³/₄ inches)
B. 172

160

Pieter de Jode II (1601–1674)

E 5 PORTRAIT OF JACOB JORDAENS Fig. 83
after A. van Dyck

Engraving, 24,5 × 17,6 cm. (9⁵/₈ × 6¹⁵/₁₆ inches)
H. 108

Johann Georg Waldreich (active ca. 1660–1680)

E 6 PORTRAIT OF PETER PAUL RUBENS Fig. 84
from J. von Sandrart, «Teutsche Academie»

Engraving, 10,2 × 10 cm. (4 × 3¹⁵/₁₆ inches)
Städtische Kunstsammlungen, Augsburg

Johann Georg Waldreich (active ca. 1660–1680)

E 7 PORTRAIT OF ADAM ELSHEIMER Fig. 85
from J. von Sandrart, «Teutsche Academie»

Engraving, 10,5 × 9,8 cm. (4¹/₈ × 3⁷/₈ inches)
Städtische Kunstsammlungen, Augsburg

Philipp Kilian (1628–1693)

E 8 PORTRAIT OF MICHELANGELO DA CARAVAGGIO Fig. 86
from J. von Sandrart, «Teutsche Academie»

Engraving, 10,6 × 10,3 cm. (4³/₁₆ × 4¹/₁₆ inches)
Städtische Kunstsammlungen, Augsburg

Pieter van Laer (1592–1642)

E 9 ARTIST'S TAVERN IN ROME WITH «BENTVÖGEL» Fig. 87
Pen and ink with brown wash, 20,3 × 25,8 cm. (8 × 10¹/₈ inches)
Staatliche Museen Preussischer Kulturbesitz, Berlin

Jan Collaert (1566–1628)

E 10 ART STUDENTS IN A STUDIO Fig. 88
(after Stradanus)

Engraving, 20 × 27 cm. (7⁷/₈ × 10⁵/₈ inches)
Rijksprentenkabinet, Rijksmuseum, Amsterdam

161

Johann Heinrich Schönfeld (1609–1684)

E 11 ACADEMY CLASS

Oil on canvas, 132,2 × 96,7 cm. (52$^{1}/_{16}$ × 38$^{1}/_{16}$ inches)

Landesmuseum Joanneum, Alte Galerie, Graz

Early Models

Lucas van Leyden (1494–1533)

E 12 THE DENTIST, 1523 Fig. 90

Engraving, 11,5 × 7,4 cm. (4$^{1}/_{2}$ × 2$^{15}/_{16}$ inches)

H. 157

See cat. nos. A 3, B$\overline{1}$3

Hans Sebald Beham (1500–1550)

E 13 PEASANT BRAWL, 1547 Fig. 91

No. 9 of the series «Festivals and Months», 1546/47

Engraving 4,9 × 7,2 cm. (1$^{15}/_{16}$ × 2$^{13}/_{16}$ inches)

See cat. nos. A 3, B 43

Lucas Vorsterman (1595–1675)

E 14 PEASANTS BRAWLING OVER A CARD GAME Fig. 89

Engraving

Parthey 599

Graphische Sammlung Albertina, Vienna

See cat. no. A3

Hans Sebald Beham (1500–1550)

E 15 Nos. 2, 6, 7 of the series «Festivals and Months», 1546/47 Figs. 92–94

Engravings, ca. 5 × 7,2 cm. (2 × 2$^{13}/_{16}$ inches)

Pauli 178, 182–183

See cat. nos. A 5, B 47

Willem Buytewech (1591–1624)
E 16 GROUP PORTRAIT Fig. 95
Oil on canvas, 56 × 70 cm. (22¹/₈ × 27⁵/₈ inches)
Rijksmuseum, Amsterdam
See cat. no. A6

Jacob Jordaens (1593–1678)
E 17 THE DAUGHTERS OF CECROPS DISCOVERING ERICHTHONIUS, dated 1617 Fig. 96
Oil on canvas, 172 × 283 cm. (67¹¹/₁₆ × 111³/₈ inches)
Koninklijk Museum voor Schone Kunsten, Antwerp
See cat. no. A8

Jacob Jordaens (1593–1678)
E 18 ALLEGORY OF FERTILITY, ca. 1617
Oil on canvas, 250 × 240 cm. (98³/₈ × 94³/₈ inches)
Bayerische Staatsgemäldesammlungen, Munich
See cat. no. A8

Paulus Moreelse (1571–1638)
E 19 SATYR AND PEASANT, dated 1611 Fig. 97
from: Album Amicorum of Arnoldus Buchelius
Pen and brown ink with brown wash, 15,9 × 19,7 cm. (6¹/₄ × 7³/₄ inches)
Library of the Rijksuniversiteit, Leiden
See cat. no. A9

Marcus Gheeraerts I (ca. 1516/21 – ca. 1590)
E 20 SATYR AND PEASANT Fig. 98
from: De Warachtige Fabulen der Dieren, 1567
Etching, 9,4 × 11,3 cm. (3¹¹/₁₆ × 4⁷/₁₆ inches)
See cat. no. A9

Lucas Vorsterman (1595–1675)
E 21 SATYR VISITING A PEASANT Fig. 99
after Jacob Jordaens
Engraving, 41,3 × 40 cm. (16¹/₄ × 15³/₄ inches)
Patrimoine des Musées des Beaux-Arts, Brussels
See cat. no. A9

Domenico Fetti (1589–1624)

E 22 THE PARABLE OF THE WORKERS IN THE VINEYARD Fig. 100

Oil on poplar panel, 61 × 45 cm. (24 × 17³/₄ inches)

Staatliche Kunstsammlungen, Dresden

See cat. nos. A12, A36

Michelangelo da Caravaggio (1573–1610)

E 23 THE CALLING OF ST. MATTHEW Fig. 103

Oil on canvas, 315 × 315 cm. (123³/₄ × 123³/₄ inches)

S. Luigi dei Francesi, Rome

See cat. no. A15

Michelangelo da Caravaggio (1573–1610)

E 24 THE FORTUNETELLER Fig. 101

Oil on canvas, 115 × 150 cm. (45⁵/₁₆ × 59¹/₁₆ inches)

Musée du Louvre, Paris

See cat. no. A15

Valentin de Boullogne (1594–1632)

E 25 THE CONCERT Fig. 102

Oil on canvas, 173 × 214 cm. (68¹/₈ × 98⁷/₁₆ inches)

Musée du Louvre, Paris

See cat. no. A15

Jacob Jordaens (1593–1678)

E 26 THE TEMPTATION OF MAGDALENE Fig. 104

Oil on oak panel, 126 × 97 cm. (49⁵/₈ × 38¹/₈ inches)

Mrs. Morris I. Kaplan, Chicago

See cat. nos. A17, A30

Abraham Janssens (1575–1632)

E 27 MELEAGER AND ATALANTA Fig. 105

Oil on oak panel, 118 × 93 cm. (46¹/₂ × 36⁵/₈ inches)

Formerly Kaiser-Friedrich-Museum, Berlin (destroyed)

See cat. no. A18

Cornelius Galle (1576–1650)

E 28 Judith Fig. 106

after lost painting by Peter Paul Rubens

Engraving, 54,5 × 37,8 cm. (21^1/$_2$ × 14^7/$_8$ inches)

H. 31

See cat. no. A19

Jusepe Ribera (1590–1652)

E 29 The Martyrdom of St. Bartholomew Fig. 107

Etching, 32,2 × 24,1 cm. (12^{11}/$_{16}$ × 9^1/$_2$ inches)

B. 6

See cat. no. A23

Adam Elsheimer (1578–1610)

E 30 Apollo and Coronis Fig. 108

Oil on copper, 17,8 × 22,8 cm. (7 × 9 inches)

Lord Methuen, England

See cat. no. A25

Titian (Tiziano Vecelli) (ca. 1487/90–1576)

E 31 Toilet of Venus, ca. 1555 Fig. 111

Oil on canvas, 124,5 × 105,5 cm. (49 × 41^1/$_2$ inches)

National Gallery of Art, Washington, Mellon Collection

See cat. no. A28

Annibale Carracci (1560–1609)

E 32 Venus adorned by the Graces, before 1595 Fig. 110

Transferred from wood to canvas, 127,9 × 170,5 cm. (52^3/$_8$ × 67^1/$_8$ inches)

National Gallery of Art, Washington, Samuel H. Kress Collection

See cat. no. A28

Francesco Albani (1578–1660)

E 33 Toilet of Venus Fig. 109

Tondo, 154 cm. (60^{13}/$_{16}$ inches)

Galleria Borghese, Rome

See cat. no. A28

Michelangelo da Caravaggio (1573–1610)
E 34 AMOR VINCIT, ca. 1600 Fig. 112
Oil on canvas, 154 × 110 cm. (60¹³/₁₆ × 43⁵/₁₆ inches)
Staatliche Museen Preussischer Kulturbesitz, Gemäldegalerie, Berlin
See cat. nos. A29, A32

Michelangelo da Caravaggio (1573–1610)
E 35 A LUTE PLAYER, 1594 Fig. 115
Oil on canvas, 94 × 119 cm. (18¹/₂ × 46⁷/₈ inches)
State Hermitage Museum, Leningrad
See cat. no. A29

Domenico Fetti (1589–1623)
E 36 AMOR, ca. 1618 Fig. 114
Red chalk heightened with white on light brown paper,
37,2 × 27,3 cm. (14⁵/₈ × 10³/₄ inches)
Count Antoine Seilern, London
See cat. no. A29

Anonymous Master from the Circle of Valentin (seventeenth century)
E 37 APOLLO CORONATO D'ACCARO Fig. 113
Oil on canvas, 66 × 50 cm. (26 × 19¹¹/₁₆ inches)
Museo Civico d'arte antica, Turin
See cat. no. A29

Paolo Veronese (ca. 1528–1588)
E 38 THE FINDING OF MOSES, ca. 1560–1570 Fig. 116
Oil on canvas, 50 × 43 cm. (19¹¹/₁₆ × 16¹⁵/₁₆ inches)
Museo del Prado, Madrid
See cat. no. A30

Jan Saenredam (1565–1607)
E 39 DAVID WITH THE HEAD OF GOLIATH, 1600 Fig. 117
after Lucas van Leyden
Engraving, 25 × 19 cm. (9¹³/₁₆ × 7¹/₂ inches)
B. 109
See cat. no. A31

Bartolomeo Manfredi (ca. 1580–1620/1)

E 40 BACCHUS, ca. 1624 Fig. 119

Oil on canvas, 96 × 132 cm. (50³/₄ × 37 inches)

Galleria Nazionale d'arte antico, Palazzo Corsini, Rome

See cat. no. A31

Hendrick Goltzius (1558–1617)

E 41 SATYR OF THE VILLA ALBANI, 1591 Fig. 120

Black chalk on blue paper heightened with white, 32,5 × 13,5 cm.
(12¹³/₁₆ × 5⁵/₁₆ inches)

Lost

See cat. no. A31

Niccolò Renieri (Regnier) (ca. 1590–1667)

E 42 DAVID, ca. 1615–1620 Fig. 118

Oil on canvas, 132,1 × 99 cm. (52 × 39 inches)

Galleria Spada, Rome

See cat. no. A31

Annibale Carracci (1560–1609)

E 43 DECISION OF HERCULES, ca. 1596 Fig. 122

Oil on canvas, 167 × 237 cm. (65³/₄ × 93⁵/₁₆ inches)

Museo Nazionale, Naples

See cat. no. A32

Pietro dal Pozzo (end of 16th century)

E 44 BACCHUS AND ARIADNE Fig. 123

Drawing from Album K, fol. 27, no. 27

British Museum, London

See cat. no. A32

Claude Mellan (1598–1688)

E 45 LUCRETIA, ca. 1625 Fig. 121

after a painting by Simon Vouet

Engraving, 39,4 × 27,8 cm. (15¹/₂ × 10¹⁵/₁₆ inches)

Bibliothèque Nationale, Paris

See cat. no. A32

167

Moyses van Uyttenbroeck (ca. 1590–1648)

E 46 Juno, Argus and Io, 1625

Oil on canvas, 51 × 88,9 cm. (20¹/₈ × 35 inches)

Bayerische Staatsgemäldesammlungen, Munich

See cat. no. A32

Fig. 124

Titian (Tiziano Vecelli) (ca. 1487/90–1576)

E 47 The Slaying of Abel

Oil on canvas, 280 × 280 cm. (110³/₁₆ × 110³/₁₆ inches)

S. Maria della Salute, Venice

See cat. no. A34

Fig. 126

Hans Sebald Beham (1500–1550)

E 48 Hercules killing Cacus, 1545

Engraving, 5 × 7,2 cm. (1¹⁵/₁₆ × 2¹³/₁₆ inches)
Pauli 102
See cat. no. A34

Fig. 130

Titian (Tiziano Vecelli) (1487/90–1576)

E 49 Sacrifice of Isaac, ca. 1542–1544

Oil on canvas, 320 × 280 cm. (128 × 110¹/₂ inches)

S. Maria della Salute, Venice (formerly S. Spirito)

See cat. no. A35

Fig. 125

Peter Paul Rubens (1577–1640)

E 50 Sacrifice of Isaac, 1614

Oil on panel, 141 × 109,8 cm. (55¹/₂ × 43¹/₄ inches)

Nelson Gallery and Atkins Museum, Kansas City

See cat. no. A35

Fig. 127

Ludovico Carracci (1555–1619)

E 51 Sacrifice of Isaac

Oil on canvas, 107 × 133 cm. (42¹/₈ × 52³/₈ inches)

Vatican Museum, Rome

See cat. no. A35

Fig. 128

Jan Saenredam (1565–1607)
E 52 Mourning for Abel Fig. 129
after Abraham Bloemart
Engraving, 25,8 × 19,2 cm. (10¹/₈ × 7⁹/₁₆ inches)
Staatliche Museen Preussischer Kulturbesitz, Kupferstichkabinett, Berlin
See cat. no. A36

Peter Paul Rubens (1577–1640)
E 53 Abel Slain by Cain
Red chalk with white heightening, 21,3 × 20,8 cm. (8³/₈ × 8³/₁₆ inches)
Fitzwilliam Museum, Cambridge
See cat. no. A36

Jacopo Tintoretto (1518–1594)
E 54 Miracle of St. Mark, 1548 Fig. 132
Oil on canvas, 415 × 541 cm. (158³/₈ × 213 inches)
Galleria dell'Accademia, Venice
See cat. no. A36

Adam Elsheimer (1578–1610)
E 55 The Good Samaritan Fig. 131
Oil on copper, 21,2 × 26,5 cm. (8⁵/₁₆ × 10⁷/₁₆ inches)
Musée du Louvre, Paris
See cat. no. A36

Lucas van Leyden (1494–1533)
E 56 Temptation of St. Anthony, 1509 Fig. 135
Copper engraving, 18,4 × 14,8 cm. (7¹/₂ × 5¹³/₁₆ inches)
H. 139
See cat. no. A37

Annibale Carracci (1560–1609)
E 57 Temptation of St. Anthony, ca. 1598 Fig. 133
Oil on copper, 49,5 × 34,4 cm. (19¹/₂ × 13⁹/₁₆ inches)
National Gallery, London
See cat. no. A37

Michelangelo da Caravaggio (1573–1610)

E 58 Rest on the Flight to Egypt (detail), ca. 1594–1596 Fig. 136

Oil on canvas, 130 × 160 cm. (51³/₁₆ × 63 inches)

Galleria Doria-Pamphili, Rome

See cat. no. A37

Hendrick Goltzius (1558–1617)

E 59 Helen of Troy, 1615 Fig. 134

Oil on canvas, 115 × 83 cm. (45¹/₄ × 32³/₄ inches)

Mr. and Mrs. David G. Carter, Montreal

See cat. no. A37

Gerard van Honthorst (1590–1656)

E 60 The Ecstasy of St. Paul, 1618 Fig. 137

Oil on canvas, 400 × 250 cm. (157¹/₂ × 98⁷/₁₆ inches)

S. Maria della Vittoria, Rome

See cat. no. A38

Peter Paul Rubens (1577–1640)

E 61 Musician Angels (detail), ca. 1613 Fig. 138

Oil on panel, 212 × 98 cm. (83⁷/₁₆ × 38⁹/₁₆ inches)

Liechtenstein'sche Gemäldesammlung, Vaduz

See cat. no. A38

Domenico Fetti (1589–1623)

E 62 The Dream of St. Peter, before 1620 Fig. 139

Oil on panel, 66 × 51 cm. (26 × 20¹/₈ inches; cut on top and left side)

Kunsthistorisches Museum, Vienna

See cat. no. A38

Agostino Carracci (1557–1602)

E 63 St. Jerome, 1588 Fig. 141

after a painting by Jacopo Tintoretto

Engraving, 40,6 × 30,5 cm. (16 × 12 inches)

The Metropolitan Museum of Art, New York

See cat. no. A39

Jacopo Tintoretto (1518–1594)

E 64 St. Jerome, ca. 1571–1575 Fig. 142

Oil on canvas, 143,5 × 103 cm. (56^1/$_2$ × 40^9/$_{16}$ inches)

Kunsthistorisches Museum, Vienna

See cat. no. A39

Michelangelo da Caravaggio (1573–1610)

E 65 St. Matthew with an Angel, ca. 1597/98 Fig. 143

Oil on canvas, 232 × 183 cm. (91^5/$_{16}$ × 72^1/$_{16}$ inches)

Formerly Kaiser-Friedrich-Museum, Berlin (destroyed)

See cat. no. A39

Jusepe Ribera (1590–1652)

E 66 St. Jerome, ca. 1621 Fig. 144

Etching, 31,8 × 23,8 cm. (12^1/$_2$ × 9^3/$_8$ inches)

The Cleveland Museum of Art

See cat. no. A39

Hans Sebald Beham (1500–1550)

E 67 The Months July and August Fig. 145
from the series «Festivals and Months», 1546/47

Engraving, 4,9 × 7,2 cm. (2 × 2^7/$_8$ inches)
Pauli 180
See cat. no. B47

Albrecht Dürer (1471–1528)

E 68 Peasant Couple Dancing

Engraving, 11,8 × 7,5 cm. (4^{11}/$_{16}$ × 3 inches)
Meder 88
See cat. no. B47

Gabriele Caliari (1568–1631)
Carletto Caliari (1570–1596)

E 69 The Doge receiving the Persian Ambassador Fig. 140

Oil painting (detail)

Sala delle quatro porte, Doge's Palace

See cat. no. B48

171

Jacques Callot (1592–1635)

E 70 FRANCA TRIPPA – FRITTELINO Fig. 146
Leaf no. 23 from the series «Balli di Sfessania»

Etching, 7,2 × 9,1 cm. (2¹³/₁₆ × 3⁹/₁₆ inches)
Lieure 401
See cat. no. B48

Works Influenced by Liss

Gilles Rousselet (1610 or 1614–1686)

E 71 STUDIO OF A PAINTER Fig. 147

Engraving, 21,9 × 27,4 cm. (8⁵/₈ × 10¹³/₁₆ inches)
Graphische Sammlung Albertina, Vienna

See cat. no. A1

Hans Ulrich Franck (1590/95–1675)

E 72 FIGHTING MEN Figs. 149/50
2 leaves from the series «Horrors of the Thirty Years War»

Etchings, 10,6 × 13,8 cm. (4³/₁₆ × 5⁷/₁₆ inches)
Andresen 5, 14
Städtische Kunstsammlungen, Augsburg

See cat. no. A 5 and essay by B. Bushart

Matthias Strasser, so-called (1638–1659)

E 73 GALLANT COUPLE WITH A GUITAR PLAYER, 1642 Fig. 148

Pen and ink over red chalk drawing, water color, 8,9 × 13,9 cm.
(3¹/₂ × 5⁷/₁₆ inches)
Städelsches Kunstinstitut, Frankfurt/Main

See cat. no. A 6 and essay by B. Bushart

Antoine de Favray (1706–1791/2)

E 74 SATYR AND PEASANT, 1741 Fig. 151

Oil on canvas, 167 × 124 cm. (65³/₄ × 48¹³/₁₆ inches)
Cathedral Museum, Medina, Malta

See cat. no. A10

Sebastiano Ricci (1659–1734)
E 75 SATYR AND PEASANT Fig. 154
Oil on canvas, 37 × 50 cm. (14^1/$_{16}$ × 19^5/$_8$ inches)
Musée du Louvre, Paris
See cat. no. A10

Sebastiano Ricci (1659–1734)
E 76 SATYR AND PEASANT · Fig. 152
Oil on canvas, 63,5 × 57,8 cm. (25 × 22^3/$_4$ inches)
Private Collection, England
See cat. no. A10

Anonymous Master of the 18th Century
E 77 SATYR AND PEASANT Fig. 153
Black chalk, 19 × 23,6 cm. (7^1/$_2$ × 9^5/$_{16}$ inches)
Staatliche Museen Preussischer Kulturbesitz, Kupferstichkabinett, Berlin
See cat. no. A10

Pietro Monaco (active 1735–1775)
E 78 THE PRODIGAL SON Fig. 155
Engraving, 51,1 × 36,5 cm. (20^1/$_8$ × 14^3/$_8$ inches)
See cat. no. A11

Johann Wolfgang Baumgartner (1712–1761)
E 79 THE PRODIGAL SON Fig. 157
Oil on canvas, 27,8 × 38 cm. (10^7/$_8$ × 14^{15}/$_{16}$ inches)
Statens Museum for Kunst, Copenhagen
See cat. no. A11

Johann Spillenberger (?) (ca. 1628–1679)
E 80 THE PRODIGAL SON Fig. 156
Oil on canvas, 93 × 75 cm. (36^5/$_8$ × 29^9/$_{16}$ inches)
Paul Leonhard Ganz, Hilterfingen, Switzerland
See cat. no. A11

Johann Jakob Haid (?) (1704–1767)
E 81 THE PRODIGAL SON
after Johann Wolfgang Baumgartner
Mezzotint, 25,3 × 35,9 cm. (9^{15}/$_{16}$ × 14^1/$_8$ inches)
Städtische Kunstsammlungen, Augsburg
See cat. no. A 11 and essay by B. Bushart

Hans Ulrich Franck (1590/95–1675)
E 82 MERCENARIES IN A TAVERN, 1656 Fig. 159
Etching, 10,8 × 13,6 cm. (4^1/$_4$ × 5^3/$_8$ inches)
Andresen 18
Städtische Kunstsammlungen, Augsburg
See cat. no. A 15 and essay by B. Bushart

Simon de Vos (1603–1676)
E 83 MUSIC MAKING COMPANY, 1646 Fig. 158
Oil on canvas
Schottenstift, Vienna
See cat. no. A15

Giovanni Antonio Guardi (1698–1760)
E 84 A WOMAN OF VENICE Fig. 162
Oil on canvas, 44,6 × 37,5 cm. (17^3/$_4$ × 14^{15}/$_{16}$ inches)
The Cleveland Museum of Art
See cat. no. A 19 and essay by A. Lurie

Franz Anton Maulbertsch (1724–1796)
E 85 JUDITH WITH THE HEAD OF HOLOFERNES Fig. 163
Oil on canvas, 50 × 35,5 cm. (19^{11}/$_{16}$ × 13^{15}/$_{16}$ inches)
Pushkin Museum of Fine Arts, Moscow
See cat. no. A 19 and essays by B. Bushart and A. Lurie

Franz Anton Maulbertsch (1724–1796)
E 86 ALLEGORY OF THE FOUR SEASONS (detail) Fig. 165
Oil on canvas (ceiling painting), ca. 300 × 650 cm. (118^1/$_8$ × 255^{15}/$_{16}$ inches)
Schloss Suttner, Kirchstetten
See cat. no. A 19 and essay by B. Bushart

Franz Anton Maulbertsch (1724–1796)
E 87 JUDITH WITH THE HEAD OF HOLOFERNES Fig. 164
Sketch for a ceiling painting
Oil on canvas, 21,7 × 29 cm. (8⁹/₁₆ × 11⁷/₁₆ inches)
Galerie St. Lukas, Vienna
See cat. no. A 19 and essay by B. Bushart

Pietro Monaco (1735–1775)
E 88 JUDITH
Engraving, 21,9 × 18,1 cm. (8⁵/₈ × 7¹/₈ inches)
Wurzbach 3
See cat. no. A20

Aegidius Sadeler (1570–1620)
E 89 ARCADIA Fig. 178
Brush and ink, heightened with white, 35,7 × 47,3 cm. (14¹/₁₆ × 18⁵/₈ inches)
Musée du Louvre, Paris
See cat. no. A27

Jacques Blanchard (1600–1638)
E 90 BACCHANALE (detail) Fig. 161
Oil on canvas, 138 × 115 cm. (54³/₈ × 45¹/₄ inches)
Musée des Beaux Arts, Nancy
See cat. no. A28

Franz Anton Maulbertsch (1724–1796)
E 91 TOILET OF DIANA Fig. 160
Oil on paper, 33 × 44 cm. (13 × 17⁵/₁₆ inches)
Österreichische Galerie, Vienna
See cat. no. A 28 and essay by B. Bushart

Anonymous Master (17th Century)
E 92 MERRY COMPANY WITH A GALLANT COUPLE Fig. 166
Oil on canvas, 74 × 99 cm. (29¹/₈ × 39 inches)
M. H. de Young Memorial Museum, San Francisco
See cat. nos. A33, B45

175

Cosimo Mogalli (1667–1730)

E 93 SACRIFICE OF ISAAC Fig. 167
after the design by Francesco Petrucci

Engraving, 48,5 × 36,2 cm. (19¹/₈ × 14¹/₄ inches)
Le Blanc 6
See cat. no. A35

Franz Sigrist (1727–1803)

E 94 SACRIFICE OF ISAAC

Oil on canvas, 44,7 × 34,5 cm. (17⁵/₈ × 13⁹/₁₆ inches)
Collection Wilhelm Reuschel, Munich
See cat. no. A35

Johann Carl Loth (1632–1698)

E 95 CAIN AND ABEL

Oil on canvas, 150 × 116 cm. (59¹/₁₆ × 45¹¹/₁₆ inches)
Formerly Städt. Suermondt-Museum, Aachen (destroyed)
See cat. no. A 36 and essay by B. Bushart

Giovanni Battista Piazzetta (1682–1754)

E 96 SACRIFICE OF ISAAC Fig. 169

Oil on canvas, 152,5 × 114,5 cm. (60¹/₁₆ × 45¹/₁₆ inches)
Staatliche Kunstsammlungen, Dresden, Gemäldegalerie Alte Meister
See cat. no. A35

Giovanni Antonio Guardi (1688–1760)

E 97 SACRIFICE OF ISAAC Fig. 168

Oil on canvas, 56,2 × 75,5 cm. (22¹/₈ × 29³/₄ inches)
The Cleveland Museum of Art
See cat. no. A 35 and essay by A. Lurie

Johann Carl Loth (1632–1698)

E 98 THE GOOD SAMARITAN

Oil on canvas, 135 × 170 cm. (53³/₁₆ × 66¹⁵/₁₆ inches)
Herzog Anton Ulrich-Museum, Braunschweig
See cat. no. A 36 and essay by B. Bushart

Johann Michael Rottmayr von Rosenbrunn (1654–1730)
E 99 MOURNING FOR ABEL, 1692 Fig. 172
Oil on canvas
Formerly in the collection of the family of Count Harrach, Vienna
See cat. no. A 36 and essay by B. Bushart

Pietro Monaco (active 1735–1775)
E 100 MOURNING FOR ABEL Fig. 171
Engraving, 31,2 × 47,9 cm. (12⁵/₁₆ × 18⁷/₈ inches)
See cat. no. A36

Jean Honoré Fragonard (1732–1806)
E 101 DREAM OF A WARRIOR Fig. 173
(Engraved by N. F. Regnault in 1791)
Oil on canvas, 61,5 × 50,5 cm. (24¹/₂ × 19⁷/₈ inches)
Musée du Louvre, Paris
See cat. no. A38

Anonymous Master (18th Century)
E 102 ECSTASY OF ST. PAUL Fig. 176
Black chalk on blue paper, heightened with white, 37,3 × 28,2 cm. (14⁵/₈ × 11¹/₁₆ inches)
British Museum, London
See cat. no. A38

Jean Honoré Fragonard (1732–1806)
E 103 ST. JEROME, ca. 1761 Fig. 174
Etching, 16,7 × 10,5 cm. (6⁹/₁₆ × 4¹/₈ inches)
The Cleveland Museum of Art, Gift of The Print Club of Cleveland
See cat. no. A39

Richard de Saint-Non (1727–1791)
E 104 ST. JEROME, 1772 Fig. 175
after Fragonard
Etching and aquatint, 20 × 14,3 cm. (7⁷/₈ × 5⁵/₈ inches)
Fogg Art Museum, Harvard University, Cambridge, Massachusetts
See cat. no. A39

Francesco Maffei (1620 [?]–1660)

E 105 THE GLORIFICATION OF ALVISE FOSCARINI WITH INQUISITOR (detail), Fig. 177
1652

Oil on canvas, 221 × 486 cm. (87 × 191³/₈ inches)

Pinacoteca, Vicenza

See cat. no. A39

Sebastiano Ricci (1659–1734)

E 106 ST. PETER FREED FROM PRISON, ca. 1721

Oil on canvas, 165 × 138 cm. (64¹⁵/₁₆ × 54⁵/₁₆ inches)

Church of S. Stae, Venice

See cat. no. A39

Wenzel Hollar (1607–1677)

E 107 PEASANT BRAWL, 1646 Fig. 179

Etching, 21,9 × 32,4 cm. (9¹/₁₆ × 12¹³/₁₆ inches)
Parthey 599
See cat. nos. A3, B43

Johann Heinrich Schönfeld (1609–1684)

E 108 HALT BEFORE AN INN

Oil on canvas, 86 × 64 cm. (33⁷/₈ × 25¹/₄ inches)

Kunsthistorisches Museum, Vienna

See essay by B. Bushart

F. Documentation

Johann Liss, otherwise called Pan, from Oldenburg

Johann Lys (otherwise called Pan) is all the more praiseworthy because he surpassed all painters in his region with his art like no other artist from the remote Land Oldenburg before him. He, however, after having learned the basics in painting went to Amsterdam where he tried very hard to learn to paint in the manner of Heinrich Golzii and where he painted clever subjects. From there he went to Paris, Venice, and Rome, adopted a completely different manner, and because he fared well in Venice he soon returned there, painted excellent paintings according to his inclination, two or three «Spannen» high, paintings in which the manner of antiquity and of modern time were well tempered and pleasantly well colored, so that he seemed well versed in all aspects of painting.

Among other remarkable things he painted in Venice, he did a life-size nude St. Jerome in the desert, quill in hand, as he hears the trumpet of the angel for the church of the Tolentini; everything very lively and touching and in pleasant colors. But the smaller pictures of two or three «Spannen» surpass the large painting by far as is proved by the painting of Abel – lying in a foreshortened position – having been killed by his brother Cain and being mourned by Adam and Eve, who have never before seen a dead human being. In the same splendid manner he painted the falling Phaeton with his chariot, the water nymphs below looking up in horror. Lys showed in the way he painted the beautiful nude nymphs as well as the delicate landscape and flaming clouds that he was a master of color and coloring. He also did several paintings, in modern manner, of lovers in conversation and of the amorous Venetian girl with music, card games, promenading and of other scenes of courtship. All done in a very sensible way that cannot be praised enough.

Furthermore he painted a village wedding when after the feast the dance begins. The pastor is leading the bride by the hand and merrily begins the dance followed by the bridegroom with the innkeeper's wife and the other peasants. All dance happily in country folk fashion to the music of bagpipes and flutes. The music is being played in the shadow of a delicate linden tree. There is a village inn and village folk; everyone

seems content. A companion to this painting depicts drunk peasants fighting with dung forks and hoes. In the midst of this run their wives in order to stop their furious white-faced husbands. The table at which they had been drinking falls over and pushes one of the peasants to the ground, and many other such rough peasant behavings are displayed.

After that he painted a Temptation of St. Anthony, very strange but pleasing. The old hairless hermit is being teased by odd imaginary spectres, lights, and females. He has fine revelries to boot, of soldiers in armor, with Venetian courtesans, playing cards to the sweet sound of strings and the refreshment of wine, amusing themselves each one as he pleases, and living in sin, wherein the diversity of individual emotions, gestures, and passions is so sensibly portrayed that these works are not only much acclaimed but are also being purchased at high prices by the lovers of fine art.

He did a lot of drawings of nude models at our academy in Venice and gave these figures particular grace and almost more than natural life when he painted them. He did not take much note of the serious school of the antiquity although he thought of it very highly. If he had tried to follow that manner so very much against his nature he would have had to start from the beginning again. He loved Titian, Tintoretto, Paul Veronese, del Fetti, and the manner of other Venetians, particularly the latter.

He was in the habit of thinking a long time before he started on his work but once a problem was resolved nothing could make him sway. When we lived together in Venice he would stay away from the house for two or three days and then come back into the room by night, quickly prepare his palette, mixing the colors the way he wanted them and spend the whole night working. In the daytime he would rest a little and then contin-ue with his work for another two or three days and nights. He hardly rested and hardly ate. No matter how many times I told him that he would ruin his health that way and shorten his life, it was no good. He continued that way, staying out several days and nights – where I do not know – until his purse was empty. Then he continued making the night into day and the day into night.

I then went to Rome. He had promised to follow me as soon as the work he had begun was completed. But luck was against him. He died along with many others during the plague which began in 1629.

Many of his works are in Venice but more are in Amsterdam where they are held in high esteem.

Translated extract from Joachim von Sandrart, *Academie der Bau-, Bild- und Mahlerey-künste von 1675*, Munich, 1925, pp. 187–88.

Early References to lost or unidentified Paintings attributed to Johann Liss

The following source material was compiled in preparing the catalogue and may be useful for future research. It lists paintings, in iconographical order, attributed to Johann Liss, which are either lost or cannot be definitely identified. Within each group paintings are numbered for easier reference. Not included are paintings mentioned by Sandrart in his chapter on Liss in his *Academie der Bau-, Bild- und Mahlerey-künste von 1675* (publ. by Peltzer, 1925), which is cited verbatim on p. 179 of this Documentation section. Paintings which to our knowledge have been dismissed from Liss's oeuvre are omitted. Also not included are the paintings listed by G. Parthey (1864, pp. 64–65), among which only nos. 1, 3, 5, and 8 have been identified and accepted as paintings by Liss; these are exhibited under cat. nos. A 17, A 28, A 13, A 15 respectively.

These early sources immediately revealed basic problems in identifying works by Johann Liss. One stems from the different ways of spelling his name. He resided in at least three different countries – hence in his native Germany it was Johann or Johan Liss, Lisz, or Lis; in the Netherlands, where he received his training, it was Jan Lis, Lys, or Lijs; and in Italy, where he spent the remainder of his short life, it was Giovanni Lys or Lis. The problem was compounded when his name became confused with that of Dirck van der Lisse alias Jan van der Lisse. (The second name quite possibly came into being because Dirck's works were confused with those of Johann Liss.) Consequently, Liss's name often turned into Jan van der Lis, or Lisse, or Jan van Lis, and so on. As a result, Johann Liss is most likely given credit in some of the sales records and inventories for a number of works which were actually by Dirck van der Lisse. Both artists shared an affinity for Cornelis Poelenburg and his circle. (Dirck van der Lisse, who was born in Breda in 1620 and died in The Hague in 1669 was actually a pupil of Poelenburg in Utrecht.)

This confusion obviously started very early. Count Algarotti's inventory of 1780 listed seven paintings under Giovanni Lys, but gave Breda as his birthplace (which is that of Dirck van der Lisse) and 1620 as the date of his birth. (Among these paintings the small *Venus and Adonis* on copper has

actually been identified with that in Karlsruhe [A 25].) A. Bredius (*Kunstchronik*, XVII, no. 45, 1882, p. 747) warned the reader not to confuse Dirck with «Jan van der Lijs» whose paintings were very similar. One may compare Dirck van der Lisse's *Lot and his Daughters* in the Staatliches Museum Schwerin with Liss's *Bathing Nymphs* in Schweinfurt [A 27] to lend support to Bredius' argument. Frimmel (1892, p. 34) warned that while the *Toilet of Venus* in Pommersfelden [A 28] was definitely by Liss, most works listed under his name in earlier catalogues were probably by Dirck van der Lisse. This confusion partly explains the length of the list, under the subject of Arcadian landscapes, of bathing women, nymphs, or stories of Diana attributed to Johann Liss in early sales.

That section, as well as the one of merry companies (and/or prodigal sons), reveals the second problem (discussed in the entry for the *Toilet of Venus* [A 28], and *The Prodigal Son* [A 11]): that is, the uncertainty regarding titles of Liss's paintings which makes it extremely difficult, if not impossible, to establish a safe list of provenances.

The most revealing (and frustrating) aspect of these early sources, however fragmentary they may be, is the considerable number of paintings by Johann Liss of biblical, mythological, and genre subjects (including portraits) which remain to be found.

I Religious Subjects – Old Testament

1 David Fleeing from King Saul

Coll.: Giovan Maria Viscardi, Venice, 1763.
C. A. Levi, *Le collezione veneziane d'arte e d'antichita del secolo XIV ai nostri gioni . . .*, Venice, 1900, II, p. 53: «1763 febbraio 21. Cose di Gio. Maria Viscardi a S. Eustachio. Un quadro di David che fugge dal Rè Saule cornise intagliata, e dorata opera di Giovanni Lis.» See G. Gronau, *Kunstchronik*, N.S., XXX, 1921–22, p. 404; Steinbart, 1940, p. 170.

2 The Finding of Moses

Coll.: Giovan Maria Viscardi, Venice. Inventories: 1674 and 1763.
Savini-Branca, *Il collezionismo veneziano nel '600*, Padua, 1964, p. 153: «1674 10 Marzo . . . nel portico. Un quadretto con la ritrovata di Moisé nel fiume soaze intagliate dorate opera di Giovanni Lis.» Levi, *op. cit.*, p. 53: «1763 febbraio 21. Cose di Gio. Maria Viscardi a S.

Eustachio. Un quadretto con la ritrovata di
Moisé nel fiume soaze intagliate dorate opera di
Giovanni Lis.» See Gronau, *op. cit.* and Steinbart (1940), p. 171.

3 *Lot and His Daughters*
Coll.: Francesco Bergonico, Venice.
See C. Ridolfi, *Le Maraviglie dell'arte*, Venice,
1648; reprint: Berlin, 1924, II, p. 56: «Possede
anco il Signor Francesco Bergonico . . . Lot con
figliuole del Nis . . .» n. 2: Nis probably printing error and should read Lis.» See Steinbart,
1940, p. 171.
Note: The Staatliches Museum Schwerin owns a
Lot and His Daughters by Dirck van der Lisse.
4 *The Angel Conducting Lot's Daughters*
Sale: Graci or Grassi, and others, Venice; London, February 3, 1764, no. 27: «The Angel
conducting Lot's Daughters, a fine picture, in a
very particular stile, on copper, by Giovanni
Lyss – 95 £ 27-6-.»

5 *Paradise*
Gino Fogolari, «Lettere pittoriche del Gran
Principe Ferdinando di Toscana a Niccolò
Cassana (1698–1709)», *Rivista del R. Istituto
d'archeologia e storia dell'arte*, Rome, 1937,
p. 161: «Lettera n. 56, Venezia 5 maggio
1708. ‹Altezza Reale, . . . Ero più che sicuro
che avrebbero incontrato il genio di poiché de
buoni quadri et originali ne ce troppa carestia.
Il Lama mi fa sperare di poter mandare a
V. A. R. un quadro di Paradiso di Gio Lis ma
non già di quelli che vennero altra volta a Firenze. Ladri, ladrissimi, onde se sarà vero non
sarà poco.› . . . Lettera n. 109 di Sebastiano
Ricci. ‹Altezza Reale, Sono stato a vedere il
quadro di Gio Lis accennato altra volta a
Vostra Altezza Reale ma non è di quella perfetione che mi pensavo, però se V. A. comanderà
sarà inviato. . . .›»

6 *Tobias and the Angel*
Sale: Jan Doedyns, Amsterdam, April 16, 1700.
G. Hoet, *Catalogus of Naamlyst van Schilderyen*, I, 's Gravenhage, 1752, p. 52, no. 4:
«Tobias met den Engel, van Jan Lis 70–10».
F. Lugt, *Repertoire des Catalogues de Ventes*,
I–III, The Hague, 1938–1964, no. 173.

II New Testament

1 *Ecco Homo*
Coll.: Henri Guérard; Galerie Pest, Hungary.
Frimmel, 1892, pp. 151–152; Frimmel, 1901,
p. 216.

2 *Our Dear Lady*
Sale: Anonymous, Amsterdam, April 9, 1687,
no. 58.
Hoet, *op. cit.*, I, 1752, p. 8, no. 58: «Een Lieve
Vrouwtje, van Jan Lis. 20–0.» Lugt, *op. cit.*,
no. 10.

Christian Parables
3 *Prodigal Son*
Sale: Maria Beukelaar and Anthony de Waart,
The Hague, April 19, 1752.
Hoet, *op. cit.*, II, 1752, p. 325, no. 165: «Een
schoon Stuk, verbeeldende de verlooren Soon
vol Beelden, door Jan Lis, h. 2 v. 7 d., br. 2 v.
2 d. 61 – 0» Steinbart, 1940, p. 57, n. 106, p. 58,
n. 107 and p. 163. Note: This painting has frequently been mentioned as having been in the
Anthony de Waart sale and it was misunderstood (by Lugt, see 781, and then carried over
by others) that Maria Beukelaar was the widow
of Anthony de Waart when, in fact, she was
the widow of Heer Halungius (see Hoet, *op.
cit.*, II, 1752, p. 314: «Vrouwe Maria Beukelaar, Douariere van den Wel-Edelen Heer . . .
Halungius, in zyn Ed. leeven Envoyé van zyne
Hoogvorstelyke Doorlugtigheid den Hertog van
Saxen-Gotha, als mede van den Konst-Schilder
Anthony de Waart . . .»). The sale was of two
different properties and, since the catalogue
does not separate the two lots, one cannot be
sure that the painting belonged to Anthony de
Waart. Unfortunately, the inventory of the
painter Anthony de Waart lists only those paintings which were not put into the sale (Bredius,
Künstlerinventare, 3, 1917, pp. 1023–34).

4 *Conversation Piece with Card- and Zither-
playing Ladies and Gentlemen*
Coll.: Hoogeveen, Leyden.
Sale: Amsterdam June 5, 1765, no. 29: «Een
Stuk verbeeldende een Buitenplaats met eenige
Heeren en Dames, speelende op de Kaart en
Cyter. Alles zeer fraai en meesterachtig op doek
geschilderd. Hoog 33, breed 27 duim. – 285.
Johan van der Marck, Aegidz.» Lugt, *op. cit.*,

no. 1467 [Hoogeveen]: see Hoet, *op. cit.*, III, 1770, p. 454, no. 20 (under anonymous sale); Johan van der Marck, Aegidz. Sale: Amsterdam, August 25, 1773, no. 169: «Lis (Jan). De verlooren Zoon, op Doek, h. 32 b. 26¹/₂ duim, 150. Vlardinge [name is not entirely legible]»; Lugt, *op. cit.*, no. 2189; Houbraken, 1943, I, p. 163; Descamps, 1753, pp. 165–266; *Blätter vermischten Inhalts*, 5, Oldenburg, 1792, p. 506; H. de Groot, 1893, p. 143; Steinbart, 1940, pp. 57, 58, and 171. See also IV, 4.

5 *Prodigal Son*
Coll.: Georg Friedrich von Hagen.
C. G. von Murr, *Journal zur Kunstgeschichte*, part 13, Nürnberg, 1784, p. 112: «‹Der verlorene Sohn unter einem Haufen lustiger Brüder› von Jan Lys»; Frimmel, 1891, p. 83, n. 12.

III Saints

1 *St. Jerome in the Desert*
Coll.: Counts of Schönborn.
Beschreibung des Fürtrefflichen Gemähld- und Bilder-Schatzes . . . deren Reichs-Grafen von Schönborn, Bucheim, Wolfsthal, u. . . ., Würtzburg, 1746, «In Sr. Hochfürstlichen Gnaden Wohnzimmer . . ., no. 37; Frimmel, 1922, p. 54, n. 70; Steinbart, 1940, p. 171.

2 *The Magdalene*
Coll.: Siewert van der Schelling, Amsterdam, 1711.
Houbraken, 1943, I, pp. 163–64: «. . . de konst‑lievende Heer Siewert van der Schelling heeft een veel gelukkiger keur gedaan . . . en een stuk van Jan Lis in zyn kunstvertrek dat zoo heerlyk geteekent, kragtig en teer geschildert is, als of Rubbens en van Dyk t'zamen de hand daar in gehad hadden: over zulks ik hem op deze proef alleen wel derf onder de grootste meesters in de konst tellen»; *Herrn Zacharias Conrad von Uffenbachs merkwürdige Reisen durch Niedersachsen, Holland und Engelland*, III, Ulm, 1754, p. 646 ff.; *Blätter vermischten Inhalts*, 5, Oldenburg, 1792, p. 506; H. de Groot, 1893, p. 143; Steinbart, 1940, pp. 129–130, 171.

IV Genre

1 *Conversation Piece with Some Figures*
Sale: Reynier van der Wolf, Rotterdam, May 15, 1676.

Hoet, *op. cit.*, II, 1752, p. 344, no. 19: «Een Conversatie van eenige Figuurtjes, door Jan Lis 300–0»; Lugt, *op. cit.*, no. 5. See also Steinbart, 1940, p. 171.

2 *Conversation Piece*
Coll.: Johannes van de Capelle (d. 1679). Inventory of January 4 to August 13, 1680: «Schilderijen, no. 14. Een gezeldschapje van Jan Lis (Lijs).»
Bredius, *Oud Holland*, X, 1892, p. 32. Steinbart, 1940, p. 171.

3 *Conversation Piece*
Sale: Philips de Flines, Amsterdam, April 20, 1700.
Hoet, *op. cit.*, I, 1752, p. 55, no. 26: «Een Geseldschapje van Jan Lis 290 – 0»; Lugt, *op. cit.*, no. 174.

4 *A Conversation Piece*
Coll.: Hoogeveen.
Sale: Anonymous, Amsterdam, June 5, 1765, no. 73: «Jo. Lis Een Binnenhuis, met een Gezelschap, en veelerlei Vruchten. Extra fraai. Hoog 23, breed 29 duim. 152. Louis de Moni»; Lugt, *op. cit.*, no. 1467: Hoogeveen. See also Hoet, *op. cit.*, III, 1770, p. 454, no. 21. See also II, 4.
Note: It is interesting to know that the buyer, Louis de Moni, of the «Binnenhuis . . .» was a painter in his own right (1698–1771) and that in a sale (under his name) on April 13, 1772 in Leyden a painting was listed under no. 43 entitled: «Historie van Apollo en Marseus naar Jan Lis door L. de Moni.»

5 *A Cavalier and His Lady*
Sale: Philips de Flines, Amsterdam, April 20, 1700.
Hoet, *op. cit.*, I, 1752, p. 55, no. 27: «Een Cavallier met zyn Dame, van denzelven [Jan Lis], 195–0.»

6 *Courtesans*
Coll.: Scheper, Rotterdam.
See Feyken Rijp, *Chronijk van Hoorn*, Hoorn, 1706, p. 318: «. . . en ik meen wel bewust te zijn/dat de Heer Schepers tot Rotterdam een groot stuk werks bezit/verbeeldende eenige vrolijke Courtisanen levensgroote . . .» [by Jan Lis].

7 *A Gallant Couple*
Sale: Adriaen Paets, Rotterdam, April 26, 1713.
Hoet, *op. cit.*, I, 1752, p. 157, no. 33: «Een
fraei stuk van Jan Lis, zynde een Coutisaen
met een Courtisane, hoog 2 voet, breed 1 voet
7 duim. 280–0.» Lugt, *op. cit.*, no. 239; Stein-
bart, 1940, pp. 37, 162–163.

8 *A Courtesan with an Old Woman*
Sale: Adriaen Paets, Rotterdam, April 26, 1713.
Hoet, *op. cit.*, I, 1752, p. 157, no. 34: «Een
dito, zynde een Courtisane met een oud Wyf,
hoog 1 voet, breed 14 duim. 55–0.» Lugt, *op.
cit.*, no. 239.

9 *A Brothel*
Sale: Pieter Six, Amsterdam, September 2,
1704.
Hoet, *op. cit.*, I, 1752, p. 72, no. 16: «Een Bor-
deel van Jan Lis, heerlyk geschildert. 465–0.»
Lugt, *op. cit.*, no. 190. See also Mireur, *Diction-
naire des Ventes d'Art*, IV, Paris, 1911, p. 345;
C. K. von Rosenroth, *Itinerarium, 1663* (extract
published in *Jaarboek van het Genootschap
Amstelodamum*, XIV, 1916, p. 239 ff.) men-
tions a «Taberna» which he saw in the Galerie
Reynst. See E. Reynst, «Sammlung Gerrit and
Jan Reynst,» unpublished dissertation, n.d.,
p. 21; Steinbart, 1940, p. 65, n. 123, pp. 162–63.
(See [A 15].)

10 *Gentlemen and Courtesans*
Sale: Adriaen Paets, Rotterdam, April 26, 1713.
Hoet, *op. cit.*, I, 1752, p. 158, no. 3: «Een uit-
muntend stukje, door Jan Lis, zynde een Ge-
seldschap van Heeren en Courtisanes. 210–0.»
Lugt, *op. cit.*, no. 239.

11 *Soldiers and Courtesans*
Sale: 1890.
Mireur, *op. cit.*, p. 387: «1890 – May. – Soldats
et courtisanes (150–240): 2.000 fr.»

12 *Musical Party in a Garden*
Coll.: Alessandro Savorgnan, Venice, 1699.
Levi, *op. cit.*, II, p. 113: «1699 agosto 7 e 31.
Quadri di Alessandro Savorgnan a S. Agnese.
Nr. 1007: Un detto con diverse figure con
istrumenti che suonano in un giardino, di q.te 6 e
mezza, soaza nera con filo d'oro, di Gio. Lis.»
See also Gronau, *op. cit.*, p. 404.

13 *An Italian Hunt*
Sale: Amsterdam, August 31, 1740, no. 31:
«Een Italiaanse Jagt, door Jan Lis, puik. –
Berkmans [?].»
Hoet, *op. cit.*, II, 1752, p. 9, no. 30; Lugt,
op. cit., no. 523.

14 *«Een Wederga»*
Sale: Amsterdam, August 31, 1740, no. 32:
«Een Wederga, niet minder. Berkmans [?].»
Hoet, *op. cit.*, II, 1752, p. 9, no. 31; Lugt, *op.
cit.*, no. 523.

15 *Lute Player*
Coll.: Jean Blanchard.
See inventory of December 13, 1645, no. 9 and
inventory of April 23/24, 1665, no. 42 in C.
Sterling, «Les peintres Jean et Jacques Blan-
chard,» *Art de France*, I, 1961, p. 104: «9. Ung
autre tableau peinct sur thoille sans bordure où
est representé une joueuse de luth original de
Jean Lis . . . 8 l.» p. 105: «42. Ung autre
tableau representant une joueuse de luth peint
sur thoille de Genlis [Jean Lis] sans bordure . . .
40 s.» See also Houbraken, 1943, III, p. 135,
who speaks of a painting he saw in the house
of Nicolaas van Suchtelen, a *Luteplayer* done
by Eglon Hendrik van der Neer in the manner
of Jan Lis; Steinbart, 1940, p. 152.

V Portraits

1 *Portrait of a Nobleman*
Sale: Arundel, Amsterdam, September 26, 1684,
no. 18.
Hoet, *op. cit.*, I, 1752, p. 2. no. 18: «Johan
Lis, een Edelmans Trony na Antony van Dyk.
15–0»; Lugt, *op. cit.*, no. 7.

2 *A Half-length Figure*
Sale: Cornelis Dusart, Haarlem, August 21,
1708, no. 141: «Een Half-beeld, op Coper,
door Jan Lis.»
Bredius, *Künstlerinventare*, I, 1915, p. 46, no.
46.

3 *Portrait of a Young Nobleman; and
Portrait of a Nobleman*
Inventory of the widow of Jürgen Ovens (d.
1678). «No. 95: Eines Jungen Edell Mannes
Contrf. von J. Liss – 6 M; no. 96: Eines Edell
Mannes Contraf. von Johann Liss – 6 M.»

See H. Schmidt, *Oud Holland*, XXXII, 1914, p. 43, n. 7; *Quellen und Forschungen zur Geschichte Schleswig-Holsteins*, IV, 1916, p. 290, n. 2; V, 1917, p. 311; H. Schmidt, *Jürgen Ovens*, 1922, p. 67; Steinbart, 1940, p. 170.

4 *Three Portrait Heads*
Inventory of the Estate of the painter Dirck Aertsz of 1644: «no. 122 Een trony door Jan Lis op een raem. no. 123 Een dito door Jan Lis. no. 124 Een dito door Jan Lis.»
Bredius, *Künstlerinventare*, part 2, 1916, p. 604.

5 *Head of an Old Man*
Coll.: Alvise Moncenigo IV, Venice, 1759.
Levi, *op. cit.*, II, p. 231: «1759 gennaio 19. Quadri di Alvise Moncenigo IV, Nr. 52: Una Testa di Vecchio, di Joan Lis.» Gronau, *op. cit.*, p. 404; Steinbart, 1940, p. 171.
Note: A painting of a *Bearded Man*, head and shoulders, wearing brown dress, on panel, 20¹/₂ × 16¹/₂ inches (52 × 41,9 cm.) attributed to Liss, appeared in a sale at Christies, London, December 20, 1973.

VI MYTHOLOGY

1 *Apollo Riding in his Chariot . . .*
Coll.: Count Francesco Algarotti, Venice.
Selva, *Catalogo dei quadri dei disegni e dei libri che trattano dell'arte del disegno della galleria del fu Sig. Conte Algarotti in Venezia*, Venice, 1776, P. 13 «Lys Giovanni – Apollo che guida il suo carro preceduto dai crepuscoli mattutini, e dall'Aurora che va spargendo rose; vi sono molte Deita sulle nubi. Venere e in letto con Marte il quale cerca coprirsi con un lenzuolo, mentre Vulcano scaglia sopra loro la rete.» A. F. Bartholomäi, *Beschreibung der Gräflich Algarottischen Gemälde- und Zeichnungs-Gallerie in Venedig*, Augsburg, 1780, p. 32–33.

2 *Vulcan Accusing Venus and Mars*
(companion picture to 1)
Coll.: Algarotti.
Selva, *op. cit.*, p. XIV: «Lys Giovanni – Vulcano che accusa Venere a Marte dinanzi al Concilio dei Dei che sono sulle nubi. Venere si copre il viso con la veste, ed Amore la consorta: vicino a Marte evvi Mercurio che con le dita gli indica le corna fatte a Vulcano. In tela alti p. 1. onc. 10. 1. p. 3 onc. 7.» Bartholomäi, *op. cit.*, p. 33.

3 *Pan and Apollo*
Sale: Wilhelm Six, Amsterdam, May 12, 1734.
Hoet, *op. cit.*, I, 1752, p. 416, no. 116. «Pan door Apollo Gestraft, door Jan Lis, 16–0.» Lugt, *op. cit.*, no. 441; Steinbart, 1940, p. 96, n. 179, p. 162.

4 *Apollo and Marsyas*
Sale: Onfanger Pook through Theodorus van Pée, 's Gravenhage, Konstschilders Confrerie-Kamer, May 23, 1747.
Hoet, *op. cit.*, III, 1770, p. 48: «32 Marsias door Apollo gevilt wordende, zeer schoon geschildert, door Jan Lis»; Lugt, *op. cit.*, no. 667; Steinbart, 1940, p. 96, n. 179 and p. 162; Pigler, 1956, II, p. 32.
Note: In a sale of Louis de Moni on April 13, 1772 in Leyden a «Historie van Apollo en Marseus naar Jan Lis door L. de Moni» is listed. Louis de Moni was a genre painter (1698–1771). See also IV, 4.

5 *Apollo and Marsyas*
Sale: David Jetswaart (art dealer) Amsterdam, April 22, 1749.
Hoet, *op. cit.*, II, 1752, p. 252: «207 Een stuk daar Mars van Apollo gevilt wordt, door van-der Lis, op koper. 18–0»; Lugt, *op. cit.*, no. 704; Steinbart, 1940, p. 96, n. 179 and p. 162.

6 *Bathing Nymphs*
Sale: Samuel van Huls, The Hague, September 3, 1737.
Hoet, *op. cit.*, I, 1752, p. 490, no. 136: «Een ongemeen uytvoerig Badje met veele Nymphjes en ander bywerk, door J. Lis, niet minder als Poelenburg, h. 7 an een vierde d. br. 9 en drie vierde d.» Lugt, *op. cit.*, no. 474.

7 *Bathing Nymphs in a Landscape*
Sale: Gerard van Oostrum, and others, 's Gravenhage, Kunst-Confrerie-Kamer van Pictura, September 23, 1765.
Hoet, *op. cit.*, III, 1770, p. 490, no. 26: «Baadende Nimphjes in een schoon Landschap, door Jan Lis; hoog 2 voet 9 duim, breet 3 voet 4 duim. 21–10.» Lugt, *op. cit.*, no. 1478.

8 *Bathing Nymphs in a Large Landscape*
Sale: Antony Grill, Amsterdam, April 14, 1728.
Hoet, *op. cit.*, I, 1752, p. 328, no. 47: «Badende Nimphjes in een groot Landschap, door Vander Lys. 14–0.» Lugt, *op. cit.*, no. 370.

9 *Bathing Women*

Sale: Amsterdam, October 8, 1700.
Hoet, *op. cit.*, I, 1752, p. 59, no. 4: «Badende Vrouwtjes, van vander Lis, ongemeen fraei. 127–0.» Lugt, *op. cit.*, no. 175.

10 *A Landscape with Bathing Woman*

Sale: Van de Amory, Amsterdam, June 23, 1722.
Hoet, *op. cit.*, I, 1752, p. 264, nos. 65–66: «Een Landschap met Badende Vrouwtjes, door Jan vander Lis, 12 d. dr. 15 d. 75–0. Een dito van dezelve, 66–0.» Lugt, *op. cit.*, no. 298.
Note: Van de Amory Sale, June 23, 1722, lists three paintings by Lis. However, Hoet differentiates between Jan Lis (*Ecstasy of St. Paul*) and Jan vander Lis for *Bathing Young Women*, thereby raising a doubt whether we have to do with only one painter.

11 *A Nude Diana*

Inventory of the estate of the painter Jacob Loys, October 30, 1680: «No 92: «Een naeckte Diana van Jan Lis.»
Bredius, *Künstlerinventare*, part 5, 1918, p. 1591.

12 *Diana and Her Nymphs Bathing*

Sale: Hendrik Schut, Rotterdam, April 8, 1739.
Hoet, *op. cit.*, I, 1752, p. 572, no. 4: «Een Stuckje verbeeldende Diana, met haar Nimphen zig badende, met veel bywerk, door Vander Lis. 110–0.» Lugt, *op. cit.*, no. 502.

13 *Bath of Diana*

Sale: Johan van Marselis, Amsterdam, April 25, 1703.
Hoet, *op. cit.*, I, 1752, p. 70, no. 20: «'t Bad van Diana van Jan vander Lis. 100–0.» Lugt, *op. cit.*, no. 185; Mireur, *op. cit.*, IV, p. 345.

14 *Bath of Diana*

Sale: Anonymous, Amsterdam, May 18, 1707.
Hoet, *op. cit.*, I, 1752, p. 103, no. 26: «'t Bad van Diana, van Jan Lis. 34–0.» Mireur, *op. cit.*, IV, p. 345: «Le même tableau.» Lugt, *op. cit.*, no. 206.

15 *Bath of Diana*

Sale: Pieter Laendert de Neufville den Ouden, Amsterdam, June 19, 1765.
Hoet, *op. cit.*, III, 1770, p. 473, no. 60: «Een

Badt van Diana, waar in de Beelden en 't Landschap overheerlyk geschildert zyn, door Johan Lis; zynde zo goed als ooit van hem gezien is; D. hoog 25, breet 44 duimen, 330–0.» Lugt, *op. cit.*, no. 1470.

16 *Diana Coming from Her Bath Accompanied by a Nymph*

Sale: De la Court van der Voort – father and son – and Catharina Backer, widow of Allard de la Court, Leiden, September 8 and 9, 1766, cat. no. 136: «Jan Lis – Diana verzeldt van een Nimph uit het Badkoomende, zeer uitvoerig, op paneel. 6½ duim hoog, 5 duim breet. 32–0 [sold to Lavicha or Savicha].
Hoet, *op. cit.*, III, 1770, p. 560, no. 136. Lugt, *op. cit.*, no. 1557.

17 *Bath of Diana in a Landscape*

Sale: Anonymous, Amsterdam, July 13, 1718.
Hoet, *op. cit.*, I, 1752, p. 217, no. 21: «Het Badt van Diana, in een konstig Landschap, door J. vander Lis, 42–0.» See also Pigler, 1956, II, p. 72; Lugt, *op. cit.*, no. 267.

18 *Bath of Diana*

Sale: Jacob Boreel, Amsterdam, April 21, 1746, cat. no. 18: «Een Badje van Diana, van Jan vander Lis 80–0. W. v. Denberg.»
Hoet, *op. cit.*, II, 1752, p. 184, no. 18; Lugt, *op. cit.*, no. 636.

19 *Diana and Callisto*

Inventory Wed. Georg Everhardt Klenck, 1649, Amsterdam.
Mentioned under Jan Lys in handwritten notes by E. W. Moes; MS in Rijksprentenkabinet, Amsterdam. Steinbart, 1940, p. 171.

20 *Diana Discovers the Pregnancy of Her Nymph Callisto*

Sale: Antony Grill, Amsterdam, April 14, 1728, no. 30: «De Ontdekking van Calisto, door Vander Lis geschildert.»
Hoet, *op. cit.*, I, 1752, p. 327, no. 30; Lugt, *op. cit.*, no. 370.

21 *Diana Discovers the Pregnancy of Her Nymph Callisto*

Sale: Samuel van Huls, 's Gravenhage, September 3, 1737.
Hoet, *op. cit.*, I, 1752, p. 490, no. 137: «Een

dito van denzelven [J. Lis]), verbeeldende de
Ontdecking van Callisto, h. 1 v. 4 d. br. 2 v.
en een halve d. 52–0.» Lugt, *op. cit.,* no. 474.

22 *The Fall of Phaeton*
See J. C. Weyerman, *De Levensbeschryvingen
der Nederlandsche Konstschilders en Konst-
Schilderessen,* I, 1729, p. 403: «. . . Desgelijks
roemen zy den Val van Phaeton, die uyt de
Zonnekar op de aarde wort nedergebonst door
den blixenflits van Jupyn, welk stukje ver-
scheyde naakte, en tot er toe verschrikte Nym-
fen vervat, beneffens een welgeordonneert land-
schap, vrolijk gekoloreert en verstandiglijk ver-
koozen . . .»

23 *The Fall of Phaeton*
Coll.: Algarotti.
Selva, *op. cit.,* p. XIII: «Lys Giovanni . . .
Fetonte che per non saper guidare il Carro del
Sole si e troppe avvicinato alla Terra. Cerere e
la Terra sulle nubi sono condotte da Mercurio
dinanzi a Giove, e lo pregano che voglia rimi-
diare all'eccessivo calore che tormentava i mor-
tali. Abbasso vedesi un Fiume col vaso che non
versa più acqua. Nettuno col suoi Cavalli
spunta dal Mare ed ancor esso ricorre e Giove
accompagnato da molte Ninfe meste e dolenti.
Diversi nudi stano al coperto sotto un tendone
tutti affannati e spossati pel gran caldo. Opera
di bizarra e particolar invenzione, condotta
con grandissima bravura ed intelligenza. In
tela, alto p. 3. onc. I 1. p. 3. onc. 9. (Il Sand-
rart ne fa menzione nella di lui vita. P. II. Lib.
III. pag. 309.)» Bartholomäi, *op. cit.,* pp. 31–32.

24 *The Fall of Phaeton*
Coll.: Hooft, Hoorn.
Rijp, *op. cit.,* p. 318 ff: «. . . By de Heern Fis-
caal Hooft is een Phaëton, ses Voet groot/dat
ook in't Paleys der Pamphiliën door hem nog
grooter geschildert is . . .»

25 *The Fall of Phaeton*
Coll.: Palazzo Pamphili, Rome.
Rijp, *op. cit.,* pp. 318 ff.
Note: The only reference to a subject of Phae-
ton in the inventory of Prince Don Giovanni
Battista Pamphilij of 1684 (Scaff. 86, N. 29,
f. 385 v) is to a drawing: «. . . Desegni diu
fattia penna, in uno vi è il carri di fetonte a

nell'altro uno paese con figure di p. uno con
cornice nere . . .» See Jörg Garms, ed., *Quel-
len aus dem Archiv Doria-Pamphilij zur Kunst-
tätigkeit in Rom unter Innocenz X,* in *Publika-
tionen des Österreichischen Kulturinstitutes in
Rom,* sect. II, series 3, vol. 4, Rome, 1972,
p. 321.
Peltzer, 1914, p. 163, mentions a *Fall of Phae-
ton* which Sandrart praised and remarks that
Liss probably painted it for Innocent X.

26 *Ganymede*
Sale: Quirin van Biesum, Rotterdam, October
18, 1719.
Hoet, *op. cit.,* I, 1752, 231, no. 95: «De Schaking
van Ganimedes, door Jan Lis, 50–0.» Lugt,
op. cit., no. 274.

27 *Venus and Adonis*
Sale: Anonymous, 's Gravenhage, July 18, 1753.
Hoet, *op. cit.,* III, 1770, p. 81, no. 50: «Venus
en Adonis met Cupido in een Landschap, door
Jan Lis. 15–5.» Lugt, *op. cit.,* no. 814.

28 *Venus, Bacchus and Flora*
Sale: Cornelius van Dyck, The Hague, May 10,
1713.
Hoet, *op. cit.,* I, 1752, p. 169, no. 125: «Een
dito, van vander Lis, zynde Venus, Bacchus en
Flora, en verder met Kindertjes seer plaizierig,
en zwaer van kouleur. 49–0.» Lugt, *op. cit.,*
no. 241.

29 *A Large Piece with Ruins, Nude Figures
and Different Animals.*
Sale: Cornelis van Dyck, The Hague, May 10,
1713.
Hoet, *op. cit.,* I, 1752, p. 169, no. 126: «Een
dito van denzelven [vander Lis], zynde een
groot Stuk, met vervallen Ruinen, naekte
Beelden en veelderley soorten van Beesten, seer
wonderschoon van kouleur. 49–0.» Lugt, *op.
cit.,* no. 241.

30 *Some Figures and Animals*
Sale: Anonymous, Amsterdam, April 9, 1687.
Hoet, *op. cit.,* I, 1752, p. 9, no. 70: «Eenige
Figuurtjes en Beesten, van Jan vander Lis,
20–0.» Lugt, *op. cit.,* no. 10.

VII Allegorical Subjects

1 *An Old Woman Gives a Sheet of Paper to a Young Girl . . . Surrounded by Young Nude Males . . .*
(companion piece to VII, 2)
Coll.: Algarotti.
Selva, *op. cit.,* p. XIV: «Una Vecchia in piedi in atto di presentare un foglio ad una gioviane a sederè attorniata da molti nudi sdrajati sul terreno. Il sito è un paese in sui si vede una gran pietra con bel bassorilievo antico. In tela, alti p. 1 onc. 10. 1. p. 3¹/₂.» Bartholomäi, *op. cit.,* pp. 33–34.

2 *Philosophers around a Table with Bacchus and Venus . . .*
(companion piece to VII, 1)
Coll.: Algarotti.
Selva, *op. cit.,* p. XIV: «Molti Filosofi dintorno ad una tavola che si affaticano a studiare in varie cose; e sul piano vi sono istrumenti di tutte le Arti, e Scienze. In dietro vedesi un Fornello con fuoco in cui due Chimici vi lavorano, uno di questo colle mani ne' capelli si dispera. Nel dinanzi evvi Bacco che suone, e Venere in atto di coprirsi con una maschere.» Bartholomäi, *op. cit.,* p. 33.

VIII Pictures Mentioned Without Subjects

1 Cochin, *Voyage d'Italie,* III, 1758, p. 143: «Palais Sagredo, Venice: . . . deux petits tableaux . . . du Caracci, représente une Notre-Dame de pitié . . . l'autre, qu'on croit de Jean du Lis, est excellent aussi . . .»

2 Inventory of the estate of Johannes de Renialme, art dealer in Amsterdam, of June 27, 1657, in Bredius, *Künstlerinventare,* 1, 1915, p. 232: «189. Een stuck op steen van Jan Lis (Lijs) . . . f 36.–»

Index of Prints and Drawings after Liss

Selected Index for Catalogue Entries

Photo credits

A. Paintings

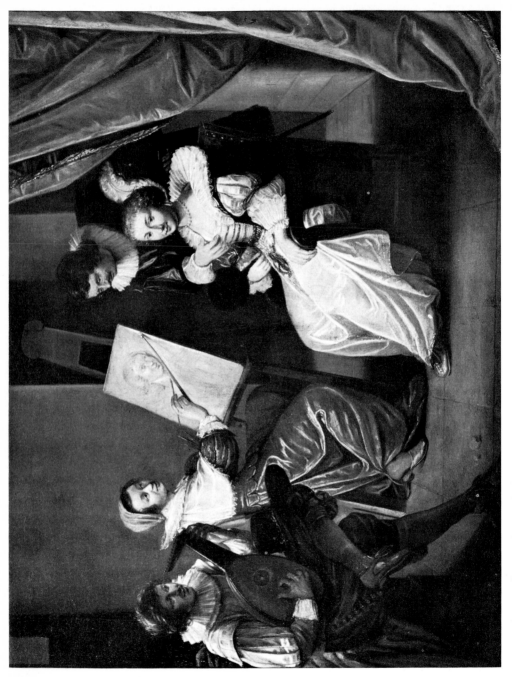

1 A Painter in her Studio · Rijksdienst voor Roerende Monumenten, The Hague [A 1]

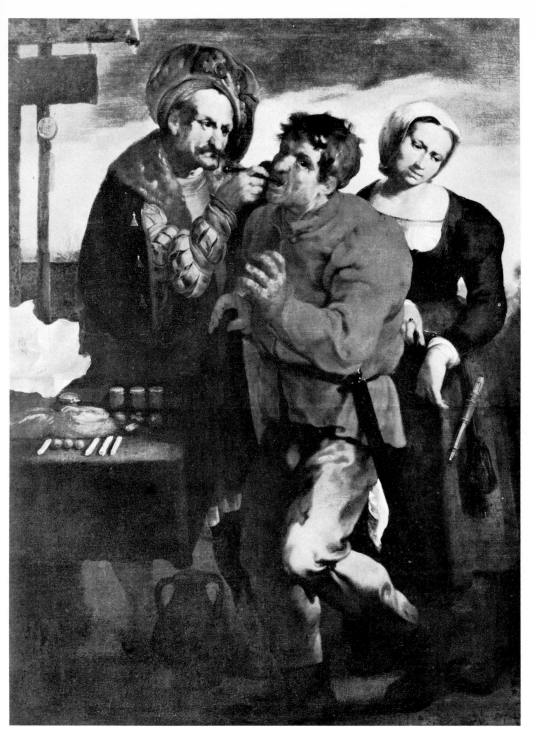

2 The Dentist · Kunsthalle Bremen [A 2]

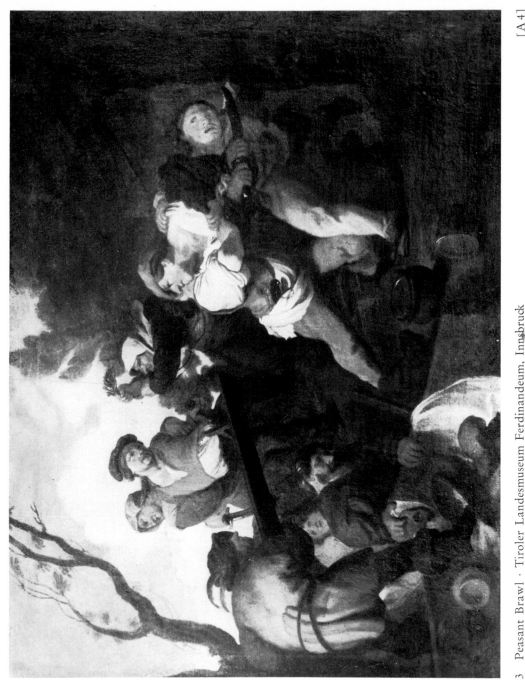

3 Peasant Brawl · Tiroler Landesmuseum Ferdinandeum, Innsbruck [A4]

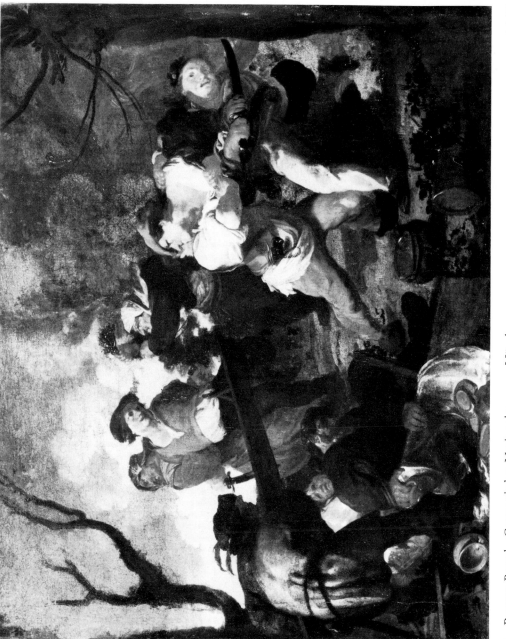

4 Peasant Brawl · Germanisches Nationalmuseum, Nürnberg

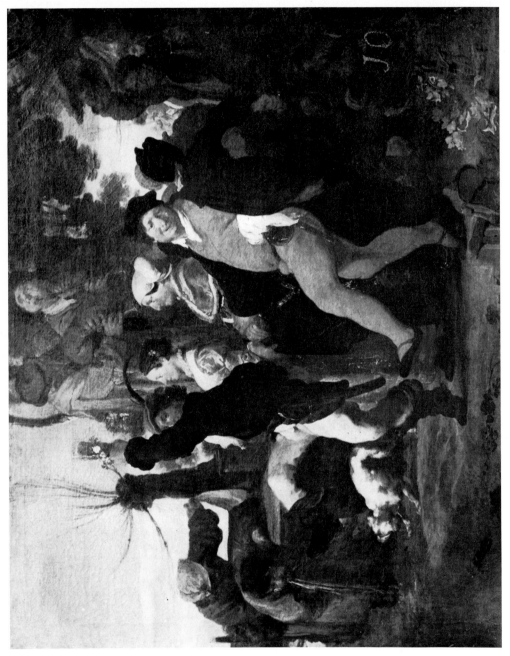

5 Peasant Wedding · Szépmüvészeti Múzeum, Budapest

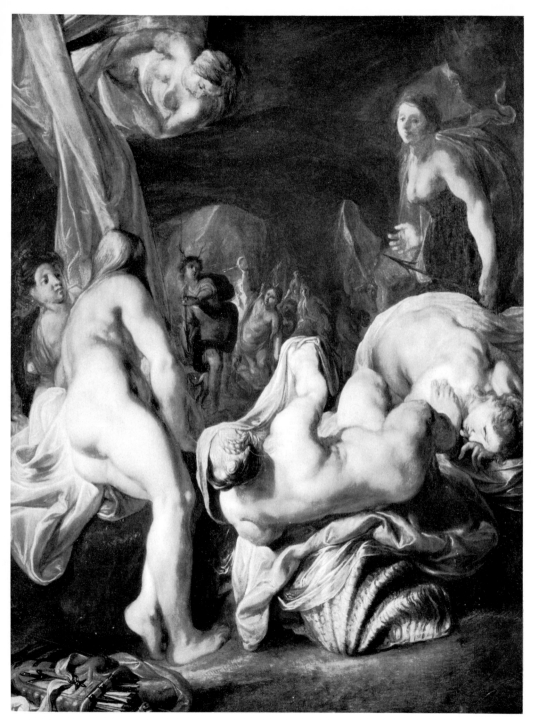

6 Diana and Actaeon · Private Collection, England [A 8]

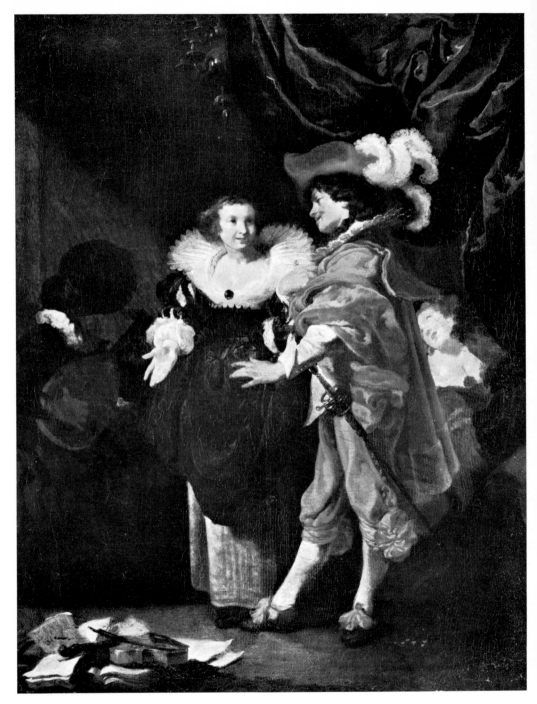

7 The Gallant Couple · Dr. Karl Graf von Schönborn-Wiesentheid, Schloss Pommersfelden [A 6]

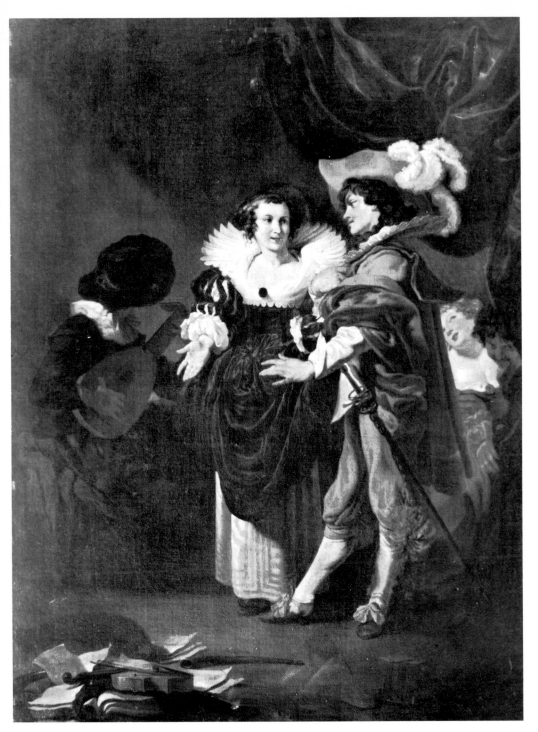

8 The Gallant Couple · Ludwig Roselius Collection of Böttcherstrasse, Bremen [A 7]

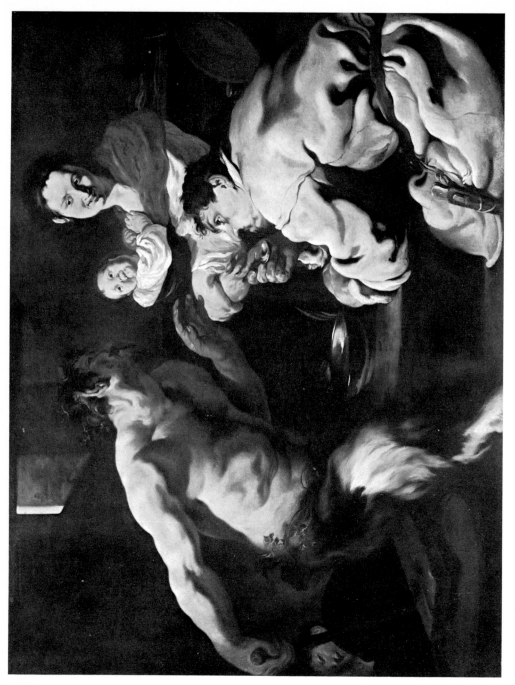

9 Satyr and Peasant · Staatliche Museen Preussischer Kulturbesitz, Gemäldegalerie, Berlin [A 9]

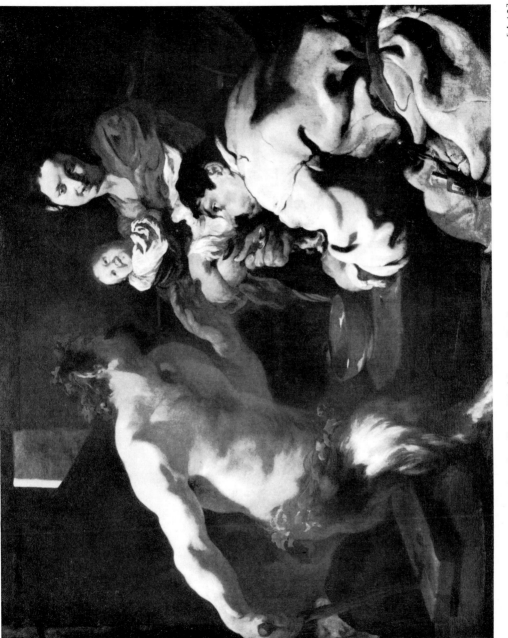

10 Satyr and Peasant · National Gallery, Washington, D. C.

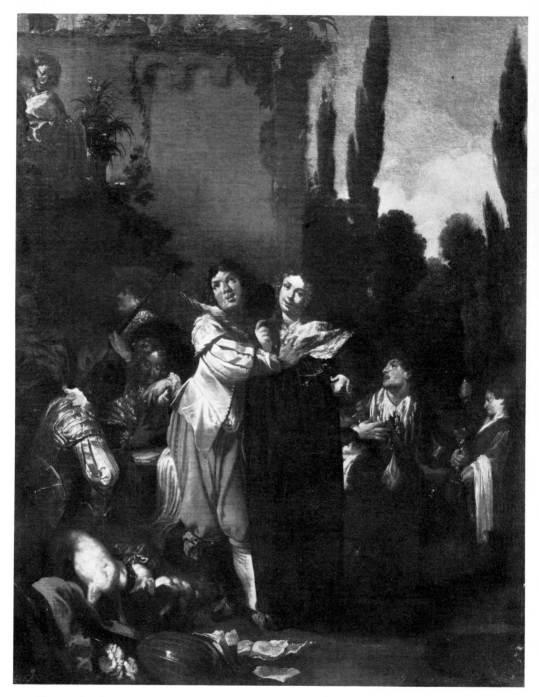

11 The Prodigal Son · Galleria degli Uffizi, Florence [A 11]

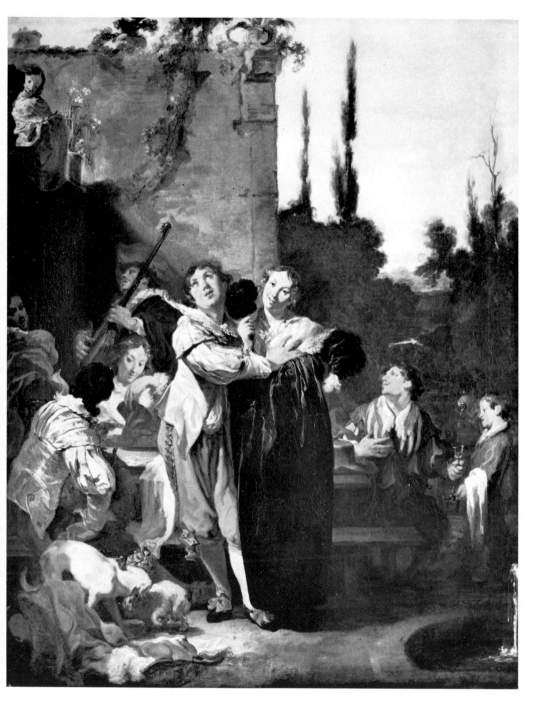

12 The Prodigal Son · Gemäldegalerie der Akademie der Bildenden Künste, Vienna [A 12]

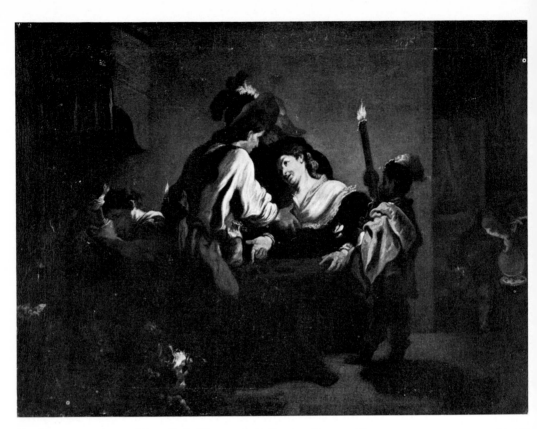

13 The Morra Game · Marie E. B. Harteneck Collection, Buenos Aires [A 14]

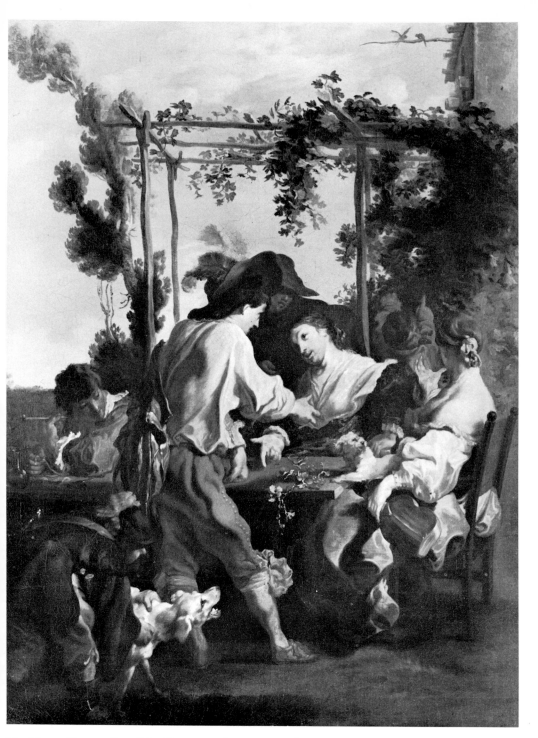

14 Morra Game · Staatliche Kunstsammlungen, Kassel [A 13]

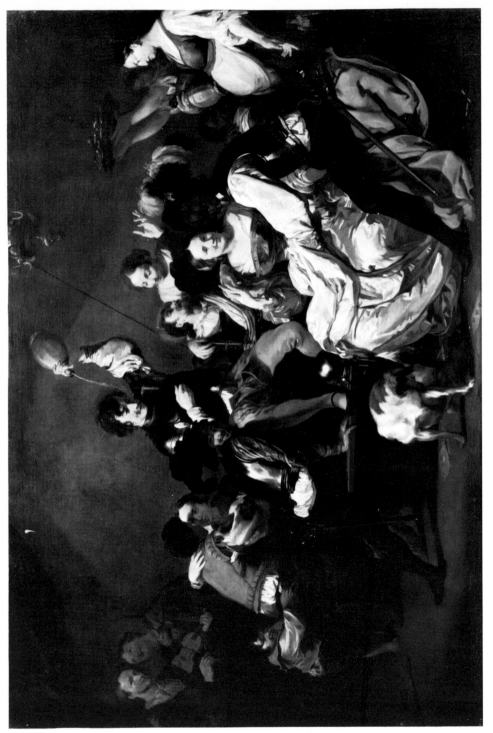

15　Banquet of Soldiers and Courtesans · Staatliche Kunstsammlungen, Kassel

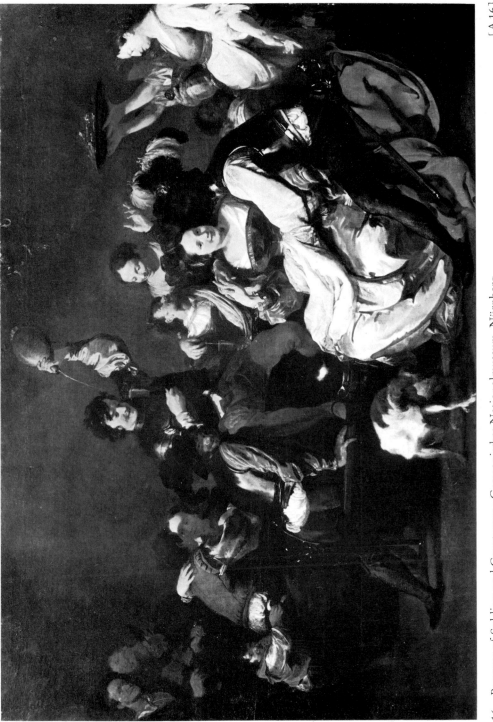

16 Banquet of Soldiers and Courtesans · Germanisches Nationalmuseum, Nürnberg

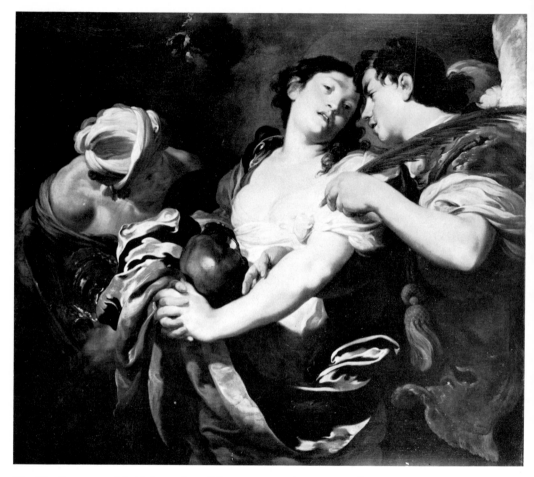

17 The Repentant Magdalene · Staatliche Kunstsammlungen Dresden, [A 17]
Gemäldegalerie Alte Meister, Deutsche Demokratische Republik

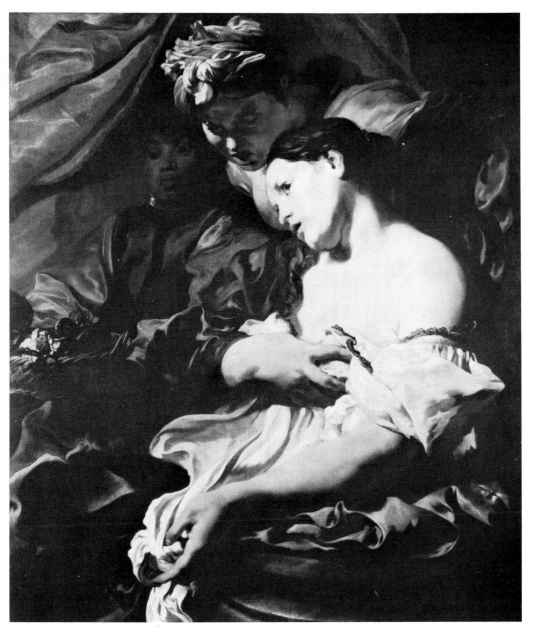

18 The Death of Cleopatra · Bayerische Staatsgemäldesammlungen, München [A 18]

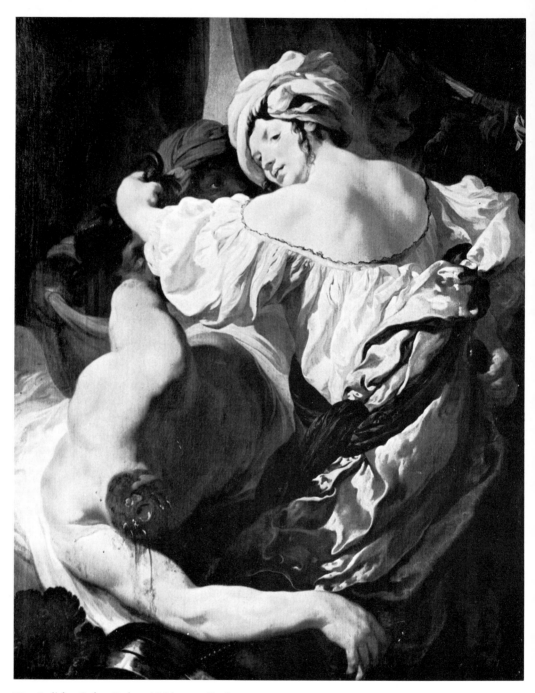

19 Judith · Szépmüvészeti Múzeum, Budapest [A 20]

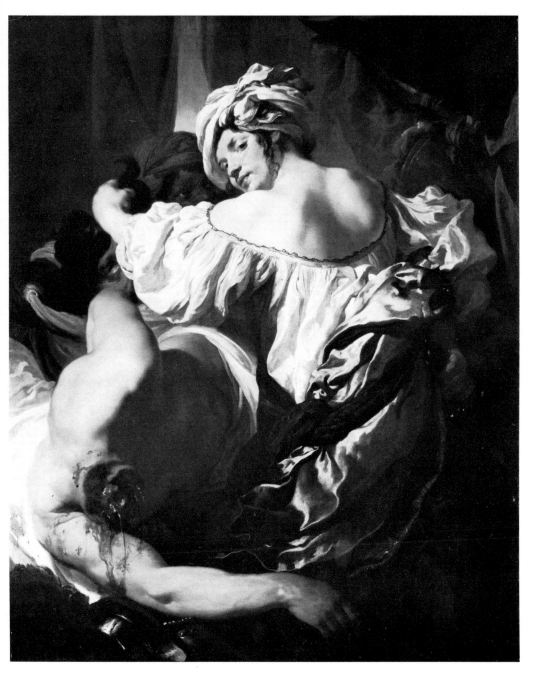

20 Judith · National Gallery, London [A 19]

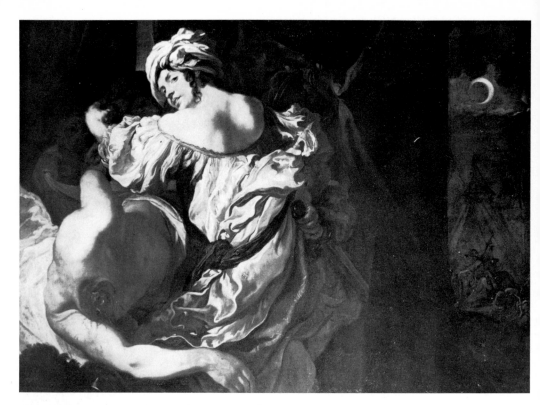

21 Judith · Ca' Rezzonica, Venice (Dono Volpi, 1950) [A 22]

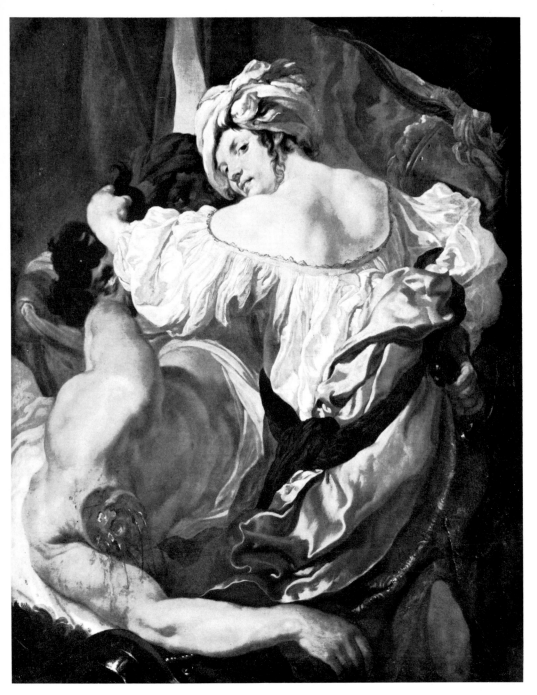

22 Judith · Kunsthistorisches Museum, Vienna [A 21]

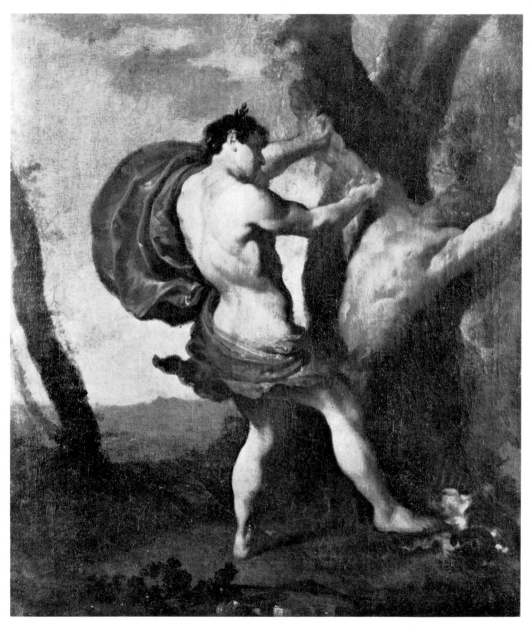

23 The Flaying of Marsyas · Gallerie dell'Accademia, Venice [A 24]

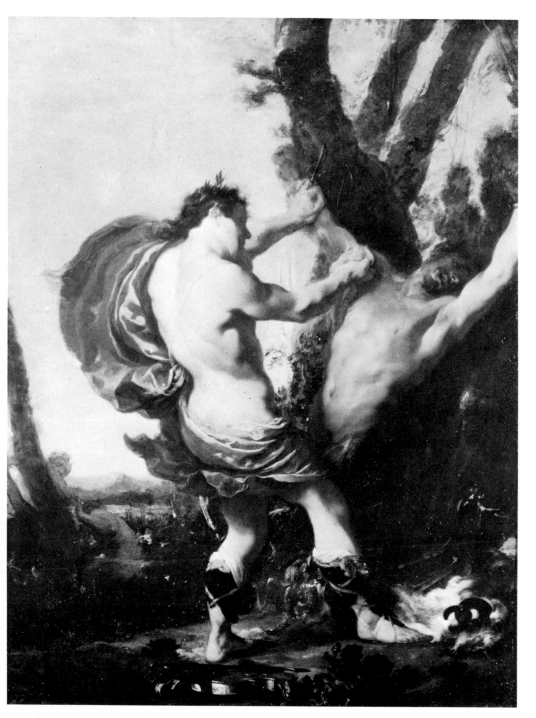

24 The Flaying of Marsyas · Pushkin Museum of Fine Arts, Moscow [A 23]

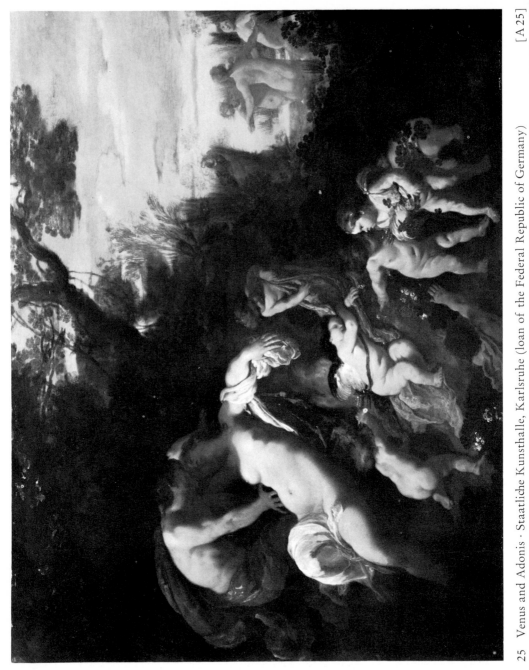

25 Venus and Adonis · Staatliche Kunsthalle, Karlsruhe (loan of the Federal Republic of Germany) [A 25]

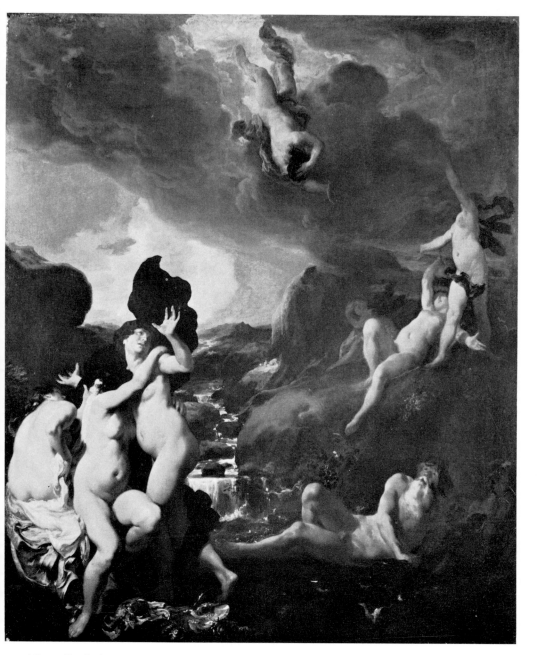

26 The Fall of Phaeton · Denis Mahon, London [A 26]

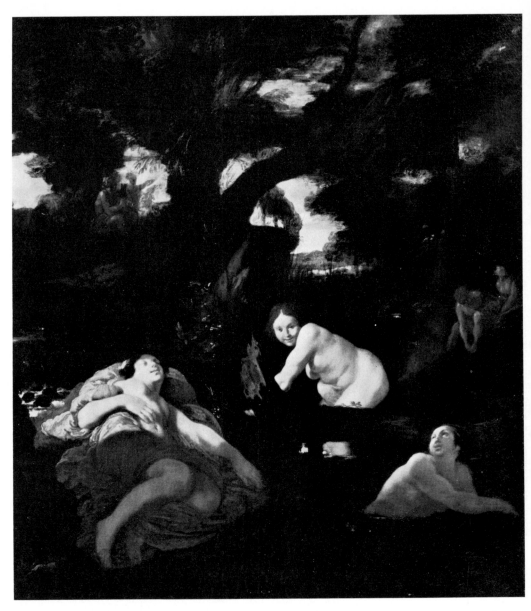

27 Bathing Nymphs · Georg Schäfer Collection, Schweinfurt [A 27]
(Deutsche Barockgalerie, Augsburg)

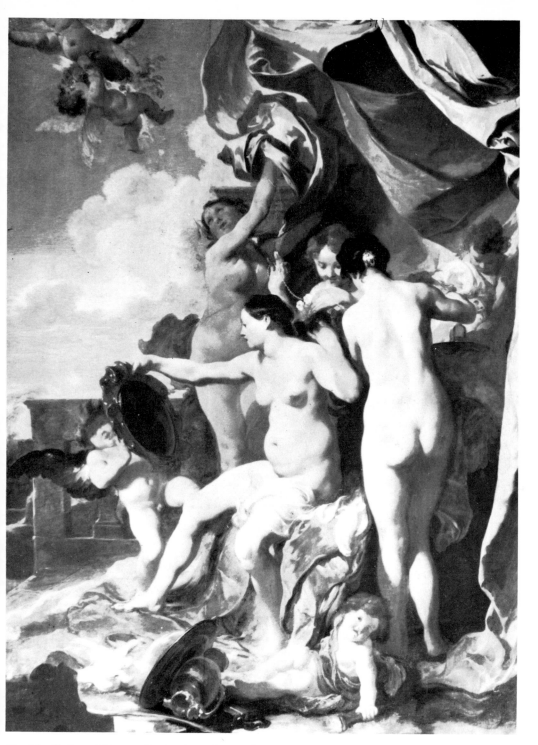

28 The Toilet of Venus · Dr. Karl Graf von Schönborn-Wiesentheid,
Schloss Pommersfelden

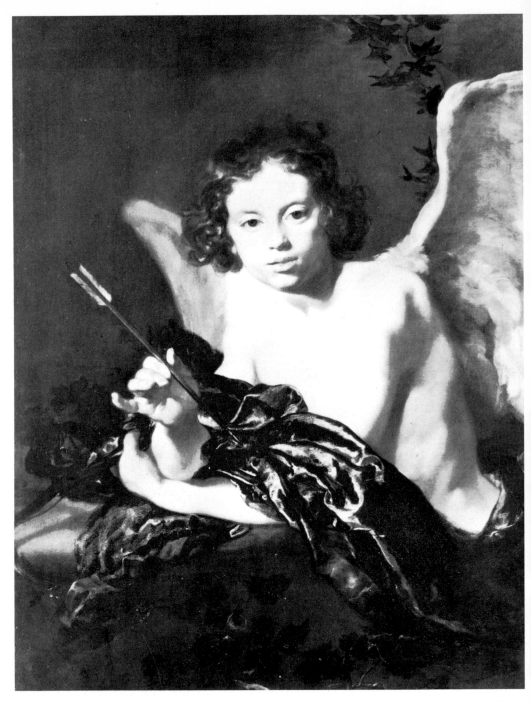

29 Amor Vincit · The Cleveland Museum of Art [A 29]

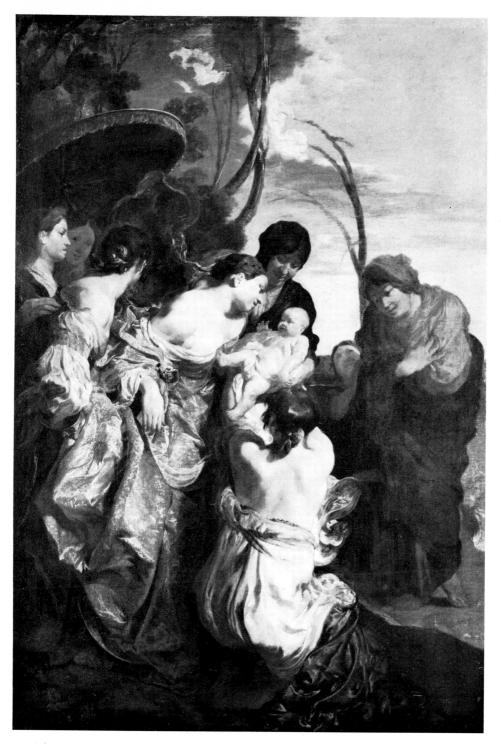

30 The Finding of Moses · Musée des Beaux-Arts, Lille [A 30]

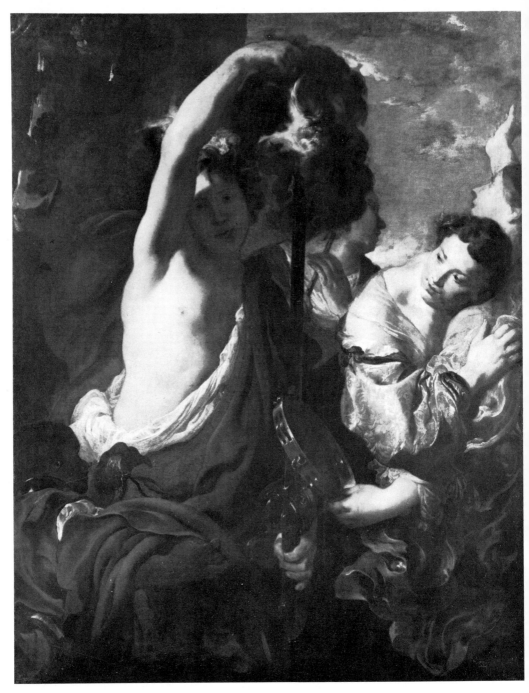

31 David with the Head of Goliath · Palazzo Reale, Naples [A 31]

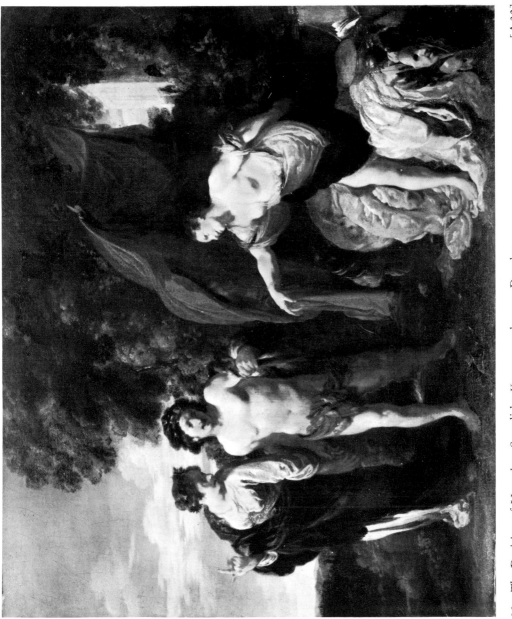

32 The Decision of Hercules · Staatliche Kunstsammlungen, Dresden, Gemäldegalerie Alte Meister, Deutsche Demokratische Republik

[A 32]

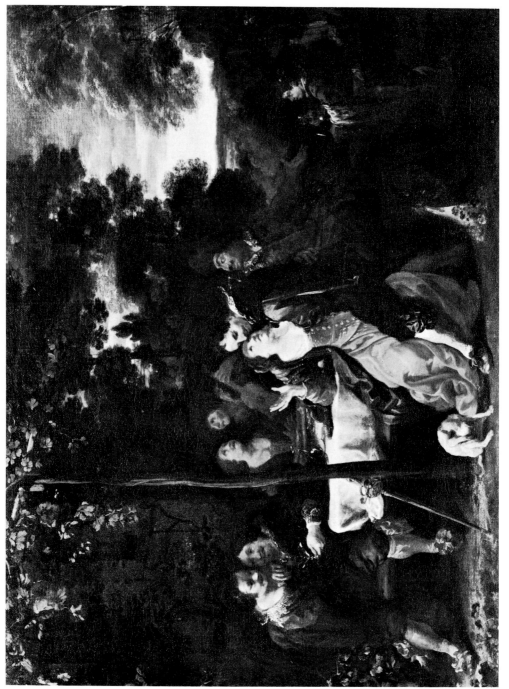

33 Merry Company Outdoors (Prodigal Son?) · Private Collection, England

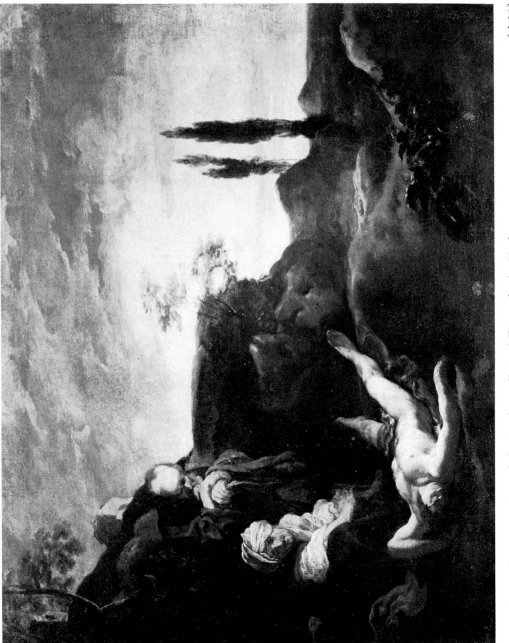

34 Adam and Eve Mourning Abel's Death · Galleria dell'Accademia, Venice [A 36]

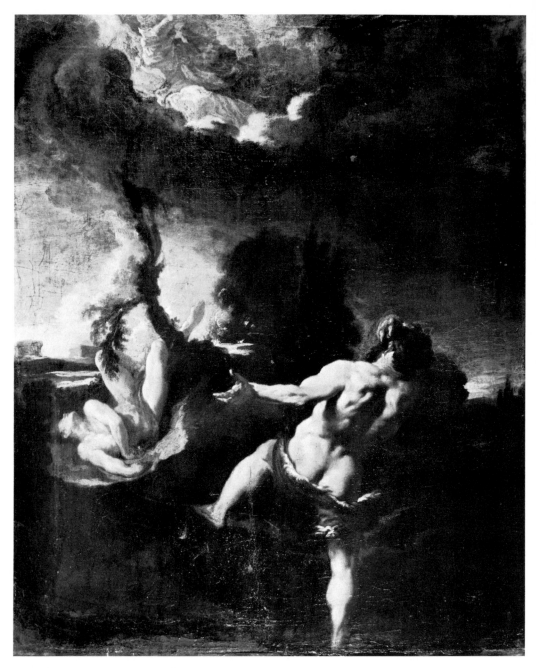

35 The Cursing of Cain · M. Knoedler & Co., New York [A 34]

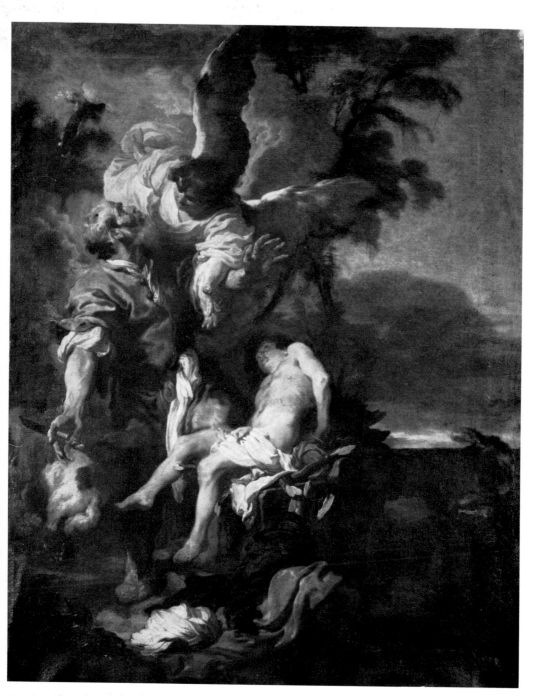

36 Sacrifice of Isaac · Galleria degli Uffizi, Florence [A 35]

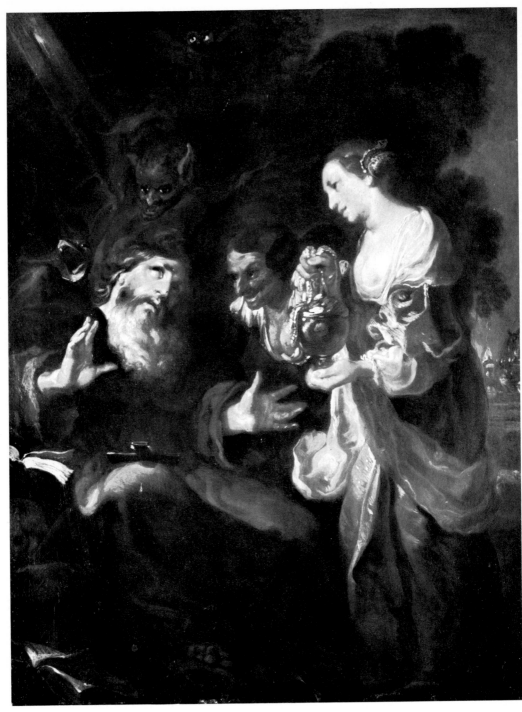

37 The Temptation of St. Anthony · Wallraf-Richartz-Museum, Cologne [A 37]

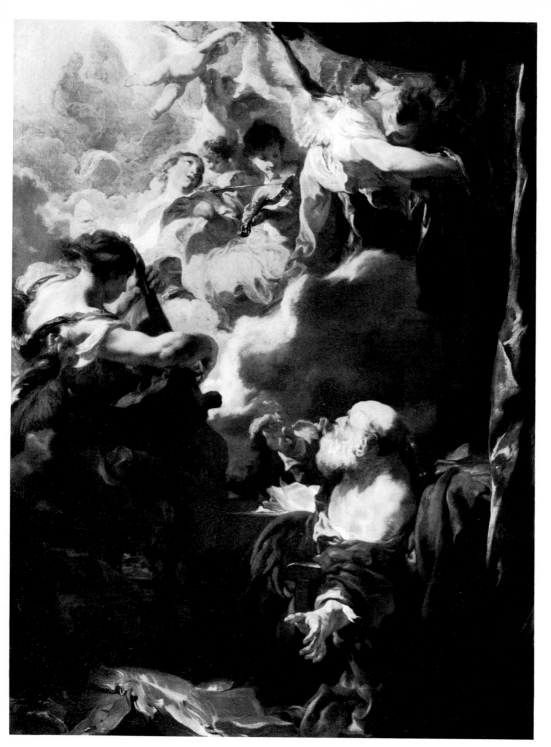

38 Ecstasy of St. Paul · Staatliche Museen Preussischer Kulturbesitz, [A 38]
Gemäldegalerie, Berlin

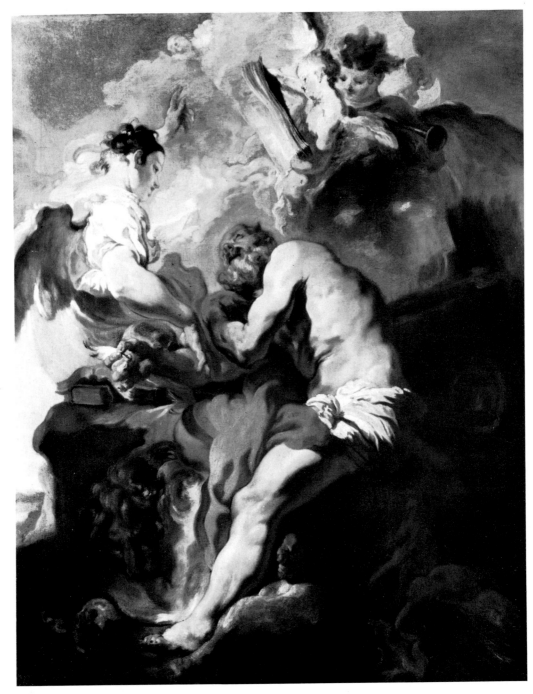

39 The Vision of St. Jerome · National Gallery of Ireland, Dublin [A 40]

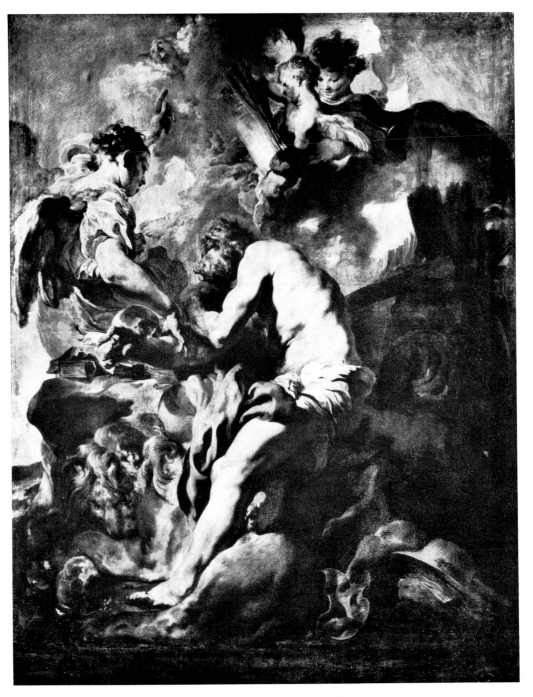

40 Vision of St. Jerome · S. Nicolò da Tolentino, Venice [A 39]

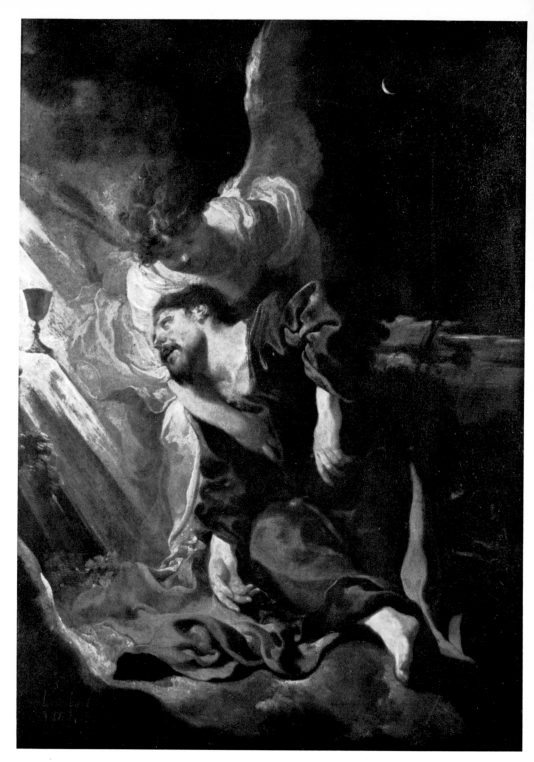

41 Christ in the Garden · Private Collection, Switzerland [A 41]

B. Drawings and Etchings

42 The Fool as Matchmaker, Etching, state I/II [B 42]
Rijksprentenkabinet, Rijksmuseum, Amsterdam

43 The Fool as Matchmaker, Etching, state II/II [B 42]
The Art Institute of Chicago, The Stanley Field Fund

44 Brawling Peasants, Drawing · Hamburger Kunsthalle, Kupferstichkabinett

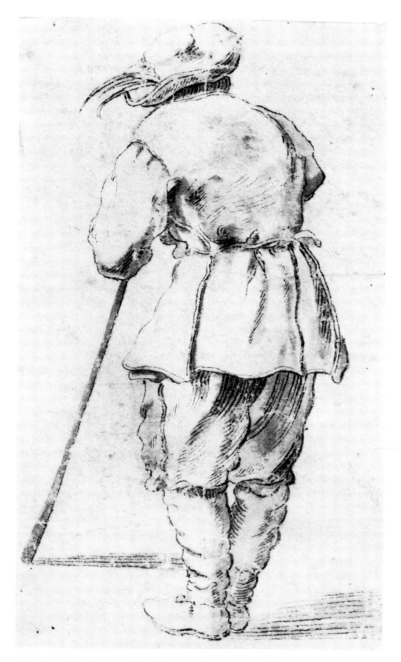

45 Standing Peasant Seen from Back, Drawing [B 44]
Georg Schäfer Collection, Schweinfurt

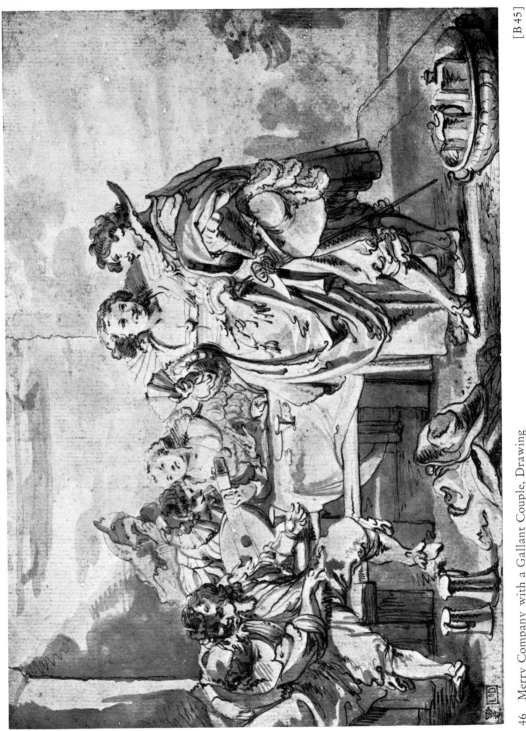

46 Merry Company with a Gallant Couple, Drawing
Staatliche Museen Preussischer Kulturbesitz, Kupferstichkabinett, Berlin

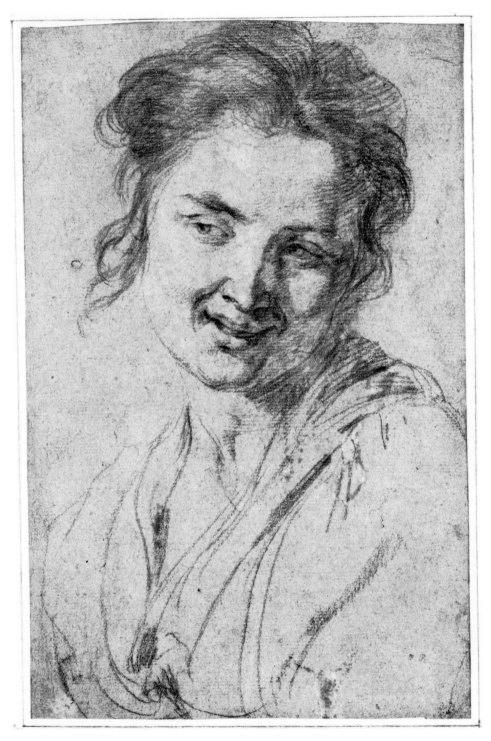

47 Study of a Woman's Head, Drawing [B 46]
Rijksprentenkabinet, Rijksmuseum, Amsterdam

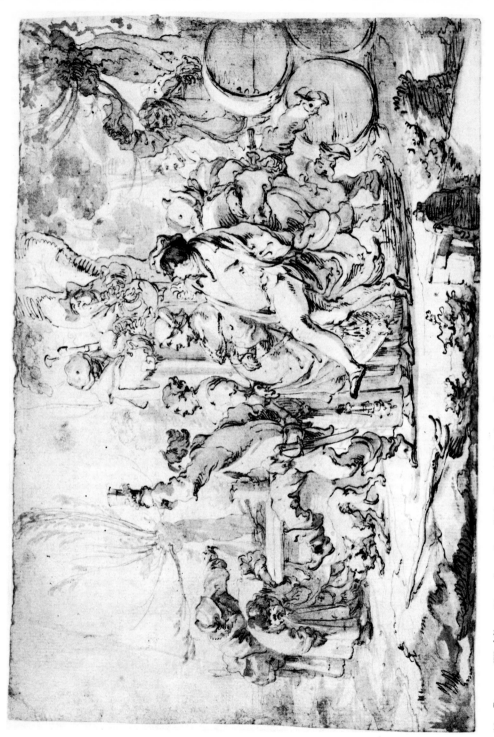

48 Peasant Wedding, Drawing · Staatliche Graphische Sammlung, Munich

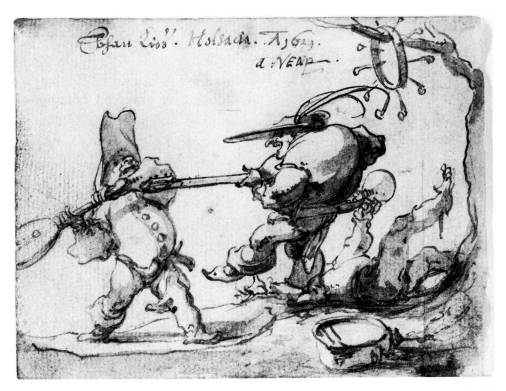

49 Fighting Gobbi Musicians, Drawing [B 48]
Hamburger Kunsthalle, Kupferstichkabinett

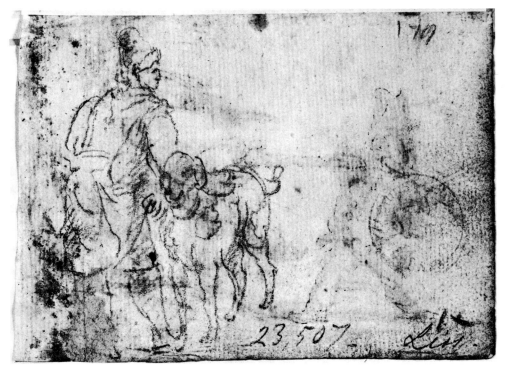

50 Verso, A Boy and Dog, red chalk [B 48]

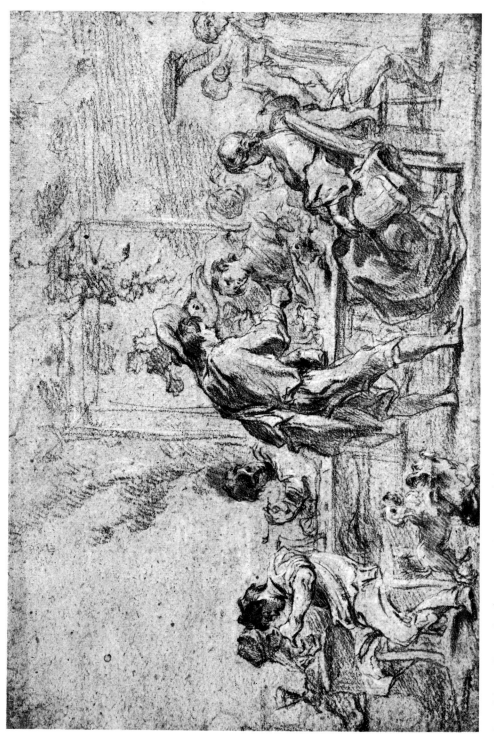

51 Morra Game Outdoors, Drawing · Staatliche Kunstsammlungen, Kassel

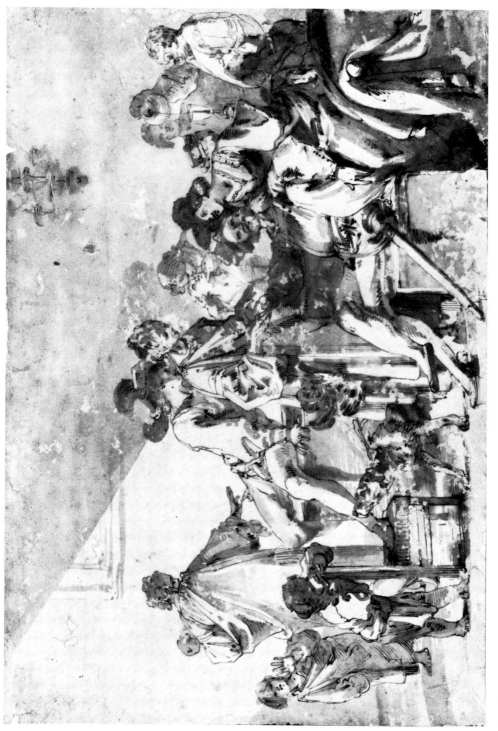

52 Merry Company with a Fortuneteller, Drawing · Lent by N. N. Collection, The Hague

[B 50a]

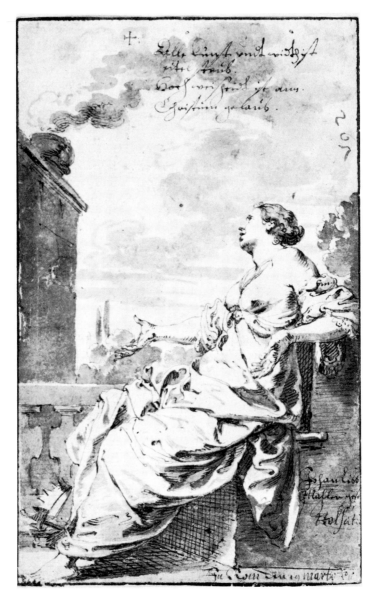

53 Allegory of Christian Faith, Drawing [B 50]
The Cleveland Museum of Art, Dudley P. Allen Fund

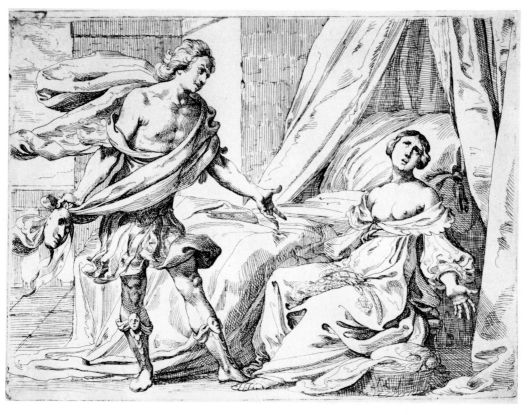

54 Cephalus and Procris, Etching, only state · Hamburger Kunsthalle, Kupferstichkabinett [B 51]

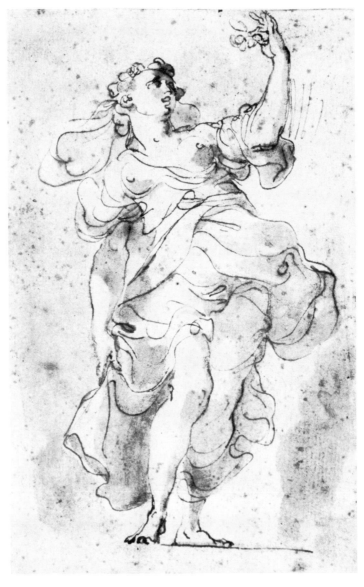

55 Standing Woman with Drapery, Drawing [B 52]
Dr. Efim Schapiro, London and Paris

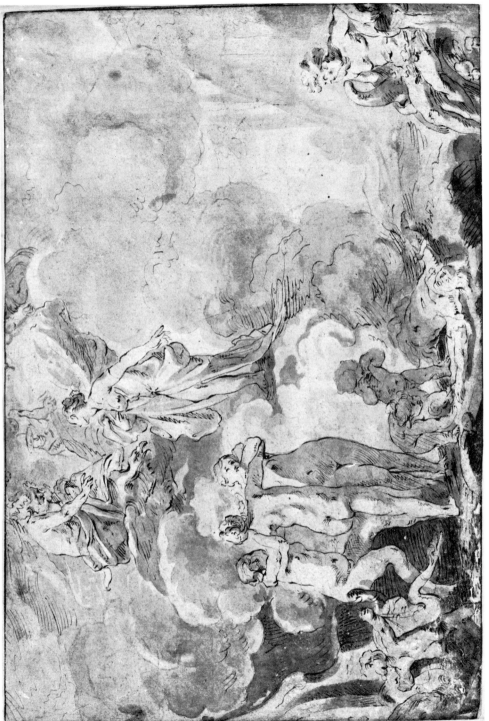

56 The Death of Phaeton, Drawing · Herzog Anton Ulrich-Museum, Braunschweig [B 53]

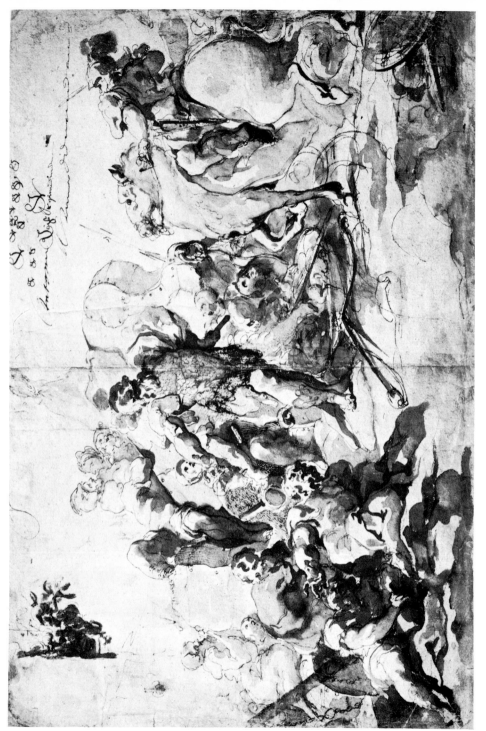

57 Manius Curius Dentatus, Drawing · Graphische Sammlung Albertina, Vienna

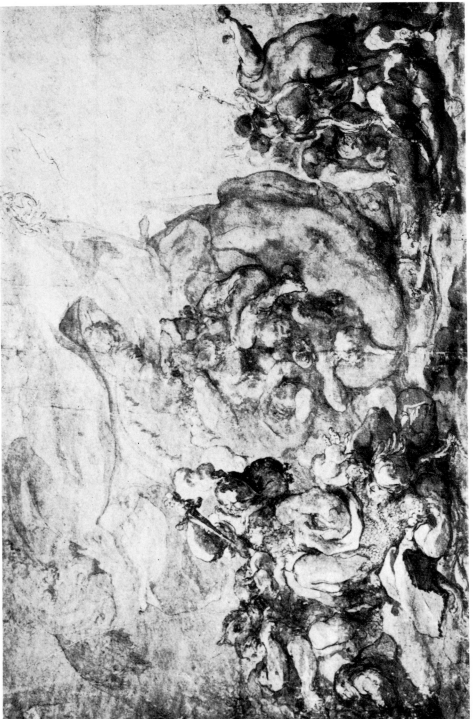

58 The Elephant of Pyrrhus, Verso

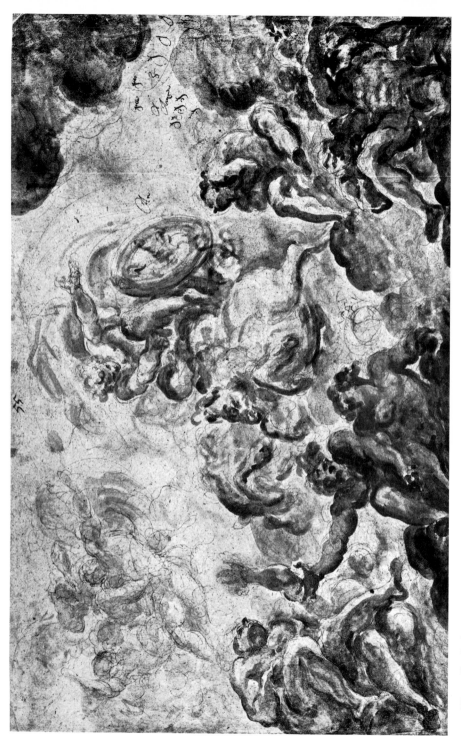

59 The Fall of Phaeton, Drawing · Private collection

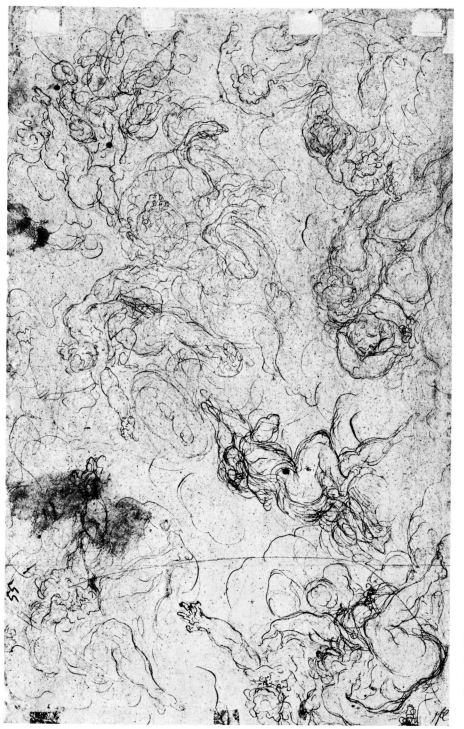

60 The Fall of Phaeton, Verso

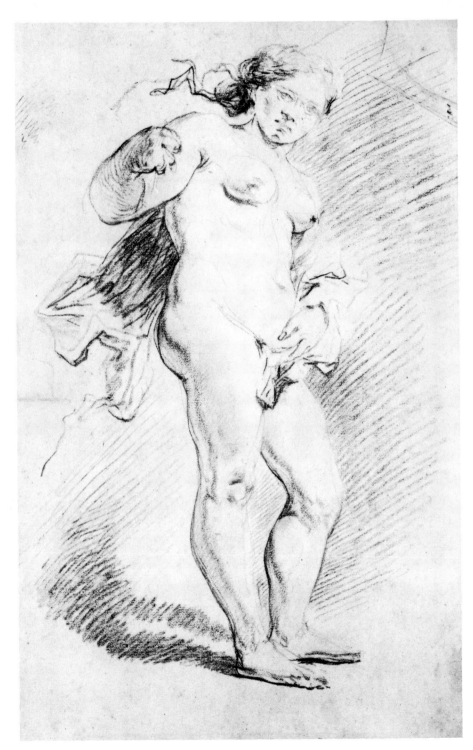

61 Nude Woman Standing, Drawing [B 54]
Fitzwilliam Museum, Cambridge, England

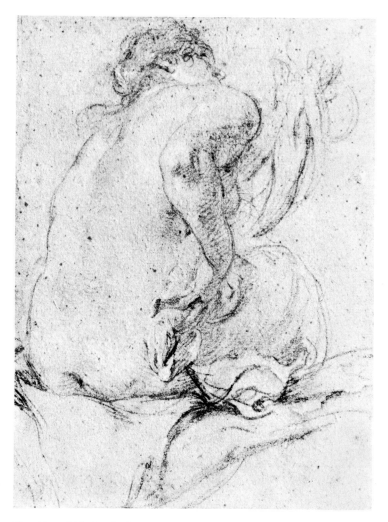

Fig. 61a Life Study for a Nymph in The Fall of Phaeton [B 56a]
Private Collection, Paris

C. Selected Drawings and Prints
after existing or lost works
by Johann Liss

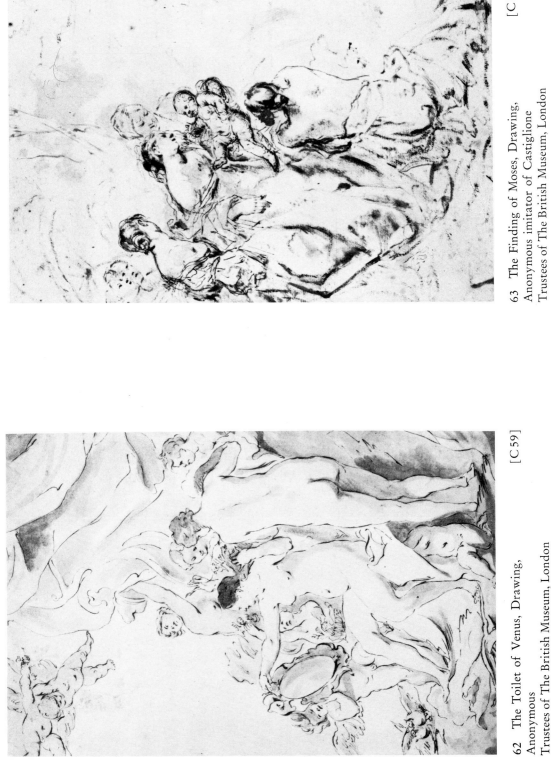

62 The Toilet of Venus, Drawing,
Anonymous
Trustees of The British Museum, London

[C 59]

63 The Finding of Moses, Drawing,
Anonymous imitator of Castiglione
Trustees of The British Museum, London

[C 57]

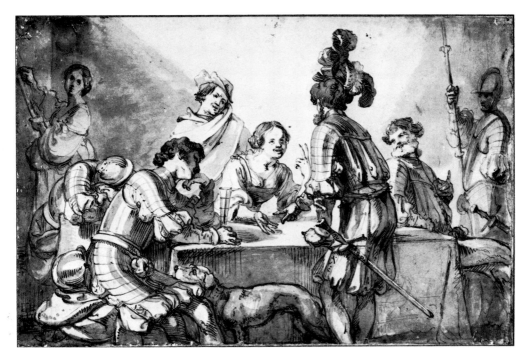

64 Morra Game in the Guard Room, Drawing, Anonymous [C 58]
Honolulu Academy of Arts

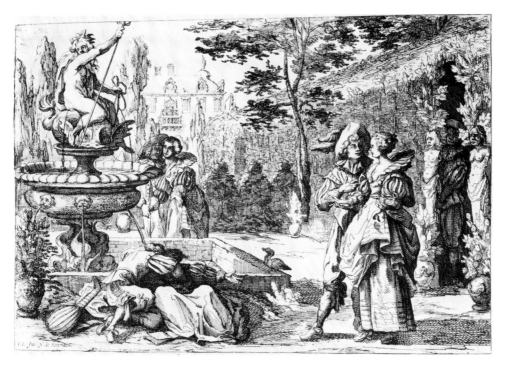

65 The Garden of Love, Etching, Nicolas de Son [C 62]
Graphische Sammlung Albertina, Vienna

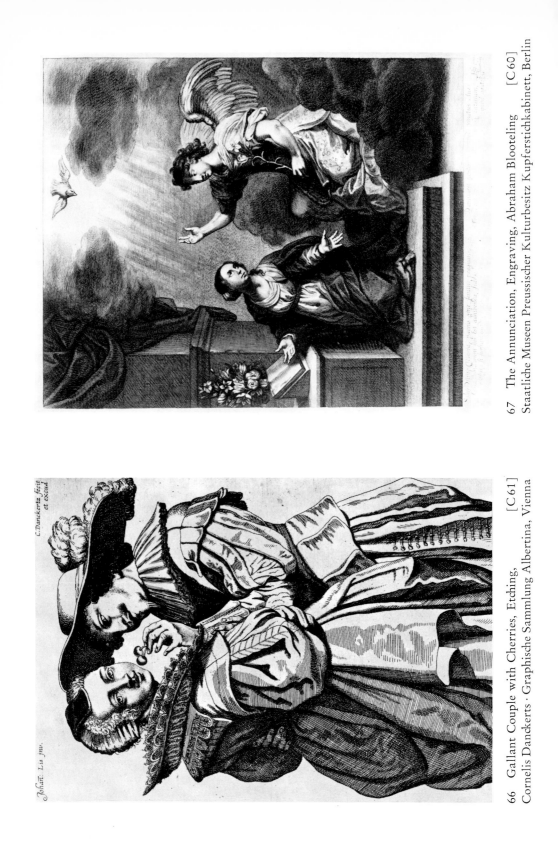

66 Gallant Couple with Cherries, Etching, [C61]
Cornelis Danckerts · Graphische Sammlung Albertina, Vienna

67 The Annunciation, Engraving, Abraham Blooteling [C60]
Staatliche Museen Preussischer Kulturbesitz Kupferstichkabinett, Berlin

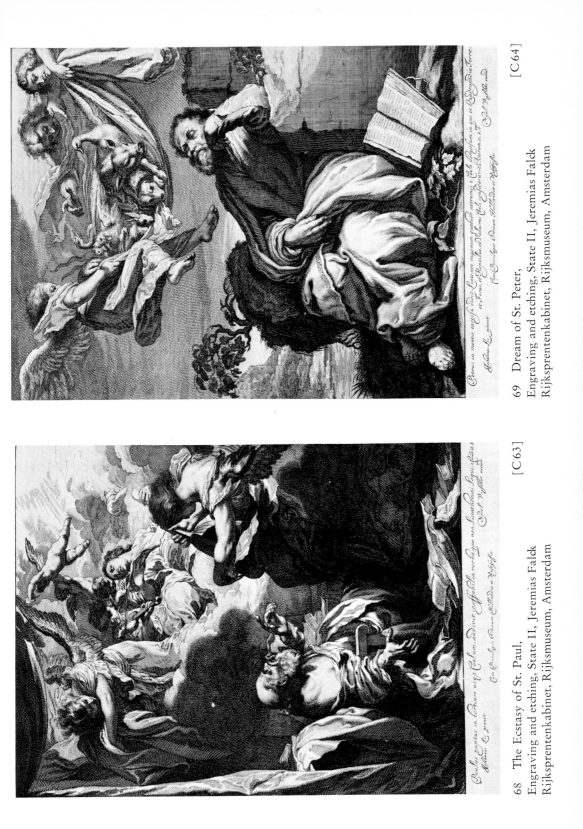

Paulus raptus in Cœlum vsq3 Cœlum, siue in Corpore siue extra Corpus nescio, rapta est in Paradisum et audiuit arcana verba, quæ non licet homini loqui. 2. Cor. 12.
Adrianus L: pinxit. D.A. V. Jest: invenit.

Cum Priuilegio Potentiss: D.D. Ordinum Holl: et Westfrisiæ.

68 The Ecstasy of St. Paul, [C63]
Engraving and etching, State II, Jeremias Falck
Rijksprentenkabinet, Rijksmuseum, Amsterdam

Petrus in mentis excessu vidit Cœlum magnum quatuor extremis e Cœlo demissum in quo et Quadrupedia Terræ
ex Fersi. et Repetilia. Delude, Cel. confirmauit Sacram. n.10. D. A. V. Jest: inuit.
Adrianus L. pinxit. Cum Priuilegio Potentiss: D.D. Ordinum Holl: et Westphrisiæ.

69 Dream of St. Peter, [C64]
Engraving and etching, State II, Jeremias Falck
Rijksprentenkabinet, Rijksmuseum, Amsterdam

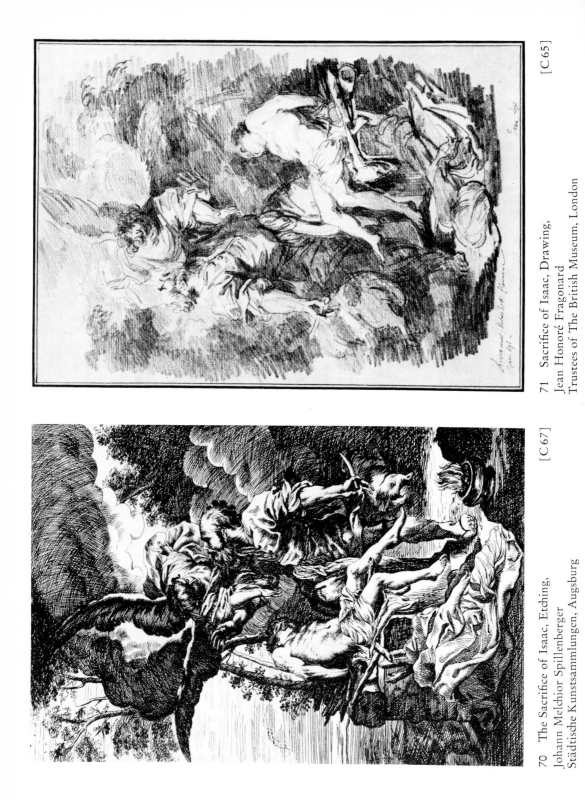

[C65]

71 Sacrifice of Isaac, Drawing,
Jean Honoré Fragonard
Trustees of The British Museum, London

[C67]

70 The Sacrifice of Isaac, Etching,
Johann Melchior Spillenberger
Städtische Kunstsammlungen, Augsburg

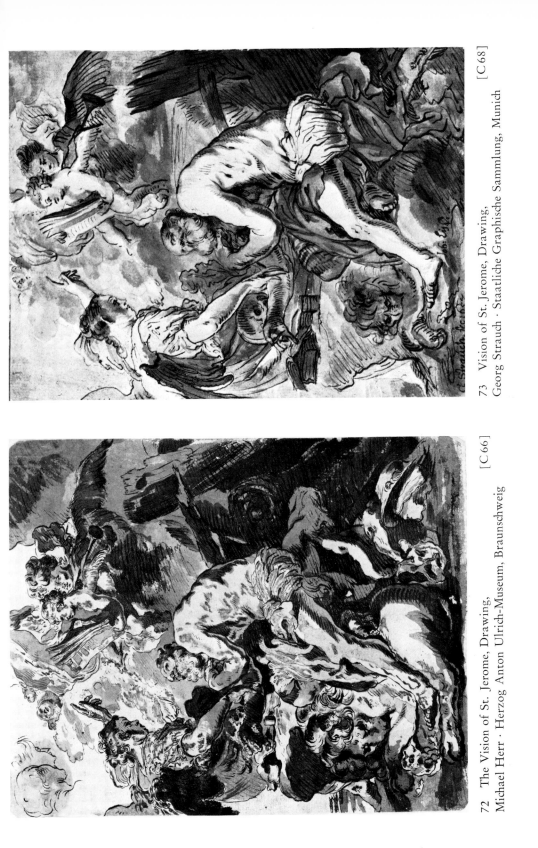

72 The Vision of St. Jerome, Drawing, [C66]
Michael Herr · Herzog Anton Ulrich-Museum, Braunschweig

73 Vision of St. Jerome, Drawing, [C68]
Georg Strauch · Staatliche Graphische Sammlung, Munich

D. Desiderata

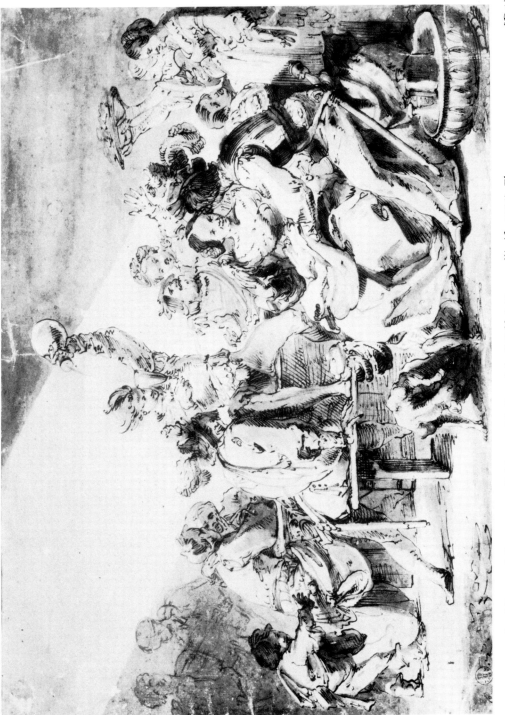

74　Banquet of Soldiers and Courtesans · Gabinetto dei disegni degli Uffizi (Santarelli gift, 1866), Florence

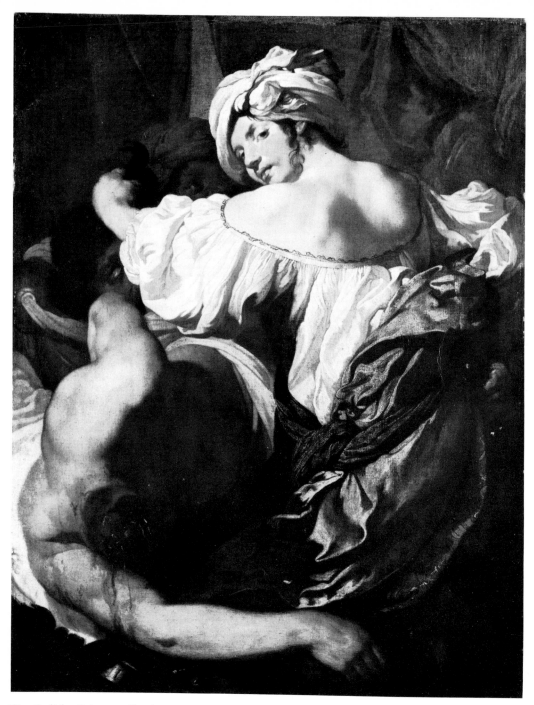

75 Judith · Private collection

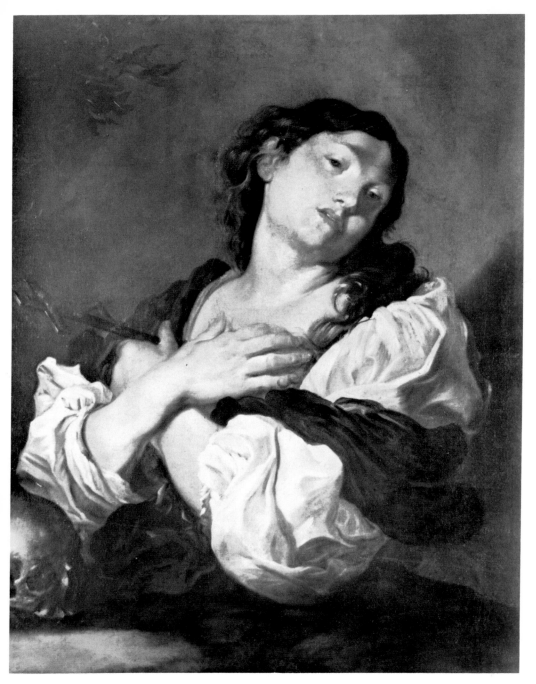

76 The Repentant Magdalene · Muzeum ve Slavkově u Brna, Slavkov, Czechoslovakia [D 3]

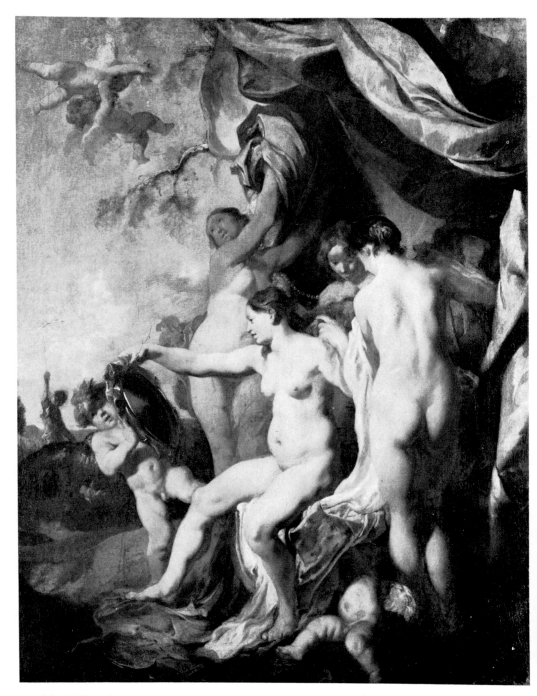

77 The Toilet of Venus · Galleria degli Uffizi, Florence [D 4]

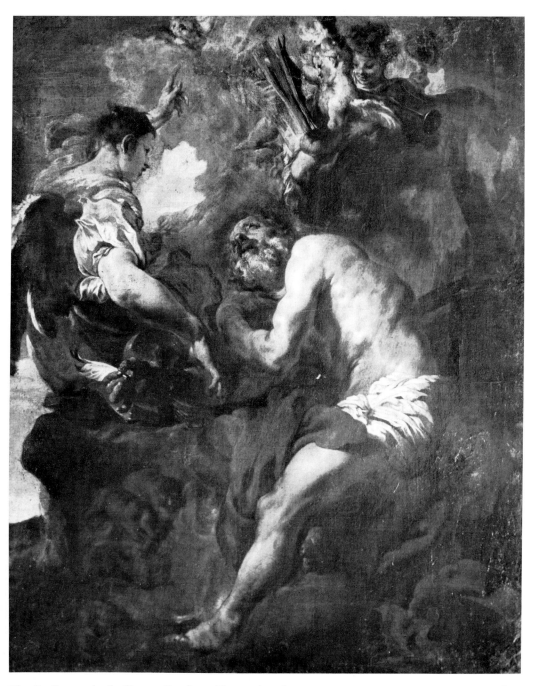

78 St. Jerome in the Desert Comforted by an Angel [D6]
Museo Civico d'Arte e Storia, Vicenza

79 Sacrifice of Isaac · Galleria dell'Accademia, Venice

E. Study Exhibition

81 Kilian [E 3]

82 Matham [E 4]

83 de Jode II [E 5]

84 Waldreich [E 6]

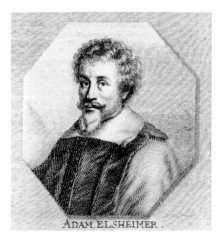

85 Waldreich [E 7]

86 Kilian [E 8]

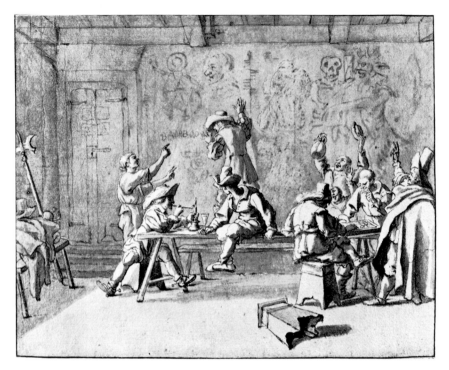

87 van Laer [E 9]

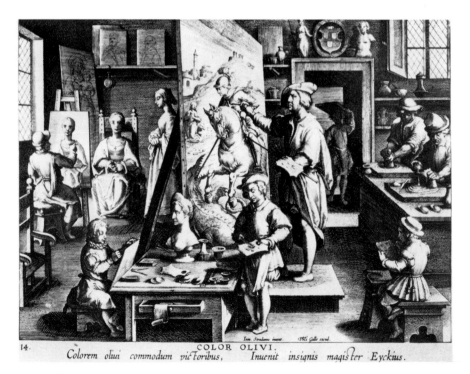

14. COLOR OLIVI.
Colorem oliui commodum pictoribus, Inuenit insignis magister Eyckius.

88 Collaert [E 10]

89 Vorsterman [E 14]

90 van Leyden [E 12]

91 Beham [E 13]

92 Beham [E 15]

93 Beham [E 15]

94 Beham [E 15]

95 Buytewech [E 16]

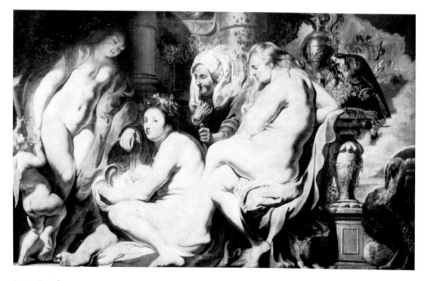

96 Jordaens [E 17]

97 Moreelse [E 19]

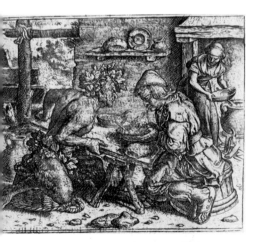

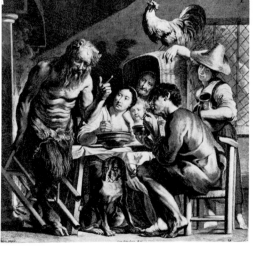

8 Gheeraerts I [E 20] 99 Vorsterman [E 21]

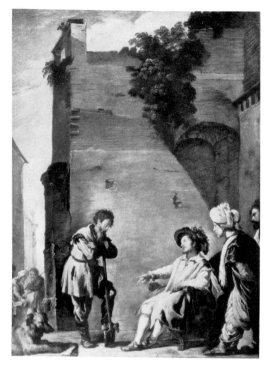

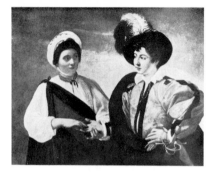

101 Caravaggio [E 24]

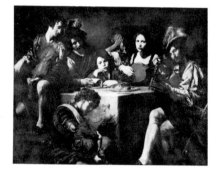

100 Fetti [E 22]

102 Valentin [E 25]

103 Caravaggio [E 23]

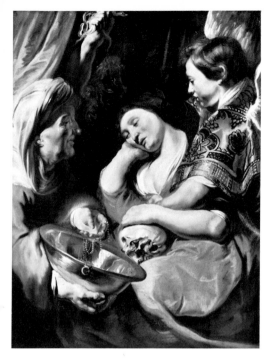

104 Jordaens [E 26]

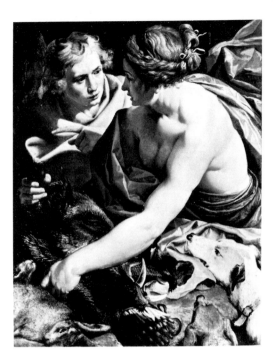

105 Janssens [E 27]

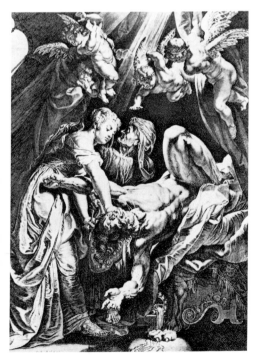

106 Galle I [E 28]

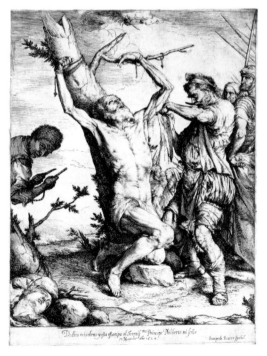

107 Ribera [E 29]

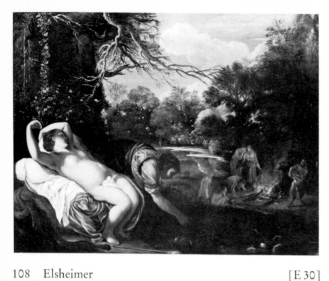

108 Elsheimer [E 30]

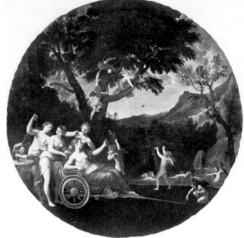

109 Albani [E 33]

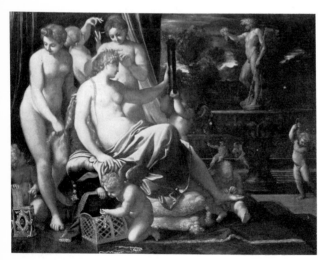

110 A. Carracci [E 32]

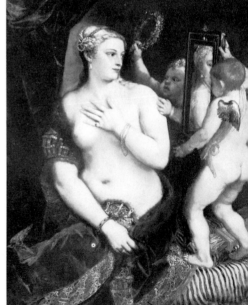

111 Titian [E 3

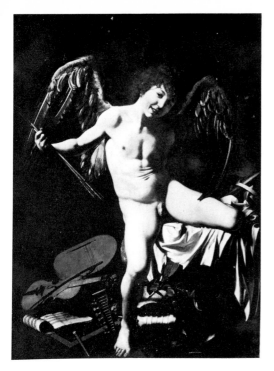

112 Caravaggio [E 34]

113 Anonymous [E 37]

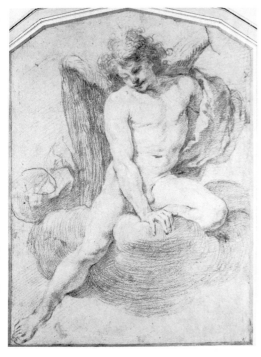

114 Fetti [E 36]

115 Caravaggio (detail) [E 35]

116 Veronese [E 38]

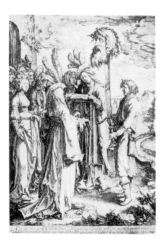

117 Saenredam [E 39]

118 Renieri [E 42]

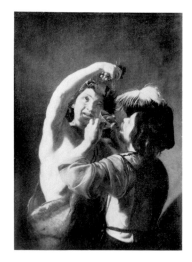

119 Manfredi [E 40]

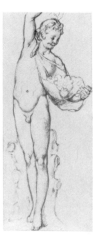

120 Goltzius [E 41]

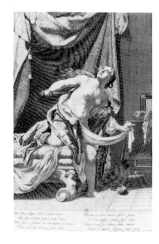

121 Mellan [E 45]

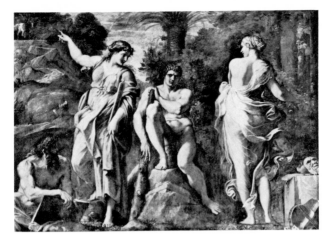

122 A. Carracci [E 43]

123 dal Pozzo [E 44]

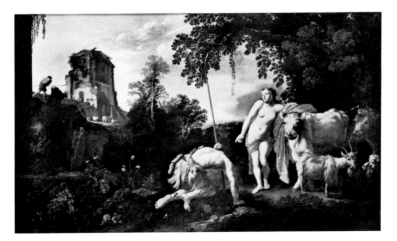

124 Uyttenbroeck [E 46]

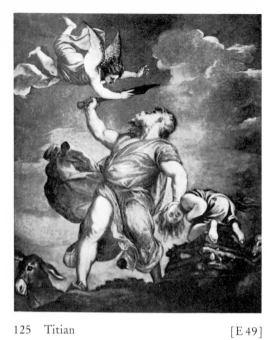

125 Titian [E 49]

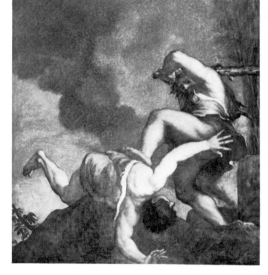

126 Titian [E 47]

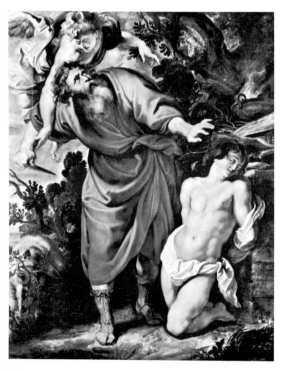

127 Rubens [E 50]

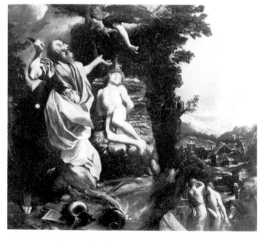

128 L. Carracci (detail) [E 51]

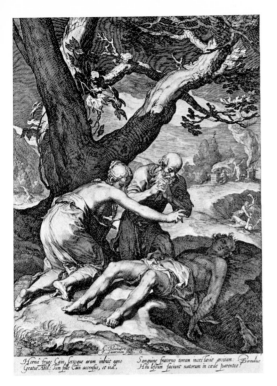

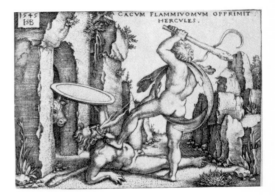

129 Saenredam [E 52]

130 Beham [E 48]

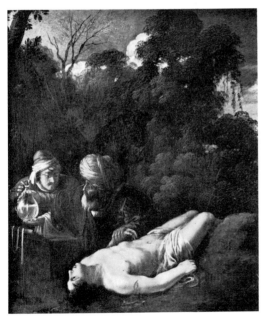

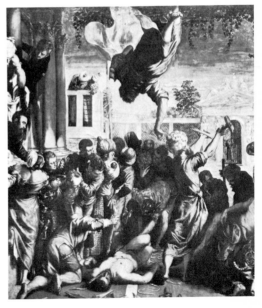

131 Elsheimer (detail) [E 55]

132 Tintoretto (detail) [E 54]

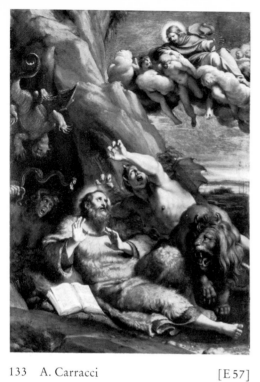

133 A. Carracci [E 57]

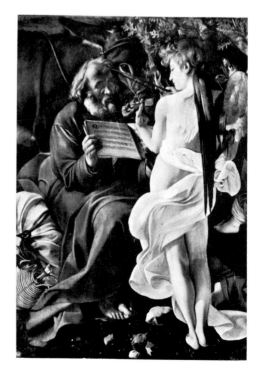

134 Goltzius [E 59]

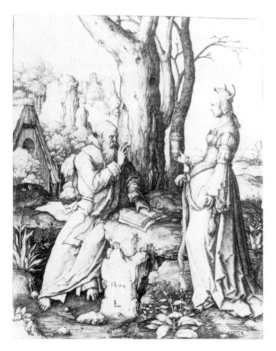

135 van Leyden [E 56]

136 Caravaggio (detail) [E 58]

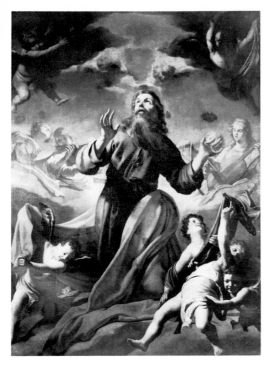

137 van Honthorst [E 60]

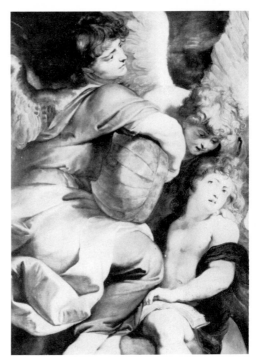

138 Rubens (detail) [E 61]

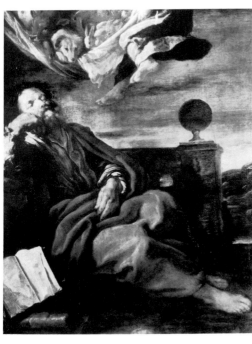

139 Fetti [E 62]

140 Caliari (detail) [E 69]

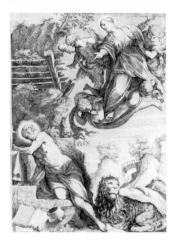

141　A. Carracci　　[E 63]

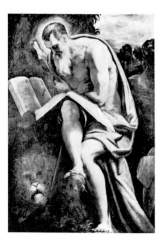

142　Tintoretto　　[E 64]

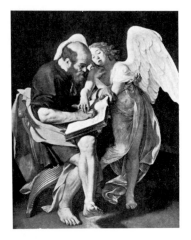

143　Caravaggio　　[E 65]

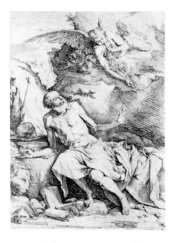

144　Ribera　　[E 66]

145　Beham　　　　　　　　　　[E 67]

146　Callot　　　　　　[E 7

147 Rousselet [E 71]

149 Franck [E 72]

148 Strasser [E 73]

150 Franck [E 72]

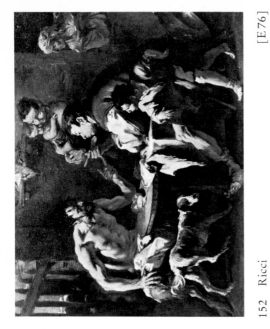

151 Favray [E 74]

152 Ricci [E 76]

154 Ricci [E 75]

153 Anonymous [E 77]

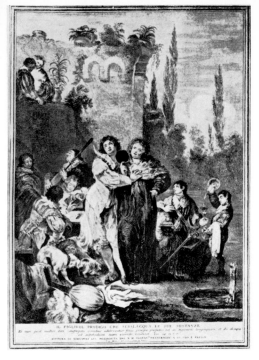

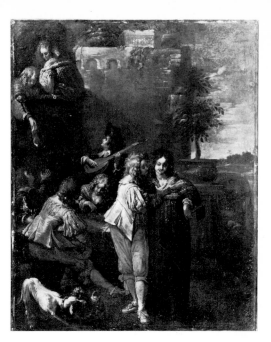

155 Monaco [E 78] 156 Spillenberger [E 80]

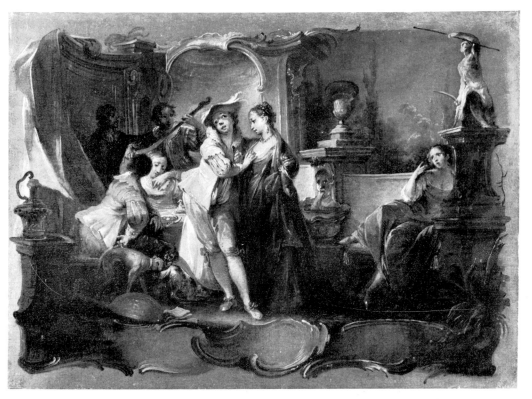

157 Baumgartner [E 79]

159 Franck [E 82]

161 Blanchard (detail) [E 90]

158 de Vos [E 83]

160 Maulbertsch [E 91]

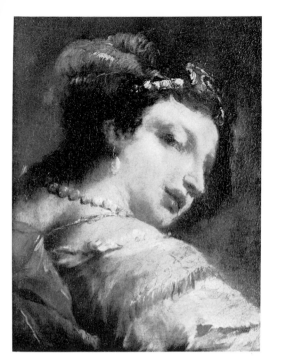

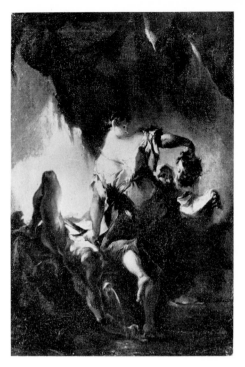

162 Guardi [E 84] 163 Maulbertsch [E 85]

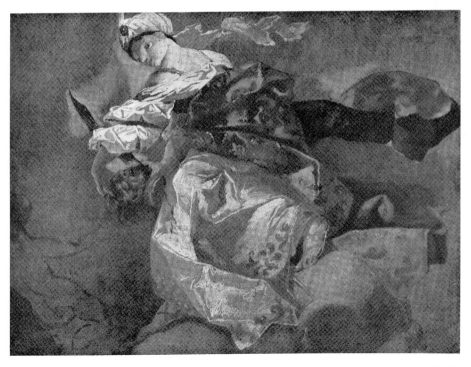

164 Maulbertsch [E 87]

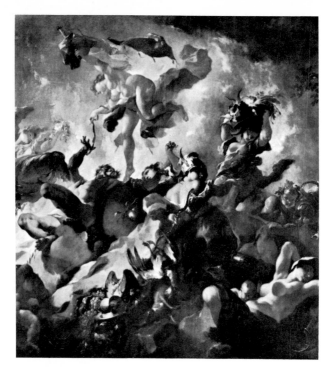

165　Maulbertsch (detail)　　　　　　　　　　[E 86]

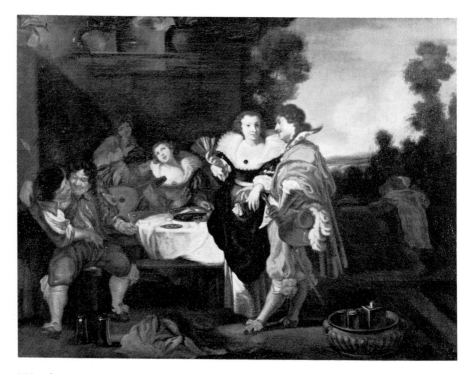

166　Anonymous　　　　　　　　　　　　　　[E 92]

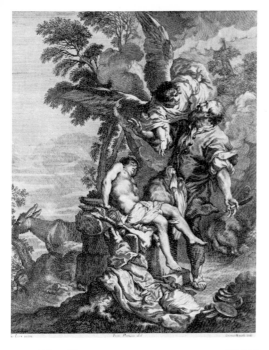

167 Mogalli [E 93]

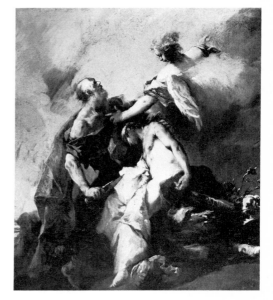

168 Guardi (detail) [E 97]

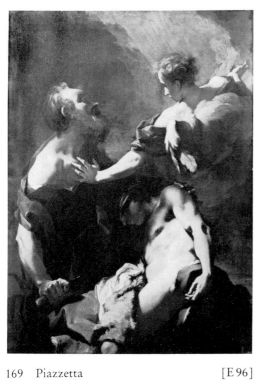

169 Piazzetta [E 96]

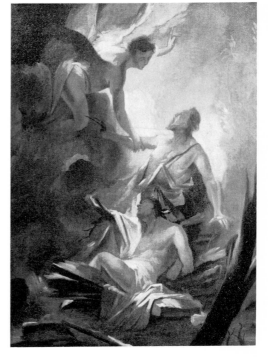

170 Sigrist [E 95]

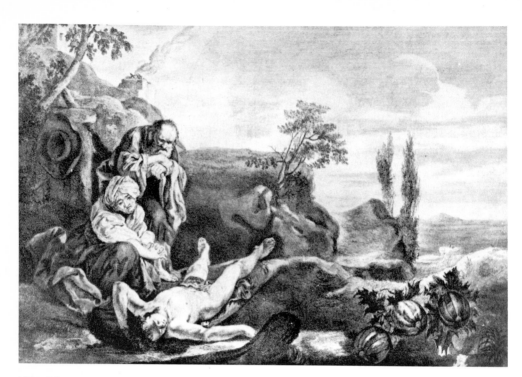

171 Monaco [E 100]

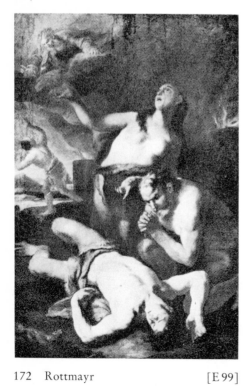

172 Rottmayr [E 99]

173 Fragonard [E 101]

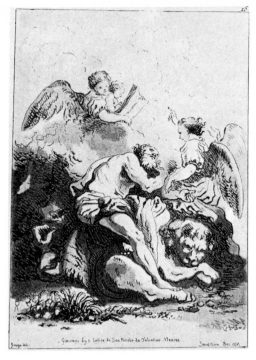

174 Fragonard [E 103] 175 Saint-Non [E 104]

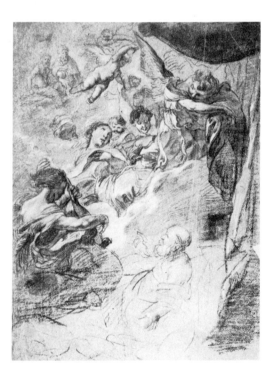

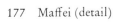

176 Anonymous [E 102] 177 Maffei (detail) [E 105]

178 Sadeler [E 89]

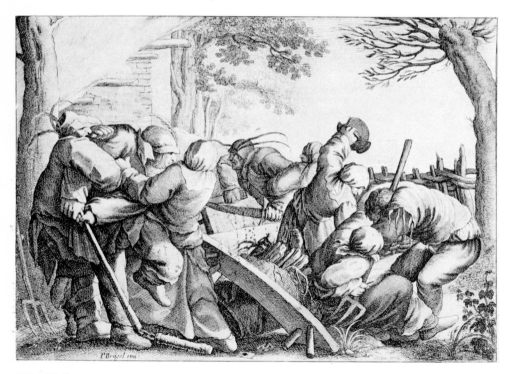

179 Hollar [E 107]